Gabriel Greenberg dedicates this book to all of my teachers.

Peter Gottschalk rededicates this book to Ariadne, my daughter and inspiration.
He also dedicates it to the late Jack Shaheen,
who revealed to us so much about the images we watch,
and to the late Saba Mahmood,
whose work changed so much so quickly, yet in too brief a time.

Contents

Acknowledgments

The seed for this book was sown in a slide lecture by Professor John Woods at the University of Chicago. Inspired by Sam Keen's *Faces of the Enemy*, this lecture discussed the portrayal of Muslims and Islam in American political cartoons. Peter, in the audience as a graduate student, left motivated to include political cartoons in his own classes once he began to teach. When he did, it helped inform the interest of Gabriel, who investigated the topic in his senior honors thesis. For both, Keen's book—its limitations notwithstanding—provided useful insights and illustrative examples for their own research.

This second, revised edition owes its greatest debt to Sarah Stanton, who is our editor, and the other members of Rowman & Littlefield who have been good friends to the first edition and helped it find reenergized life a decade after its original publication. We also thank Courtney Packard and Janice Braunstein, as well as all the others at our publisher who made this edition possible.

Both authors are indebted to Wesleyan University, which provided funds to defray the copyright costs of publishing the cartoons included in the volume. Special thanks go to Deans Don Moon and Marc Eisner for their unwavering support. We also acknowledge the important insights contributed by members of the Wesleyan University community, especially Patricia Rodriguez Mosquera, Charles Sanislow, Sarah Kamens, and Bruce Masters, as well as students whose various observations and insights in class have contributed to our understanding. Both of us are under a great debt of obligation

to Sheri Dursin, Millie Hunter, and the late Rhonda Kissinger, who worked so hard tracking down and obtaining the permissions necessary for the volume, and to Allyn Wilkinson and Kendall Hobbs for their help with the cartoons. Meanwhile, Shoko Yamada offered a critically important response that helped reshape chapter 6. Beyond Wesleyan, we appreciate Carl Ernst for his comments, Margrit Pernau for her suggestions, Bruce Lawrence for his insights, and John Esposito for his support.

Gabriel would personally like to offer thanks to his family and his professors at Wesleyan, especially Vijay Pinch, who prodded me toward a love of history and knowing; Vera Schwarcz, for her compassionate approach to understanding; and Peter Gottschalk, who inspired this work through his commitment to revealing to us what it is we think. Peter has much to teach about tolerance and coexistence, and I am a proud (yet work-in-progress) product of that education.

Peter would like to acknowledge his father, Rudolf Gottschalk, and his friend Phil Hopkins for their invaluable and insightful editorial comments and suggestions. Shannon Winnubst deserves particular thanks for her encouragement to pursue this project. I also appreciate the insights offered by faculty and students at Wesleyan University and Southwestern University with whom I have had the privilege of sharing my thoughts on these matters and who prove the adage that we are all teachers of one another. Of course, Gabe Greenberg deserves my deepest appreciation for working with me. This book results directly from his interest, which nurtured the nascent project; his research, which established its historical roots; and his outstanding writing and editing, which brought it to fruition. Finally, and always first, I acknowledge the inestimable support of my mother and the rest of my family during the difficult days of this work's initial composition, and—most of all—the exuberant, loving presence of my daughter, Ariadne, in my life and work: Writing remains lifeless without love.

Note on Terms and Names

The difficulties of rendering names and terms originating in non-English languages into English are numerous. This has been particularly true of words that derive from Arabic, a language both written in scripts that do not commonly depict short vowels and pronounced with variations by its myriad speakers. The same is somewhat true for Persian. Therefore, the name Muhammad—most commonly written in Arabic using only the consonants *m*, *h*, *m*, *d*—has variously been reproduced in English as Mohammad, Mohammed, Muhammad, and Muhammed. Historically, those with an incomplete understanding of Arabic have also rendered the name as Mahomet and Mohamed. Meanwhile, some authors have attempted to reflect long vowels by doubling them in English, writing *Islaam* for *Islām*, for instance. Finally, some terms have worked their way into the English language with a popular, albeit less accurate, version such as Koran instead of the more accurate transliteration of Quran.

Because this book is intended for a general audience, it represents non-English words and names following scholarly convention except where this causes unnecessary confusion. Therefore, transliteration markings used to denote Qur'ān are omitted and Quran preferred instead.

Finally, as a product of empirical scholarship, this book makes no claims about the "true" definition of Islam or the "proper" behavior and beliefs of Muslims. The large scope of its investigation requires that the volume necessarily generalizes about the religion and its adherents without making definitive claims about either. The authors avoid universalizations by using modifiers

like "many" and "most" rather than "all" in describing even the most common concepts and practices. One and a half billion people across myriad cultures and countries identify themselves as Muslim. The only thing more astonishing than their diversity as Muslims is the common significance of the term "Islam"—variously defined in meaning and requirement—in so many of their lives. We take this as a nonpartisan starting point in the description of Muslims and their cultures—their self-description as part of Islam—while we, as non-Muslim scholars, reference "Islamic traditions" in order to avoid the suggestion that we claim to describe or define "Islam" as a singularity.

Introduction to the Second Edition

If you are skeptical about the notions "Islamophobia" or "anti-Muslim sentiment," get a piece of paper and brainstorm. Write down, with as little thought and as much honesty as possible, all the words that come to mind when you think of the words "Islam" or "Muslim." What names, places, events, ideas, practices, and objects do you associate with these terms?[1]

Most non-Muslim Americans whom we have asked to do this exercise over the past two decades have given an almost routine set of answers. The names and events they think of tend to be associated with violence (e.g., the Taliban, the 9/11 tragedies, Palestinian suicide bombers), the ideas and practices associated with oppression (e.g., jihad, veiling, Islamic law), and places limited to the Middle East (e.g., Syria, Iran, Saudi Arabia). Some of these vary with their pertinence to the day's headlines; so the so-called Islamic State takes precedence as Osama bin Laden's name dims in memory. To be sure, some answers escape this pattern (e.g., boxer Muhammad Ali, pilgrimage to Mecca, the Quran), but these are relatively few. When asked about their answers, many Americans respond that, unfortunate as such associations may be, Muslims and Islamic traditions feature prominently in many of the world's conflicts and injustices. Meanwhile, given their virality, various falsehoods ("most of the world's terrorists are Muslims," "Muslims must kill all infidels," "they hate us because we're free") have risen to the level of cultural meme, seemingly becoming true through mere repetition. And this, Americans often conclude, reflects something inherent about Islamic traditions and their associated cultures. Judging from the unnuanced, negative

1

portrayals of Muslims and their heritage that are still too prevalent in the American media, it's hard to argue with those Americans.

However, these answers seem less certain in the face of certain facts. For instance, more Muslims live east of Afghanistan than west of it, rendering the Middle East a demographically minor place in the "Muslim world" relative to South and Southeast Asia. As of 2018, the nations with the most Muslims are, in order, Indonesia, Pakistan, India, and Bangladesh. Although the numbers can only be estimated, about 1.8 billion people identify themselves as Muslim globally—that is, roughly one in four people.[2] The vast majority of these Muslims do not participate in political violence, and few aspire to establish an Islamic state in their own country, let alone force one upon others. If the case were otherwise, the world would be incalculably more convulsed than it is. Indeed, the "Islamic State" that first emerged in Syria and Iraq is notable for the uncommonness of its religiopolitical self-description.

The question, then, is how, in the minds of so many Americans, has "Islam" become synonymous with the Middle East, Muslim men with violence, and Muslim women with oppression? The answer points to a history—almost as old as the oldest Islamic community—of confrontation between a principally Christian Europe and predominantly Muslim Middle East over economic resources, political power, and religious sites. Or so it would be portrayed; in fact, the supposed "two sides" never represented a united Europe nor Middle East, and members of each "side" often battled among their coreligionists as much as against their presumed enemies. For instance, during that quintessential set of events associated with the supposed division between Christian Europeans and Muslim Middle Easterners—the Crusades—Christians left a politically fractious Europe and attached themselves to Crusader states that as often allied themselves with Muslim-led states against other Crusaders as they did with Christian-led ones. Many Muslim heads of state made similar alliances with Crusaders against other Muslim-led forces. Nevertheless, during the centuries of crusading and in other instances when competition unfolded between Christian Europeans and Muslim Mediterraneans (often enough, until the last two centuries, unfavorably for Europeans), Europeans came to negatively portray all Muslims so effectively and so universally that the terms "Islam" and "Muslim" inherently evoked suspicion and fear on the part of many in Europe and its erstwhile colonies, such as those in North America.*

*Any antipathies that were caused by the Crusades and arose toward Christians and their religious traditions within Muslim-majority Mediterranean lands were mitigated by two factors. First, Christian minorities enjoyed a significant presence in many regions (no similar Muslim minority existed in most of Europe) and, second, most Islamic traditions have positively recognized Jesus and Christians

These are the roots of Islamophobia and anti-Muslim sentiment.

One measure of the significance of these phenomena is the tenacity of their stereotypes. Despite more than a half century of both economic dependence on Middle Eastern oil and political involvement in regional political affairs, American images and understandings of the cultures there remain largely unchanged. Pyramids, men in kaffiyehs, exotic women, minarets, and onion-domed mosques remain as central components of a stereotypical scene, from the package for Camel cigarettes to the decor of the former Trump Taj Mahal Casino in Atlantic City to the settings of innumerable Hollywood films. Often these Western symbols of Muslims and Islamic traditions imply latent or actual violence directed outward at "unbelievers" or inward toward women. For instance, even the stereotype-busting blockbuster film *Black Panther* (2018)—celebrated for its endeavors to defy typical American views of black cultures—traffics in these images: the hero T'Challa attacks a convoy filled with kaffiyeh-swathed soldiers transporting captive women who remove their head scarves when relieved by their rescue.[3] The implied Muslim identity of these antagonists offers nothing that advances the film's storyline, which includes no other Muslims. As many Muslim women who wear head scarves in public have attested, non-Muslim Westerners often assume that the women cover themselves under the coercive command of their fathers or husbands, whereas many—though certainly not all—have chosen to do so over the protests of these men.[4] Meanwhile, the kaffiyeh has become symbolic of "Islamic terrorism" even in Western depictions of Muslim men who largely do not wear it, such as Afghans and Pakistanis.

Despite nearly 1,500 years of Jewish-Christian-Muslim interaction and dialogue, most Western Jews and Christians (as well as atheists and agnostics) today are likely to depict Muslims as holding jihad (struggle) as a central tenet, assuming it essentially equates with violence. In doing so, they fail to understand that Islamic conceptions of jihad actually reference a variety of religious struggles (including against one's personal failures of faith and practice), that only a small minority of Muslims today and historically has ever engaged in religiously motivated armed conflict, and that those who do so today most commonly face criticism—not cooperation—from fellow Muslims. For in-

(a similar view of Muslims has no parallel in most Christian traditions). However, the centuries of modern European colonial and imperial conquest of almost every predominantly Muslim country (among others), accompanied by missionary proselytization efforts beginning in the seventeenth century, have created a broader suspicion and antagonism among many Muslims. In a similar manner, deep hostility to Jews erupted among many Muslim Arabs following the post–World War I arrival of Jewish settlers in British-mandate Palestine and the eventual creation of the state of Israel. This led to the persecution and even exile of Jewish communities that had existed for more than a millennium in the Middle East and North Africa. Hence, it would be anachronistic to project these antipathies back across the breadth of Islamic history.

stance in 2014, following Abu Bakr al-Baghdadi's declaration of the so-called Islamic State caliphate established by jihad, a group of 126 leading Islamic scholars wrote an open letter that joined many other Muslims in condemning both the caliphate and its justification of violence.[5] Unfortunately, the 2005 riots that overtook many French cities demonstrated the presumption of this violent tendency, despite such condemnations.

Although led by some North African immigrants and their French-born children, who felt racially marginalized as Arabs and roundly rejected as French—and despite the urging of Muslim French leaders for peace—the riots were depicted promptly by many European and American newscasters as instigated by Muslims. No evidence existed that they acted out of religious motivations. While the last thirty years have seen the emergence of many relatively small militant movements legitimating their violence against governments and civilians through specific interpretations of Islamic ideologies, the assumption that any violence is religious by nature when perpetuated by someone who happens to be Muslim remains unfortunately common among many non-Muslim Westerners. Such misperceptions feed a deepening cycle of misinformation about Muslims that heightens Islamophobia and aggravates the marginalization and grievances of Muslims.

Islamophobia: "anxiety of Islam"? Can this really be compared to individual psychological traumas such as acrophobia, arachnophobia, or xenophobia? The authors believe that "Islamophobia" accurately reflects a *social* anxiety toward Islamic traditions and Muslim-majority cultures that is largely unexamined by, yet deeply ingrained in, Americans (even some Muslim Americans). Instead of arising from traumatic personal experiences, like its more psychological cousins, this phobia results for most from distant social experiences that mainstream American culture has perpetuated in popular memory, which are in turn buttressed by a similar understanding of current events. This anxiety relies on a sense of otherness, despite many common sources of thought.

Different but not entirely distinct, "anti-Muslim sentiment" refers to the racist and ethnocentric attitudes and emotions that particularly have burgeoned among Americans in the past few decades. While Islamophobia instills unfounded fears such as all Muslim Americans promote the nation's "shariaization" or pass death sentences on all non-Muslims, anti-Muslim sentiment fosters repugnance toward those stereotyped as "Arab," "Pakistani," and/ or "brown." More simply put, Islamophobia is *fear* of a religious ideology and practice, while anti-Muslim sentiment is the *rejection* of certain types of bodies.

Unfortunately, American and European attention has focused most readily on divergence instead of convergence. For example, we might consider

the geographic proximity of the roots claimed by mainstream America and Muslims. Until the recent engagement with multiculturalism, the custodians of American culture traced its historical trajectory backward along an arc reaching through Europe to the ancient eastern Mediterranean: classic Rome and Greece. This often overlooked the fact that the Arabs of the medieval period bore primary responsibility for bequeathing the Greek classics, having translated and developed them in Arabic over centuries (as evidenced by the presence in English and other languages of Arabic mathematical and scientific loan words such as algebra, algorithm, giraffe, nadir, and zenith), to "the West" as it emerged from its self-described "Dark Ages." Religiously, too, American popular wisdom has alienated itself from Islamic traditions as it has defined Christian and Jewish traditions as "Western religious traditions" and Islamic ones as "Eastern." It has done so despite the fact that the first two sets of traditions originated in a region less than two hundred miles west of where Muhammad lived and that all three sets of religious traditions have been infused with ideals of monotheism and recognition of nearly the same prophets. In happy contrast, more recent endeavors to instead think in terms of "Abrahamic traditions"—based on a common heritage traced to the patriarch/prophet Abraham/Ibrahim and other features shared by many if not most Jews, Christians, and Muslims—have gained greater acceptance in the United States.

Of course, one reason that many non-Muslim Americans have misperceptions about Muslims or Islamic traditions is that they are unlikely to encounter either. With only about 3 million Muslims in a population of 325 million and little representation on film or television (beyond the news), the public profile of most Muslim Americans remains low, although it is rising. According to a 2014 Pew poll, only about 38 percent of Americans report knowing a Muslim.[6] Meanwhile, with the exceptions of Jerusalem, Turkey, Egypt, and India, places with significant Muslim populations have rarely featured prominently on American tourist itineraries. However, in times of crisis, such as the 1979 Iranian hostage situation or, more recently, the September 11, 2001, attacks and the ensuing, occasional attacks against civilians elsewhere in the United States and in European metropolises, long-simmering resentments, suspicions, and fears manifest themselves most directly in conditions that appear to affirm many Americans' darkest concerns.

The importance of recognizing these sentiments grows increasingly more urgent for three reasons. First, foreign Muslim populations increasingly consider intrusive, international American interests as antithetical to their own and American foreign policy as threatening to Muslim-majority states. The 2003 US-led invasion of Iraq, with its unsubstantiated justifications

for regime change in a resource-rich nation, represented just the most recent fulfillment of decades of suspicions and fears among many Muslims in the Middle East and beyond. Second, as a tiny but dedicated fraction of these populations employ very lethal means of retaliating against what they perceive as the anti-Islamic or anti-Muslim policies of the US government, these unwarranted prejudices will appear to be confirmed among Americans. Third, as increasing numbers of Muslims live in the United States—and will eventually represent the largest non-Christian religious population—they increasingly become the targets of hate crimes and discrimination, particularly after attacks by international and domestic Muslim militants with whom only the smallest numbers of American Muslims have any sympathy. Although some news sources in the past two decades increasingly have endeavored to portray people who happen to be Muslim in ways that do not forefront their Muslim identity while also drawing positive attention to the presence of Muslim communities in ways that normalize their Americanness, negative attitudes remain virulent and in particular circumstances erupt into view.

Like a vicious cyclone feeding off its own energy, these sentiments cumulatively feed policies that in turn produce reactions that reinforce the original sentiments. Certainly, American suspicions of Muslims and their rage regarding the attacks of September 11 facilitated popular acceptance of the Bush administration's claims that Saddam Hussein's Iraq had cultivated ties with "Islamic terrorists" and harbored weapons of mass destruction that they might pass to radical Islamic organizations or rogue Muslim governments. For some Americans, domestic Muslims either have come under increasing suspicion as a potential fifth column or have become symbols of "those people." Meanwhile, in the aftermath of the invasion of Iraq, Muslim opinion of the United States in most countries has plummeted. Despite the assurances of the Bush administration that their war targeted terrorism—not Islam—its use of the term "crusade," its invasion of two Muslim-majority countries and belligerence toward Iran and Syria, and the employment of Christian aid organizations in reconstruction efforts all appear to reaffirm international and domestic Muslim opinion that Americans inherently distrust and disrespect Muslims while pursuing destructive economic interests and proselytizing Christianity. Although initially encouraged by President Obama's 2009 Cairo speech to Muslims around the world, many Muslims at home and abroad found too little change in the new administration's prosecution of war in Afghanistan, use of drone strikes, and unwillingness to speak more directly to endemic American Islamophobia. Meanwhile, the ascent of Donald Trump to the presidency only appears to affirm the worst fears of

many Americans and non-Americans, particularly given his successful use of nativist and Islamophobic rhetoric (among other forms of divisive speech) to successfully pursue the campaign. The outrage that all of this prompts among many Muslims feeds violent responses perpetrated by a few, which, completing the cycle, are used to justify yet more attacks against Muslim targets.

The present work attempts to demonstrate the presence of these anxieties by examining two types of popular expression: film and, in particular, the editorial or political cartoon. Whereas previous authors have documented the anti-Muslim content of literature, movies, and the media in general,[7] none have considered political cartoons at length. These cartoons offer vivid expressions of Islamophobia because they are images created as immediate responses to events. As such, they clearly express the latent sensibilities of their cartoonists (and, by extension, of society), who must craft their responses quickly in order to remain current. Our argument is not that these depictions represent prejudiced artists but that they reflect attitudes that are widely disseminated among non-Muslim Americans, including the artists. Meanwhile, a brief exploration of Hollywood films complements this investigation of political cartoons by demonstrating how a globally influential medium has broadcast the tropes of Islamic terrorism and misogynistic violence as well as the image of Muslims who appear "safe" only when devoid of religious commitments. While some screenwriters, directors, and producers may deliberately project such messages, many others undoubtedly draw on latent notions and attitudes as they apply well-known images, storylines, and character-types to appeal to the largest potential audience.

The terms "Islamophobia" and "anti-Muslim sentiment" hope to suggest exactly these latent ideas and feelings. Despite accelerating efforts to recognize and call out these prejudices, their invisible normality in many parts of society makes the antagonism toward Muslims and Islamic traditions difficult to engage, let alone counter. This remains evident specifically in particular memes so frequently repeated that they appear self-evidently true. Since the September 11 attacks, it has become common to hear media figures and everyday folk argue with statements that most Muslims do not support that crime and similar acts of violence. "Most Muslims aren't terrorists," a popular truism goes, "but all terrorists are Muslims." Few people wonder why reporters, editors, and law enforcement have for too long labeled violence committed against civil society by predominantly white, right-wing extremists as "crime" perpetuated by individuals, while that done by predominantly nonwhite Muslim extremists is labeled as "terrorism" inspired by religion. Many people ask, "Where are the moderate Muslims? If most Muslims don't

like the terrorists, why don't their leaders say so?" When asked, "How would you know if they did condemn the violence?" they reply, with absolute confidence, that their news sources would certainly tell them.

Sadly, media outlets have consistently overlooked the voices of moderation that come from the majority of Muslims, although some improvements have recently appeared. When violence flared in 2006 over the controversial Danish cartoons of the prophet Muhammad, most of America's frontline newspapers took days to report—if they did at all—condemnation of the violence, which was issued immediately by the Council on American-Islamic Relations (CAIR), one of the most important Islamic organizations in the United States and only one of many that decried the attacks. In another instance the year before, a Connecticut newspaper ran an editorial disparaging the lack of public statements by Muslim leaders against the then recent terrorist attacks in London.[8] The state chapter of CAIR wrote back asking why the newspaper had not mentioned its denunciation of the violence, which the group had sent the newspaper. In fact, after this event, a great variety and number of Muslim leaders in the United States and abroad condemned the attacks but received little coverage in American media. A large proportion of Americans rely on the mass media for news of the world, but this collection of news and entertainment agencies operates under most of the same ingrained perspectives as their audiences. Their reporting often reinforces these views, challenging them only at the risk of losing popularity, ratings, and commercial success.

It has been observed that movements against discrimination do not begin until a commonly understood label evolves that brings together under one banner all forms of that particular prejudice. Resistance to gender discrimination coalesced around "sexism." The Civil Rights Movement gained momentum when harnessed to the notion of "racism" that encapsulated a variety of innate prejudices and institutional obstacles in a white-dominated society. The concept of "anti-Semitism" has provided a powerful tool to object to anti-Jewish sentiment that was once, like the disparagement of women and blacks, considered normal and left largely unchallenged by people fitting the norm. And "homophobia"—coined with its current meaning in the 1960s—helped those outside queer communities appreciate the unconscious fears and reactive hatreds that their societies had so deeply instilled within them.

When we first published this volume in 2007, only a handful of books in English had previously used the term "Islamophobia" in their titles, and few news outlets used it. We wrote at the time, "Increasingly, and particularly among Muslims, 'Islamophobia' provides a term to similarly draw attention to a normalized prejudice and unjustified discrimination. Undoubtedly this

term will elicit the same unease among and even backlash from some of those whose notions of normal it challenges, just as its historical predecessors have and still do."[9] This proved unfortunately accurate. As the term has found a ballooning acceptance—and the phenomenon accelerating acknowledgment—many public commentators have denied the reality of Islamophobia and refuted the use of the term. Some have complained that it is not a phobia (that is, an exaggerated fear) if the threat proves real. For increasing numbers of Americans as well as Europeans (although not nearly enough), such arguments sound as convincing as those denying that women have fewer opportunities than men, those blaming people of color for racism, those promoting an international Jewish conspiracy, and those viewing gay love as a mental disorder.

This revised second edition continues the work of the first edition of explaining Islamophobia and anti-Muslim sentiment while complementing the growing scholarly attempts to map the landscape of these antagonisms, with particular attention to the changes of the past decade in the United States. Much more than any decade in US history, the last ten years have proven particularly dynamic with regard to social, cultural, and political re-orientations and contestations regarding Muslims, their relationships with non-Muslim Americans, and Islamic traditions. The election of Donald Trump to the presidency represents less a change in earlier conditions than the unfortunate culmination and seeming legitimation of longstanding na-tivist, racist, and Christocentric forces for whom the president's manifest bigotry offers license to publicly express their own prejudices. In contrast, his effort to impose immigration bans against certain Muslim-majority countries motivated thousands of non-Muslims to keep vigil at airports across the country in order to welcome Muslims to the United States. Their pervasive use of "Islamophobia" as a rallying cry demonstrates the impor-tant work that the term accomplishes.

Political cartoons—born in a strict economy of word and image and drawn under the pressures of the news cycle and its expiring relevance, and expressive of popular thoughts and feelings regarding topics that they seek to address—often reflect perspectives either expressive or critical of Islamopho-bic and anti-Muslim sentiment. Many films offer similar expressions, albeit through a very different and far more complicated use of imagery. For that reason, as well as the fact that we two authors like to indulge in cartoons ourselves for both their editorial and comedic value as well as in movies, we have chosen to use this argumentative art form to explore the depths of and recent changes to American Islamophobic and anti-Muslim sentiment.

CHAPTER 1

—m—

How Cartoons Work
and Why Images Matter

In May 2015, an Islamophobic provocateur sponsored a "Draw Muhammad" competition in Garland, Texas. This proficient agitator undoubtedly chose the site knowing that a neighboring town's mayor had previously cultivated controversy using false claims about Muslims[1] to successfully bolster her political career.* Two Muslim Americans rose to the bait and attacked the gathering, both dying in the ensuing police shoot-out. A court found a third man guilty of aiding them with the intent of supporting the so-called Islamic State, which belatedly took responsibility for the attacks days later.[2] The organizer, Pamela Geller, claimed she planned the event in order to encourage people to draw the Muslim prophet as a response to the murderous attack on the offices of the French satiric magazine *Charlie Hebdo* earlier that year, which left twelve people dead, including five cartoonists. That magazine regularly used caustic cartoons to lampoon prominent political, business, and religious figures. The governments of Saudi Arabia, Iran, Jordan, Morocco, Algeria, the authoritative Al-Azhar University in Cairo, and Muslim organizations in France, Europe, and elsewhere all condemned the attack even as some Islamic State members celebrated.[3] Relatedly, the magazine had already courted controversy with Muslims in 2006 by republishing the (in)famous Danish-patronized cartoons of Muhammad from the year before.

In September 2005, the Danish newspaper *Jyllands-Posten* published twelve depictions of Muhammad that its culture editor, Flemming Rose, had

*Indeed, Mayor Beth Van Duyne became a regional administrator for the Department of Housing and Urban Development in 2017 at the invitation of the newly inaugurated Trump administration.

commissioned from artists. Rose had tendered this commission as a protest to the hesitancy he noticed among some Europeans to offend Muslims. He noted artists who would not illustrate a biography of the prophet and who would performatively urinate on a Bible but not on a Quran, and an art museum that withdrew an installation depicting the shredded remains of the Quran, Talmud, and Christian Bible.[4] A Dutch Muslim, offended by some of the images that *Jyllands-Posten* published, sought redress from the newspaper and the government but found none. At his prompting, eleven ambassadors of Muslim-majority nations asked for a meeting with the Danish government, which turned down their request. The plaintiff then turned to the scholars of Al-Azhar University and the secretary general of the Arab League in Lebanon, all of whom condemned the images.[5] Finally, awareness of the cartoons became widespread after they made the rounds at an Islamic conference in Mecca.[6] A global protest soon grew, typified by peaceful gatherings of thousands of protestors in many places but overshadowed in the Western media by more attention-grabbing violence in Damascus, Beirut, Tehran, Kabul, Lahore, and Benghazi.

Once more the familiar pattern had unfolded, as some Muslims reacted violently to an ostensibly insignificant event that seemed to represent the latest battlefront in the West's holding action to preserve inalienable rights against ever-threatening Islamic intolerance. Although the Muslims involved never represented more than a fraction of a fraction of the world's 1.8 billion Muslims, this tiny minority's vociferous fury only confirmed a Western image of inherent Muslim intolerance and divergent Islamic values. The media's consistent disinterest in nonviolent Muslim perspectives hardened this view. The perception of this conclusion, already familiar to many Muslims in the West and elsewhere, in turn alienated ever more Muslims.

This particular set of controversies perfectly illuminates the multiple dynamics at work in Islamophobic and anti-Muslim sentiments in the United States (and elsewhere) today. The widespread puzzlement among many non-Muslim Americans over the sharp responses reflects how little they understand Muslims. The breadth of Muslim response demonstrates both a heightened sensitivity to Western disparagement of Islamic traditions and an increasing sense that the West seeks a war against Muslims through outright conquest, such as in Afghanistan and Iraq, or through more "soft-power" avenues, as in the constant deprecations of the cartoon controversies. All of this turns wildly on the fulcrum of asymmetrical power. Muslims in the West and elsewhere know that now, as has been the case since the era when European imperialists ruled over most Muslims, what they think about Christians has far fewer consequences than what Westerners think about Muslims.

With each passing skirmish, Muslims characterize these Western thoughts as Islamophobic. Simultaneously, the predominantly Christian and/or secular populations of the West do not appreciate that their attitudes toward Islamic traditions both presume the norms of Christian and secular ideology and negatively reflect centuries of religious and political conflict around the world.

Ultimately very few on any side wish to pick a fight. Yet the distance between the various perspectives involved allows some to opportunistically manipulate Islamophobia for their own advancement. The Danish editor, disagreeing with the hesitancy of some Europeans to offend, deliberately defied Muslim sensitivities. The Syrian government doubtlessly allowed, and in fact may have promoted, the burning of the Danish and Norwegian embassies to serve its own political ends. Sadly, dozens of people died because of the agitations, while political fissures and social stereotypes have deepened.

Despite the rhetoric, no essential difference underlies imagined Western and Islamic civilizations. In fact, three years before the current controversy, the same editor for *Jyllands-Posten* turned down cartoons satirizing the resurrection of Jesus because it would "provoke an outcry" among Christians.[7] This demonstrates exactly how some Westerners perceive a radical difference between themselves and Muslims when, with regard to this issue, none exists. The editor obviously recognized that members of both Muslim and Christian Danish communities might object to negative caricatures of their most important figures. However, whereas he voluntarily censored himself in deference to Christians, Rose deliberately provoked the outrage of Muslims in order to protest the self-censorship of those deferring to this group.* Clearly, in his view, Muslims represented a threat in the same scenario in which Christians did not. Meanwhile, a representative of *Charlie Hebdo* rejected the comparison Geller made between his magazine and her contrived cartoon competition: "Comparing this Pamela Geller thing and *Charlie Hebdo* is nonsense. . . . It's an anti-Islamic movement, and she said it's an anti-Islamic movement, fighting against what she called the Islamization of the U.S."[8] Islamophobia and anti-Muslim sentiment—enacted by Westerners and perceived by Muslims—plays a critically central role in convincing many that a civilizational clash, like the one forecast by political scientist Samuel Huntington in a 1993 *Foreign Affairs* essay, will be inevitable and all-consuming by establishing the "fact" of an essential and irreconcilable difference between "them" and "us." Not only do the unfortunately fatal conflicts involving the *Jyllands-Posten, Charlie Hebdo,* and Garland, Texas,

*In his own defense, Rose argued that that case differed because he had not commissioned the earlier images.

cartoon controversies demonstrate the dynamics we identify as Islamophobia and anti-Muslim sentiment, but they also demonstrate the seriousness with which political cartoons can be taken.

Editorial Cartoons

Why cartoons?

Of all the media that could be used to depict Muhammad, why did *Jyllands-Posten*, *Charlie Hebdo*, and Pamela Geller choose cartoons? Other options exist, as one agitator demonstrated when he posted on YouTube a "trailer" for a supposed film that excoriated the prophet (see chapter 8). However, as a form of art and argumentation, political cartoons signify and provoke in certain unique ways. One immediately salient attribute is that they tend to provide intense expressions of opinion, owing to the artists having to create them in immediate response to events. The short time frame for response creates a situation in which cartoonists very much show what is on their mind and thus offer insights into ideas and feelings prevailing in broader society. Whereas verbal expressions are subordinated more easily to the internalized editor of cultural sensitivity, the visual borrows from a broad pool of images and symbols that have drawn less criticism.

Some might protest that cartoons are not a very appropriate medium by which to examine American perspectives and sentiments. They are, after all, "only joking." But the prevalence of editorial cartoons in newspapers, newsmagazines, and online news sites demonstrates how popular—and effective—they are. William "Boss" Tweed, the infamous New York City politician of the nineteenth century, once said of the cartoons Thomas Nast drew to criticize him, "Stop them damn pictures. I don't care so much what the papers write about me. My constituents can't read. But, damn it, they can see pictures."[9] He was not alone in his appraisal of the damage Nast's cartoons did. Ulysses S. Grant attributed "the sword of Sheridan and the pencil of Thomas Nast" for his successful presidential campaign of 1868.[10] Even the near-total absence of cartoons of any sort in the print edition of the *New York Times* perhaps testifies to the power of the political cartoon. One *Times* editor remarked, "Cartoons suck the air out of editorial pages because they are the one thing many people glom onto. In other words, they get in the way of people reading the page more closely."[11]

Editorial cartoons are popular for some very clear reasons. Among these is their ability to briefly but powerfully communicate ideas and sentiments that resonate with readers. Through the use of humor in particular, editorial cartoons may speak the unspoken, explicitly connecting with implicit assumptions of their readers in ways that generate powerful responses: readers

nod their heads in avid agreement, shake their heads in grim acknowledgment, and share favorites with friends by hanging them on refrigerator doors, taping them onto office doors, and posting them on Facebook or other social media. Cartoons have historically captured not only contemporary thoughts but feelings regarding current events: the rage regarding Pearl Harbor, the sorrow of John F. Kennedy's assassination, the frustration of Vietnam, the devastation of 9/11, the surprise of Donald Trump's election. Many cartoonists clearly consider themselves to be protective critics for American society. For instance, cartoonist Walt Kelly understood the function of the political cartoonist to be "that of the watchdog. It is the duty of the watchdog to growl warnings, to bark, to surmise that every strange footfall is that of a cat."[12]

However, the job of watchdog can be fraught, given the sensitive issues with which cartoonists often engage in such a restricted space with a modicum of word and image. The outrage following a cover for the July 21, 2008, edition of the *New Yorker* amply demonstrates this. Despite the vastly larger space in which he had to work than most editorial artists enjoy, artist Barry Blitt's drawing appeared to many readers to communicate a very different message than he intended. At the height of Obama's initial presidential campaign, Blitt crafted a detailed image of the candidate and his wife fist-bumping. While Michelle sports camouflage pants and an assault rifle, Barack wears stereotypical Arab/Muslim garb with a turban matching the one on Osama bin Laden's head in the portrait hanging above the fireplace, where an American flag burns. Many readers—even some subscribers to the liberal magazine—expressed outrage, interpreting Blitt's work as repeating Republican innuendo that the candidate was an undercover Muslim. While Blitt benefited from the unusually large size of his canvas, he suffered from a peccadillo peculiar to the *New Yorker*. While famed for its cover art, the magazine only publishes the title of the art *inside* the magazine. Had the title "The Politics of Fear" appeared on the cover, it would doubtlessly have allowed most if not all readers to appreciate that Blitt was not implying that the Obamas were Muslim but was satirizing others' claims that they were. The controversy illustrates well the delicate dance editorial cartoonists perform in leveraging image and word, caricature and symbol, against one another with an audience who must be aware enough to understand the references and generous enough to accept the satire.

Cartoons, "Muslim Values," and the Freedom of Expression

Many, if not most, Americans have little appreciation for the daily impact American politics, lifestyles, economics, and values have on the world. It is not, after all, Americans who flock to mushrooming numbers of foreign

fast-food restaurants or worry about the foreign values instilled in their children by pervasive and eye-catching foreign films and music channels or worry about the impact on their population and politics of foreign military personnel stationed in their country. The alarm among many in the country regarding Russian interference in the 2016 presidential election offered a rare opportunity for Americans to experience concerns and suspicions many other nations experience with regard to the United States. The existing asymmetry of cultural, economic, and political power imparts to Americans a greater responsibility to question the norms by which they understand themselves and the world, but not in order to reject their systems of values out of hand. Instead, US news and entertainment outlets would do well to appreciate their hegemonic power of persuasion and influence. Meanwhile, those Americans hoping to promote their values abroad might put them in perspective relative to those of others, who will be far less interested in exploring those values if they suspect an inherent lack of respect toward their own.

There are those who have responded with wrath to similar arguments for American responsibility. They judge such comments to be "anti-American" because they imply blame on the victims (Americans) and justification for the victimizers (Muslims). We believe that the virulence of these responses reflects the degree to which certain views described in this book have been normalized. That is, they demonstrate *how natural* for so many Americans the *image* of Muslims as irrational aggressors and Americans as righteous innocents abroad and at home (and the misinformed mutual exclusion of these two groups) has become, so that any other perspective becomes not a counterargument but a challenge to an unquestionable world order. The emotional outrage that such views at times elicit reflects the deep investment many Americans have in a self-perception of their nation as a force of goodness in a world defined by either evil or capitulation. One of the central qualities of that self-perception is the supposed inviolability of the right to free expression, which some Americans have argued to distinguish their values from those of Muslims.

This became evident in the aftermath of the Danish cartoon controversy. American reporters repeatedly declared that Muslim anger grew from the mere depiction of their prophet, which they intoned was forbidden "by Islam." While aniconic traditions have existed among many Muslim communities at different times historically,* any universal claim regarding Muslims is easily undone by a quick trip to any large museum with art from

*Aniconic movements have also existed among Jews and Christians. For instance, Protestant iconoclasts made a practice of removing statues from medieval churches during the Reformation.

the Ottoman, Persian, or Mughal periods of West Asian, Iranian, or South Asian history. At times, some elites in these premodern Muslim-majority societies commissioned miniature art that graphically portrayed Muhammad, his family, and his companions, and this art has long been on display with little controversy in American and European museums. Nevertheless, the truism intoned by a reporter a decade later, following the Garland shooting—"physical depictions of Muhammad are considered blasphemous under Islamic tradition"[13]—continues to hold sway among news outlets.

This stubborn pattern emerging from the cartoon controversies demonstrates two dynamics. First, some news outlets show little interest both in moving beyond their assumptions about Islamic traditions and in asking Muslims about their responses. Among the Muslims with whom we have spoken who have objected to some of the *Jyllands-Posten* cartoons (and not all have), the primary reason for doing so derives from the role Muhammad plays as the most exemplary Muslim. Muslims developed an entire genre of literature—Hadith—soon after Muhammad's death and over the next several centuries in order to meticulously record and verify every observation made of his disposition, behavior, and emotions as well as his views on significant topics. Although different Muslims have different attitudes about the importance of the Hadith, for nearly a millennium and a half, many Muslims have used it to create models for how they live not only as Muslims but as parents, spouses, workers, leaders, and neighbors. This type of expansive example has almost no parallel among Jews and Christians. Rose himself explains that Muslims shared with him such views, which he evidently either could not understand or simply dismissed.

> One cartoon—depicting the prophet with a bomb in his turban—has drawn the harshest criticism. Angry voices claim the cartoon is saying that the prophet is a terrorist or *that every Muslim is a terrorist*. I read it differently: Some individuals have taken the religion of Islam hostage by committing terrorist acts in the name of the prophet. They are the ones who have given the religion a bad name. The cartoon also plays into the fairy tale about Aladdin and the orange that fell into his turban and made his fortune. This suggests that the bomb comes from the outside world and is not an inherent characteristic of the prophet.[14] [italics added]

As an editor, Rose should not need to be reminded about the divergent interpretations audiences can bring to their reading. Instead of acknowledging that his perception differs from some Muslims, he rejects their view that the cartoon slanders *them* because they model themselves after Muhammad. Hence, if the prophet is explosive-minded, then so are they.

Instead, Rose uses his own interpretation to definitively declare that the cartoon is not inflammatory.

By repeating the mischaracterization of Muslim objections to the cartoons, news outlets promote another supposed piece of evidence that Muslims cannot respect Western values of free expression, demonstrating yet another way in which Islamic traditions supposedly conflict with Western ones. Moreover, by doing so, news sources do not hesitate to repeat the claim that Muslims commonly respond with violence to "blasphemy," providing more evidence for how purportedly ill-fitted they are for life in the West. For instance, reporters make scant reference to Muslim tolerance of an image of Muhammad in the Supreme Court in Washington, DC, where he stands among other famous lawgivers. While some Muslims have sought the removal of this image, it has remained in place without major protest. However, a 2015 *New York Times* article published days after the *Charlie Hebdo* attack reminisced about the 1955 removal of a statue of Muhammad from atop a Manhattan court building at the request of the embassies of Egypt, Pakistan, and Indonesia, as well as of individual Muslims. When the article declared that "the statue was finally removed out of deference to Muslims, to whom depictions of the prophet are an affront,"[15] it reflected once again the dubious truism about all Muslims and their views of imagery.

This misperception notwithstanding, the editors of the *New York Times* demonstrated the strides some news sources have taken to work around—without submitting to—Muslim sensibilities. In the 2015 article on the removed statue, the paper decided against publishing an image of the sculpture out of respect for the views of some Muslims. Similarly, nearly all major American newspapers refused to publish any of the Danish cartoons in their reporting on the controversy a decade earlier. Some commentators viewed this as a dangerous backslide of rights to free expression. Many critics became vocal again in 2015, when the *Times* broke with many other major papers in not republishing the cover of *Charlie Hebdo* that followed the attack. The cover depicted a tearful Muhammad holding a sign that read, "*Je Suis Charlie*" ("I am Charlie," the epithet many supporters adopted following the tragedy). The paper's executive editor explained to the *Huffington Post* (which did show the image), "Out of respect to our readers we have avoided those [images] we felt were offensive. . . . Many Muslims consider publishing images of their prophet innately offensive and we have refrained from doing so." While some viewed this logic as unevenly applied to images that might upset members of other religious communities, the endeavor to avoid republishing "gratuitous insults" reflects a heightened media awareness of how they have served as unwitting megaphones amplifying the inflammatory views of media-savvy individuals.[16]

The case of Terry Jones illustrates this change. In 2010, the pastor of a Florida church that promoted the slogan "Islam is of the Devil" threatened to burn Qurans in memory of the September 2001 attacks. The American news media provided Jones extensive coverage, with backstories and interviews that attracted audiences around the world and provoked protests in Afghanistan and elsewhere. In essence, the media provided Jones a global loudspeaker by which to amplify his voice far more extensively than any other leader of a diminutive community with only four dozen members could hope to do. Ultimately he backed down from that threat. A year later, however, he declared he would put the Quran "on trial." As judge he declared the book guilty and burned it. But this time very few mainstream news outlets covered the story, having determined not to help set off the cycle of insult, outrage, violence, and sympathy for Jones, the person responsible for the original insult. Even the Council of American-Islamic Relations and the Muslim Public Affairs Council resisted issuing press releases. Unfortunately, news did reach Afghanistan, where protests led to twenty deaths.[17] Nevertheless, the decision by most news outlets in this case, like the decisions by the *New York Times* mentioned above, demonstrates that freedom of expression does not require one to satirize or disparage others and that restraint can be an expression of the values of inclusivity, pluralism, and acceptance rather than the necessary erosion of the right to free speech.

As the late anthropologist Saba Mahmood demonstrated so well, the concept of "freedom" can be understood differently among various societies and cultures. She explained how Western liberal discourse emphasizes freedom as "the capacity to realize an autonomous will, one generally fashioned in accord with the dictates of 'universal reason' or 'self-interest,' and hence unencumbered by the weight of custom, transcendental will, and tradition."[18] The call to report all events and publish all images without regard to community sensibilities reflects this notion, and their protests against news media exercising this freedom make the Muslims who complain appear not only contrary to professed "Western values" but additionally, ipso facto, burdened by "custom, transcendental will [of God], and tradition." This helps explain the persistence of universal claims about universal Muslim objections to images of the prophet. However, Mahmood demonstrates how the ability to exercise restraint also exhibits autonomy and freedom. Even if this perspective gets little attention in the United States, many Americans intuitively understand it.

Blacks, women, Jews, Irish, Italians, Latinos, Latinas, gays, and lesbians represent some groups that have called on Hollywood writers, television producers, and editorial cartoonists to be more careful in how they represent

these minority groups. Over time, more of these opinion shapers have complied. As an example of such calls for sensitivity, in 2009 the *New York Post* published artwork from cartoonist Sean Delonas that many judged racist. It depicts two white police officers standing over the body of a chimpanzee that they have just shot dead. One says to the other, "They'll have to find someone else to write the next stimulus bill." Given that President Obama had signed the latest stimulus bill into law the day before, many readers overlooked the reference to a rampaging chimp killed by Connecticut police that week and interpreted the cartoon as deliberately playing on old racial slurs equating blacks with primates. Neither calls by the National Association for the Advancement of Colored People for Delonas's firing[19] nor similar critiques of racist media depictions of blacks brought claims of "black values" running contrary to American ones in the way some have made accusations about "Muslim values." Instead, an implicit understanding seemed to prevail that restraining certain types of representations has less to do with restricting freedom than demonstrating respect in a pluralistic society.

Because Muslims infrequently appear in news reports or other media sources except as perpetrators of violence supposedly in the name of Islam, as demonstrated in the Parisian offices of *Charlie Hebdo* and outside the event in Garland, many Americans understandably conclude that all Muslims act from inherently religious motivations and that Islamic traditions are dangerous. Muslims become two-dimensional, existing only *as Muslims*, seemingly never sharing identities or interests with non-Muslims. However, non-Muslim Americans engage Muslim Americans in myriad ways every day: a student and his classmates, a banker and her customer, a police officer and a family in need of help, and homeowners and their neighbors. Moreover, Americans and foreign Muslims encounter one another daily in hundreds of thousands of interactions. The globalized world we inhabit makes possible increasingly intimate connections between distant individuals with increasing speed. Why, despite all of this contact, do domestic news and entertainment sources most often mention the terms "Muslim" or "Islam" in the context of conflict, violence, and bloodshed?

Our argument here is not that the American or Western depiction of Muslims and Islamic traditions has not changed for the past 1,400 years or even the past 40 years. Indeed, some very important shifts have occurred in the decade since the first edition of this book was published, as will be demonstrated in chapter 7. Many news sources have endeavored to provide more stories regarding Muslims in the context of their peaceful, everyday lives. These reports consider Muslim Americans as well as Muslims living elsewhere. News sources increasingly have highlighted various Islamic

traditions, such as the pilgrimage to Mecca or the celebration of the end of Ramadan, in ways similar to their coverage of Passover or Christmas. Much of this has occurred because of Muslim efforts to educate news outlets about previous deficiencies, inaccuracies, and biases.

However, what has remained constant has been a nervousness and distrust of those associated with these terms, a persistent sense that to be Muslim is to be a distrusted "other." The exact terms of that otherness depend on who is doing the imagining and on their self-understanding, with far less importance given to how individual Muslims view themselves and their religion, if they even identify with Islamic traditions. Meanwhile, as the controversies about the cartoons in *Jyllands-Posten*, *Charlie Hebdo*, and the Garland, Texas, event have amply shown, the accelerating pace of globalization, transportation, and communication has meant that the expressions of these perceptions travel to an increasingly farther and wider audience that can, with increasing impact, respond in diverse ways. Foreign journalists report the latest American government policy toward Iran or the Palestinians through simultaneous international broadcasts. Hollywood projects popular American representations of Muslims in movie theaters, on home televisions, and through computers in myriad cities, towns, and villages around the globe. Meanwhile, the internet allows people throughout the world to read American newspapers, including their political cartoons.

This book does not attempt to detail at length the causes of the antagonisms and conflicts to which it refers through cartoons. It does not seek to blame Americans or Westerners in general for the current controversies. Certainly, some Muslims use equally simplistic and bias-laden images in their depictions of Americans. For instance, concern has been raised regarding occasionally racist depictions of Jews in Middle Eastern cartoons.* However, the incredible power—economic, political, cultural, and military—that the United States projects throughout the world today demands that Americans accept the responsibility to understand and engage the people beyond (and increasingly within) its borders with the least historical impairment possible.

*Some readers responded to the first edition by asking why we did not similarly explore cartoon characterizations of Americans in Muslim-majority countries. We find the question indicative of the basic problem we address here for two reasons. One, it assumes such a project possible. In fact, the immense variety of cultures and languages represented by 1.8 billion Muslims makes even a book dedicated to just that subject impossible to imagine. At best, a volume could explore the reciprocal attitudes of non-Muslim Americans and the members of a specific Muslim-majority culture toward one another. Second, the request appears to suggest that Muslims have no right to complain about the stereotypes foisted on them by American cartoonists if Muslim cartoonists do the same to Americans. Such a claim ignores the vast asymmetries that make American views far more consequential to the lives of non-Americans than the other way around. It also implies a sad school-yard logic that we need not change our biases so long as some others hold some against us.

CHAPTER 2

—w—

Overview of Western Interactions with Muslims

During the first half of 2003, Gen. William G. Boykin, deputy undersecretary of defense for intelligence, addressed a series of Christian groups. Reflecting on his experience in Somalia as American military forces battled against the fractious warlords of that starvation-threatened country, especially the elusive and powerful Mohamed Farah Aidid, General Boykin offered comparisons meant to explicitly define the distinctive qualities of the United States. At the time, the nation was struggling with the repercussions of September 11, celebrating the demise of the Taliban in Afghanistan, and gearing up for an invasion of Iraq. And so, in June 2003, he addressed the First Baptist Church of Broken Arrow, Oklahoma, and asked,

> But who is that enemy? It's not Osama bin Laden. Our enemy is a spiritual enemy because we are a nation of believers. You go back and look at our history, and you will find that we were founded on faith. Look at what the writers of the Constitution said. We are a nation of believers. We were founded on faith. And the enemy that has come against our nation is a spiritual enemy. His name is Satan. And if you do not believe that Satan is real, you are ignoring the same Bible that tells you about God. Now I'm a warrior. One day I'm going to take off this uniform and I'm still going to be a warrior. And what I'm here to do today is to recruit you to be warriors of God's kingdom.

Earlier in the year, Boykin had offered a very specific example of the manifest power of God in America's affairs when he addressed the First Baptist Church in Dayton, Florida. He reflected on Osman Atto, a Somali leader who became an American target and narrowly missed capture:

And then he went on CNN and he laughed at us, and he said, "They'll never get me because Allah will protect me. Allah will protect me."

Well, you know what? I knew that my God was bigger than his. I knew that my God was a real God, and his was an idol. But I prayed, Lord let us get that man.

Three days later we went after him again, and this time we got him. Not a mark on him. We got him. We brought him back into our base there and we had a Sea Land container set up to hold prisoners in, and I said put him in there. They put him in there, there was one guard with him. I said search him, they searched him, and then I walked in with no one in there but the guard, and I looked at him and said, "Are you Osman Atto?" And he said, "Yes." And I said, "Mr. Atto, you underestimated our God."[1]

When a video of these addresses came to the attention of newspapers and television news programs, a debate erupted. Because Boykin wore his uniform while making these remarks, various American political and religious figures argued that he should be reprimanded for making divisive comments while dressed as a representative of the US armed forces. Despite the protests, no such reprimand materialized.[2]

Boykin's perspective and the complaints against it reflect the twin roots of Islamophobia in the United States. On the one hand, many Christians undoubtedly applaud Boykin's unfettered public expression of their own sentiments that God actively stirs America's destiny to counter evil—as personified by Satan—and to correct the idolatrous like Osman Atto. For them, the world is divided between those on the side of the angels and those who oppose them. Those in the middle are complicit with evil or otherwise compromised. Proponents of this view unwittingly lay claim to a theological heritage that, since the first Islamic traditions, considers Muslims to be inherently dangerous because of their (at best) erroneous understandings or (at worst) satanic strivings.

On the other hand, many Americans interpret the stridency of Boykin's statements and their potential negative impact as a demonstration of the threat religion presents when expressed in public or by public officials (in this case a military official in uniform who holds a public position). Indeed, some of these individuals may consider themselves devoutly Christian or otherwise religious, yet they remain suspicious of those who promote, practice, or espouse their religion outside the privacy of their homes and places of worship. Informed by the tenacious Western idea that Islam persistently, even fanatically, strives for dominion over all dimensions of life—particularly the political—many Americans remain inherently wary of Muslims. While some Americans may suspect politically committed Christians some

of the time, they doubt most Muslims most of the time. Until recently, this distrust may have been equally shared—for different reasons—by political and religious liberals and conservatives.

The brief historical overview that follows mentions the turning point when many Europeans changed their characterization of Muslims from theological competitors according to Christian doctrine to an abiding religious threat according to a secularist worldview. Key to this shift in perception was the emergence of secularism in the eighteenth century. Although most Europeans may have defined themselves and their societies as Christian before this, secular ideals increasingly valued national over religious identity. As we shall see, this meant that as Europeans shifted the understanding of their social order from one identified primarily as Christian to one known principally as secular, "Muslim" continued to serve as a negative identity by which first Christian and then secular norms could be contrasted, defined, and valorized. In other words, for centuries Muslims and Islam have served as European abstractions acting as negative foils by which many non-Muslim Westerners have positively defined their societies, politics, and religions. Distinctively, influential trends in American society simultaneously project this expectation of a secular social order while in other ways reinforcing the characterization of the United States as divinely mandated and guided as, indeed, "one nation, under God."

Although an amazing array of influences shapes American popular culture and the population collectively counts nearly every, if not literally every, country as a source of ethnic heritage, there can be no denying that Europe and its Christian traditions loom largest on the American cultural landscape. This is so because some European Christians and their descendants held—and still hold (though less absolutely)—the greatest economic and political power and, in turn, exerted the most sway in defining the nascent nation. Although a large number of the earliest Americans did not count Europe as their place of origin (specifically the millions of Native Americans and enslaved Africans), their relative lack of political influence by and large left their perspectives less influential. Nevertheless, most of their descendants became thoroughly imbued with the European cultural inheritance that seemed so normal to European Americans through the reinforcement of public education and mass media. The following account, therefore, traces the passage of Islamophobia and anti-Muslim sentiment to the United States through Europe as a general cultural inheritance even as it recognizes that an increasingly smaller proportion of Americans lay claim to Europe in their personal heritage.

Because of its brevity, this historical outline is necessarily incomplete and fails to describe many of the nuanced changes that have occurred over time.

It focuses instead on the most significant and pervasive themes that have persisted throughout these 1,400 years: religiously tinged anxiety regarding Muslims, theological depreciation of Islamic traditions, and an antipathy for Arab Muslims that at times has been tinted with respect. This reluctant regard evolved out of specific moments in the relationship between Europe and Muslims: the success of Arab Muslim armies in equal combat, such as during the Crusades, and the remarkable emblems of diverse Muslim cultures, such as the Taj Mahal. However, these positive impressions seemed to always occur as but lingering moments in some battle for supremacy that, finally, only served to reaffirm anxieties and fears that have loomed larger than positive impressions since the first Islamic traditions. Meanwhile, in the past few centuries, racial stereotypes have contributed a new dimension to Western anti-Muslim sentiment.

In keeping with the overall theme of the book, this chapter restricts most of its discussion to non-Muslim Western perspectives on Muslims and Islamic traditions. Of course, Muslims have had their own perspectives on interrelations—views that also span the spectrum from celebratory to caustic. A general history of mutual engagements, interactions, interpenetrations, and antagonisms would require more attention to Muslim views, but since the present work engages in an already difficult task, we can only refer readers interested in these important perspectives to the works listed on this topic in the bibliography.

The Spread of Islamic Traditions
and Competition with Christian Ones

Over the past fourteen centuries, Muslims have spoken and written myriad narratives about the life of the man most of them consider the last prophet. Currently, many if not most would agree that the following milestones represent salient moments in his life. In 610 CE, a man by the name of Muhammad declared that he had begun to receive revelations from the god Allah ("the One"), whom he considered to be the one and only god. Although some people in Mecca, the Arab city in which he lived, welcomed him as a prophet, others felt threatened theologically and economically by this critic of a social order that in many ways relied on the pilgrimage of nomadic tribes to Mecca to visit the images of their various deities installed there. These nomadic devotees housed these images in and around a large, cubical structure called the Kaba, which followers of Muhammad believed to actually be an ancient mosque, the first place constructed to worship Allah. Forced by mounting oppression to leave Mecca but guided by continuing revela-

tions, the early community of followers departed Mecca in 622 and settled in Medina, a city whose leaders had invited Muhammad to act as arbitrator of their urban squabbles. These followers called themselves "Muslims," the Arabic word for "one who submits," which is related to "Islam," meaning "submission."[3] These words occurred in the revelations that were referred to collectively as both "the book" and "the recitation" (Quran), which became the most authoritative textual source—albeit not the only one—for most Muslims throughout the next millennium and a half.

We should take a moment to consider how we use the term "Islam" in this book. The Quran appears quite straightforward about the singularity of the term, with passages such as "The religion with Allah is Islam" (3:19).[4] However, like all other Islamic books—and any book—the Quran must be read or heard to be understood, and this necessarily involves a process of interpretation, since those reading and hearing have their minds shaped by their specific historical, social, religious, political, and economic circumstances. While Muhammad may have had in mind a precise meaning for what "Islam" meant and entailed, the myriad manners in which Muslims historically and contemporarily have lived and worshiped in relation to that term amply demonstrate the innumerable possible meanings associated that it might bear. When non-Muslims write about "Islam" as though it was a singular religion with a canonical set of texts, doctrines, and practices, they obscure the multivocality and multitudinous expressions of Muslim devotions, observances, and sentiments. Meanwhile, many Muslims also reference "Islam" in singular ways that imply or explicate a homogeneity. For instance, as many Muslims and Muslim leaders in recent years have condemned the appalling acts of the so-called Islamic State, they have declared that members of this insurgency are not "true" Muslims. Alternatively, other Muslims have accepted that this movement evinces a certain Islamic perspective, yet they condemn its followers for incorrectly interpreting the religion. Ultimately many people try to lay claim to what "Islam" says or does or is. When Muslims do it, it can often be understood as a political/theological/ideological assertion that their own preferred form is the "correct" one, trumping other forms. In contrast, some non-Muslims mischaracterize particular Muslim views of Islam as universal while others decisively declare their own definitions of Islam. By doing so, both obscure the myriad and varied expressions of Muslim devotions, rituals, sentiments, and beliefs.

Instead of using such singular connotations, this book will reference "Islam" only in the context of claims by Muslims or non-Muslims that it is a singular phenomenon; it will use "Islamic traditions" to reference the vast collection of phenomena that Muslims have enacted in their relationship

with what they understand to be Islam. This strategy avoids two pitfalls altogether apparent today. First, in their use of the term "Islam," scholars (whether Muslim or not) who empirically study Islamic traditions often unwittingly project portrayals of a uniform Islam that do not match what some or many Muslims recognize as their religion. Second, Islamophobic commentators often rely on their own spurious claims about "what Islam requires," "what the Quran says," and "what a true Muslim must do" in order to condemn the religion without recognizing the endlessly multiple ways in which Muslims collectively have thought about such matters, beginning with the first generation of Muslims galvanized by Muhammad.

Recognizing Muhammad as not only a prophet but also a leader of the first Islamic society, Muslims in Medina agreed to live according to the many guidelines and rules revealed to Muhammad in an effort to engender a new ideal of social justice and divine relationship. As a social leader, Muhammad became distinct from foundational figures associated with certain other religions, such as Jesus and the Buddha, because he did not live as an itinerant teacher focused primarily on preaching. Instead, like David, Solomon, Rama, Ashoka, Constantine, and other religious exemplars of leadership, Muhammad became a religiously legitimated head of state and took on associated duties. These included leading military operations when necessary.

Armed defense became a paramount concern for the next decade as Meccan leaders became incensed with the Muslims for another economic reason. The Medinian Muslims, following traditions long common among Arabs, raided trade caravans. These caravans represented the economic foundation of Meccan merchants, who mounted military expeditions to assault the Muslim raiders and their city. Muslims interpreted the many routs they achieved in battle as signs of Allah's support for their cause. Meanwhile, the need for defense of the Muslim community became legitimized through the concept of jihad (striving). Indeed, it is written in the Quran, "And fight for the Cause of Allah those who fight you, but do not be aggressive. Surely Allah does not like the aggressors" (2:190). Meanwhile, the prophet put armed jihad in perspective when a returning warrior extolled Muslim victories. The prophet replied that two types of jihad existed: the lesser was the struggle against the enemies of Islam and the greater was against the evil within oneself. Ultimately Muhammad's success in military leadership and diplomatic finesse led to the nearly bloodless capitulation of Mecca and the rededication of the Kaba to Allah alone.

Muhammad's diplomacy not only allowed for the union of the disparate tribes on the Arabian Peninsula during his lifetime but also made possible the astonishing expansion of this united Arab political power following his

death. Perhaps propelled by a population that had begun burgeoning before Muhammad's birth, Arab armies unified by an Islamic ideology quickly moved out of the peninsula and, within but one hundred years, fashioned an empire that stretched from the Iberian Peninsula of contemporary Spain and Portugal to the western edge of what is today Pakistan. This success came at the particular expense of the Byzantine empire. With its capital in Constantinople, the Byzantines had dominated the Mediterranean Sea for centuries, struggling all that time against various competing states. They understood themselves to be the orthodox successor to both the Roman empire and the Christian church. Their emperors legitimated their rule through Orthodox Christian traditions that they lavishly sponsored. The singular success of Muslim Arabs to displace both Byzantine rule and Orthodox dominance in such stalwart Christian realms as North Africa shocked rulers and prelates alike and challenged their expectations for the success of "Christendom." Although medieval Christians often imagined a unified realm, this fractious region was actually riven by competing states. Christians had understood the astonishing growth of their movement from diminutive Jewish sect to Roman-persecuted church to Rome's official imperial religion as evidence of the miracle of Christ's word and the inexorable Christian spirit. The sudden loss of so much Byzantine territory and accelerating conversions of Christian souls precipitated three responses that might be expected in the face of such successful competition: (1) an effort to explain the losses and (2) an attempt to disparage the competitor while (3) affirming the truth of the home team. (Not all Christians felt this way. Those communities outside the fold of dominant Christian traditions, such as the Copts of Egypt, often welcomed the arrival of Muslim rule. Because of their recognition of Christians as recipients of early instances of Allah's revelation, Muslim rulers often afforded protection to minority Christian groups against the persecution they regularly experienced under Roman Catholic and Orthodox rule. Jews, too, often—but not always—benefited from Muslim rule because they were recognized as "People of the Book.")

For many medieval Christians, if the success of their churches and the expansion of Christendom resulted from the grace of God, then the success of Islamic traditions and the expansion of Muslim rule must be either the outcome of grace or the result of some other supernatural force. Obviously, since the former conclusion necessarily displaced Christianity as God's truth, most Christians were unlikely to embrace it. In the binary world of medieval Christian traditions—where God stood countered by Satan, good by evil—the alternative meant that Satan must have engendered these successes. Jews had already, at times, been depicted within this framework as handmaidens

of Satan and a community blinded by deceit. A similar place would be added for Muslims. While generally forgotten in Western cultures, these fears represent the oldest root of Islamophobia. They expressed a very real sense of anxiety that Islam threatened Christians and Christianity.

Medieval Christians often also responded through efforts to disparage their competitors. Although there was no centrally planned program of disinformation, the disparagement commonly focused on three elements of Islamic traditions: the person of Muhammad, the message of the Quran, and the character of Muslim societies. While Christian writers certainly chose a topic sensitive for Muslims when they condemned Muhammad, they did so with a misperception of his role for most Muslims. It is true that no person has as much stature for most Muslims as Muhammad. As recipient of the final revelation of God, as leader of the first Muslim community, and as the exemplar of Muslim behavior, Muhammad continues to hold a very special place of veneration among Muslims. However, Christians often assumed his role in Islam to be comparable to that of Christ in Christianity. The parallel is a faulty one. The thrust for many Muslims, as is obvious from the story of the purging of the images of the various gods and goddesses in the Kaba, is that Allah alone should be worshiped, never a human.[5] When Muhammad died in 634, one of his closest followers immediately declared, "O men, if anyone worships Muhammad, Muhammad is dead: if anyone worships God, God is alive, immortal."[6] Although many Europeans and some Muslims would refer to Muslims as "Muhammadans," most Muslims now bristle at the term because their faith and practice centers on Allah, not Muhammad. This stands in obvious contrast with the relation of the identity "Christian" to Jesus Christ.

Nevertheless, Muhammad became the target of medieval Christian derision. Attacks often focused on one or both of two features: Muhammad as a hedonist and Muhammad as a shyster. The contrast appeared stark when comparing Jesus's presumed sexual chastity, material impoverishment, political disinterest, and devotion to peace with Muhammad's multiple marriages, economic involvement, political rule, and military leadership. For instance, Muhammad's marriage to fourteen wives contrasts starkly with Jesus's celibacy. Since Jesus provided the paradigm of godliness for Christians, Muhammad seemed to be his polar opposite. Muslims, as evidenced by their deep regard for Muhammad and his message, indicted themselves as similarly hedonistic and misdirected. In an odd paradox that will be better understood when we consider the issue of "norm" in chapter 4, later Europeans and Americans would criticize Muhammad for his perceived puritanical stringency as evidenced by restrictions on the consumption of wine and the segregation of men and women.

Anyone who has read the Quran, the Hadith (records of the sayings and practices of Muhammad), and other Islamic texts will know that the derision has flowed both ways. Passages in the Quran and Hadith warn against the faulty conclusions of Christians that Jesus, an important prophet for Muslims, existed as the incarnation of God. In fact, various lines in both sets of texts repeat the claim that the Quran provides a perfect replacement for the preceding books, as described below. Christians (and Jews) who contradicted Muhammad's message also find rebuke in the Quran.

Such supposed misdirection of Muslims, and of the many Christians who converted to Islam, demonstrated the other Christian accusation against Muhammad: that he scammed his followers. For this reason, the fourteenth-century Italian poet Dante Alighieri consigned the prophet and his son-in-law Ali to the second-lowest circle of hell in his *Inferno* (even as he borrowed, perhaps unconsciously, the notion of nine levels of heaven and hell from Islamic theology!):[7]

> A rundlet [cask], that hath lost
> Its middle or side stave, gaps not so wide
> As one I marked, torn from the chin throughout
> Down to the hinder passage: 'twixt the legs
> Dangling his entrails hung, the midriff lay
> Open to view, and wretched ventricle,
> That turns the englutted [swallowed] aliment to dross [excrement].
> Whilst eagerly I fix on him my gaze,
> He eyed me, with his hands laid his breast bare,
> And cried, "Now mark how I do rip me: lo!
> How is Mohammed mangled: before me
> Walks Ali weeping, from the chin his face
> Cleft to the forelock; and the others all,
> Whom here thou seest, while they lived, did sow
> Scandal and schism, and therefore thus are rent."[8]

Nowhere could this charge of scam artist be better demonstrated than in the "heresy" of the book that Muhammad championed as a correction of the Christian Bible.

If the analogy between Christ and Muhammad fails because Christians understand Christ as God incarnate and Muslims accept Muhammad as only human, then the more correct analogy would be between Christ and the Quran. The followers of each religion understand both the Messiah and the Book to be the physical expression of God's word.[9] Although Muslims revere Muhammad for many reasons, none surpasses his role as the medium through

which the final revelation came to humanity. The Quran claims itself to be the answer to previous failures on the part of humans to maintain, free from error, God's earlier efforts to send books of guidance to three specially chosen prophets. As such it surpasses the Psalms sent to David, the Torah sent to Moses, and the Gospels sent to Jesus. Thus, as mentioned above, the Quran refers to Jews and Christians as "People of the Book," who had previously received written revelation, as opposed to *kafir* ("unbelievers"), who never had. If the medieval churches condemned Jews for failing to recognize the truth of the "New" Testament and remaining mired in the legalism of the "Old" Testament, then this Muslim claim of a correction to both would obviously not be well received. Many medieval Christian authors (and quite a few since then as well) roundly attacked the Quran as a spuriously written book concocted by the devious Muhammad for his own material and political gain and/or because of his manipulation by Satan. Current Muslim sensitivities to disparaging depictions of Muhammad by non-Muslims derive in part from an awareness of such historical (and contemporary) vilifications.

Meanwhile, some Christians alternatively depicted Muhammad as an idolator, a particularly odd claim given the avoidance of the physical representation of prophets or God in most Islamic traditions and the widespread use of devotional images and statues in medieval Christian churches. Nevertheless, this allegation remains a way in which some Christians continue to dismiss Muslim belief as not directed toward the one true God but toward something else, thus severing a potential sense of similarity. General Boykin's comment about his Muslim opponent, mentioned at this chapter's beginning, demonstrates the survival of this millennium-old disparagement, "I knew that my God was a real God, and his was an idol."[10]

All these responses intended to reaffirm the truth of Christianity and the institutions that perpetuated its practice and teachings. By negating the purported claims of Islam, it was hoped that Christianity would be affirmed inherently. Nevertheless, even in the Middle Ages there existed those who considered the similarities between Judaic, Christian, and Islamic traditions as favorably numerous and cause for communication, and there were Christians who admired certain specific Muslims. For instance, various medieval European artists and authors depicted the supposed meeting pursued by St. Francis of Assisi with Sultan al-Malik al-Kamil in the thirteenth century.[11] Meanwhile, Pope Gregory VII, in a letter to a Muslim Algerian prince, wrote, "[T]here is a charity which we owe to each other more than to other peoples because we recognize and confess one sole God, although in different ways, and we praise and worship Him every day as creator and ruler of the world." Although he probably had political reasons to highlight this com-

mon ground and would write harshly about Muslims elsewhere, this pope's conceptualization of any common ground remains significant, if not widely embraced by Christians.[12]

The Crusades

For skeptics of mutual acceptance, no event would appear to be more emblematic of the seemingly inevitable conflict between Christians and Muslims than the Crusades. The use of the term today by Muslim extremists to condemn any Western presence in the Middle East appears to confirm their commitment to viewing the world through a religious lens. However, it is significant that the Crusaders unintentionally ignited an Islamic unity that had previously not existed in the region for centuries. It was a Christian ideology of conquest that inspired an equally effective Islamic ideology of defense. Meanwhile, many Europeans and Middle Easterners were mutually impressed by one another's courage and ability in the ferocity of combat.

The Crusades have provided salient memories of interaction to both European Christians and eastern Mediterranean Muslims. Although most Americans consider themselves too future-oriented and pragmatic to be mired in the enduring antagonisms and balkanizing strife of the "old world" of Europe or the Middle East, very old social memories nevertheless resonate in popular American culture (as current debates about the meaning and importance of memorials to Confederate leaders amply demonstrate). They do so on an almost unconscious level that remains unnoticed by most people in their everyday lives. One need only reflect on the prevalence of the term "crusader" in popular culture to see this point. Many school teams, social activists, and community leaders proudly refer to themselves as crusaders and may indeed adopt the anachronistic image of the armor-clad knight with jousting pole and cross-emblazoned shield mounted upon a brawny steed as their mascot or emblem. The American military certainly embraced this image when it named an important North African campaign in World War II Operation Crusader,[13] supplied the navy with the F-8 Crusader fighter aircraft beginning in the 1950s, and almost financed the state-of-the-art Crusader self-propelled gun in the 1990s. And if the pervasiveness of the symbol does not seem evidence enough of the potency of the memory, one only need consider the widespread memory of Richard the Lionheart, recognized by many if not most Americans for no other reason than his presence as the well-meaning English hero in most renditions of the Robin Hood legend. He appears as an indispensable component of film portrayals from Douglas Fairbanks's 1922 classic to Disney's 1973 animation to Kevin Costner's *Robin Hood: Prince of Thieves* in 1991.

The Crusades, however, did not begin with Richard the Lionheart but with the head of the Roman Catholic church, Pope Urban II. Recognizing an opportunity to expand the influence of the church abroad and tapping into a pool of unengaged European noble youths who lacked opportunities to exercise their ambitions and sought penitential acts to ameliorate their sins,[14] the pope suggested that an assault should be mounted to free Jerusalem from Muslim rule. Jerusalem had long been a destination for Christian pilgrims who sought to visit the places associated with Jesus's final days, crucifixion, and resurrection. At times, brigands (many of whom were Muslims who were acting out of greed and not religious animosity) robbed these pilgrims. By identifying these bandits primarily as Muslims, the pope successfully fired a religious enthusiasm for his effort. Urban II, in his written call for a crusade, encouraged Christians to hasten to the aid of the Byzantine empire—"your brethren in the east"—which had lost lands to "the Turks and the Arabs." Synonyms Urban used in his letter for the latter groups included "vile race," "pagans," "infidels," "barbarians," and "a despised and base race, which worships demons." These descriptions contrasted with references to those who would heed his call as "sons of God," "the faithful of God," "Christ's heralds," and those with "the faith of omnipotent God."[15] This antagonism toward not only Muslims but non-Christians in general proved such a successful motivator that the First Crusade began with assaults on various Jewish communities in Europe and resulted in slaughters like those in Mainz and Worms, in which almost all resident Jews were murdered.[16] When this army appeared at the walls of Constantinople, the capital of the Byzantine empire, the emperor there welcomed it with trepidation, not knowing whether Crusader antagonism would extend to the Orthodox Christians under his rule. Two centuries later, his anxieties proved justified.

Although some authors might depict the response to Urban II's call as only the first of a series of unavoidable conflicts between implacable foes, this was not the case. The popular assumption that the Crusades comprised a battle between Christianity and Islam assumes that both sides understood themselves primarily through a religious lens. In fact, the initial success of the Crusades was made possible just as much by the collective response of European Christians to the pope's call as by the very lack of a unifying ideology or identity among those in eastern Mediterranean countries who found themselves under attack. Although most of the rulers of the diverse kingdoms in that region were Muslims, they were as likely at war with one another as with Christians, as was the case among the nominally Christian princes in Europe. Political power and economic wealth motivated conflict far more than religious identity did. Ironically, the Crusaders' violent antago-

nism toward Muslims and their example of a successfully unifying religious identity inspired the Kurdish general Salah ud-Din to use Islam to promote a unified defense. It worked. He rose to the position of sultan and then took Jerusalem, putting the Crusaders into a slow retreat of defeat. While the region would be convulsed by crusading efforts for the next two centuries, North Africa and the Balkans would be objects of crusades until the sixteenth and seventeenth centuries, respectively.[17]

And so, although before the Crusaders' arrival the Middle East had been a group of disparate kingdoms that happened to have Muslim rulers, after their departure these kingdoms became a set of larger, more powerful states operating more centrally—if not consistently—from Islamic ideologies. Nevertheless, political interests frequently trumped religious commitments. Muslim-led states often allied with Crusader states against other Muslim-led states throughout the Crusader period, as Christian-led states conspired against one another in kind. Reflecting the growth of the movement to include attacks on any non-Latin Christian community for political purposes, the later Crusaders sacked the previously unvanquished city of Constantinople in 1204 in a naked exercise of political expansion. Ironically, this perhaps contributed to the capture of the weakened city in 1453 by the Turks, who had long sought its submission. The newly renamed Istanbul would serve as the capital of the Ottoman Empire for the next four and a half centuries. Meanwhile, the ascent of the sophisticated Ottomans, who would control Greece and the Balkans, advancing as far as Vienna, provided a new sense of Muslim threat to the rest of Europe.

Nevertheless, the Crusaders' experience in the eastern Mediterranean, although fired by a depreciative theological perspective, often allowed for respect for some "Saracens," their term for Arab Muslims (deriving, perhaps, from the Arabic *sharqi*, "eastern"). European folklore would describe the magnanimous heroism of Saladin and his personal relationship with Richard the Lionheart based upon their mutual respect for one another's bravery and chivalry. (Salah ud-Din was such a well-known figure in Europe that "Saladin," a Romanized version of his name, became—and still is—popular.) Although some contemporary authors portrayed him in sinister shades, others applauded his nobility and generosity. Dante placed him in Limbo with non-Christian luminaries like Socrates and Plato.[18] Favorable Western representations of Saladin can be seen even as recently as Hollywood's Crusade epic *Kingdom of Heaven* (2005). The fear of the scimitar that inspired European Christians to take it as a symbol of Islam and fanaticism also compelled a respect for the technological sophistication of certain Arab swords. The scimitar as a European symbol of Islam, then, reflects the double-edged

quality of many European attitudes toward Muslims: the same warfare skills, civilizational successes, and religious devotion that engendered European anxieties also encouraged some respect. Perhaps for this reason the British have named their army's latest assault vehicle "Scimitar," a successor to the armored car "Saladin" and armored personnel carrier "Saracen" deployed a few decades after they fielded their "Crusader" tank in World War II (including in Muslim-majority areas such as Algeria, Libya, and Egypt). However, this respect arises only in the larger context of Christian European antipathy for Muslims as inherently warlike, Muslim civilizations as manifestly decadent, and Islamic theology as decidedly heretical.

The Reconquista

This pattern of using a Christian ideology to unite a group in the pursuit of economic and political expansion would be repeated at the other end of the Mediterranean Sea. Following the Arab conquests in the eighth century, Jews, Christians, and Muslims cooperated in an amazing common culture that had evolved on the Iberian Peninsula. Benefiting from the transmission of the Greek classics through Arabic writers, the lands of present-day Spain and Portugal enjoyed an intellectual and artistic flourishing that allowed for, and owed equally to, the Jewish philosopher Maimonides and the Muslim philosopher Ibn Sina (Avicenna), whose medical texts would be used in European medical colleges for centuries. Although described as "Muslim Spain," the tenets associated with Islamic traditions had little to do with political governing and decision making on the Iberian Peninsula until at least 1000 CE.[19] Clearly, there was no contrast between "the West" and "the Muslim world" here. Nevertheless, ambitious Christian political leaders later sharpened a diatribe, in a manner wholly parallel to Crusader rhetoric, against the "Moor" (Iberian Muslim).[20]

Although northern kingdoms had sought expansion into the Muslim-ruled south for centuries, they had not used religious motivation to unite a common Christian opposition to the Moors before the new millennium. Alliances fluidly shifted so that Christians and Muslims would be as likely allied with fellow Christians and Muslims as in opposition to them, as was the case elsewhere in Europe and the Mediterranean.[21] However, at the same time he launched the First Crusade against Palestine, Pope Urban II also encouraged a crusade in Iberia. The northern kingdoms soon realized the power that a crusading ideology lent to their political efforts and enjoined their nobles and peasants to join in the united Christian campaign against Muslims. This effectively polarized all parts of the political contest into two

sides and forced Arabs to view themselves as Muslims qua Muslims, engaged in the defense of "Islamic territory." But the ideology of a unified Christendom could not easily overcome the political suspicions and rivalries between the self-described Christian kingdoms, and so the Reconquista dragged on for centuries. The final assault against the last "Moorish" state, Granada, succeeded in large part due to the financial backing provided to the courts of Aragon and Castile by successive popes.[22] Allied through the marriage of their rulers, King Ferdinand and Queen Isabella, respectively, the armies of these states defeated Granada in 1492.

Most contemporary Americans associate the year 1492 with at least one of two events: Christopher Columbus's departure on his famous voyage of discovery and the expulsion of the Jews from Spain. These events share more than a common date. It was the economic windfall following Ferdinand and Isabella's final victory that allowed them to finance Columbus's trip. The religious motivation not only made their military success possible but also led to the expulsion or conversion of all Jews under the threat of execution and inspired Columbus to embark on his perilous voyage in order to find the riches required to militarily liberate Jerusalem.[23] While seldom mentioned in contemporary American accounts of the expulsion of the Iberian Jews, Muslims, too, ultimately suffered the same choices: emigration, conversion, or death.

Although far less well known to popular American audiences, the Reconquista through its victory served to reestablish the supposedly natural Christian order of Europe for Christian Europeans, just as the Crusades through their defeats had affirmed the purportedly Arab and Muslim nature of the Middle East. While the Reconquista would be remembered as the closing of a chapter in European history—the term "reconquest" suggesting the restoration of an inherently Christian territory—that enabled the beginning chapter of the "discovery of the New World," the failure of the last Crusades permanently cauterized the wound of a lost Jerusalem and established the Middle East as the land of Turks/Arabs/Muslims. This would be reemphasized when Western Europeans returned four centuries later and subjugated these lands to their economic and political—if not military—control with remarkable rapidity.

European Imperialism and Hegemony

The French Revolution and Industrial Revolution notwithstanding, no series of events has had as marked an influence on the modern world as European imperialism and hegemony.[24] The forces of nationalism, capitalism,

and industrialization that engendered those two other events also served to make possible an astounding projection of power across the globe from the territorially small and demographically insignificant continent of Europe. The wave of exploration that Columbus spearheaded established new lines of transportation that would soon be woven into a global network of communication and exchange by European commercial ventures. Increasingly recognizing the significance of overseas trade and wealth extraction for their economic well-being, European states became increasingly competitive with one another in their quest for new resources for production, new markets for their products, and new ports for their traders and the navies that protected them. Hence, the "age of discovery" represented only an initial phase—albeit a critical one—of much longer age of European imperialism.

This competition dominated the early colonial history of North America as the Spanish, Dutch, French, and English soon defended their fragile toeholds on the continent with the establishment of more permanent settlements and the aggressive use of military forces. The native inhabitants were often pushed aside or annihilated once their utility—instructing settlers in how to survive in the new climes—was exhausted and they were found not to produce commodities of practical value to Europeans. In a worldview that found significant differentiation only between Christians, Jews, heretics, and idolatrous pagans, the indigenous Americans fit into the last, least respected category and were accorded little concern (meanwhile, Europeans alternatively defined Muslims as heretics or idolaters). Some settlers viewed the decimation of Native Americans by the invisible tsunami of disease brought by Europeans as evidence that, as a writer then put it, "God made way for his people by removing the heathen and planting them in the ground."[25] Violent efforts by original inhabitants to oust European settlers deepened the antagonism and sharpened the response.

Many of the colonists had left Europe to find respite from the religious persecutions that had washed throughout that continent since the Protestant Reformation. Later Americans would interpret this as emblematic of the unique quality of their country as a haven from religious intolerance. However, this was not, by and large, the case. Few of these previously persecuted groups showed any hesitancy in ridding themselves of those who diverged in dogma or practice from their rigidly defined norms. The Puritans, the exemplary group for this theme, at times executed people like Ann Dyer, who preached alternative theologies, or they cast them out, as they did Anne Hutchinson and her family—deliberately leaving many to slaughter outside the protected walls of their theologically defined settlements.[26] Just as surely as groups like the Puritans carried their religious intolerance from Europe

into their relations with one another and with the "pagan" natives, they also transported far older antagonisms toward Muslims. Although these, for the most part, did not derive from contemporary contact, they represented a social memory of past encounters perpetuated through popular narratives and religious instruction. The responses to the presence of Muslims among African slaves reflect many of the sentiments of the time and are discussed below.

Encounters, through expanding European imperial projects, with people who happened to be Muslim also served to reinforce antagonisms even as they recharacterized Muslims. This was true in different ways for the variety of European empires that competed with one another's reach across the globe. However, given the space constraints here, we will focus more on the British empire than others, since it had the greatest (but certainly not the only) impact on impressions among North Americans.

At its height, the British empire directly or indirectly controlled one-fifth of the globe's land surface and one-quarter of its people. As was the case in other European empires, such extensive holdings required Britons to subjugate those inhabitants who either could or did serve British commercial interests or could not be easily displaced. Due to their recently developed technological sophistication and nationalist social organization, Europeans successfully subordinated other societies on a demographic and geographic scale never witnessed before. But this did not result from simple military conquest: It would have been impossible for the small European population to control through direct coercion. Rather, Europeans successfully maintained their global empires by incorporating local people into their systems of domination. That is, Europeans effectively convinced many conquered people to become agents of their own subjugation. This is a mark of what is referred to as "hegemony."

More than simple physical control, hegemony involves the cooperation of the subjugated. This cooperation may appear to be consensual but must be understood as occurring in a situation in which another state or culture dominates the power relationship between the two. To offer an instance of this dynamic, almost every person engaged in international business today makes appointments using the Gregorian calendar. Four hundred years ago, at the advent of European imperialism, myriad calendars guided the lives of people around the globe. But the incredible success of the Europeans in dominating other cultures and devising a system through which most of the world now interacts created a global economic and political order that can only be bucked at great cost. Who would decide to use their lunar calendar instead of the solar Gregorian calendar when scheduling an overseas shipment of computers? What would an American bank make of a check written with a date

based on the Islamic calendar? Further evidence of European hegemonic success can be glimpsed when considering how capitalism has overtaken almost all economies. A global banking system allows an American to withdraw money from his or her checking account through an ATM in Europe, China, or India. This victory can be seen also in the total eclipse of principalities, cantons, city-states, and the myriad other political sovereignties that existed even two centuries ago, replaced by some form of the nation-state in which nearly everyone now lives, almost every one of which flies a rectangular or square flag of the same shape as those devised by European nationalists.

But perhaps the most resounding victory for Europeans was not simply that they fashioned the world's economies, political units, and flags in their own image but that they successfully established the means by which many of those they conquered understood themselves. This lent an authority to Europeans in their knowledge not only of the natural world but of the human realm, too. And so, many institutions—exhibitions, museums, universities, and learned societies—established by Westerners in subjugated lands authoritatively presented information about these peoples to those dominated, who increasingly understood themselves using European perspectives. The rising success of Europeans scientifically, economically, militarily, and imperially convinced many of the conquered to rely on Western ways of knowing the natural and human world from the seventeenth to the twenty-first centuries.

Of course, many communities and movements resisted European imperialism using violence and other means, but so successful was European hegemony that resistance could be convincingly represented as a rejection of "progress" and "development," not of domination. This was but one of the many ways in which imperialists secured the support of local groups by convincing them of their own inferiority. After all, how else to explain their conquest? Many dominated groups accepted the European offer to participate in their own social, political, and economic development and the Western-defined terms through which improvement was described. Those who resisted this vision and the ideals they used to define themselves as apart from European norms came to be negatively defined by Europeans and their allies as "regressive," "traditional," and "backward." Sir Syed Ahmad Khan, a Muslim reformer who founded India's first Western-style college in 1875, defended his efforts against those who feared that Islamic traditions would be undermined:

> It is not only because the British are today our rulers, and we have to recognize this fact if we are to survive, that I am advocating the adoption of their system of education, but also because Europe has made such remarkable progress in science that it would be suicidal not to make an effort to acquire it.[27]

Note that Sir Syed self-consciously appreciated the potency of Western science within the context of British domination. For many Europeans, Islamic traditions represented an obstacle to such national development. Whereas in the Crusades Europeans saw these as the source of fanatic armed power, now many Westerners would interpret Islam as a force that encouraged insolence, debauchery, and laziness.

This decrepitude among Islamic civilizations seemed particularly prominent in the three previously dominant empires controlled by Muslims: those of the Ottomans in the eastern Mediterranean, the Safavids in Persia (today Iran), and the Mughals in what is now India, Pakistan, and Bangladesh. At a time when Europeans emerged from their self-described Dark Ages, each of these empires had commanded wealth beyond the dreams of any European monarch, patronized towering examples of sophisticated architecture, and controlled huge territories. In an irony of world historical importance, these empires began a period of decline just as Western European empires initiated their ascent. The changing context of competition shifted the terms of the debate and recast Muslims, in part, from fanatic warriors of inexorable conquest to decrepit inheritors of former glories. Cast upon a timeline of world history, Muslims seemed to Europeans as part of a past order surpassed by a new world order defined by them. But perhaps more importantly, Europeans overwhelmingly fastened on the view that many of the people of these realms were not Turks and Arabs, Persians, or South Asians but "Muslims." For the British and many other Europeans, those people who happened to be Muslims were particularly and primarily Muslim, suggesting that these people held religious identity more centrally than many of them likely did.

A political cartoon from 1787 reflects this dynamic of identifying Europeans as such and Turks as "Muslims" (figure 2.1). It depicts Catherine the Great of Russia—the "Christian Amazon"—battling Sultan Selim III and his "300,000 Infidels." Even though different European allies side with each, the cartoonist focuses primarily not on these competing alliances but on the religious identity of their two leaders. Notably, the empress's brave stance and confident temperament evokes different emotions than the sultan's seemingly mutilated nose and angry disposition.

Many Europeans justified their imperialism through their efforts to improve and uplift "backward" peoples. These efforts included not only the necessary subjugation of non-Europeans for purposes of ensuring social order but also, at times, proselytism to the true Christian faith. Although among the British, various colonial administrators sought to minimize the presence of missionaries, the rise of a fervent Evangelicalism in the nineteenth century overcame bureaucratic objections in the English Parliament, so mis-

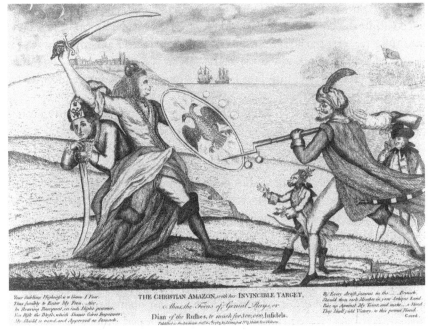

THE CHRISTIAN AMAZON, with her INVINCIBLE TARGET, Alias, the Focus of Genial Rays, or Dian of the Rushes, to much for 300,000, Infidels.

Figure 2.1. Published by J. Crawford, October 24, 1787. Courtesy of the Library of Congress, Prints & Photographs Division, LC-USZ62-123020.

sionaries, often with sharply anti-Islamic messages, held forth as never before throughout the British empire. Reflecting the spirit of competition inherent in much of this thought (and echoing medieval Christian sentiments), one Evangelical-minded British official remarked that Islam was "the only undisguised and formidable antagonist of Christianity . . . an active and powerful enemy. . . . It is just because Muhammadanism acknowledges the divine original, and has borrowed so many of the weapons of Christianity, that it is so dangerous an adversary."[28] The common experience—that Muslims proved particularly resistant to their efforts—among many missionaries and other proselytizing Evangelicals only deepened their anti-Islamic sentiments.

Imperialists found more success in reshaping societies in terms of European-style nationalism. As European empires usurped the place of indigenous rulers, they redefined each of their conquests as a nation—that is, as unified people of a common character who inhabit a territory defined by internationally recognized borders. To understand this national character, Europeans initiated projects to write national histories based on the efforts of European and European-trained archaeologists, historians, and other experts.

Because most vanquished non-Europeans did not understand themselves in this specific way, it was left to Europeans to "discover" their past and, therefore, make yet another contribution to the progress of each non-Western nation. With their earlier ways of knowing disparaged and delegitimized as "traditional," "primitive," or "medieval," non-Europeans often found their endeavors to master Western forms of knowledge disregarded as meritless mimicry. Meanwhile, where previously state power radiated from a ruler's capital and encompassed as many subjects as militarily or politically possible, European ideologies in the service of their empires drew lines that defined the nation and became permanent national borders. In the late eighteenth century, just as the notion of nationalism coalesced in Europe, some North American colonists demonstrated how these currents of thought could not only serve the dominant conquerors but also unify rebellious subjects.

Colonial and Nineteenth-Century American Interactions with Muslims: Slavery, Despotism, and Sensuality

At this point in our story, we shift from the general attitudes toward Muslims that arrived with Europeans in America to the specific contacts European Americans had with Muslims in America and abroad. These occurred primarily in the context of either Mediterranean shipping conflicts or the enslavement of African Muslims. However, the prohibition on slave transportation in 1808 and a general intolerance toward non-Christian religions eclipsed whatever little interest whites had in sub-Saharan Muslims. The consistently derogatory depictions of Muslims in cultural expressions of the era reflect the tenacity of European views in the new nation even as they suggest the unique perspectives of a changing nation. Overall, three themes dominated this period: Muslims as slaves, Muslims as despots, and Muslims as sex-obsessed men or sex objects. These themes, compounded by the biological racism ascendant during this era, reflected the development of anti-Muslim sentiments that extended—yet diverged from—Islamophobic attitudes. Although Christians in the Iberian Peninsula had already developed ideas regarding Muslims (and Jews) as having biologically inherent qualities as early as the fifteenth century, Europeans and Americans of the modern era not only feared the threat they perceived in Islamic traditions but increasingly held negative sentiments toward Muslims based on stereotypes regarding their supposed race, culture, and civilization.

Muslims lived in America before the first English colonists arrived, having already been brought as slaves from Africa by the Spanish.[29] Yet it has taken

until the last couple of decades for scholars to determine that perhaps one of every five Africans enslaved in Africa for transportation to the United States was a Muslim. This demonstrates how completely slavers and the Christianity of slaveholding society erased the religious heritage of slaves. When Alex Haley portrayed his enslaved African ancestor as a Muslim in his 1976 book *Roots*, his fellow historical novelist James Michener criticized him for such an unrealistic characterization.[30] This historical amnesia reflects a general British disinterest, shared by the French, in whether their slaves were Muslim or not and the historical distance these Europeans had traveled since they were threatened by Muslim armies.

This contrasted with the attitude of the Spanish, who preceded the British and French in introducing African slaves. Spanish colonists in the Americas, informed by a sharper cultural memory of combat with the Iberian Moors, actively sought to exclude Muslim slaves from the New World. They feared that Islamic proselytism might instill resistance among not only slaves but indigenous peoples as well, while undermining Catholic efforts at conversion.[31] Conversion provided a justification central to not only the colonial conquest of indigenous peoples and their resources, but, for some Europeans, their enslavement as well. Biological notions of breeding and stock—differentiating Christians from Jews and Muslims and existent in the Iberian Peninsula almost a century before the final victory over the Moors—meant that many Spaniards did not view conversion as erasing difference. These ideas distinguished "natural" Christians from those descended from Jews and Muslims.[32] Meanwhile, Spanish and Portuguese colonists attempted to instill the memory of the Reconquista among their Christianized slaves by requiring them to perform the *Moros y cristianos* play that victoriously reenacted the Christian expulsion of the Muslims from Iberia.[33] In contrast, British Protestants resisted slave conversion until the late eighteenth century because it prompted questions as to whether Christians could be enslaved.[34]

The assumption preferred by British colonists and their descendants was that Africans were inherently unable to be civilized without outside help.[35] If a Muslim African demonstrated abilities in Arabic literacy, then colonists labeled him or her as "Arab," since reading supposedly defied African abilities. Whites considered such a quality as evidence of "foreign blood," which made for a respectable difference from "true Africans" (not so respectable as to excuse them from enslavement, of course) whom the "Arab" could then be trusted to supervise. This situation reinforced the terrible logic and racial premises of slavery: "Arab Africans" demonstrated capabilities that reflected a bloodline considered white and affirmed white superiority over "true Africans," who, as blacks, deserved slavery.[36] Many English-speaking slaveholders

preferred "Mandingo" slaves (those from Senegambia and Sierra Leone) and others from Muslim-majority regions because of a perceived higher intelligence and European-like facial features that distinguished them from other blacks.[37] A comment by Mark Twain about Abd ar-Rahman reflects that this privileged portrayal of some Muslim Africans did not translate into an overall respect for Muslims. In 1867, Twain viewed the portrait of a Muslim African who had escaped slavery and settled in Liberia. Twain commented on this "dignified old darkey," saying, "I, for one, sincerely hope that after all his trials he is now peacefully enjoying the evening of his life and eating and relishing the unsaleable niggers from neighboring tribes who fall into his hands."[38] Even if Twain was speaking through his trademark irony, he voiced a disparagement with which he expected his American audience to be familiar, if not to hold. However, public recognition of Islamic traditions among slaves or former slaves, though never prominent, slowly disappeared; meanwhile, the context of American awareness of Muslims and their religious customs had already arisen in international relations.

The first international conflict in which the new American republic involved itself took place in the Mediterranean soon after independence. Not surprisingly, it quickly proved the prevalence of the second theme many Americans in the new republic held regarding Muslims: the extreme despotism of their rulers. This was a time after the Turkish Ottoman empire had ended its efforts to expand into Europe yet still controlled a vast area of Mediterranean lands and loomed large in European imaginations. Like many among the British, Americans agreed in their depictions that the Turks lived under a despotic rule that leaned toward anarchy, in large part due to Islam.[39] Turks, and Muslims in general, often served as a negative foil when compared with American ideals. In 1790, John Adams criticized the excesses of the French Revolution by arguing that it would lead the French to "soon wish their books in ashes, seek for darkness and ignorance, superstition and fanaticism, as blessings, and follow the standard of the first mad despot, who, with the enthusiasm of another Mahomet, will endeavor to obtain them" (figure 2.2). His son, John Quincy Adams, relied on a common understanding of a militant Muhammad to malign Thomas Jefferson when he thought that the Virginian had described his father's ideology as one among other "political heresies." In print, the younger Adams portrayed Jefferson as calling on "all true believers in the Islam of democracy to draw their swords." Then he referenced the popular Islamic statement of faith (the shahada: "There is no god but God, and Muhammad is His prophet") to disparage Jefferson's excessive support of republicanism as represented in Thomas Paine's famous publication. And so Adams mockingly depicted Jefferson as shouting, "There

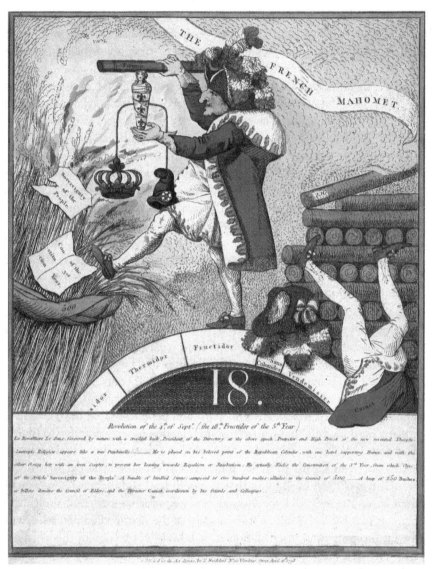

Figure 2.2. This British cartoon from 1798 satirizing Napoleon demonstrates how, despite the recent unpleasantness between the two nations, British attitudes toward Islamic traditions paralleled American ones. Courtesy of the Library of Congress, Prints & Photographs Division, LC-DIG-ds-11645.

is one Goddess of Liberty, and *Common Sense* is her prophet."[40] Regardless of their mutual disagreements, postindependence American politicians could agree that Muslim despotism represented the salient example of what had to be avoided at all costs.[41] They therefore called on this mutually understood negative example to illustrate where the policies of their opponents would lead America, reinforcing the image of inherently despotic Muslims while using the image as an effective rhetorical tool.[42]

Meanwhile, various states along the North African coast—known to Americans as the Barbary States—demanded tribute of nations whose merchants plied western Mediterranean waters. The states often made captives of men and women aboard the ships of those who defied them, extracting the neglected tribute from the ransom they set. Although many European countries acquiesced, the United States eventually refused, and thus began a series of diplomatic wrangles and naval skirmishes over the next few decades (figure 2.3). Relying on the same rhetoric of Muslim despotism and anarchy, American leaders portrayed themselves as uncompromising defenders of liberty in the struggle for free enterprise. They distanced themselves from Europeans who acquiesced to the extortions and so, they argued, abetted tyranny. Though Adams and Jefferson may have disagreed on other matters, they could together decry that the "Policy of Christendom has made Cowards of all their Sailors before the Standard of Mahomet."[43] The social memory of this early conflict would be instilled in future generations of Americans through the lines of the Marine Corps hymn: "From the halls of Montezuma / To the shores of Tripoli / We will fight our country's battles / In the air, on land, and sea." Meanwhile, Francis Scott Key composed a song celebrating America's ultimate victory. It included the following verses:

How triumphant they rode, o'er the wandering flood, and stain'd the blue waters with infidel blood
How mixed with the olive, the laurel did wave, and formed a bright wreath for the brows of the brave.[44]

A later rewrite that adapted the song to the context of the War of 1812 against the British removed mention of "the Crescent" and "the turban'd head" as symbolic references to the Muslim Tripolitan enemy but retained patriotic mention of "the star-spangled flag." Of course, it was this version that would become the American national anthem. Although the recently independent Americans attempted to distance themselves from their European cousins still caught in the royalist thrall of nondemocratic rule, they continued to reflect European obsession with the Ottomans in which the

Figure 2.3. The curved blades, facial hair, and dark complexion helped identify Stephen Decatur's "Algerine" enemies as Arabs/Muslims for American viewers of the popular images that depicted his famous 1804 battle in Tripoli. Courtesy of the Library of Congress, Prints & Photographs Division, LC-USZ62-2466.

category "Turk" encompassed all Muslims. In an 1805 instance, New York newspapers portrayed Tripolitan sailors captured in American naval operations and put on public display at various city theaters as "your real *bona fide* imported Turks."[45] Meanwhile, Key's use of the crescent to refer to the Muslim Tripolitans demonstrates the popular American association of what was then a solely Ottoman symbol with Islamic traditions universally.

The display of Muslims as visual entertainment represents the third theme in non-Muslim American encounters with Muslims in this period. Undoubt-

edly the captured "Turks" paraded on stages in New York City drew crowds as tamed representatives of the Ottoman sultan, who, in actuality, exercised little if any influence over the so-called Barbary States. If theirs was the masculine face of the armed might of Muslim despotism, then a feminine face was at least equally an object of fascination since it represented the subjugated victims of Muslim (male) depravity. Fueled by concepts of the Romantic movement that emphasized the "exotic," nineteenth-century European and American depictions of the courts of Muslim rulers rarely missed an opportunity to depict both the tyrant's spear- and sword-armed soldiers and his sensually and scantily clad harem. Artistic schools of realism produced convincing paintings and, later, photographs of women of the harem or seraglio. ("Harem" derives from the Arabic *harima*, "inviolable," "forbidden." "Seraglio" derives partly from the Turkish *saray*, "palace.") These images satisfied Western appetites for the titillating secrets of forbidden places that teasingly promised prohibited sensual delights. Who could resist? Even the most puritanical could nod agreeably at depictions of nude or seminude women enchained to the whims of lascivious men, recognizing the negative morality it demonstrated. The century ended with the World's Fair of 1893 and the arrival of the "hoochy-coochy" as performed by undulating Algerian dancing women. At a time when stage dancing by women was rare, the "cooch" would become common on stages and carnivals alike, as would the moral outrage that some initially expressed against it.[46] The continued association of "harem" with Arabs and Muslims reflects how skewed knowledge about these people is among English speakers. Not many Anglophones associate the words "algebra," "alcohol," "banana," "coffee," and "cotton" with Arabs or Muslims, although all those words originated in Arabic.

Advertisers, recognizing an overall American association of sensuality with Arabs/Muslims (indeed, these identities had become a singular abstraction in many American minds), used images of Arabs/Muslims and Arab/Muslim-associated places and objects to market their products. Camel cigarettes, with the eponymous camel standing in front of pyramids, best illustrates this, while other early cigarette brands included Fatima, Mecca, Medina, and Omar. Advertisements often suggested "romance, self-indulgence, or sexual innuendo." In the next century, the new cinema industry would associate these very themes with productions like *The Sheik* (1921), starring Rudolph Valentino, and *The Thief of Baghdad* (1924), starring Douglas Fairbanks.[47] Although these movies would have valorous Arab protagonists who represented exotic romance, they also often included villainous, debauched Arabs threatening the female lead. Publicity for the enormously popular *Sheik* stated, "When an Arab sees a woman he wants to take her" and "See

the auction of beautiful girls to the lords of Algerian harems." A condom would later be marketed with both the name and the image of an Arab in robes, straddling a stallion.[48] Through depictions of Arab characters praying in a mosque, the film deliberately connected them with Islamic traditions. Overall, the effectiveness of the Arab/Muslim in advertising at this time rested in their association with a sensuality bordering on the depraved.

The nineteenth century closed as it had opened, with American combat against enemies overseas, some of whom happened to be Muslims. The Spanish-American War of 1898, precipitated by the Cuban rebellion against their Spanish masters and the sinking of the US battleship *Maine* in Havana harbor, ended with Spanish defeat and the American annexation of the former Spanish possession of the Philippines. President William McKinley explained his decision to a delegation of Methodist clergymen: "There was nothing left for us to do but to take them all, and to educate the Filipinos, and uplift and Christianize them, and by God's grace do the very best we could by them, as our fellow-men for whom Christ also died."[49] Apparently McKinley did not think much of the Christianity of the Filipino Catholic majority. McKinley's successor, Theodore Roosevelt, inherited a rebellion by Filipinos who were as unwilling to embrace the imperialism of Americans as they had been that of the Spanish. This perhaps reflected the rising distrust among many imperially and colonially dominated groups regarding the goodwill and superiority of their European (and American) masters. Roosevelt characterized the Filipino opposition as threefold, using deliberately religious terms when he differentiated them as "half-caste Christians, warlike Muslims, and wild pagans."[50] This categorization suggested that the resistance of the violent Muslim and disorderly pagan was simply in character, while local Christians rebelled only due to their half-caste nature. (Filipino Muslims continue to be known as *Moros*, the local adaptation of the Spanish *moro*—"Moor" in English—that initially referenced only inhabitants of North Africa but later became synonymous with "Muslim.")

Near the end of the nineteenth century, a more domestic set of encounters began as the first wave of willing Muslim immigrants arrived in the United States. But they too would find that their race more than religion determined their status in America. Indeed, these Muslim Syrians and Lebanese arrivals were only a minority among the Christian compatriots with whom they arrived. Their opportunity to naturalize as US citizens depended on the government creating a racial classification for them and then determining whether or not their now established "race" disqualified them. All this reflected how ambiguous the perception of Arabs continued to be

for white Americans. Until 1952, federal law followed the Naturalization Act of 1790, which allowed naturalization only to "free white persons and persons of African nativity or descent." Courts made contradictory rulings of Arabs as "yellow," "Caucasian," and "about walnut."[51] Jews faced similarly varied opinions. Although other waves would follow and some Muslims, depending on perceived race, would be accepted as Americans, a popular and unfavorable impression of Muslims as associated with specific ethnicities and inherently different from Americans never seriously diminished. In the middle of the next century, the number of Muslims immigrating to the United States increased tremendously when President Lyndon Johnson ended the existing quota system that restricted most immigration to ethnicities already represented in the country (i.e., Europeans).[52] Paradoxically, these new Americans would arrive just as an increasingly prevalent media image of inexorable conflict between "Islam" and "the West" would more powerfully reflect and reaffirm the generally understood notion that the two were mutually exclusive.

Twentieth- and Twenty-First-Century Interactions: Soviet Containment, Oil, Zionism, and Terrorism

American popular interest in Muslims moved from the incidental interactions and clashes in the nineteenth century to conflicts Americans considered endemic in the twentieth and twenty-first centuries. Economic, religious, and strategic concerns had led American foreign policy and businesses to become very involved in the Middle East at the end of World War II. Few Americans held interest in other Muslim-majority areas. For instance, American tourists did not find South and Southeast Asia in large numbers until the 1960s. Even then, the cultures and religions that attracted most of these travelers and that supposedly typified these regions were Hindu and Buddhist, not Muslim. This only reaffirmed American impressions of the supposed equivalence of the Middle East and "the Muslim world." Lacking interest in or experience of Muslim-majority cultures to the east of the Middle East, where most of the world's Muslims live, Americans continued to imagine all Arabs as Muslim and see all Muslims as Arab, although many Arabs are Christian and only 20 percent of all Muslims are Arab. A vague awareness of the Muslim nature of Middle Easterners became hardened into cold geopolitical fact through American interests in four realms that have become increasingly and unexpectedly interrelated. More elaboration on these interests and the political events that they helped engender can be found in chapter 5.

Soviet Containment

The primary American concern with the world beyond its borders following World War II and until the fall of the Berlin Wall in 1989 was containment of the brawny Soviet Union. The Berlin Wall appeared to be the perfect symbol of the Soviet-NATO divide: a seemingly impenetrable divider that starkly separated two sides into camps demarcated by barbed wire and guard towers. In reality, however, much of the world found itself in a no-man's-land stretching between the two sides, enticed by favorable trade agreements and generous military assistance while threatened with arms for opposition parties and penalties in international forums. As early as 1947, President Harry S. Truman declared the nation's willingness to back "free peoples who are resisting subjugation by armed minorities or outside pressures."[53] The world understood that the Truman Doctrine meant more certain support to those facing Soviet pressure than to those still wrestling to throw off the remaining vestiges of Western European imperialism.

Neither Americans nor Soviets cared much for the cultural or ideological backgrounds of their proxies, and so at various times Turkey, Iran, Pakistan, and Egypt became valuable and well-endowed allies of the United States. Their Muslim cultures neither mattered nor were noticed in the popular imagination, as demonstrated in the 1963 James Bond film *From Russia with Love* (see chapter 8). All that mattered was whether a country embraced or resisted Soviet Communism, which was characterized as a totalitarianism and an irreligious religion. According to one highly influential government finding, Soviet Communism encouraged individuals to "an act of willing submission . . . under the compulsion of a perverted faith."[54] In order to underscore how America differed, in 1954 the Eisenhower administration inserted the line "one nation, under God" into the Pledge of Allegiance. Meanwhile, the rise of the Pan-Arab movement as resistance to continued British and French regional involvements in the 1950s threatened to unite "the Arab world" without a clear sense whether they would become client states of the West or the Soviets. President Dwight D. Eisenhower understood this and surprised Israel, Britain, and France by not supporting their invasion of Egypt in 1956 when that country nationalized the Suez Canal. Said he, "How can we possibly support Britain and France if in doing so we were to lose the whole Arab world?"[55] Arab identity, then, was becoming of interest to American audiences. Although understood to be inherently Muslim, this aspect of the Arab identity would not become foremost for Americans until the late 1970s. Before then, anti-Arab sentiment often simmered with anti-Muslim themes that may have had historical connections to Islamophobia, yet it was not immediately informed by anxieties about Islamic traditions.

Oil

Although during the Cold War Americans sought to entice many nations to enter their sphere of influence, the contest with the Soviets was particularly pointed in the Middle East because of the presence there of the primary fuel that propelled the success of each economy and military: oil. Many of the region's nations already owed their borders and ruling dynasties mainly to European imperial efforts to ensure a politically secure supply of oil once the costs of military occupation became unsustainable. The straight lines of national borders in the Middle East remain as the artifact of these European machinations. The Allies, expecting the Ottoman empire's demise even before the end of World War I, planned the partition of the Middle East into parcels based almost entirely on their political and economic interests. For instance, at the war's conclusion, the British melded three oil-rich Ottoman provinces together to establish Iraq.[56] Nearby, they carved out a smaller territory as Kuwait and handpicked the Sabah family as its ruling dynasty. Few of these decisions placed much emphasis on the needs, perceptions, or desires of the area's inhabitants. Whereas the less linear borders of Europe reflect how nations there formed through self-determination largely according to local efforts to define a common language and culture, the straight lines of Egypt, Iraq, and other Middle Eastern countries evidence the artifice of European projects to establish nations among peoples who seldom understood themselves according to this European notion of social organization and who, for the most part, did not participate in their own national definition until later.

American anxieties about "Arab oil" heightened only in the 1970s, after the Organization of Petroleum Exporting Countries (OPEC) exerted its control over a large percentage of international oil supplies and forced Americans to pay more at the gas pump than they ever imagined. For decades, the United States had built its economy on the assumption of inexpensive oil. Therefore the shocking energy price increases threatened not only the overall economy but also the car culture through which so many Americans expressed their individuality and freedom. Both of these elements had made possible such features of the cultural landscape as drive-in diners and movies, Jack Kerouac's *On the Road*, and Ken Kesey's psychedelic magic bus trip that helped define successive generations. OPEC, dominated by Arab states, came to be seen not simply as an economic competitor in the capitalist marketplace but as a cultural opponent to America, a threat to the "American lifestyle." Anti-Arab sentiment flared, and anti-Muslim bias prevalent in stereotypes became more glaringly apparent, although still with little expression of Islamophobia. What immediately occasioned the 1973 oil embargo that

signaled the rise of this dual economic and cultural danger was American support for Israel in the 1973 October War.

Zionism

It seems odd to imagine that Jewish nationalists once considered Madagascar a serious candidate for a Jewish state. In the years preceding World War I, many sites, including Palestine, were contemplated. Even after the League of Nations included provisions for the establishment of a Jewish national home when it established the British Mandate in Palestine in 1922, some Jews rejected the concept out of hand as either unnecessary due to European Christian tolerance or, especially among the Orthodox, impious in light of the messiah's expected reestablishment of the kingdom of David. However, the unparalleled horrors of the Holocaust—which represented the culminating mutation of more than a millennium of Christian European antagonism toward Judaic traditions into a virulently racist anti-Semitism—silenced all meaningful opposition in the West, including that of most Jews. The settlers who lived under the auspices of the British Mandate prepared to declare an independent Israel once the war-weary British departed in 1948. Many local and regional Arabs resisted the establishment of Israel. This opposition culminated in five outright wars in 1948, 1956, 1967, 1973, and 1982 between Israel and some Arab states. Meanwhile, a persistent tension between Israeli Jews (Israeli Arabs are few) and Palestinians (which include Christians among a Muslim-majority population) continues to generate violence and victims.

American support for Israel, unmatched in tenacity by any other nation, has resulted from a variety of factors. First, many American Jews have considered the Holocaust as justification enough for a Jewish state. For them, the Holocaust was the final evidence that Jews needed a self-established nation as a sanctuary in a world in which no nation dominated by Gentiles could be entirely trusted and no people fully recognized unless organized into a nation-state. A great many also felt an overwhelming guilt at their perceived inaction during—or even their survival of—the Shoah and found an outlet for their feelings through support for Israel via Washington lobbyists and charity donations. Second, Israel had offered to be a bulwark in the anti-Communist system of alliances in a region critical to American economic interests. Third, Israel has represented a nation far more familiar in outline, at least in its initial decades, to Americans than its regional neighbors seem: it was founded on biblical and frontier myths, democratic ideals, and European sensibilities. Anti-Semitism in the United States, which had become particularly pronounced in the 1930s as Americans sought scapegoats for

the Great Depression, was neutralized in American support for a Jewish land heroically wrested from Arab hands.

Although many Americans today perceive the Israeli-Palestinian conflict as one between Jews and Muslims, this is not the way those involved have always understood it. The regional support for Palestinians would originally—and, in large part, still does—gravitate around a shared Arab identity. The European origin of most of the first Zionist settlers prompted Arabs to consider the Jewish land as a final act of colonization in the two-hundred-year drama of European imperial control. In the eyes of many Arabs, these Jewish settlers represented the last remnant of European Jewish populations that Christians had failed to annihilate and now sought to relocate from their countries. For Arabs, the quality of this conflict became more Islamic in orientation with the 1967 Israeli capture of the Al-Aqsa Mosque on what many Jews refer to as the Temple Mount and the demise of the Palestinian Liberation Organization (PLO) and its perennial leader, Yasser Arafat, as a credible vehicle of resistance. Hamas and other organizations that defined themselves through Islamic ideologies ascended. American bonds with Israel appeared to be palpably tightened with the September 11 attacks, sharing in the persistent threat of "Islamic terrorism."

Terrorism

It would be nearly impossible for the American reader to consider the matter of Muslims and terrorism without the attacks of September 11, 2001, as the starting point for any discussion. The monumental shock of this catastrophic event—as absolute in its unexpectedness as it was complete in its devastation—has led many observers to agree that the world irrevocably changed as a result. Although others around the globe, especially those who have long suffered the imminent threat of violence from subversive groups, may be impatient with what they consider an American naïveté regarding terrorism, the impact of the event remains seminal. The deeply felt American vulnerability to an Islamic threat, the use of this in the justification for US aggression abroad, and the soaring suspicion of the United States felt among Muslims globally are all on a higher level of magnitude from previous events. Nothing before had so crystallized fears of Muslims and Islam: not the 444-day confinement of American embassy staff by Iranian students (1979), the deaths of hundreds of US Marines in Lebanon due to Hezbollah suicide car bombers (1983), the Ayatollah Khomeini's fatwa (legal ruling) consigning author Salman Rushdie to death for his novel *The Satanic Verses* (1989), or the first bombing of the World Trade Center (1993).

As terrorism has become one of the defining issues of both domestic and foreign policy in the United States in the twenty-first century, Muslims have become nearly synonymous with the term in the minds of many Americans. This represents a significant change from earlier decades, when groups that attacked civilians tended to be viewed as insurgent nationalist movements. For instance, throughout much of the last half of the twentieth century, the American media portrayed Arab organizations as figuring among a variety of terrorist movements that included those run by Nicaraguans, West Germans, Puerto Ricans, Filipinos, Italians, and Irishmen and women. Palestinian groups, for instance, embarked upon a series of crimes, often murderous, to gain global attention to their causes. The PLO hijacked airliners, and, perhaps most infamously, the Black September group despicably slew Israeli athletes during the 1972 Munich Olympics. However, despite the predominantly Muslim composition of the PLO, it was more likely to be identified by Americans as Arab than Muslim at least until the 1980s, as contemporary editorial cartoons attest. American news outlets have portrayed the subsequent rise of Hamas as the result of an Islamic surge among Palestinians, shifting the focus from nationalist struggle to religious fanaticism, despite the Palestinians' undiminished desire for a self-determined state.

When the Ottoman empire imploded after World War I, Europeans (and Americans) lost the final, direct threat of military or political competition from a Muslim-led state. Yes, Saudi Arabia and other OPEC nations momentarily curtailed exports, Muslim Arab states occasionally rattled their swords at or back at Israel, and Iran would challenge the geopolitical balance in the Middle East that Americans preferred, but none of these provided the persistent level of imminent threat that helped promote the image of Muslims as foils to "Western" states, cultures, religions, and values that their perceived looming danger made significant. The ascent of feminism in the 1970s, with its attendant rising recognition of domestic violence, glass ceilings, restrictive clothing, and gender stereotypes among Americans that victimized women, made attention to the supposed marginalization of Muslim women a way of emphasizing progressive values toward women while redeeming American culture as flawed but not *that* flawed. Perhaps not coincidentally, after progressives had finally failed to popularize bra burning and to pass the Equal Rights Amendment as signs of American women's liberation, wearing hijabs and Islamic laws have usefully served as emblematic of Muslim women's subservience.

Meanwhile, the perpetual "mess" that Middle Eastern politics seemed to Americans since the 1960s promoted the sense that Arabs/Muslims posed a greater military and political threat to one another than to the United

States. The administration of George W. Bush had to purport Saddam Hussein's government as immediately threatening American troops with weapons of mass destruction in order to create a convincing notion of imminent threat that justified the invasion of Iraq. But even that alone may not have been enough to garner the necessary congressional and public support without the allied allegation that the Baathist government worked in concert with al Qaeda. Terrorism, more than any other qualifier, permitted the US government, news outlets, and the rising "Islamophobia industry" to promote a new sense of violent Muslim threat. The War on Terror instantiated a "forever war" with an enemy whose religiousness, statelessness, and ruthlessness made certain Muslims—or, in the eyes of some, all Muslims—enemies by definition (see chapter 8).

Since the tragic disasters of September 11, non-Muslim American responses toward Muslims in the United States have varied. Many Muslims, their homes, businesses, and mosques suffered threats and, at times, even assault by outraged fellow citizens. The immediate violence arose from misplaced anger. Other forms of menace and conflict arose later, prompted by the claims of politicians, commentators, entertainment media, and law enforcement officials about sleeper cells and "terrorists living among us." Television shows like *24* and *Homeland*, and a Showtime miniseries titled *Sleeper Cell*, reinforced the image of Muslim Americans dedicated to harming their neighbors. Occasionally individuals or couples have acted violently, claiming vindication through some uncommon Islamic ideology. The assaults on innocents at Fort Hood, San Bernardino, and Garland, as well as failed attempts such as those in Portland, Oregon, and Times Square, New York City, have unjustifiably helped—despite their rareness—quicken exaggerated fears of all Muslims.

Some non-Muslim Americans have redoubled their efforts at interfaith communication as Muslims increase their attempts to educate the general population about Islamic traditions while condemning such crimes. Islamic organizations ran out of outreach materials in the year following 9/11 as they scrambled to answer questions about Muslim lives and Islamic practices and beliefs and as churches, synagogues, and other non-Muslim organizations sought to better understand their neighbors. The presence of Muslim domestic groups reflects both the rising numbers of American Muslims and their increasing organizing efforts to counter anti-Islamic and anti-Muslim perceptions. However, since at least 2006, some Republican Party members have characterized the presence of Muslim Americans as a threat in order to harness Islamophobic and anti-Muslim sentiment for political gain. Their endeavor culminated with the successful presidential campaign of Donald

Trump, who adroitly forged a dedicated electoral base in part by feeding these unfortunate ingredients to those who hungrily consumed his larger nativist, nostalgic, protectionist, and racist message.

While some non-Muslims have attempted to emphasize the spirit of "charity which we owe to each other" that Pope Gregory VII described at the turn of the last millennium, unfortunately the overall impression—also dominant earlier in US history—of Muslims and Islam as a barbarous, expanding, oppressive force has found apparent reinforcement in the minds of many—perhaps most—Americans since the events of 2001.

CHAPTER 3

—ɯ—

Symbols of Islam,
Symbols of Difference

Simply put, a symbol is an object and/or image meant to represent something else. For instance, VW in a circle symbolizes Volkswagen for consumers, H_2O symbolizes water for those who know chemistry, and the cross symbolizes Christianity for Christians and others. Symbols are necessarily contextual, depending on the circumstances of their recognition. For example, neither VW nor H_2O would have meant "Volkswagen" or "water" to anyone five centuries ago. For a Roman in the first third of the first century, the cross might have signified painful execution but nothing else. Today, national symbols are perhaps more ubiquitous than most others: the maple leaf symbolizes Canada; the rising sun, Japan; the Star of David, Israel; and the bear, Russia. Americans refer to the United States using a number of symbols: the bald eagle, the Stars and Stripes, and Uncle Sam. In addition, the Capitol Building and White House represent the government, the Constitution the nation's political ideals, and the Statue of Liberty a beacon of freedom.

Every symbol relies on agreement among a group of people that when they see the object or image, it will signify something else to them. Some symbols, like those mentioned above, result from a group determining that a symbol will stand for their collectivity. But some symbols are created by one party to refer to another, and the other may or may not welcome or embrace the symbol used. So, for instance, Nazi Germans viciously required gays and lesbians to wear an inverted pink triangle on their clothing, having invented this as a symbol of their victims' queerness or alleged queerness.[1]

Political cartoons rely on symbols as a shorthand by which the reader can understand to whom the cartoonist refers. The artist must clearly establish whom he or she is commenting upon in the very limited space afforded most cartoons. Symbols effectively conserve space; through them a people, an object, an idea, a corporation, or a religion can be immediately signified as being part of the depicted issue without the use of any words or excessive images. The symbols chosen by American political cartoonists to connote Muslims and Islamic traditions primarily derive from American and European experiences of Middle Eastern Muslims and thereby project onto all Muslims symbols that, by and large, do not derive from their own self-understanding.

This chapter examines these symbols so we can understand how they work and what they communicate about American perceptions of Muslims and their religious practices and beliefs. Their full importance becomes clearer in the more detailed analysis we will undertake in later chapters. The use of "Islamic" symbols by contemporary cartoonists demonstrates that even when Americans did not consciously associate Middle Eastern political activity with religion, they have often equated all Muslims with the Middle East and all Muslims with "Islam." This chapter contrasts these depictions with a consideration of American political cartoonists' use of symbols depicting their own country.

It is important to keep in mind the distinction between symbols of Islamic traditions and caricatures of Muslims. The next chapter will consider how cartoonists have caricatured Muslims—that is, drawn Muslims in ways the cartoonist assumes his or her readers will recognize. Caricatures are not symbols, because they operate under the assumption that the representation physically resembles, even if in an embellished manner, the person or people to whom it refers. No one assumes that all Americans look like the symbolic Uncle Sam or Ms. Liberty. One does expect that a caricature of the serving president will resemble in a perhaps exaggerated way the president's actual appearance. This difference will become more important in the next chapter when we examine the widespread use of caricature in American cartoons to represent Muslims in a way that finds little parallel with caricatures of Americans—or, for that matter, Christians and Jews.

The Scimitar

Although the Arab defenders in the Levant used straight-edged swords for the first two centuries of the Crusades, as was the norm among Crusaders, Western cultural memory forgets this.[2] Instead, the sharply curved scimitar[3] became a primary symbol of difference, marking the supposed chasm between Arab Muslims and European Christians, as seen in any number of Hollywood films. This may have become the case, in part, because one Eu-

ropean weapon—the cruciform-shaped long sword—served many Crusaders as symbolic of their movement since it was so similar to the central emblem of Christianity: the cross.

The irony of the negative symbolism of the scimitar is that different branches of the US armed forces have armed themselves with curve-bladed swords in imitation of these weapons. George S. Patton, while still in the horse cavalry and long before he became one of the last century's most famous generals, noted that the contemporary American cavalry saber directly descended from the Arab "curved scimitar-like saber."[4] US Marine Corps officers continue to wear the ceremonial Mameluke scimitar sword in symbolic memory of the 1805 campaign on the "shores of Tripoli," when a local chieftain gifted one to the Marines' commanding officer.[5] Meanwhile, the US Air Force named two jet fighters "Sabre," and the word even was taken as the name of Buffalo's ice hockey team.* Nevertheless, American cartoonists reserve the scimitar as a symbol of Muslim barbarity, showing it repeatedly in the hands or by the sides of unjustifiably violent characters, yet seldom, if ever, in their depictions of the American military.

In figure 3.1, Lisa Benson weaves together the phenomenon of beheadings— currently associated in the minds of many Americans with the violence and

Ringing in the New Fear

Figure 3.1. Ringing in the New Fear. © 2015 Lisa Benson/*The Washington Post.*

*In line with the expression of their military appreciation for Muslim warriors in the Crusades by naming weapon systems "Saracen" and "Saladin," the British military has similarly used the term "scimitar," first for a 1960s naval fighter aircraft and currently for an armored vehicle.

lawlessness of "Islamic fundamentalism"—with the implied threat of the scimitar. Although cartoonists occasionally put outsized scimitars in Muslim hands to make them appear comically barbaric, this figure specifically pictures a scimitar communicating a serious threat. Its presence serves to inform the reader that the fearsomeness of Muslim violence is total—threatening to overtake the entire year with violence against even the most innocent.

The Mosque

Muhammad directed the building of the first historical mosque soon after Muslims settled in Medina and established the first Islamic society. Since then, mosques have served most Muslim cultures as a place for communal prayer, if not also as a community center and general social space. The call to prayer often emanates from the top of a minaret that commonly, though not always, stands attached to the mosque. Reflecting the egalitarian impulses of many Islamic ideologies, many mosques encompass a courtyard open to the sky and a fully enclosed space that allows the devout to stand side by side during their prayers no matter what the weather brings. However, this egalitarianism applies almost exclusively to men in many Muslim cultures. Women remain excluded from most mosques in some regions—such as South Asia—due to patriarchal concerns for the purity of the mosque (possibly compromised by a menstruating woman) and the concentration of men (possibly troubled by the presence of prostrating women). Most commonly in regions where men and women pray together in mosques, they are separated by a curtain, a wall, or a floor.

Understandably, American cartoonists have seized upon the mosque as a symbol of a people's Islamic character since it serves as the most conspicuous place of Islamic prayer (although many Muslims also pray in their homes and businesses). Of course, mosques stand on almost every continent, but they figure into cartoon skylines as an indicator of the otherness of a place if the cartoonist wants to indicate that the setting is a place inhabited predominantly by Muslims. The onion-domed shadow of the stereotyped mosque commonly looms in the background of cartoons of Iranian, Iraqi, or Afghan cities, marking the space and its people as Muslim, even when the cartoon's editorial content makes this fact irrelevant. Although many cities in these countries do indeed have mosques, their inclusion in American cartoons serves less to provide some realistic portrayal of a cityscape (that would not serve the cartoonist's editorial goals) than to symbolize the presumed Muslim and/or Arab character of the people.

Figure 3.2. Tony Auth, 2001. © Tony Auth.

The prominence in cartoons of the mosque as a symbol for both the Middle East and Islamic traditions cannot be overstated. It demonstrates an American perception that Middle Easterners are almost always Muslim. As Muslims, they are expected to adhere to a set of beliefs that, the cartoonist suggests, causes them to behave differently from his or her mainstream American audience.

In figure 3.2, the minaret stands in for the whole mosque while doubling as symbol of "Islam" that dominates the cityscape. Using a singular abstraction, the artist implies that bin Laden can damage all Islamic traditions.

The Crescent

Few Europeans or Americans have heard the tale that the croissant they eat for breakfast originated among Viennese bakers in 1689 in celebration of the Turkish failure that year to seize the city after a long siege. The act of eating croissants (French for "crescent") was a symbolic act perpetrated, according to folklore, against the crescent symbol of the vanquished Ottomans, who also abandoned their supply of coffee and in so doing provided the foundation of the famous Viennese brew.[6] At that time, however, few of the world's Muslims would have associated their religion with this symbol.

How the crescent (often with a star perched between its two horns) came to be considered three hundred years later a universal symbol of Islam remains historically unclear. However, its application by non-Muslims to symbolize Islamic traditions found outside the Ottoman empire likely began with the same reliance on unnuanced stereotypes that has persuaded many Americans that all Muslims are Arab.

What is known is that in the nineteenth century, the Ottomans—ruling the last of the great Muslim-run empires—adopted the crescent moon in their effort to fashion a rectangular nationalist flag compatible with those of their European neighbors. It had served as an ornament, such as atop some of their standards, but not because of any theological meaning. However, the Ottomans promoted the Red Crescent in answer to Muslim concerns of insensitivity and exclusion on behalf of the Red Cross international organization, suggesting that by the late nineteenth century they embraced the crescent as a religious symbol.[7] Today, at least eleven Muslim-majority countries—as far from the old Ottoman lands as Malaysia—include a crescent moon on their national flags. Despite these adoptions by some Muslims, other Muslims reject the crescent as a symbol of Islam because they reject the use of all religious symbols.

Many political cartoonists use the crescent moon, like the mosque, to act as a symbol associating places and people with Islam and/or Muslims. The otherness of Afghanistan as depicted by cartoonist Jeff Danziger (figure 3.3)

Figure 3.3. Jeff Danziger, 2001. Jeff Danziger, New York Times Syndicate.

IT BECAME NECESSARY TO DESTROY THE CITY TO SAVE IT.

Figure 3.4. Paul Conrad, 2004. © Tribune Content Agency, LLC. All rights reserved. Reprinted with permission.

is marked not only by the diminutive "tallest buildings" barely rising above the rubble of the city but also by the distant crescent moon atop the dome of what is presumably a mosque.

A comparison of the deliberately designated Muslim space in Danziger's cartoon with the undifferentiated any-city portrait of Paul Conrad's image (figure 3.4) raises two important questions. Does Conrad omit all symbolic differences that would differentiate an Iraqi city from an American one in order to better promote both empathy for the destroyed city and his criticism of American attacks?[8] Conversely, does Danziger include the mosque as a mark of difference so as to emotionally distance his audience from the targets—architectural and human—of American bombing?

Muslim Men

Ironically, unless cartoonists intend to depict the supposed oppressiveness of Islam toward women, they will most likely use the figure of a man or collection of men as a symbol of Islam. In an odd reenactment of the very patriarchal focus on men that they so often criticize in Islamic traditions, most American cartoonists exclude women as symbols of the religion.

This would surprise and alarm many Muslim women (and men), who understand that women play a critical role in maintaining Muslim cultures and continuing Islamic practices and beliefs. Even in the most patriarchal of Muslim societies (patriarchy, of course, not being limited to Muslim cultures), women consider Islamic traditions to be fully their concern and duty, too, and not just the purview of the local mullah or imam or of the men in their family. Some of these men have more authority than any woman to interpret religious dictates, but women still actively fashion their own practice and teach children what their mothers taught them.[9] Moreover, from Cairo to California many Muslim women serve as respected teachers in mosques and other environments, leading the study of Quran, Hadith, sharia law, and other Islamic subjects.[10]

In figure 3.5, Glenn McCoy depicts four nearly identical men as "Islam." They wear physically indistinguishable turbans, black shirts, and pants. Of course, the gigantic and fire-bound head of bin Laden merely mirrors the faces we see in profile, at best. All but one of the four has a beard and holds a book or scroll. The usage of only homogeneous men to represent Islam suggests various generalizations to the reader. On a basic level, we have the

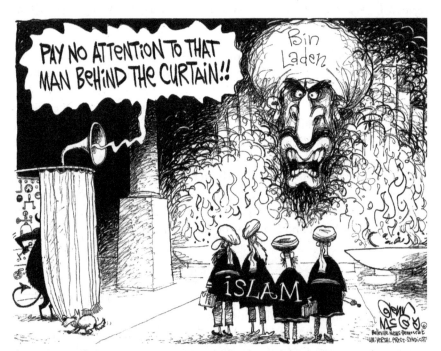

Figure 3.5. Glenn McCoy, 2002. Glenn McCoy © 2002, *Belleville News-Democrat.* Reprinted with permission of Universal Press Syndicate. All rights reserved.

physical: although many pious Muslim men do wear headgear out of respect for Allah and grow beards in imitation of the prophet Muhammad, such is not universally the case. Also clear is the intimation that Islamic traditions are defined solely by men. But perhaps more insidious is the notion that terrorist organizations like bin Laden's can dupe and befoul the entire religion. The presence of Satan connects more subtly with Christian accusations that demonic forces manipulated Muslims, as we considered in the medieval context in the preceding chapter and also shall see in chapter 5.

The Veil

If a generalized image of a Muslim man comes to represent all Islamic traditions—and subsequently all the negative stereotypes that accrue to them—a much more specific marker is used to symbolize Muslim oppression with regard to women. As mentioned earlier, cartoonists almost never symbolize Islam or Muslims with images of women. When females do appear, they are almost always depicted as veiled and oppressed. The veil, then, and not a woman, symbolizes all Islamic traditions and their implied oppressiveness. In other words, it is the invisibility of a woman, seldom her presence, that symbolizes Islam. Islamic traditions, through this symbol, can only be considered as inherently lacking.

Conrad's arresting cartoon (figure 3.6) superimposes two symbols in one intentionally frightening image. It serves simultaneously as a warning regarding both the oppression of women and the threat of Muslims with nuclear technology. In another example, a 2003 cartoon by Walt Handelsman played on the assumed normality of Barbie and Ken dolls when it depicted the "Saudi-approved Burqa Barbie" and "Jihad Ken" as a mocking derision of the society these figures supposedly symbolized. Commonly, such portrayals show little awareness of the vast array of clothing that Muslim women may choose (and, in some cases, are forced) to wear over their head, if they choose any. Hijab, niqab, dupatta, burka, and head scarf represent some of the options that, of course, vary according to cultural context.

More recently, the twin obsessions of oppressed Muslim women and violent Muslim men have occasionally collapsed together, and some cartoonists have used stereotypes of Muslim women to argue that all Muslims represent a threat, no matter their gender or age (figure 3.7).

Overall, then, symbols of Islam used by American cartoonists place Muslims and their social settings apart from what the cartoonists presume American audiences consider normal. In their efforts to symbolize Muslims and Islamic traditions for the ease of reader identification, they both

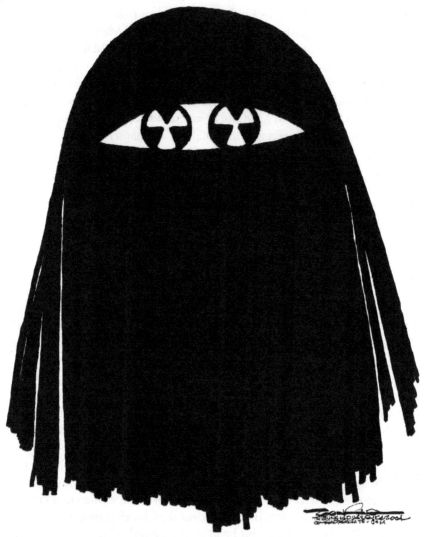

Figure 3.6. Paul Conrad, 2004. © 2004 Tribune Media Services Inc.

demonstrate and reinforce the broad generalizations about Muslims with which their audiences are already familiar.

Although no reader would assume that Islamic traditions are as compact or tangible as a single mosque, Ben Sargent's cartoon (figure 3.8) nevertheless implies that one man, in this case Osama bin Laden, can hijack a religion associated with at least 1.8 billion people throughout the world. Even allowing for the constraints of space and necessary brevity of comment, the cartoon's contention defies tenable argument. Yet the presumed difference of

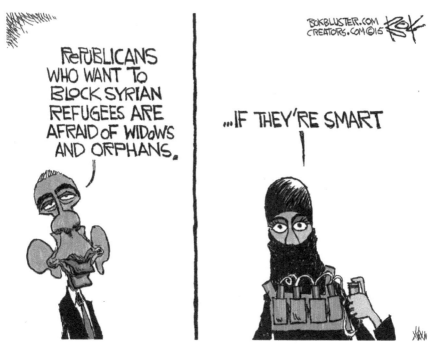

Figure 3.7. Chip Bok, 2016. By permission of Chip Bok and Creators Syndicate, Inc.

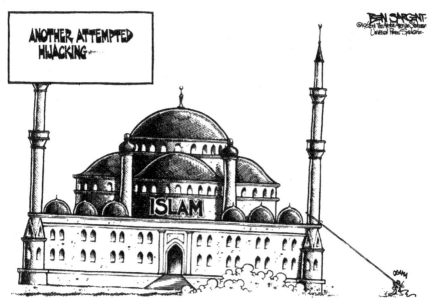

Figure 3.8. Ben Sargent, 2001. Sargent © 2001 *Austin American-Statesman*. Reprinted with permission of Universal Press Syndicate. All rights reserved.

and lack of experience with Islamic traditions undoubtedly makes it possible for many Americans to accept the portrayed singularity of the religion and the uniformity of those who adhere to it. Few Americans would likely take seriously a similar image of or claim regarding "Christianity" in the thrall of, for example, a single conservative Christian like Franklin Graham. The difference between acceptance and rejection of such claims hinges on abstraction. Because many Christian Americans do not have personal experience of the variety of Islamic traditions that they have of Christian ones, they more easily might accept a claim about what all Muslims do or believe based on an abstract concept of "Islam."

The ultimate result of such abstraction and universalization, hinted at in Chuck Asay's cartoon (figure 3.9), is nondifferentiation and broad bias. Asay's character expresses outrage that starkly distinguishes between "we . . . in this country" (including his family who are individually pictured) and "these animals" (who do not appear at all). The latter apparently represents a conflation of the al Qaeda group in Saudi Arabia that brutally murdered American contractor Paul Johnson with all those incarcerated by American forces in Iraqi and Afghan prisons and Guantánamo Bay—despite their diversity in nation of origin and degree of innocence. If this reading is correct,

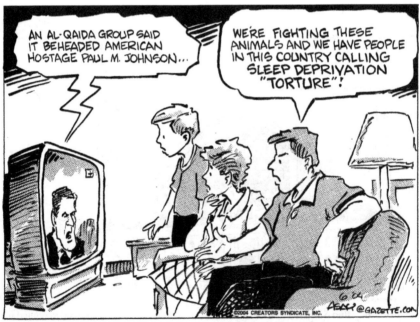

Figure 3.9. Chuck Asay, 2004. By permission of Chuck Asay and Creators Syndicate, Inc.

then the cartoon uses a dehumanizing disparagement that reduces a group of unconnected individuals to a single dehumanized abstraction in order to dismiss allegations of prisoner abuse by Americans. And if that is so, it demonstrates how the universalizing of symbols can slide so easily into caricature and stereotype, as described in the next chapter, while justifying normally unjustifiable behavior such as sleep deprivation and other forms of torture.

Another outcome of overgeneralization is the straightforward equation of all Muslims with violence—specifically, terrorism, civil war, and violence against women. In many cartoons, a caricature of the "Muslim" becomes the symbol of terrorism itself. In Ben Sargent's cartoon (figure 3.10), "Terrorism" labels a bearded man who wears both a vest and hat common to Pathan men in Afghanistan and Pakistan. Sargent does not label the second figure, expecting that almost any reader will identify the character as Uncle Sam, who has served as a symbol of the United States for more than a century. The cartoon, therefore, usefully demonstrates that the image of a "Muslim" does not necessarily symbolize terrorism. If it did, there would be no need to label the figure, just as there is no need to label Uncle Sam. However, Sargent connects Muslims to the character representing terrorism by dressing him in a way that his audience will associate with Muslims. After all, he could have

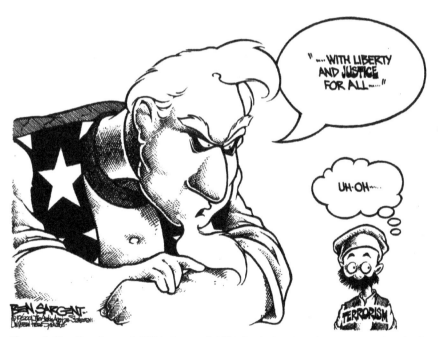

Figure 3.10. Ben Sargent, 2001. Sargent © 2001 *Austin American-Statesman*. Reprinted with permission of Universal Press Syndicate. All rights reserved.

drawn the figure wearing a dress shirt and pants, which those commonly identified as terrorists—Muslim or not—have been more likely to wear than the traditional clothing of Pathan men. Instead, Sargent explicitly denotes the supposedly Muslim quality of terrorism.

It is important to note that while the person used to depict "terrorism" in this example symbolizes Muslims because of his resemblance to the American image of a Muslim man, Uncle Sam symbolizes the United States not because of his physical resemblance to Americans but because of American familiarity with this symbol, who is partially identified by clothes decorated with the stars and stripes of the US flag. This use of symbols for the United States by American cartoonists bears further examination in order to better demonstrate how it differs from the symbolization of Muslims and their religious traditions.

Uncle Sam and Lady Liberty

The frequency with which these depictions of Muslims are publicized inures many readers to their insidious nature. Moreover, the implicitly humorous character of political cartoons—which spend far more time satirizing non-Muslims than Muslims—may seem to make criticism of their depreciatory depiction of Muslims too thin-skinned, especially in light of the skeptical tone implicit in most cartoons. However, a closer look at American cartoonists' use of Uncle Sam and the Statue of Liberty as symbols for the United States demonstrates important insights regarding their treatment of non-Muslim Americans relative to Muslims in general. Each of these symbols has long personified the American people and their highest ideals, although in divergent ways.

For more than a century, Americans have considered Uncle Sam as one of the most symbolic figures of their country. It is not by coincidence that he shares the same initials as the United States. Cartoonists overwhelmingly picture him as older, straight-shouldered, and white-bearded, as he was portrayed in the famous recruiting poster for World War I, in which he pointed at the viewer and exclaimed, "I want *you* for the U.S. Army." A century later, the memory of this iconic image remains strong enough for Lalo Alcaraz to rely on it in his critique of President Trump (figure 3.11). However, cartoonists do not limit their depictions of Uncle Sam to the big and brawny. He may be diminutive in size, quizzical in appearance, or downright naïve, depending on the context in which the artist situates him.

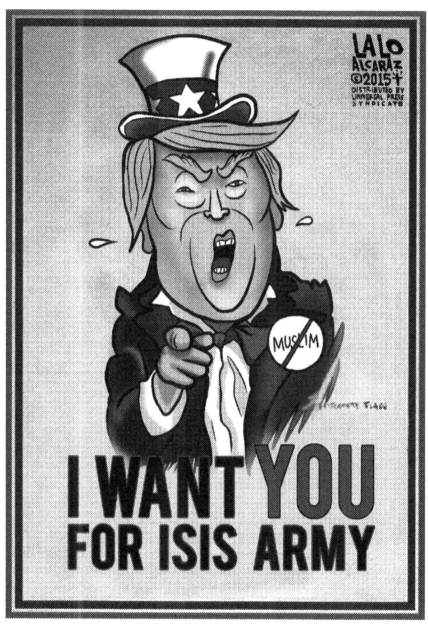

Figure 3.11. Lalo Alcaraz, 2015. Lalo Alcaraz © 2015. Distributed by Andrews McMeel Syndication. Reprinted with permission. All rights reserved.

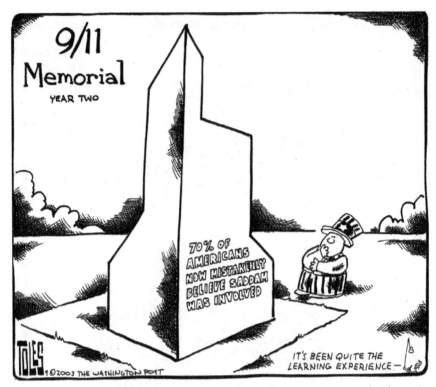

Figure 3.12. Tom Toles, 2003. Toles © 2003 *The Washington Post*. Reprinted with permission of Universal Press Syndicate. All rights reserved.

For example, Tom Toles's squat and innocent Uncle Sam (figure 3.12) contrasts with the burly and determined Uncle Sam that graced many cartoons immediately following 9/11. The contrast between such depictions shows how cartoonists intend to express some character of Americans in general or their government in particular through what Uncle Sam does or says or how Uncle Sam appears. If Uncle Sam moves forcefully, it is because the United States moves forcefully. If Uncle Sam appears confounded, it is because the nation is so. But nowhere do artists intentionally portray Uncle Sam as some realistic depiction of what Americans look like, beyond his near universal—and problematic—rendering as white and male.

The same is true of the Statue of Liberty, which has also served as a symbol of America and its values since the late nineteenth century, when the French people gifted it to the United States. However, Ms. Liberty usually communicates different dimensions of the American character than Uncle Sam, and the difference is a gendered one. Whereas Uncle Sam usually connotes strength, Lady Liberty obviously symbolizes the ideal of liberty. Therefore, in

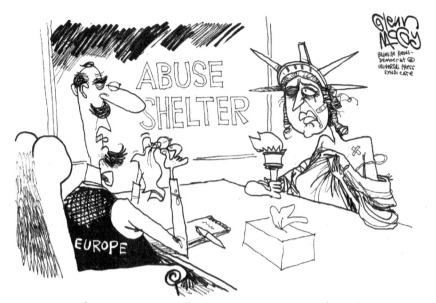

NOW THINK... WHAT COULD YOU HAVE DONE TO PROVOKE THIS ATTACK?

Figure 3.13. Glenn McCoy, 2002. Glenn McCoy 2002 *Belleville News-Democrat*. Reprinted with permission of Universal Press Syndicate. All rights reserved.

situations where this ideal is seemingly under attack, it makes sense that we often see her as the beleaguered target (figure 3.13). But more importantly, it is Liberty's feminine aspect that comes to represent the victimized, delicate counterpart to Uncle Sam's heroic, strong male protector.

In relying upon this dichotomy, cartoonists often reflect the patriarchal sentiments of mainstream American culture that still, after a century of feminist agitation and consciousness-raising, commonly casts men as protective leaders and women as vulnerable victims. The parallel is not serendipitous. Once again we are reminded that representations of others often say far more about the unconscious cultural assumptions of the cartoonists than the cultural realities of those whom they satirize. This proves a central theme throughout the history of non-Muslim American representations of Muslims.

CHAPTER 4

—⁓—

Stereotyping Muslims and Establishing the American Norm

Even before *The Siege* was released in 1998, the film's producers faced protests regarding its depiction of Muslims and Islamic traditions. They responded by arguing that the film actually shows Muslims in a good light, not a negative one. The difference between these two perspectives is illustrative of the dynamics of stereotyping and the power of "the norm."

The film, with eerie foreshadowing, focuses on the efforts of Federal Bureau of Investigation agents to combat Islamic terrorists who are killing civilians for the sake of media coverage. Tony Shalhoub costars as a Muslim Arab American serving as an agent; his superior is played by Denzel Washington. The director obviously intended to provoke the audience's sympathy for Shalhoub's character, especially at the point in the plot when the city comes under martial law enforced by a ruthless general, played by Bruce Willis, who creates internment camps for the city's Muslim men, including the son of Shalhoub's character. So what's objectionable about the film? Careful consideration of the visual depiction of the two primary Muslim characters— the FBI agent and the chief terrorist—reveals themes that, however unintentional on the part of the producers, demonstrate some of the dynamics of Islamophobia and anti-Muslim sentiment.

At first glance, the film appears to promote a positive image of Muslims. The most prominent difference between the Muslim terrorist and the Muslim agent is obvious: the first kills hapless civilians while the second protects them. This parallels the difference between the army general and the FBI superior; the former imprisons innocent Muslim New Yorkers, while

the latter protects them. The film clearly—and understandably—defines terrorist violence and martial law as antagonistic to normal American life. Enemies to this norm, the film declares, can be found among Americans as well as among foreigners, and among Muslims as well as among non-Muslims. Muslims, including the courageous Arab American agent, can be part of this norm that ideally reflects the multireligious and multiethnic reality of America, as evidenced by the African American FBI chief and various European American characters.

Undermining this seemingly color-blind portrait of a pluralist America is the fact that all the Muslims portrayed, whether on the side of good or not, are characterized as Arab. Despite the fact that only a fifth of the world's Muslims identify as Arab, the film's creators do not appear to imagine a Muslim character of another ethnic or racial heritage. As he has been called on to do on other occasions, the well-known actor, commentator, and self-described "Indo-Muslim-British-American actor" Aasif Mandvi plays a Muslim Arab terrorist, chosen because of his brown skin.[1] Notably, the positive primary characters besides Tony Shalhoub's are all played by white or black actors, demonstrating a crucial point advanced by scholar Sherman Jackson about race and belonging in America. In an argument that we will develop further in chapter 7, Jackson suggests that despite their often marginal existence in the United States, blacks join whites as the only groups irrefutably "American." People of Asian, Latin American, Oceanic, and—yes—Arab heritage occasionally enjoy "honorary whiteness" and acceptance as Americans, but this always remains contingent on political circumstances and can be (and often has been) withdrawn, as Shalhoub's character experiences.[2] Apparently proving this point, the film appeared devoid of Latino or Hispanic characters and actors, notwithstanding their obvious presence in New York City, including in law enforcement.

Despite their supposed racial commonness, an important difference exists between the two Muslim characters, one that undermines this message of Muslim inclusion in the American norm. This difference derives from the role of Islamic traditions in each character's life: the favorably depicted FBI agent never does anything that he associates with any of these traditions, while the terrorist frequently performs acts deriving from them. The only images of *salat* (the formal Islamic prayer involving standing, bowing, kneeling, and prostration) occur when the terrorist prepares to kill. The only references to Islamic beliefs occur in situations of violent conflict. The FBI agent identifies himself as a Muslim only in the context of defining himself as not like the terrorists; otherwise, he says and does nothing associated with religion. In other words, he acts "normally," that is, like the other Americans

in the film, who also make no verbal or physical reference to their religion, if indeed they have any. The terrorists, with their solemn prayers and angry declarations, all act aberrantly to this secular norm. Significantly, too, the general played by Willis warns against entrusting the military with control of the city because he recognizes the abuse of power that might—and does—result. However, the Islamic terrorist demonstrates a total absence of regret, remorse, or restraint. Ultimately, religious beliefs and acts not only distinguish the terrorists but also motivate the terrorists' irrational violence. The implicit message, then, is that Muslims who do not act religiously can be good, normal Americans, while Muslims who perform Islamic rituals and espouse Islamic beliefs also commit terrorist acts.

It should not come as a surprise that a character acting on religious impulse would be depicted negatively in a mainstream American film. Relatively few movies or television shows include characters who participate in organized religion of any sort. For those who do—and do so in non-Christian communities—religion often motivates dark behavior (e.g., *X-Men: Apocalypse*; *Homeland*). The exception would be Hollywood portrayals of practicing Buddhists, which are almost uniformly favorable (e.g., *Lost Horizon*; *Seven Years in Tibet*; *Kundun*). All the more significant, then, that *The Siege* includes only two religiously self-identified characters and that one of the heroes distinguishes himself as on the side of angels by acting nonreligiously while publicly subordinating his Muslim identity to his American identity. The screenwriter and director's inclusion of a Muslim hero along with the producers' public proclamation of the role's positiveness reflect the studio's expectation that American audiences implicitly equate Muslims with violence and therefore need a counterexample to show otherwise. Ambiguous portrayals of Christian faith in modern films and shows (e.g., *The Godfather* trilogy, *Doubt*, *The Sopranos*, *Mad Men*) often center on flawed Christian protagonists, yet seldom express such need for balance.

The lesson of *The Siege* is that when one describes others as being aberrant, one relies on an audience's implicit understanding of what is normal. "Others" are distinguished from "us" by characteristics that "they" have and, implicitly, "we" do not (e.g., disunity, wickedness, irrationality). Or they may be distinguishable by characteristics "they" lack (e.g., civilization, restraint, morality) that "we" presumably have. So the qualities that the person making the distinction uses usually reflect what is considered normal or natural to the group with which he or she associates—or, more specifically, with himself or herself. If you were to describe someone to a friend, you'd be unlikely to characterize him as someone with two eyes—unless, perhaps, neither you nor your friend had two eyes—because this characterization

would not seem distinctive enough to help the other person very much. On the other hand, if the person being described had only one eye, you might be tempted to describe her by this distinctive feature. In the end, the ways in which one describes others often implicitly describe oneself at the same time. This becomes particularly obvious with stereotypes.

Stereotypes are simply descriptions of a group by nonmembers using characteristics understood both to be shared by all members and to define them as different from "normal" society. These characteristics may be physical (e.g., tall), behavioral (e.g., excitable), or moral (e.g., conservative). Stereotypes often generate specific symbols of difference from the norm. Undoubtedly, the complaint many Muslims had about *The Siege* arose from its assumption that performing Islamic rituals should be a distinction that costs one membership in the norm by immediately triggering the suspicion connected to a negative stereotype. In other words, many Muslims felt that the film made the Islamic ritual washing and prayer symbolic of terrorism and feared that these symbols of Islam would register as antithetical to the American norm.

How could the presumably non-Muslim producers of the film not understand this? Norms work by establishing expectations so fundamental to a society that they operate invisibly, or at least they remain invisible to most of those who fit the parameters of normality. An exercise in imaginative inversion helps these norms become visible to those who take them for granted. So, for instance, how would most American men see their position in society if only women had ever been elected as president and vice president of the United States? In another inversion, we might wonder how European Americans would see the legal system if all but two Supreme Court justices were African American. How would it seem to most Americans if Passover but not Christmas was a national holiday?

These exercises are not intended to deny that Christian, European Americans make up the largest demographic group in the country but rather, by putting the shoe on the other foot, to make apparent the inequalities stemming from majority rule that many if not most Americans take for granted. This helps those who fit the norm recognize how the nation seems to many of those who do not. Tragically, many of those excluded from the privileges associated with being "normal" accept the norm that undermines their self-esteem and sense of worth. They often try to downplay or, if possible, erase the differences that distinguish them. Some immigrants anglicize their names, some southerners "lose their accents," and some gays "act straight." Partly in recognition of and resistance to this dynamic, Malcolm X chose a separatist strategy in addressing racial inequality in the United States, rejecting the integrationist efforts of the Civil Rights Movement, and criticizing

Dr. Martin Luther King Jr., because Malcolm X did not believe that whites, no matter what other concessions they might offer, would ever give up their power to define the norm. It is perhaps not incidental that he embraced the Nation of Islam and, later, Sunni Islam, as part of his effort to convince blacks of their worth outside of white norms.

It is similarly important to establish that the norm is not necessarily a reflection of the majority. Women outnumber men in the United States, and yet moviegoers appear content with more male heroes than female. Meanwhile, whites will soon be a minority in the country, yet white performers are the norm in television, film, and video depictions of American life. The celebrated success of *Wonder Woman* (2017) and *Black Panther* (2018) in disrupting these norms in superhero films only underlines the prevalence and power of those norms. Norms reflect the privilege of being taken as the standard of the everyday, and those who establish this standard of normality are able to do so because they have more power than other groups. Again, many may exercise that power and privilege without ever recognizing them as such, because norms often operate invisibly to those fortunate enough to find themselves comfortably within their bounds. Some may decide to revolt against the strictures norms require (e.g., speaking "articulately," behaving "properly," dressing "appropriately"), but theirs is the luxury to reject what others may never be privy to no matter what they do or say.

And so, in the consideration of stereotyping that follows, it is worthwhile to consider how cartoonists have depicted people as Muslim through caricatures meant to immediately signal to the audience, through specific symbols, that Muslims stand outside of the accepted norm. Many social groups have struggled with stereotyping in the mass media that has straitjacketed them in specific roles within the norm. For decades, directors cast African Americans only when they wanted to portray the impoverished, the criminal, or the enslaved. Mexican Americans found work performing primarily as bandidos, Mexican soldiers, and illegal immigrants. And, of course, women have long struggled to play more varied roles in film than mothers, sisters, wives, lovers, prostitutes, and short-lived victims. According to the movies, the typical police officer, soldier, lawyer, doctor, investigative reporter, or FBI agent has been for a very long time a European American male of uncertain (i.e., not conspicuous) religion.

From Caricature to Stereotype

Caricature is the practice by which artists focus on one or more unusual physical or behavioral features of an individual and portray those features

in an exaggerated manner.[3] The desired effect of caricature is to satirize the individual. The audience must recognize both the individual being ridiculed and the meaning the cartoonist is communicating regarding the individual's actions or character. This is generally done through popularly recognizable symbols. For instance, the noses of dishonest politicians are prolonged in a Pinocchio-like fashion, adulterers are given horns, and those perceived as cunning have their eyes slanted and faces elongated in a fox-like manner.[4] Or a cartoonist may settle into a standard caricature of a person, exaggerating what may already be unusual characteristics in order to quicken the reader's identification of the individual, as with Richard Nixon's hanging jowls, Ronald Reagan's pompadour, and Barack Obama's large ears.

In the artist's challenge to portray a political situation and his or her opinions about it in a very small space with far fewer words than are available to the editorial columnist, caricature is a necessary strategy. However, when this caricature of an individual according to unique physical and behavioral characteristics relies on the assumed characteristics of an entire people, the caricature slides into the realm of stereotype.

The term "stereotype" itself originated in the publishing industry, referring to the print block from which identical prints were repeatedly produced without variation.[5] Walter Lippmann, in *Public Opinion*, his seminal treatise on the media, coined the term in its current usage. He explained how stereotypes work: "We notice a trait which marks a well known type, and fill in the rest of the picture by means of the stereotypes we carry about in our heads." He noted, however, "The pictures inside people's heads do not automatically correspond with the world outside." In other words, what people associate—positively or negatively—with the stereotyped group often comes from their own society's assumptions rather than from experience with that group.[6]

Like a symbol, as described in the previous chapter, the stereotype works because when viewers encounter one, they associate a great deal more with it than the simple depiction itself offers. Figure 4.1 amply demonstrates the differences between symbol, caricature, and stereotype. In it, cartoonist Ann Telnaes uses a camel, oil derricks, and onion-domed minarets to symbolize Saudi Arabia and to prompt reader associations of desert life, oil wealth, and Islam with the kingdom. Telnaes uses caricatures of former president George H. W. Bush (exaggerating his characteristically large chin and glasses), President George W. Bush (with large ears and prominent eyebrows), Vice President Dick Cheney (with a dour expression on his small mouth), and Secretary of State Condoleezza Rice (unhappy and hard-faced). Telnaes expects readers to identify them through these characteristics and so does not

There's so much that we share, that it's time we're aware,

It's a Small World after all

Figure 4.1. Ann Telnaes, 2004.

label the individuals with their names. The depiction of the Saudi man differs because he represents something quite apart from the specific individuals found in the portrayal of the Americans.

Instead of depicting the Saudi king or individual government ministers who could be labeled with their names or positions for reader identification, the cartoonist opts instead for a single, stereotyped Saudi. He sits with the politicians—corpulent, bearded, and mustachioed, and wearing the other dress of kaffiyeh headdress and *thobe* (the long robe-like clothing worn by many Arab men). Whereas the American men wear the kaffiyeh and sit cross-legged to symbolize their collaboration with the Saudis, the Saudi man's clothing and physical position reflect part of the stereotype of all Saudi men.

Perhaps few enjoy the caricatures cartoonists make of them. (Anyone who has spent time on a grade-school playground knows how it feels to have someone draw attention and exaggerate one's distinctive physical or behavioral qualities.) Such are the hazards of a public life. However, caricatures or stereotypes of whole groups risk causing greater injury than dented egos. Instead of an individual made readily identifiable at a specific moment through specific

characteristics, stereotypes lead to universalizations that label all individuals who deliberately or accidentally manifest some or all of the stereotyped characteristics and create an anticipation of how and why they will act in the future. This forces an identification and characterization on these persons, none of whom may understand himself or herself in this manner.

A stereotype of Muslim men relies on the characteristics of the beard and mustache, kaffiyeh or turban, and brown skin. In the week immediately following the September 11 tragedy, scores of incidents involving police arrests and public harassment of not only Muslims but also Sikh men occurred throughout the United States. The first victim of dozens of "revenge" killings targeting Muslims in the weeks following the tragedy was Sikh American Balbir Singh Sodhi in Mesa, Arizona. His murderer had declared, a few days before the killing, "I'm going to go out and shoot some towel heads."[7] Sikh traditions originated in what is now India and Pakistan, and many of its male adherents wear a turban and long beard and carry a small, emblematic knife out of view. Because these symbols of their personal religious commitment coincided with the longstanding stereotype of Muslim men in the United States, many found themselves falsely under suspicion by both police officials and their fellow citizens. If this suspicion motivates a search of a Sikh man, police might discover such a knife and have cause for arrest. Like Sodhi's murder, this is a result of stereotyping.

Stereotyping figured also into the 2006 controversy regarding the publication of cartoons depicting the prophet Muhammad, first by a Danish newspaper and later by other news outlets. The cartoon at the heart of this scandal—a portrait of the prophet Muhammad with a bomb as a turban—might appear to be caricature and not a stereotype. If the cartoon portrayed Osama bin Laden, it would be taken as such. However, because Western audiences recognize Muhammad as a symbol of Islam, they cannot but read this specific caricature as a claim that all Muslims are essentially violent. When a caricature of an individual relies on symbols used by outsiders to depict a group, the image passes from caricature to stereotype. If an American political cartoon critiqued Henry Kissinger's political opinions while portraying him with exaggerated bushy hair, unusually large glasses, and a heavier-than-actual German accent, these would be understood as an acceptable caricature. However, should the cartoon depict him as a Jew with the exaggerations common to anti-Semitic images, it would become an unacceptable stereotype. The same could be said about a caricature as an African American of Dr. Martin Luther King Jr. Significantly, many Europeans and Americans failed to understand how this could be the case with regard to a Muslim.

Stereotypes of Muslims as Arabs, and the Creation of the Arab/Muslim

If one asks Americans which countries have the most Muslims, Middle Eastern nations such as Egypt, Syria, and Saudi Arabia will be among the most frequent answers. However—demonstrating how news and popular media shape our perceptions of Muslims—these represent only the Muslim populations most frequently in the news. Since Arabs represent the majority population of most of these nations, it is not surprising (however regrettably) that one of the most pervasive stereotypes of Muslims is Arab descent. Yet only 20 percent of all Muslims in the world identify themselves as Arabs. The nations with the largest Muslim populations are Indonesia, Pakistan, India, and Bangladesh—very few of whose Muslims consider themselves Arab. Meanwhile, significant numbers of Arabs identify as Christian. Nevertheless, the persistence of the Arab caricature in American stereotypes of Muslims leads to a confusing collapse of difference between the two somewhat overlapping groups that, at times, descends to a racial stereotype of the Arab/Muslim. This stereotype serves as a prime component of anti-Muslim sentiment and distinguishes it from Islamophobia, from which it is different yet not distinct. While Balbir Singh Sodhi's murderer killed him after mistaking his turban for a symbol of commitment to Islam, other innocents killed the same day died based on an antipathy toward their skin color, which was mistakenly viewed as inherently Muslim.

Cartoonists routinely use American symbols for Arabs to caricature Muslims. For example, Jeff Danziger's cartoon (figure 4.2) portrays the predominantly Pashtun Taliban using symbols of Arabs: The men wear the Arab kaffiyeh and *thobe*, entirely unlike what most Pashtun men wear. The underlying presumption is that Pashtun Muslims dress as all Muslims dress: as the stereotyped Arab. The cartoonist includes the two figures in burqas and the exhortation "Praise Allah" to emphasize the Muslim quality of the characters. Similarly, in the 2012 film *Zero Dark Thirty*, after US Special Forces enter Pakistan and establish a perimeter around Osama bin Laden's house in Abbottabad, the film portrays their interpreter using Arabic to address curious neighbors. In fact, almost no one uses Arabic as a conversational language in Pakistan, where Urdu is the official language and many regional languages are spoken.

The stereotype of the Muslim as Arab also relies on expectations of both groups being violent and hypocritical. In Pat Oliphant's cartoon (figure 4.3), the Arab is sullen before shrieking his true thoughts about September 11. His words express not simply anti-American sentiment but religious intolerance

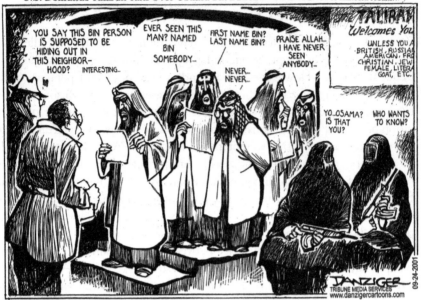

Figure 4.2. Jeff Danziger, 2001. Jeff Danziger, New York Times Syndicate.

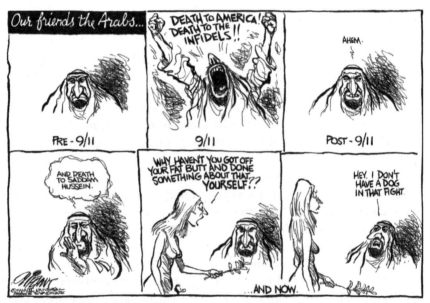

Figure 4.3. Pat Oliphant, 2003. Oliphant © 2003 Universal Press Syndicate. Reprinted with permission. All rights reserved.

as well, suggesting that Islamic beliefs inflamed Arab hatred of the United States. Without any labels but "the Arabs," the audience is meant to assume that the figure represents all Arabs. Also, "the Arabs" are shown to be hypocritical, calling for Saddam Hussein's death but unwilling to do anything about him. Finally, the exaggerated size of the large, beaklike nose serves as a racial symbol of Arab difference. Comparison with the facial features of the woman who questions the Arab draws the reader's attention to the difference between the norm and the Arab.

Of course, the conflation of distinctive physical features with specific behavioral characteristics has occurred before. Despite the differences in their historical contexts, the two cartoons in figures 4.4 and 4.5—one from France in 1903[8] and the other from an American news service a half century later—make nearly identical claims. Figure 4.4 is titled, in French, "The Qualities of the Jew." In the several compartments of his brain there exist a propensity to theft, a worship of money, and an unwillingness to serve his country. The Arab in figure 4.5, meanwhile, is dominated by vengeance, fanaticism, fantasy, blackmail, and distaste for compromise. In addition to the shared general concept, the figures share a curved, broken nose; facial hair; socially and politically hostile outlooks; and strict, rigid, and narrow thinking. Each racial/ethnic group is affiliated with a common group mindset and is denied individual, rational thought. Both cartoonists implicitly reaffirm the normality of their target audience by explicitly detailing what supposedly characterizes Jews or Arabs—that which makes them different from us.[9]

A common symbol used to depict all Arabs is that of an Arab man who looks unkempt or disheveled. This hints at the "dirty Arab" stereotype not uncommon in both the United States and Europe. In this context, Arabs represent the unhygienic inhabitants of the bleak and waterless desert or of foul and overcrowded cities. Representations of facial hair—unshaven or untidy—most obviously reflect this quality in editorial cartoons (figure 4.6).

Finally, the conflation of "the Arab" with "the Muslim" as an American racial stereotype relies on perceived skin color. Less evident in black-and-white editorial cartoons but obvious with Muslim characters in color films such as The Siege, this misjudgment of Arab/Muslim complexion played its own sad role in the reactive violence following the September 11 attacks. Outside Dallas, Texas, on the same day as Balbir Singh Sodhi's death, a vigilante shot dead Waqar Hasan and Vasudev Patel before wounding Rais Bhuiyan. Respectively, these men were a Muslim Pakistani American, a Hindu Indian American, and a Muslim Bangladeshi American. Only misinformed yet popular portrayals of what Arabs/Muslims "look like" can explain the

Les qualités du Juif d'après la méthode de Gall

Figure 4.4. Emile Courte, 1903.

victims' connection to the murderer's confessed goal "to retaliate on local Arab Americans, or whatever you want to call them."[10]

Of course, it would be an exaggeration to say that all editorial cartoons rely solely on these stereotypes. There are some, though relatively few, examples in which the cartoonist attempts to create sympathy in his or her audience for those who are usually on the receiving end of stereotyped descriptions.

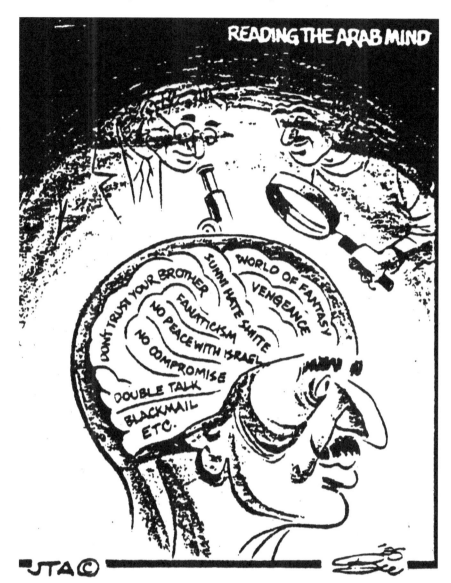

Figure 4.5.　Noah Bee. JTA, c. 1956.

One such approach to a more favorable portrayal has stereotyped characteristics give way to difference and individuality—in other words, showing a group of Muslims or Arabs who look, dress, or act in heterogeneous ways.

Another approach is more subversive, criticizing the very propensity to stereotype unfairly. This means lampooning not those depicted stereotypi-

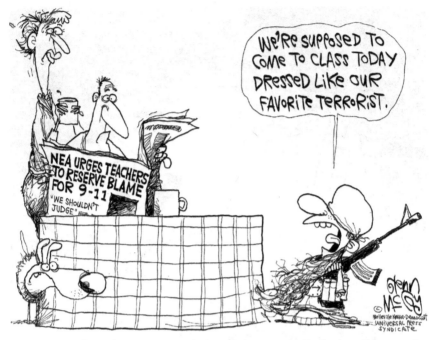

Figure 4.6. Glenn McCoy, 2002. Glenn McCoy © 2002 *Belleville News-Democrat.* Reprinted with permission of Universal Press Syndicate. All rights reserved.

cally but rather those who rely on stereotypes, in an attempt to ridicule and undermine the fear-filled universalizations.

Using Negative Stereotypes to Define America as the Good Norm

As already mentioned, stereotypes often implicitly serve to define those who create the stereotype through the very act of defining others. Through their negative depiction of "them," stereotypes positively define "us" as not like that. Just as when the members of a group are depicted as all having large noses only when it is assumed that this would appear abnormal for the intended audience, so, too, when a person stereotypes one community as dishonest, he insinuates that his own community is generally honest. Chapter 2 described how Middle Eastern Muslims historically have played a role in the negative definition—socially, theologically, and morally—of Western Christians. Although the specific dimensions continue to change over time, the same general dynamic exists today.

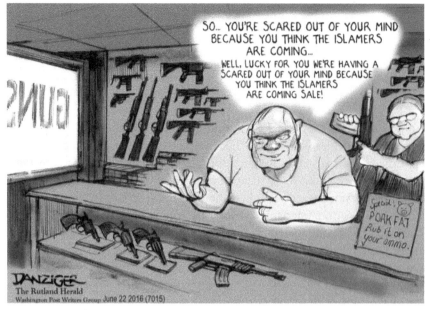

Figure 4.7. Jeff Danziger, 2016. Jeff Danziger, New York Times Syndicate.

Overall, these comparisons help Americans affirm their sense of general success in the face of not only the inability of foreign nations to live up to American ideals but also of various American failures to realize those ideals. In a way, America's enemies help solidify a singular American identity even as they threaten its citizens and interests. They unwittingly do this when US media outlets represent them in such ways that they define what America *is not*. This lends itself to a total alienation of these enemies in order to erase any possibility of commonality or shared quality. In some circumstances, deliberate efforts to stoke anxiety toward others can advance vested interests through the resulting non-Muslim solidarity, as satirized by Jeff Danziger (figure 4.7).

Of course, the key to understanding this enemy is that it is defined not only by those who deliberately aim to be inimical to US goals but also by an American media that provides the primary means by which most Americans access the representation and interpretation of those antagonists. That media has implicitly implicated Muslim men, and some Muslim women, as inherently enemies of America's "way of life." This implies both a unity in lifestyle that Americans must unite to protect and a vast, undefined field of "American interests"—including international commitments, investments, and resources—whose defense justifies American foreign interventions. It

Table 4.1. Stereotypes of "Muslims" and "Americans"

"Muslims"	"Americans"
two-faced and untrustworthy	truthful
regressive or backward	progressive
medieval	modern
evil	good

also presumes that, as table 4.1 illustrates, Muslims by their very nature are inimical to that lifestyle—hence the oft-repeated calls by media pundits for an "Enlightenment" and "Reformation" by which Muslims can "become modern," that is, endorse our social choices.

For many American cartoonists, the differences from Muslims stem not only from a superior American character but also from the fundamental characteristics that define society in the United States, ignoring that nearly 3.5 million Americans are also Muslim. Perhaps unknowingly, Doug Marlette demonstrated this in 2004 (figure 4.8) with the juxtaposition of his imagined set of stereotypical Arab/Muslim enemies with the all–European American cast of the turn-of-the-century television show *Friends*. But while the title for the latter implies that the characters are *friends of one another*, Marlette's cartoon relies upon the implication that those on the familiar couch are *enemies of us*, at whom they leer angrily. The couch thus becomes a shared setting that serves to contrast the "normal, American" friends and the Arab and/or Muslim enemy.

Meanwhile, Danziger's 2001 cartoon (figure 4.9) offers no more insight than a comparison of the supposed sophistication of American baseball to

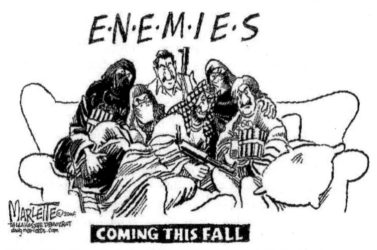

Figure 4.8. Doug Marlette, 2004. © 2004 Tribune Media Services Inc.

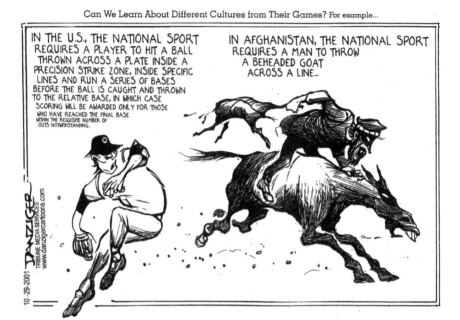

Figure 4.9. **Jeff Danziger, 2001.** Jeff Danziger, New York Times Syndicate.

the raw primitiveness of the Afghan game *buzkashi*. He expects his audience to draw for themselves the self-evident conclusions about the different cultures. The reader notices as well the contrast between the white ballplayer and the dark face of the rider (matching his horse) with his menacing silhouetted eyes.

Interestingly enough, *buzkashi* served as a positive measure of Afghan masculinity and courage in the face of American mendacity and subterfuge in the 1988 movie *Rambo III*. Filmed when Americans celebrated and supported Afghan Islamic militants (mujahidin) in their jihad against Soviet invaders, the movie depicts brawny hero John Rambo playing *buzkashi* with equally virile mujahidin, some of whom will risk their lives with him in rescuing an American officer abandoned by the US military. The producers went so far as to dedicate the film to the "gallant people of Afghanistan." As the USSR's 1979–1989 fiasco in Afghanistan—the "Soviet's Vietnam"—evoked memories of America's Vietnam with its bitter experiences of combat troops feeling betrayed by distant politicians as atheistic Communism outlasted US resolve, to some Americans the mujahidin represented God-fearing, heroic men whose mettle the Communists could not defeat. The good feelings toward Afghan Muslims did not last, as some of the mujahidin leaders became opportunistic warlords and many ordinary Afghans (or at least many of those

who were Pashtun) turned to the Taliban for protection against them, fuel-ing and legitimating that movement's rise to power.

The industrious effort to make Muslims appear so different emerges from the potential of them to appear so similar. The actuality of Muslim lives may uncomfortably remind some Americans of the reality of their fellow citizens that defies their preferred vision of the United States. For instance, a 2006 Gallup poll demonstrated that 42 percent of Americans want religious leaders to play a role in crafting constitutional law while 55 percent prefer them to have no such role. As John Esposito and Dalia Mogahed have noted, this closely matched opinions in Iran, a country often portrayed as religiously defined and uncompromising in supposed contrast with the United States' secularism and pluralism.[11] Certainly, the post-Revolution Iranian government has brought difficult strictures on its citizens, especially the non-Muslim ones. Nevertheless, many Americans—secularly minded and Christian-identified alike—might not wish to admit how much their country shares a similar popular religious landscape with Iran nor how theologically similar the Ayatollah Khomeini's declaration of the United States as "the great Satan" might be to President George W. Bush's inclusion of Iran in an "Axis of Evil."

The Duplicitous Muslim: The Saudi Example

If American cartoonists have taken Arabs for stereotypical Muslims, since the September 11 attacks they have most frequently portrayed Saudi Ara-bians as the nadir of Muslim duplicity, repression, backwardness, and evil. America's longstanding though troubled relationship with the Kingdom of Saudi Arabia took a particularly awkward turn following the 2001 tragedies. The majority of the hijackers that day originated from the kingdom, as did the plot's presumed mastermind, Osama bin Laden. During the political, economic, and military posturing that followed, President George W. Bush cast the world in Manichaean terms when he informed all non-Americans that "every nation, in every region, now has a decision to make. Either you are with us, or you are with the terrorists."[12] Saudi Arabia did not appear to acquiesce to American needs as readily as the Bush administration preferred. The Saudi government failed to adequately implement oil policies intended to ensure inexpensive oil for America and balked at acting as the launchpad for an invasion of Iraq, while wobbly allegations arose of ties between al Qaeda and some members of the royal family. Then militants in the country itself began targeting Western contractors on which the government and many companies there relied.

True to the nature of stereotypes, many political cartoons collapsed the government, terrorists, and general population in Saudi Arabia into a single depiction that drew on not only physical stereotypes of Arabs but also long-standing assumptions among non-Muslim Europeans and Americans. One such notion is that of deception.

The idea of deception was manifested in these ways: "The Saudi" threatens not only his professed enemies but those to whom he professes loyalty as well. "The Saudi" says one thing but means another, swears alliance with one group but backs another, and smiles to your face while planting a knife in your back (figure 4.10). In other words, Saudis, like other Arabs in many Western depictions, deceive everyone and cannot be trusted.

Such a representation in America echoes attitudes dating at least as early as 1780 with the New York premiere of the play *Mahomet the Imposter* [sic], which focused on the manipulation by the prophet "Mahomet" of two innocents for his own nefarious ends. In 1796, Philadelphia audiences also enjoyed a production of the play, which, based on one by Voltaire, had earlier become so popular in England that for more than three decades it was reprinted annually.[13] These merely echoed centuries of similar portrayals of Muhammad in English publications dedicated to demonstrating his despicable character and reprehensible goals.

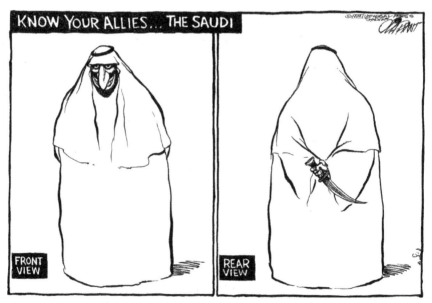

Figure 4.10. Pat Oliphant, 2001. Oliphant © 2001 Universal Press Syndicate. Reprinted with permission. All rights reserved.

The role of ethnic and racist stereotypes in such depictions becomes more evident when compared with contemporary depictions of France and Germany. To the chagrin of the Bush administration, these erstwhile allies who had cooperated with previous American foreign policy agendas even more directly challenged the US government's plans in Iraq than did Saudi Arabia. Yet cartoonists, though critical of the two European nations, did not resort to the same backstabbing caricature, as demonstrated in the consideration of the depictions of the French at the chapter's end.

Medieval Muslims against Progress

Perhaps most central to American perceptions of their own society is the notion of being modern. To be modern is to be as close to the benefits of tomorrow as possible today. As a self-described "modern society," America continually puts greater distance between itself and a less enlightened, less developed, and less free past. At its most optimistic, this confidence in modernity relies on a history that arcs from a "primitive" past toward an expected end: a more promising future. The term "progress" defines the distance traveled on this one-way highway of change.

In general, many Americans continue to fundamentally trust that overall conditions are improving, if not for the world then at least for their country. Moreover, many take as a matter of faith that America moves at the forefront of progress in most, if not all, fields: government, science, education, technology, entertainment, and medicine, among others. Although some may be suspicious of some elements of modernity while others prefer "how things were," Americans in general positively describe themselves and their nation as modern, developed, advanced, and future-oriented, as opposed to others that are medieval, undeveloped, backward, and past-obsessed. Tiny minorities like the Amish and Luddites notwithstanding, even those Americans who espouse "traditional" values commonly conceive their most foundational principles as representing the apex of historical development.

Traditionalists may pine for a return to the moral conditions of some point in the past, but seldom do they wish to reestablish the entire past. One rarely hears anyone promoting the resurrection of monarchical rule, a rescinding of equal rights for minorities or women, or the abolition of surgical anesthesia. Instead, most traditionalists and modernists alike promote democracy, equal rights, and scientific advance as the hallmarks of American progress. Both liberals and conservatives rely heavily on the language of development: change for a better tomorrow. They imagine a common road that all humanity treads—some communities farther along than others—albeit with

perhaps differing views of what defines "advanced." Indeed, the language chosen to describe proposed outcomes gives ample testimony to the American faith in a historical arc—a teleology—of progress.

This makes for high-wire acts balancing core values with devotion to progress. Although, for instance, conservatives characterize progressive efforts to extend equal rights to gays and lesbians as undermining "traditional values," they may support an American civilizing mission promoting democratic political institutions in an effort to "bring the world into the twenty-first century." Meanwhile, many American liberals condemn such projects as dangerously self-congratulatory and ethnocentric, yet nevertheless promote "uplifting" and "empowering" women or "improving" overall human rights in foreign countries through diplomatic and economic pressure to adhere to their own progressive norms. Even Christian Fundamentalists, who may decry the corrosive effects of secularism and reflect fondly on an earlier time of supposedly more earnest Christian living, often understand their Christianity as the apex of religious development, a "new" message for the world. In order to disqualify those who claim a newer message, they may explain religions originating since the time of Jesus as "cults," re-embraced relics of the pagan past, or (as we have seen alleged in the case of Islam) degenerate Christian traditions.

Western Europeans and Americans have long considered Arabs, and Muslims in general, to be one of the most prominent examples of social, political, moral, and religious backwardness, if not regression. In the late eighteenth and early nineteenth centuries, men like Thomas Jefferson and John Adams, despite their very different political visions, could agree that Islam—synonymous with "Oriental despotism"—obstructed progress because it stood against personal liberty. American writers shared the conclusion with European authors that this despotism resulted from the nature of Islamic traditions, which engendered bad government and led to public ignorance and social indolence. The Ottoman empire typically served as their key example.[14]

At least one important change has occurred in the understanding of Muslim/Arab backwardness since the days of the early American republic. Whereas Jefferson and Adams imagined an Islam that was inherently reinforcing the conditions for a nonmodern society, contemporary American commentators often project an Islam that is deliberately *anti*-modern. Muslims become defined by their willful rejection of all things modern.[15] "Traditional" clothing and camel riding are but the external signs of a conscious rejection of the true knowledge, morality, and values of "the modern world." Of course, this simplification disregards the sophisticated commercial and

social infrastructure that the Saudis have created that has made it possible for them to export more oil than any other country. Ironically, for the better part of the past sixty years, Saudi Arabia's highly developed oil industry allowed Americans to rely on it, taking for granted its steady flow of crude—unless Saudis and other Arabs decided to withhold or raise its price. In those historical moments, many cartoonists swiftly changed their depictions of Arabs from a backward people to powerful men who brandish their oil business as a threatening weapon (see figure 4.11). Similarly, some artists portrayed Saudi "primitiveness" in the context of alleged duplicity against America's War on Terror (see figure 4.12).

Political cartoonists also have used the Taliban of Afghanistan to demonstrate the antimodernity of a purportedly singular Islam. The Taliban's severe enforcement of religious maxims for personal appearance, behavior, and gender roles appealed to the worst American expectations for a government motivated by an Islamic ideology. Its rejection of many Western norms led to media descriptions of the movement as "medieval" and "regressive," driven by its desire to "return to the days of Muhammad," turning away from the advances of the present that supposedly promise so much for the future. For some, the Taliban's rejection of Western values could be equated with the rejection of modernity itself, and this, by default, meant that they must be anti-American. So, for instance, American media sources often portrayed

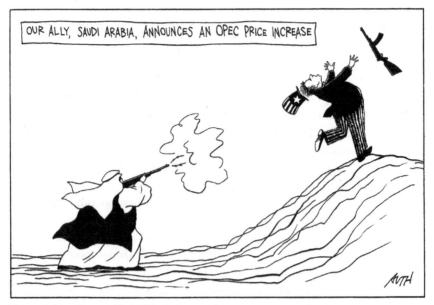

Figure 4.11. Tony Auth, 2002. © Tony Auth.

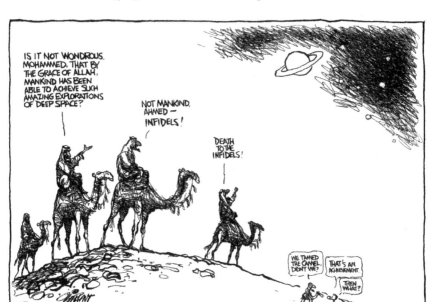

Figure 4.12. Pat Oliphant, 2004. Oliphant © 2004 Universal Press Syndicate. Reprinted with permission. All rights reserved.

the severe restrictions imposed on Afghan television watching and music listening as a rejection of all things Western: entertainment and technology. Several observers wryly noted the supposed hypocrisy of the same Taliban government employing modern tanks and aircraft. These conclusions reveal far more about the commentators' worldview than about the Taliban's logic and imply that modernity comes as a package bound in a Western-designed wrapping that must be accepted—or rejected—as a whole. Disapproval of any part of the package may be interpreted as not only antimodern but anti-Western and/or anti-American as well.

Many American observers project this equation of antimodernism and anti-Americanism onto all Muslim militants (see figure 4.13). For instance, President Bush in his 2005 Veterans Day speech described Islamic radicals: "The rest of their grim vision is defined by a warped image of the past—a declaration of war on the idea of progress itself." They must hate America, in this view, because they "despise freedom and progress."[16] There can be no doubting the oppressive rule of the Taliban and the unjustifiable violence inflicted by so many militants. However, presuming that their motivations derive primarily from anti-Americanism at best provides little insight into such diverse, complex, and dangerous movements beyond hyperbolic versions of the simplistic conclusion that they are not like us. At worst it sug-

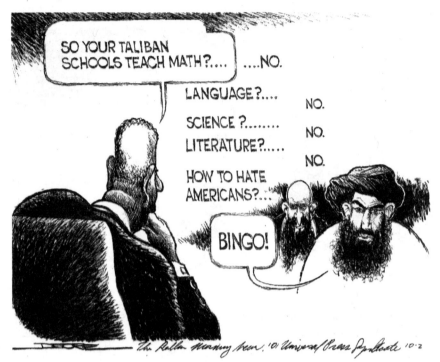

Figure 4.13. Bill DeOre, 2001. DeOre © 2001 *Dallas Morning News*. Reprinted with permission of Universal Press Syndicate. All rights reserved.

gests a view that other cultures primarily and essentially define themselves relative to the United States.

It is important to recognize that editorial cartoonists at times also critique certain Americans as being against modernity and progress. They have been particularly attentive to the efforts of intelligent-design proponents to promote their theories in public school systems, if not to prohibit the teaching of evolution. Significantly enough, however, the cartoons commonly characterize these proponents according to their state or city—Kansas, or Dover, Pennsylvania, to name two places where they have had limited success in pursuance of their agenda—rather than as "Christians." Moreover, no single caricature of intelligent-design supporters emerges that allows the audience to physically identify them as a stereotype, despite their unflattering portrayal as primitive or violent. A cartoon may depict antievolutionists as blunt-bodied Neolithic cave dwellers (figure 4.14), but viewers do not read this as a claim about their actual physique. Cumulatively, political cartoons depict some Christians as antimodern some of the time *if* they are Fundamentalists but most Muslims as antimodern most of the time *because* they are Muslims.

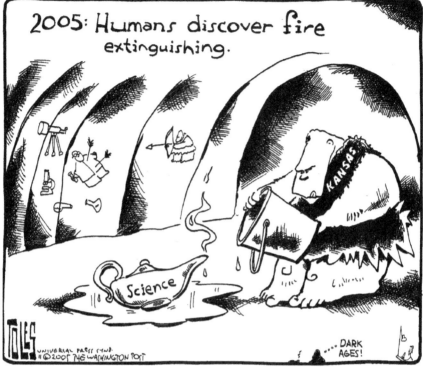

Figure 4.14. Tom Toles, 2005. Toles © 2005 *The Washington Post*. Reprinted with permission of Universal Press Syndicate. All rights reserved.

This dynamic not only establishes Muslims as undifferentiated and collectively apart from the norm but also as always defined and motivated by their religion. Whereas cartoonists routinely acknowledge the variety among Christians and distinguish radicals from the mainstream, Muslims too often appear without such nuance. Moreover, misbehaving Christians tend to be labeled by their misconduct rather than as Christians, insulating the majority from the inference of guilt while artists tend to identify Muslims much more readily. For instance, in a 1993 image titled "We're Doing God's Work," Herb Block depicts four men standing in identical poses bearing weapons. Their shirts identify them as "terrorism at abortion clinics," "the Waco Wacko" (David Koresh), "Muslim terrorists," and "non-Muslim terrorists." Although the first two clearly reference certain Christians, nothing in their depiction indicates them as such, as opposed to the Muslims. Such images promote a Christian normality untouched by these violent Christians and a Muslim abnormality characterized by aggression. This propensity, which will be illustrated again in chapter 7, figure 11, helps explain President Obama's preference to reference "terrorism" without using the term "Islamic terrorism."

Evil Muslims

The most radical view of how Islam deviates from the American norm has to do with Islam's supposed role as a tool of Satan. This perspective is a direct descendant of medieval Christian allegations regarding Muhammad and all Muslims as either the naïve puppets or dedicated minions of Satan. Of course, any criminal responsible for the slaughter of thousands of innocents could be portrayed in this manner—as Hitler has been—without any specific theological intent. Hell and heaven can serve simply as image-evoking metaphors of moral punishment and reward. However, the overwhelming numbers of such portrayals in light of millennia-old Christian characterizations of Muslims as demonically influenced make such a conclusion difficult to avoid (figures 4.15 and 4.16).

One need only revisit the controversial contrast that General Boykin drew in 2003 between his "real God" and the "idol" god of his Somali Muslim opponent (see chapter 2). Although the Bush administration's support for Boykin did not necessarily signal its agreement with his theology, its unwillingness to reprimand him probably reflected its interest in appeasing the significant number of conservative Christians who did. At least one cartoonist saw the contradiction between Boykin's self-congratulatory nationalism and triumphalist theology (figure 4.17).

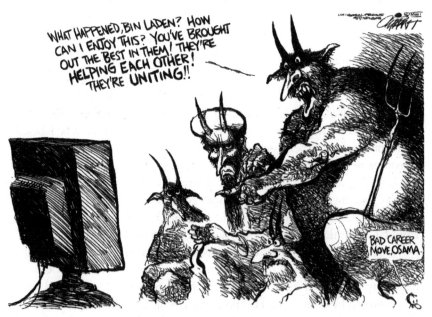

Figure 4.15. Pat Oliphant, 2001. Oliphant © 2001 Universal Press Syndicate. Reprinted with permission. All rights reserved.

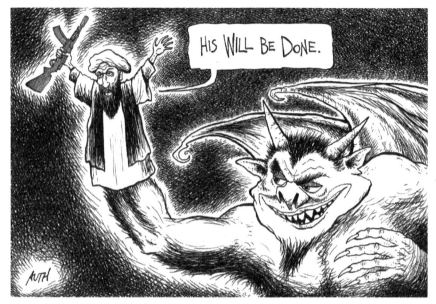

Figure 4.16. Tony Auth, 2001. © Tony Auth.

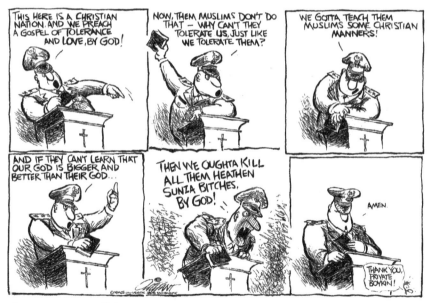

Figure 4.17. Pat Oliphant, 2003. Oliphant © 2003 Universal Press Syndicate. Reprinted with permission. All rights reserved.

And Then There's the French . . .

In order to address the argument that editorial cartoons necessarily lampoon other peoples and nations in nonflattering terms, it will be useful to consider depictions of the French in this century. Many Americans and French people have warily stared at one another across the Atlantic since at least the days of French president Charles de Gaulle, who often steered his nation's foreign and military policies independently of American and NATO concerns. In addition, French antipathy for the rising tide of American cultural hegemony—marked by the arrival of Euro Disney and a proliferation of McDonald's restaurants—heightened the level of mutual disregard. From the American side, the unwillingness of the French, among other governments, to support the American-led invasion of Iraq in 2003 spurred an energetic round of French-bashing by editorialists (figure 4.18).

The portrayal of the French in editorial cartoons for the ensuing decade tended to characterize them as capricious and unreliable, characterized as white men with pronounced noses, thin and pointy moustaches, and effete demeanor. (As figure 6.5 demonstrates, this image is not new. Also see figure 3.13.) Although such a portrayal has faint parallels with Muslims depicted as irrational, duplicitous, and large-nosed, the two clearly stand in stark con-

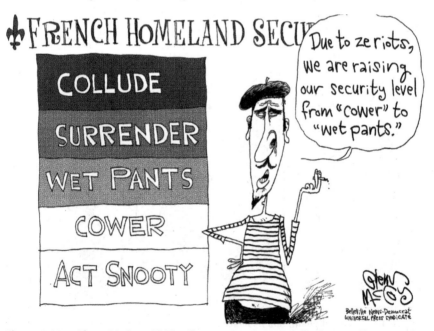

Figure 4.18. Glenn McCoy, 2005. Glenn McCoy © 2005 *Belleville News-Democrat*. Reprinted with permission of Universal Press Syndicate. All rights reserved.

trast because of the lack of any racial and religious stereotypes in the French caricatures. Despite the common features in their symbolic depiction, "the French" do not suffer from a universalized physical image as found in the stereotypes of Muslims. This weakens the overall strength of the impression, since as a symbol "the French" figure can be no more convincing about some uniform French quality than Uncle Sam can be for Americans, John Bull for the British, or the bear for Russians. The conviction with which many cartoonists depict Muslims physically and personally communicates itself more forcefully to their audience, which understands the difference between symbol, caricature, and stereotype and draws different conclusions from each. Significantly, the escalating level of terrorist violence committed by Muslims out of grievances regarding French policies toward Muslims at home and abroad has softened American portrayals of the French. Meanwhile, racialized anti-Muslim stereotypes continue to feed from and further propagate Islamophobic sentiment while serving to valorize American norms, although this is decreasingly so for liberal commentators than for conservative ones.

CHAPTER 5

—ᴥ—

Extreme Muslims and the American Middle Ground

In December 2001, the National Geographic Society published *The World of Islam*, a volume that included excerpts from articles dealing with Muslim cultures printed over nearly a century in the *National Geographic* magazine. The advertisement in the regular magazine caught the overall tenor of the volume when it announced, "Long before our nation focused its attention on the world of Islam, NATIONAL GEOGRAPHIC was there. At a time when most Westerners were forbidden access, our writers and photographers explored the history, culture, and religion, first hand."[1] Projecting the fictional image of a singular and self-isolated world, the Society intended to generate an audience by appealing to American expectations of a singular Islam associated with withdrawal and secrecy while offering the alluring prospect of revealing tantalizing secrets.

The book underscores these themes of exotic difference in a number of ways. For instance, the volume stands out on a bookshelf because a colorful photo of an exotically masked woman in red acts as a visual exclamation mark above the title printed along the book's spine. Removing the volume from the shelf, one lingers over the cover, with its eerie image of faceless, completely veiled women standing like salt pillars without obvious purpose, direction, or identity. Inside, following an old photograph of the Kaba in Mecca and preceding the foreword, six double-page photographs depict camels below an oil-smoke–darkened sky (Kuwait, 1991), the pilgrim-surrounded Kaba at night (Mecca, 1966), the shah of Iran facing a Muslim cleric (Iran, 1968), a boy leading camels in front of a Palestinian refugee camp (Jordan,

1952), Palestinian security forces raiding a Gaza home (Palestine, 1996), and Afghan soldiers assembling before a line of tanks (Afghanistan, 1993).[2] The themes? Religion, camels, alluring and forbidden women, social turmoil, violence, and American geopolitical interests.

Although the editor in chief of National Geographic explains in the foreword that earlier articles unfortunately included "impolitic," "patronizing," and racial insensitivities, he misses at least as important a point. Despite his honesty regarding these embarrassing anachronisms, the editor fails to recognize how essay after essay with image after image in the 2001 volume propounds a portrayal of Muslims as eternally exotic and essentially different from the American target audience. The cameras of National Geographic appear particularly drawn to the visual and (supposedly) cultural contrasts of kaffiyeh-wearing men flying a modern helicopter or Arabs in a Kentucky Fried Chicken restaurant. Although these images admit the presence among Muslims of these normal components of most Americans' lives, the quaintness and emphasis of the repeated juxtapositions simultaneously reaffirm an implication of how surprising—if not misbegotten—is the connection between the normal and the exotic.

This connection between the normal and the exotic occurs not only in some of the volume's photography, but also in the editor's choice of articles. The Kuwaiti oil wells, shah of Iran, Palestinian refugees, and Afghan soldiers of the photographs that introduce the volume all speak to events when and places where American interests have connected with foreign Muslim lives. Oil reserves, international allies, Israeli security, and the demise of the Soviets after their Afghan fiasco stood as some of the most important US foreign policy concerns throughout the last half of the twentieth century. Meanwhile, more than half of the book's articles deal with that vortex of American political, military, and economic engagements: the Middle East. Although the majority of Muslims live east of Afghanistan, only seven of twenty-seven articles deal with regions in South, East, and Southeast Asia. While National Geographic undoubtedly seeks to inform its American readers about regions in the news, it unintentionally reemphasizes to those readers the message that mainstream news reporting repeatedly underscores: the "world of Islam" is defined as inherently in conflict with the interests of Americans. Edward Said's pathbreaking book Orientalism applied that term to similar forms of exotification and differentialization of Muslims in Western portrayals that helped justify nineteenth- and twentieth-century European colonialism and imperialism in the Middle East and North Africa.

By 2018, the National Geographic Society had stopped publishing The World of Islam. Its sales catalog had not replaced it with any other book

specifically about Islamic traditions. Under the heading of "religion," its online store listed eight titles. Of these, two focused specifically on Jesus from a Christian perspective (despite his importance as a prophet to most Muslims), two dealt exclusively with Christian traditions, three considered the Bible with a few mentions of Islamic sites. Of the topics in the final title, *Ten Prayers That Changed the World*, eight come from Jesus and Christians, one from the patriarch Abraham, and one from a Hindu. Thus, as of 2018, all but one of the books that National Geographic published specifically on religion centered almost exclusively on Christian traditions, including only a few instances of overlapping Islamic ones despite myriad possible examples.

The Society also published *The Rose Hotel*, a memoir by Rahimeh Andalibian, an Iranian American whose family escaped the 1979 Revolution and settled in California. Besides the traumatic upheavals that upended her family's life and sent them fleeing, associations with Islamic traditions are limited to the figure of the author's father, whose unwillingness to adapt to his new culture and changing times leads to repeated friction with those around him. Ultimately Andalibian characterizes her father: "In the chaos of a punishing war and changing times, his devout Muslim faith failed to save his son and led him to make grievous errors. He had alienated the very children he tried to protect, but there was never any doubt about the love between Baba and his children."[3] The book's listing on Amazon.com shows a cover featuring the silhouette of a mosque and describes *The Rose Hotel* as "in the tradition of *The Kite Runner* . . . and *Reading Lolita in Tehran*"—two books focused on life under the tyrannies of two of the most restrictive Islamic states of recent times. Almost two decades since it published *The World of Islam*, the books published by the National Geographic Society have promoted slim attention to Islamic traditions. Most of what little does exist notes as background some continuities with the traditions of the nation's Christian majority, while one book portrays the importance of the Islamic commitments for one of its central characters as a retarding feature of his and his children's acceptance of—and by—American society.

It would be an exaggeration to imagine that most non-Muslim Americans consciously cast Muslims as their antagonists in a deliberate effort to construct an adversary. While certain professional provocateurs do exactly this, most Americans' perceptions have mainly been shaped—as chapter 2 has demonstrated—by the cumulative experience and memories found in the dominant European American culture. These have roots in centuries of geopolitical, economic, and theological competition with Mediterranean Muslims, taking different shape and having varying influence in various historical contexts. Such experiences and memories have generated

assumptions largely left unchallenged due to the lack of wide-scale Western contact with Muslims in a context of political neutrality, or at least equality. These assumptions collide with the norms of mainstream American culture as it has developed historically.

As chapter 4 showed, the concept of the norm helps us understand how invisible and unconscious certain oppressive expectations can be, not only among those who suffer them but especially among those who perpetuate them. Norms are often so pervasive in a community or society that they are not explicitly taught but rather implicitly transmitted from generation to generation. The casual comment of a mother about "those people," a father protectively drawing a child to his side as a member of a particular group passes, or the wrinkled nose of a cousin's disapproval at the sight of "one of them" represents but one more stone in the foundation of norms by which a child increasingly engages her world. Although those who do not fit the norm are more likely conscious of these expectations, many of them will likely internalize the norm and may even disparage themselves for not "living up" to it. Ultimately such norms comprise what we consider "common sense": knowledge so entirely assumed that we may have difficulty remembering when we ever learned it and are entirely unlikely to even consider challenging it.

The invisibility of the norm to those who fit it is well demonstrated with the example of regional accents. Those from a specific area believe themselves to speak "normally," while others appear to have an accent. Of course, this norm changes from location to location. A resident of central Connecticut recently explained to one of the authors that only people in the middle of the state had no accent: people on one side sounded like Rhode Islanders and on another like Massachusetts residents. However, the national media have created and reinforced a national norm that transcends regional ones. This is evident in the predominance among national television, radio, and film personalities of a particular type of accent. However one might describe it, this accent makes Southern or New England or Texan accents sound like, well, accents. Most commonly, mainstream television and film feature a person speaking with a regional accent only when some stereotypical quality associated with that accent matters for the character: the redneck Southerner, the prim New Englander, or the garrulous Texan. Mainstream media productions, therefore, often communicate a negative impression to the very people they pretend to portray, spurring many Americans from these regions to "lose" their accents for the sake of professional and social advancement.

The previous chapter considered how political cartoons often project Muslims and Islamic traditions as opposite to and antagonistic of "the American character." This derives from a bipolar worldview common in the consideration of trustworthiness, progress, modernity, freedom, and basic morality. However, another realm of comparison exists that establishes the norm not simply as "good" relative to a negative foil that illustrates what might be "bad," but as a moderate middle ground on a spectrum bracketed by extremes. Once again, we notice how the negative representations of a group, culture, or religion often present an insight into the self-perceptions of those making the representation. Americans are not unique in this dynamic: many, if not most, communities affirm themselves, their ideals, and their values using ethnocentric norms. By examining mainstream US norms, we learn how many Americans have historically relied upon a particular view of Muslims to confirm America's normality.

This chapter will examine five themes through which contemporary Americans often have positioned themselves as representing the norm of the middle ground. The common depiction of Muslims as extremists becomes more understandable in light of their association in the minds of Americans with excessive behavior and belief, as table 5.1 shows. Often, Islam represents the extreme of too much: too much religion in the wrong places, too much masculinity, or too much female modesty. In some cases, Americans have portrayed individual Muslim cultures as flawed because they suffer from *either* too much of one quality *or* too little of the same. So, for instance, Muslim-majority countries seem *either* crippled from a lack of a unifying nationalist sentiment *or* dangerous due to their promotion of a transnational Islamic community. The chapter will conclude with a brief exploration of instances in which themes, caricatures, and symbols associated with Muslims are used to mark abnormality in contexts devoid of Muslim involvement.

Table 5.1. Extremes and Norms of American Cultural Ideas

	Extreme of Too Little	Norm of the Middle Ground	Extreme of Too Much
Religion and government	official atheism	secularism	politicized religion
Nationalism	factionalized	united	none, due to transnationalism
Men	effeminate passivity	proper masculinity	hypermasculine rage
Women	scantily clothed; objects of desire	clothed according to choice	entirely covered; objects of oppression
Morality	hedonistic	balanced	puritanical

Religion and Government

It often strikes Americans as odd that religion has played such an important role in the shaping of their national identity since, in various parts of the country, the public discussion of religion makes many uncomfortable. For them, religion belongs to the private realm of the individual conscience, the place of worship, and the home. If made public, religion appears aggressive and seemingly threatens to unleash dissension and division. Because of this, many of us were warned never to discuss religion or politics at the dinner table, and the unannounced appearance of polite yet proselytizing Mormons or Jehovah's Witnesses at the front door puts some of us on edge.

These sentiments derive from the earliest history of the independent United States that struggled to define itself against its English parent and cope with its multiple religious communities. Thomas Jefferson may have referred to "Nature's God" in the Declaration of Independence, but he and most of the Constitution signers (a great many of whom held Deist beliefs) were uninterested in promoting a specific church. After all, dissidents such as Puritans and Quakers had fled to this side of the Atlantic to escape the persecutions of the state-affiliated Church of England. Meanwhile, Jews and Catholics also had a presence, although they would be denied equal rights until the next century. In addition, the centuries of bloodletting on the European continent that were motivated (or at least legitimated) in part by Protestant-Catholic antagonisms following the Reformation convinced many eighteenth-century intellectuals like Jefferson that political and public religion threatened social harmony. Secularism offered an alternative that would be enshrined in the first article of the Bill of Rights: "Congress shall make no law respecting an establishment of religion, or prohibiting the free exercise thereof." In many ways, the two dimensions of the first amendment—the establishment clause and the free exercise clause—mirror how the ascent of secularist ideologies and their cultivation around the globe by European imperialism molded the prevailing definitions of religion today.

Despite these secularist sentiments, a normative Protestant Christianity has deeply influenced the shaping of American mainstream culture and contributed to a paradoxical legacy. If many Americans fear religion pushed on their doorsteps, many fear its absence among their leaders. A 2015 survey showed that only 58 percent of Americans polled said they would be willing to vote for an atheist presidential candidate. Although women, blacks, Jews, and Hispanics can hardly be considered the norm in American politics, 92 percent of respondents replied that they would be willing to vote for a woman or black candidate, and 91 percent would vote for a Jewish or Hispanic candidate. Even a gay candidate had a better

chance of being elected than an atheist (Muslim candidates were about as popular as atheist ones).[4]

The sharp debates regarding the presence of "In God We Trust" on every American bill and coin large enough to bear the line and the presence of "one nation under God" in the Pledge of Allegiance are not relics of a quaint but faded religiosity. In fact, it was only in 1954 that Congress added the phrase to the pledge in an effort to help underline the difference between "faithful" Americans and "godless" Soviets. Throughout the Cold War, the official atheism of Soviet Communism served Americans as one of the primary measures of difference with the United States. Americans came to treat Communism as a type of "perverted faith" that supplanted the proper values of individualism and freedom[5] promoted by true religions. Perhaps this notion informed President Ronald Reagan's famous description of the Soviet Union as an "Evil Empire."

It is also significant that, two decades later, President George W. Bush defined another realm of malevolence when he declared Iran, Iraq, and North Korea an "axis of evil." By associating two Muslim-majority nations with the evil of Communist North Korea, Bush may have contributed to impressions that Islam was replacing Communism as the ideology of perennial conflict in America's foreign affairs and perpetual fear in domestic life.

Overall, then, this history of secularism among a religiously active population has inculcated both reservations regarding religion in public life and an aversion to atheism. It has defined religion as both essential to the nation but necessarily separate from government. This has combined with popular Christian ideas that the divine and political realms are ordained to be mutually exclusive—echoing the biblical proscription, "Give to the emperor the things that are the emperor's, and to God the things that are God's" (Mark 12:17)—creating a popular notion of religion as a distinct realm, wholly set apart from politics (and economics). A secular norm has resulted that sits between the extremes of overtly religious politics and patently nonbelieving leaders or official atheism.

Two cartoons by artist Jeff Danziger illustrate the multiple levels of American suspicion regarding Islam. As will become apparent, secular concerns at times faintly mask much older Christian sentiments.

The most common suspicion considers Islamic traditions inherently violent. Figure 5.1 cautions the reader about the militantly religious nature of America's allies in the war against the Taliban. The image of a prostrate Afghan doing his prescribed prayers atop a falling bomb while clutching a gun demonstrates the failure of secularism among the Muslims of Afghanistan's Northern Alliance and mirrors the superimposed images of Muslim prayer and violence seen in *The Siege*, discussed at the beginning of chapter 4. Whereas personal acts of religious devotion remain safely private in the

The Northern Alliance

Figure 5.1. Jeff Danziger, 2001. Jeff Danziger, New York Times Syndicate.

American secularist ideal, the (male) Afghan Muslim's faith is intrinsically married to violence.

In Danziger's image of Iraq (figure 5.2), unkempt, dark fundamentalists pursue their own agendas, equating the innocuous owners of liquor stores and women baring their ankles with the Baathists threatening the social order, to the dismay of an American GI. "Fundamentalist" Islam distorts reality for the unrestrained fanatics warped by it.[6]

At times, a cartoonist attempts to defend "Islam" from claims regarding its inherent violence and oppression by impugning its "manipulation" by a certain group of Muslims. This places the cartoonist, who is projecting a singular image that simplifies the complexity and multiplicity of Muslim traditions, in the odd position of defining (1) which interpretations of the Quran are accurate, (2) Islamic beliefs proper, and (3) appropriate forms of practice. Simultaneously, this dismisses the claims to religious motivations of those who do not fit the cartoonist's definition of the proper Muslim (figure 5.3),

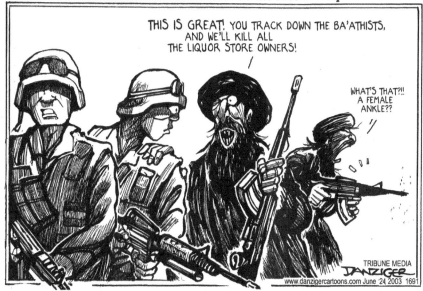

Figure 5.2. Jeff Danziger, 2002. Jeff Danziger, New York Times Syndicate.

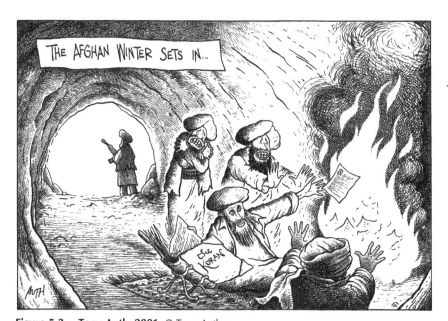

Figure 5.3. Tony Auth, 2001. © Tony Auth.

relabeling their intentions as merely political, economic, or misogynistic. Overall, then, these cartoons unwittingly reinforce the notion that religion, when true and good, is relegated primarily to a spiritual realm. Those who bring it into other realms "use" it for their own ends, not with appropriately religious intentions.

The American norm of the United States as a God-fearing yet secular nation obscures the historical and political connections between Christian traditions and government readily apparent to many outsiders. American policies have relied on the acquiescence, if not outright support, of many churches. Three centuries and even longer ago, Christian justifications for enslaving Africans helped perpetuate the slave trade. From the nineteenth century on, many Christian missionaries actively collaborated with the federal government's efforts to subjugate Native Americans to reservation life. And, in the past two decades, some Christian nonprofit organizations have blended their government-sponsored roles of administering relief in Afghanistan and Iraq with efforts to proselytize,[7] while the military has been shaken by repeated revelations of coercive and intolerant policies toward non-Christians at home and in combat zones.[8] Despite the long, complicated history of the constitutional battle to define and defend the line between church and state, Christian ideologies, institutions, and language often have infused government policies in the United States. This is not a claim that American secularism has failed, but it is an observation that its application— like that of any ideology—falls short of what many Americans consider its ideals. Consequently, the supposedly distinctive line that separates this norm from those to which it is compared, blurs.

Nationalism

One of the hallmarks of the contemporary world has been the development of the nation-state. Allegiance to the nation—a collection of individual citizens whose primary attachment is to one another and to their country— began supplanting loyalty to monarchy in eighteenth-century Europe. Over time, governments began to gain legitimacy not from royal claims to divine right but from their ability to represent their nation's citizens and defend the integrity of the fixed borders of the nation, which represented the physical expression of sovereignty. During the next two centuries, many of the directly colonized and imperially dominated peoples of most of the rest of the world would begin imagining themselves as nations. They did so in their attempts to justify self-determination and independence, following European and American models. At least as often as not, their borders, and thus their

definition of nation, were determined by European imperial powers. This contrasted significantly with American and European patriotic histories, which portrayed each Western nation as coalescing naturally through the mutual recognition of its residents as "a people." As the experiences of Native Americans in the United States, Irish Catholics in Great Britain, and Basques in Spain would demonstrate, the exact bounds of membership to the nation were not always quite so self-evident, open, or accepted. Nevertheless, a different situation existed for those whose encounter with the very notion of nationalism arose from the experience of imperial domination.

For instance, in the wake of the defeat of the Ottoman empire at the close of World War I, the British seized the three provinces of Basra, Baghdad, and Mosul.[9] From these Ottoman administrative regions, the British created the "nations" of Iraq and Kuwait by drawing borderlines and establishing friendly ruling monarchies according to British economic and political interests and with the cooperation of certain members of the population. The multiethnic and multireligious "people of Iraq" were then left to discover how they would fulfill their foreign-imposed identity. The borders of tiny Kuwait not accidentally contained the lion's share of the region's oil, and its pro-Western dynasty has since ensured the British constant access.

Afghanistan also owes its origins to the British, who in this case established borders not to contain resources but to create a buffer state. The Russian and British empires had played "the Great Game" throughout the nineteenth century in the region between the North-West Frontier of India and the Russian-controlled Central Asian states. They agreed to borders intended to keep one another at arm's length. The British, meanwhile, deliberately divided the ethnic Pathan tribes of the Hindu Kush mountains between India and Afghanistan to retard their political consolidation. Contemporary Pakistan inherited this situation when it won independence in 1947, and Pathans continue to often derisively mock their supposedly national government in Islamabad. Few governments have long maintained control over an Afghanistan divided into remote regions by difficult terrain and characterized by widely varying languages, customs, and practices.

The irony of the problems with unity that many of these European-defined nations face is that Europeans and Americans often condemn them today for their divisiveness. Taking nationalism as a normative form of social organization and imperially established borders as the natural bounds of a people, Westerners often blame a lack of unity for the failures of some nations—a unity seldom self-understood before the arrival of the Europeans. Since nationalism is a norm of American life, Muslims, most of whom live in areas previously under European domination, appear implicitly unwilling or

unable to accede to the sacrifices and compromises required of nationhood as demonstrated in cartoons dealing with the twenty-first-century situation in Iraq (figure 5.4) or Afghanistan (figure 5.5). This factionalism is, at one end of the spectrum of nationalism, extremely deficient.

The other extreme that helps define American nationalism as normal is that of transnational Islamism. Although few Muslim leaders have proposed a single transnational Islamic state to replace nations and a tiny percentage of Muslims seek to establish such an entity, the concept looms large in the minds of many non-Muslim Westerners. It is perhaps for this reason that American news outlets consistently had interpreted Osama bin Laden's statements and activities as intending to reestablish the long-extinct caliphate and install himself as caliph. In an address in 2005, Bush argued, "These militants believe that controlling one country will rally the Muslim masses, enabling them to overthrow moderate governments in the region, and establish a radical Islamic empire that reaches from Indonesia to Spain."[10] Little in bin Laden's or al Qaeda's declarations justified such conclusions, however, since most of those

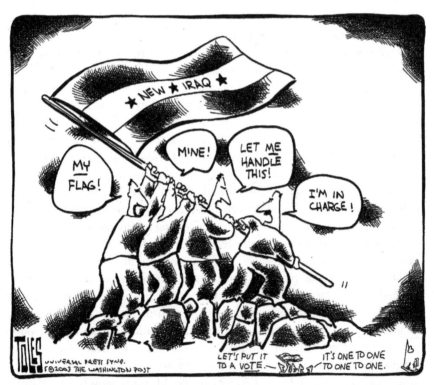

Figure 5.4. Tom Toles, 2003. Toles © 2003 *The Washington Post*. Reprinted with permission of Universal Press Syndicate. All rights reserved.

Schedule

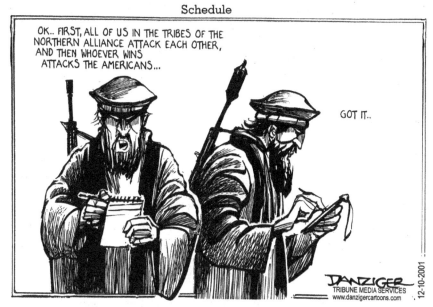

Figure 5.5. Jeff Danziger, 2001. Jeff Danziger, New York Times Syndicate.

declarations have focused on freeing Muslim-majority nations from Western-allied governments in order to cultivate Islamist rule. Establishing a caliphate had been, at best, a long-term goal for bin Laden and al Qaeda.[11] In contrast, the self-description of the so-called Islamic State (IS) as a caliphate emerging from the chaos of postinvasion Iraq and civil war–immersed Syria seems the perfect manifestation of Western fears. Since the movement's advent in 2013, the success of IS leaders in broadcasting their appalling cruelty on social media (and enticing news media to repeat and amplify their message) attracts the Western condemnation their propaganda and recruiting requires as they seek to stoke an upward spiral of violence. Yet, their "caliphate" has existed in little but name, as the vast majority of Muslims reject the notion—as reflected by the Syrian refugee crisis partly caused by their rule—and many bridle at the very conceit of the movement's murderous rule bearing any semblance to what they imagine as an appropriately called Islamic state.

Meanwhile, when fears of Islamic terrorism peak, suspicion has often fallen upon Muslim citizens of the United States, as alarmists assume that all Muslims pledge allegiance to their religion rather than their nation. The Nation of Islam, often victim of its own intentionally provocative rhetoric, has long garnered such doubts. The Federal Bureau of Investigation, for its part, compiled at least three lengthy monographs on the "Muslim Cult of Islam" beginning at least in 1955.[12]

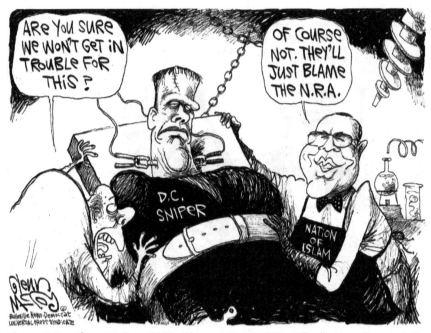

Figure 5.6. Glenn McCoy, 2002. Glenn McCoy © 2002 *Belleville News-Democrat*. Reprinted with permission of Universal Press Syndicate. All rights reserved.

In light of this, it was possible for cartoonist Glenn McCoy to depict "DC sniper" John Allen Muhammad and his homicidal actions in 2002 as the product of the Nation of Islam because of his nominal connections with the Nation (figure 5.6). Media attention on the deliberately incendiary, anti-Jewish, and threatening rhetoric (though the Nation rarely has sponsored actual violence) that was used to preach black separatism from white America so dominates non-Muslim perceptions of African American Muslims that most are surprised to learn that merely 10 percent of African American Muslims belong to the Nation. Ninety percent belong to Sunni traditions.

Men

Overwhelmingly, the most popular American depiction of Muslims is of Muslim men. These men, as evidenced by most of the cartoons cited in this and earlier chapters, are most often violent and uncouth. Their masculinity is exaggerated in negative directions—toward malevolence and uncontrollability—as opposed to positive directions such as heroism and protectiveness. The abnormality of Muslim masculinity is evident in excessive and unruly facial and body hair. Although many Muslim men adopt a beard in respectful

imitation of the prophet Muhammad, the stereotype that they are unkempt communicates a lack of restraint, as well as masculine excess.

Historically, American and European depictions of the threatening pose of the hypermasculine Muslim—sometimes drawn as exaggeratedly tall and broad—has contrasted with another image, that of the effeminate Muslim man. As will be seen in the next chapter, the extreme of the effeminate Muslim becomes most apparent in incidents involving Muslim-predominant states cautiously negotiating with better-armed Western powers.

The depiction of Iraqi dictator Saddam Hussein changed during the 2003 standoff between him and the US government before the American-led invasion. As the possibilities of negotiation evaporated, so did depictions of him as effeminate (figure 5.7). Perhaps because the portrayal of Saddam as a threat proved so unconvincing to many, some cartoonists focused instead on the Bush administration's depiction of a nefarious Saddam (figure 5.8), questioning the government's portrayal and drawing on menacing masculine caricatures to do so.

These reflections on the two extremes of Muslim masculinity help explain a particularly disturbing character change in *The Siege*, the film that was considered at the beginning of the previous chapter. The film surprises the

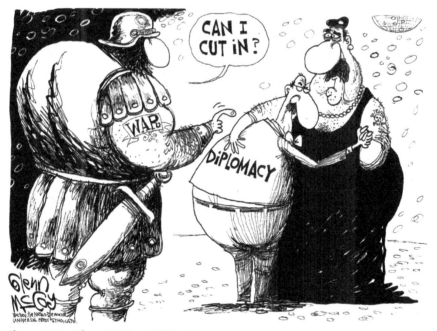

Figure 5.7. Glenn McCoy, 2003. Glenn McCoy © 2003 *Belleville News-Democrat*. Reprinted with permission of Universal Press Syndicate. All rights reserved.

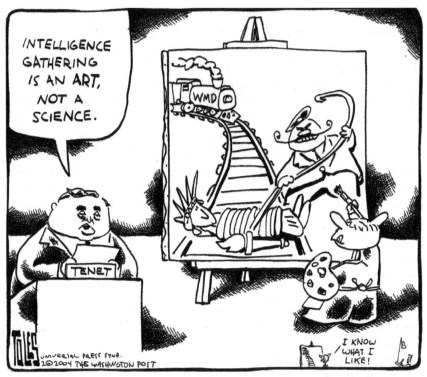

Figure 5.8. Tom Toles, 2004. Toles © 2004 *The Washington Post*. Reprinted with permission of Universal Press Syndicate. All rights reserved.

audience when a particularly passive character, previously manipulated as an informant by a female FBI agent, suddenly proves himself the long-sought terrorist mastermind behind a series of explosions by berating and shooting her. The movie successfully hoodwinks many of its viewers by playing to the audience's expectations of the effeminate Muslim before shattering these expectations through the character's metamorphosis into the other extreme of Muslim masculinity, a change signaled by his abuse of a woman. Tony Shalhoub's "good Muslim" Arab American character joins Denzel Washington's protagonist in inhabiting the middle ground of normal American masculinity by entirely shedding any outward manifestation of his religion beyond a hollow self-identification as a Muslim.

Women

One of the defining issues for many Americans regarding the presumed backwardness of Muslims is the position of women in Muslim communities.

Whereas Muslim women with bare midriffs who peek around diaphanous veils represented an object of exotic titillation for many nineteenth- and early twentieth-century Americans and Europeans, the impact of the feminist movement and increased awareness of gender inequality in the United States and Europe led to an important change. The naïve eroticism of the 1960s television program *I Dream of Jeannie*, with its scantily clad and bottle-dwelling female genie eager to please her male "master," gave way to the accusatory hyperbole of the 1991 film *Not Without My Daughter*, in which a duplicitous Iranian man—in league with his entire family in Tehran—holds hostage his loving European American wife and their innocent daughter.[13] In the meantime, the Cold War between the "free world" and "enslaved" Soviet Bloc had concluded, and a rhetorical shift ensued that repositioned the United States as a champion of freedom, relative no longer to Communist masters but instead to the fanatic men (figure 5.9) and subjugated women of "the Islamic world."[14]

The totalitarian excesses of the Stalinist state that for so long fueled the justification to interfere in any "Communist-leaning" country's political

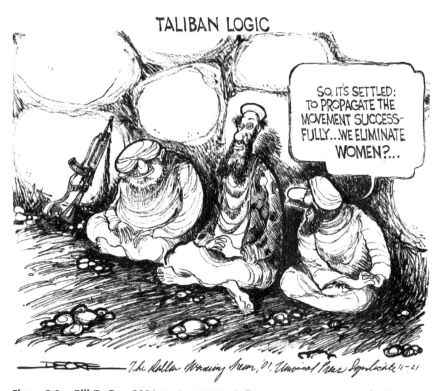

Figure 5.9. Bill DeOre, 2001. DeOre © 2001 *Dallas Morning News*. Reprinted with permission of Universal Press Syndicate. All rights reserved.

process now appeared to take similarly threatening form in Islamic politics. Thus the Bush administration portrayed the American invasion of Afghanistan and the overthrow of the Taliban government in response to their harboring al Qaeda operatives such as Osama bin Laden as also liberating that country and, more specifically, its enslaved women. First Lady Laura Bush seminally expressed this when she declared on Thanksgiving 2001, "Because of our recent military gains in much of Afghanistan, women are no longer imprisoned in their homes. They can listen to music and teach their daughters without fear of punishment. Yet the terrorists who helped rule that country now plot and plan in many countries. And they must be stopped. The fight against terrorism is also a fight for the rights and dignity of women."[15] While the Taliban had indeed established a rule of law that severely limited the freedoms enjoyed by many Afghan women, Bush's conflation of them with al Qaeda—a global organization entirely different from, albeit supportive of, the nationalist government of the Taliban—merged America's effort to liberate women (uncompleted at home) with her husband's foreign policy agenda.

When the War on Terror then targeted Iraq, dictator Saddam Hussein became the face of tyranny. However, the liberation of women still provided a trump card for the war's apologists as they addressed complaints about the treatment of Iraqis by American occupation forces after the invasion of the country, including the infamous revelations from Abu Ghraib prison (figure 5.10). In perhaps not indeliberate contrast, among the first heroes of the US-led assault promoted by the military was Private Jessica Lynch. Grievously wounded in an ambush in 2003, she has since publicly wondered why the military made her into the "little girl Rambo from the hills of West Virginia." In official statements, the Pentagon exaggerated Lynch's actions in combat and the heroism of her (male) rescuers while ignoring the efforts of Iraqis to medically treat her and return her to American forces.[16] In any case, it did not seem to matter to the apologists for the invasion that before the 1991 Gulf War, Iraqi women enjoyed one of the highest levels of education and medical care in the Middle East, often higher than those found in many of the neighboring countries that the United States enlisted as allies.[17]

Among the many political cartoons depicting Muslims, almost none show Muslim women unless to explicitly remark on their oppressed status. Muslim women seldom figure into representations of Muslims in general. Overall, then, cartoonists appear to practice their own marginalization of Muslim women by denying that they represent Islamic traditions at all, although mothers commonly act as the first Islamic teachers for their children. Moreover, cartoonists often ignore the choices many, though certainly not

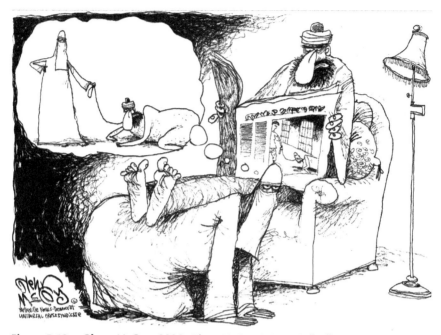

Figure 5.10. Glenn McCoy, 2004. Glenn McCoy © 2004 *Belleville News-Democrat*. Reprinted with permission of Universal Press Syndicate. All rights reserved.

all, Muslim women make with regard to their lives, such as the trend among many young women in Egypt, the United States, and other nations over the past two decades to voluntarily adopt the head scarves that their mothers did not wear and that, in some cases, their families prefer them not to wear.[18]

Although an awareness of gender inequality internationally may have motivated concern among editorial cartoonists regarding some "universal plight" among Muslim women, it does not appear that all ensuing critiques have entirely shed the enduring Western titillation with "exotic" and "Oriental" women as either teasingly clad or tantalizingly covered (figure 5.11). To be sure, many Muslim women do suffer very real and tragic oppression. The place of honor killing, genital mutilation, and forced marriage in many cultures—not just Muslim ones—demands attention and concern. However, the assumption that American women live in some ideal normality belies common realities of sexual exploitation and gender oppression that inarguably manifest themselves in the pervasive everyday American tragedies of sexual assault, domestic violence, and eating disorders,[19] not to mention persistently lower pay and promotion rates in the workplace. Perhaps it is the focus on the purported miseries of Muslim women that helps many Americans acquiesce more comfortably to the normality of such local inequalities

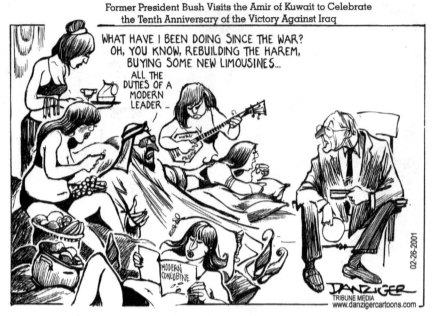

Figure 5.11. Jeff Danziger, 2001. Jeff Danziger, New York Times Syndicate.

and domestic crimes. Certainly, heightened awareness of discrimination against women in America has foreclosed romanticizing the genie/Jeannie in a bottle, as the Arab/Muslim woman of popular imagination has transformed from the diaphanously dressed object of sexual fantasies to the oppressively veiled object of political liberation.

Morality

American cartoonists primarily represent Muslim women in order to project their editorial opinion about Islamic morality as expressed by Muslim men. Historically, Western views have oscillated between two extreme views of Muslims: as militants for morality and as sensually insatiable. Ironically, Muhammad has been portrayed historically as both a puritan for Quranic restrictions on wine drinking and as a hedonist for his marriage to multiple wives. Portrayals of Muslims today continue to gravitate to one or the other of these two extremes. Occasionally, they show both extremes in order to demonstrate Muslim hypocrisy. In one example (figure 5.12), the exaggerated puritanical misogyny of the Taliban defeats their attempt to rouse a boy's lust as motivation for violence.

A Possible Martyr

Figure 5.12. **Jeff Danziger, 2001.** Jeff Danziger, New York Times Syndicate.

Women remain notably absent in these critiques of Muslim morality, just as in general depictions of Islam. The cartoons focus on them as the objects of male desire and the victims of male power yet seldom consider Muslim women's perspectives beyond those assumed from afar.

Some cartoons explicitly portray the overall theme of extremism. They express the popular assumption of an inherent extremism among Muslims. For instance, a Pat Oliphant cartoon in the last chapter (figure 4.12) depicts some Muslims or Arabs (the object of scorn is unclear) as motivated by their radical Islamic views to willfully reject all advancements engineered by non-Muslims while recently contributing nothing themselves. Other cartoons have excoriated the possibility of moderation by either individual Muslim leaders or any Islamic tradition (figure 5.13).

Challenging the Norm

A final measure of the extremes that Muslims represent relative to the American norm appears when people or objects associated with Islam become symbols of abnormality *in situations that do not involve Muslims*. Whereas the previous examples used symbols of Islamic traditions and stereotypes of Muslims

Figure 5.13. Chip Bok, 2003. © 2003 Chip Bok. Reprint permission granted by Chip Bok and Creators Syndicate. All rights reserved.

in negative contrast with American ideals and individuals during encounters between the United States and Muslims, political cartoonists occasionally use symbols of "Islam" to symbolize unacceptable deviance in general. In this way, various Muslim cultures or individuals, or Islamic traditions in total, serve as an absolute marker of abnormality by which to measure divergence from an American norm. And so, a member of the federal administration dons the symbolic gear of a mullah or an oppressive burqa drapes Ms. Liberty as evidence of an oppressive domestic policy.

In an instance demonstrating once again how Muslims provide the context in which to reaffirm American norms that include the depiction of women as weak, Nick Anderson mocks the fearfulness of Republican men using a supposed symbol of Muslim femininity (figure 5.14). This demonstrates the dynamic of "Muslim," "Islam," and associated symbols serving as empty signifiers—as mere emblems of difference from American values without regard to the meanings that certain terms, identities, and objects have among Muslims. Hence, we return to the notion discussed in the previous chapter of many Americans perceiving Muslims and Islamic traditions as mere abstractions that serve as foils to negatively define what is good and right about the United States.

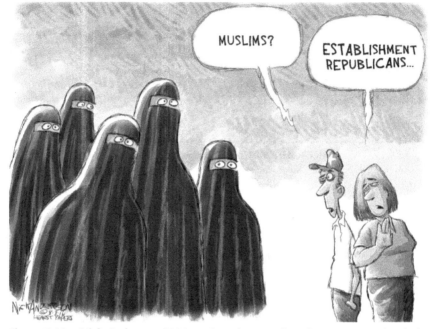

Figure 5.14. Nick Anderson, 2016. Nick Anderson's Editorial Cartoon is used with the permission of Nick Anderson, the Washington Post Writers Group, and the Cartoonist Group. All rights reserved.

In other instances, however, some artists apparently endeavor to reveal and critique this dynamic of using Muslims and Islamic traditions as foils. They attempt to draw parallels between excoriated Muslim figures or situations in Muslim-majority cultures and American ones in an effort to challenge the unquestioned acceptance of a specific American norm. In these cases, cartoonists demonstrate how arguments used to deprecate a Muslim individual or culture may apply to Americans as well. By doing so, they attempt to show how some American norms prove to be more of an ideal than a political or social reality, as demonstrated by Aaron McGruder (figure 5.15). In comparing the idealistic rhetoric of American policy makers regarding Muslim leadership, education, or women's rights to actual conditions on the ground in the United States, these cartoonists turn complaints about Muslim societies into editorial commentary on conditions in the United States itself.

Most importantly, perhaps, such editorials demonstrate a common mistake in logic that non-Muslim Americans make when criticizing Muslim-majority societies and Islamic traditions. That is, they compare what they know about Muslims from news reports (that emphasize the dramatic, conflictual, and

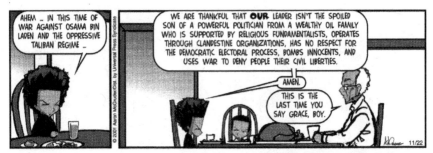

Figure 5.15. Aaron McGruder, 2001. *The Boondocks* © 2001 Aaron McGruder. Distributed by Universal Press Syndicate. Reprinted with permission. All rights reserved.

extreme) with an American social self-concept that often emphasizes the ideal. For instance, Tony Auth in 2002 created an image of a mother sending her children to school while thinking, "You never know for sure when you leave the house whether you'll be alive at the end of the day. . . ." The image then identifies the scene as the Middle East as the woman completes her thought: ". . . in other words everything's normal." It has taken the culmination of mass school shootings like that at Parkland, Florida, in 2018 to create sustained national debate about endemic American gun violence, while surveys demonstrate that per capita Americans died from gun violence at higher rates in 2016 than in any Middle Eastern nation other than Iraq.[20] This defies what many Americans (though certainly not all) understand as "common sense" that the Middle East is a dangerous place and the United States a safe one. Once again, they demonstrate the dynamic apparent since the founding of the country that "Islam" and Muslims often have served as foils by which to define "America" and Americans.

CHAPTER 6

—⚮—

Moments
1956–2006

What follows is an examination of four distinct moments in the history of the relationship between the United States and Muslim-majority cultures and the changes in depictions over a half century: the Egyptian nationalization of the Suez Canal in 1956, the oil crisis of 1973, the Iranian Revolution and hostage crisis of 1979–1980, and the September 11, 2001, attacks with their immediate, succeeding events. These do not represent all of the major moments in that relationship, but they do allow us to track some important continuities and discontinuities in representations of Muslims. On each occasion, some cartoonists drew on repeating sets of themes, symbols, caricatures, and stereotypes that depicted the group in question in a negative, even hostile, fashion. While political cartooning as a whole is an essentially critical art, as discussed in the introduction, these cartoons often go beyond the basic negativity of caricature. Probably unintentional in most cases, many images depict Islamic traditions as an inherent foil to "American values" and Muslims as essentially outside American definitions of normality. A minority of cartoons demonstrate more nuance in their depiction of Islamic traditions and Muslim communities, carefully distinguishing militants from the majority of Muslims and avoiding overgeneralizations about Islamic traditions, if not positively recognizing Muslims as integral to the American national landscape.

As we shall see, an evolution occurs in which political figures and movements that happen to include Muslims increasingly become identified primarily *as* Muslim. Ultimately the depiction of these opponents of the United

States as Muslim, through symbols and stereotypes, inherently means to signal to the American audience that they are necessarily antithetical to the audience's values. The symbols and images used serve to associate a wholly negative notion of Islam with these political movements, even when such associations are not appropriate. Moreover, the US-Muslim dichotomy created here necessarily impugns the loyalty of more than three million Muslim Americans,[1] who must first be suspect as Muslims before being embraced as Americans.

The changes and continuities during the fifty years covered by these cartoons reflect the shifting popular concerns toward—and increasingly troubled rendering of—Muslims and Islam in the mainstream American imagination. The next chapter will demonstrate how rising awareness of Islamophobia and anti-Muslim sentiment among liberal cartoonists has led them to diverge from conservative cartoonists in their depictions of Muslims in the second decade of the new millennium.

Nasser and the Suez Canal: 1956–1958

Egyptian leader Gamal Abdel Nasser was a worrying figure for the US government in the 1950s and 1960s, as the United States had a shaky relationship with Egypt following World War II. US interests were torn between Cold War partner Britain, which wished to maintain military forces in Egypt, and the increasingly nationalistic Egypt, which sought complete national sovereignty. Concern over continued and unfettered access to Egypt's strategically vital Suez Canal, which allowed American—and other nations'—naval forces and merchant shipping rapid transit from the Mediterranean to the Red Sea and into both the Persian Gulf and Indian Ocean, further quickened anxieties.

Each side in the dispute initially sought American support. Finally, in 1952, Nasser negotiated the departure of British troops.[2] In late 1955, the United States attempted to assert new influence in the Middle East, as Secretary of State John Foster Dulles proffered financial support for Egypt's nascent Aswan Dam project. However, when Dulles unexpectedly withdrew the offer, Nasser responded by immediately seizing and nationalizing the Suez Canal, which had in the 1950s stood under the controlling interest of the British and French. This in turn provoked Britain and France to enlist Israel's help and attack Egypt in late 1956.[3] Ultimately the Eisenhower administration joined the Soviets in pressuring the British, French, and Israelis to abandon their invasion. Nevertheless, the United States remained worried about the prominent and assertive Nasser.

Throughout the next several years, Nasser espoused a rhetoric of Arab unity and socialism. The Egyptian leader became popular and influential among Arabs in and beyond Egypt after the successful Suez standoff, fashioning and presiding over the short-lived United Arab Republic. He received steady aid from the Soviet Union while allowing an increasing number of Russians into Egypt. Compelled by a Cold War logic of domino theory and zero-sum diplomacy, US leaders feared that Nasser had opened up the entire Middle East to Soviet influence and that his principle of Arab nationalism might eventually threaten Western access to Middle Eastern oil.[4]

Cartoons of Nasser during this period reflect the American view that Egypt was important only insofar as it had strategic significance in the context of the Cold War. Despite these very contemporary concerns and Nasser's thoroughly modern political outlook, personality, and dress, cartoonists of the period represented him, as well as Egypt as a whole, using the traditional tropes of Arabs, Middle Easterners, and the desert. Furthermore, Nasser and the Middle East were portrayed recurrently as women, or with feminine overtones: this trope connected Nasser to the pervasive European rendering of the Middle East at this time as easily subjugated and Middle Eastern men as feminine and passive. Two cartoons in particular demonstrate these perceptions.[5]

The first cartoon (figure 6.1) draws explicit attention to the notion of the Middle East as a "vacuum" of political power. This attitude, which understandably frustrated Arab leadership,[6] reflects the US belief that the Arab states stood incapable of exerting meaningful political power. Meanwhile, the pyramid in the first frame acts as a visual clue situating the characters in the land of archaic Egypt, contrasting the Soviet officer's modern uniform and vacuum cleaner with the landscape's antiquated architecture and the Arab's medieval dress. Of note, the hirsute, stocky Soviet evinces a hypermasculinity that might communicate aggression and uncouthness in contrast with many of the contemporary, masculine personifications of the United States.

The second cartoon (figure 6.2) uses the same trope of femininity, this time to portray Nasser as the resplendent recipient of fawning Soviet and US attention. Similarly luscious, sensuous imagery is used, with revealing clothing but also including jewelry, cushions, and a divan. The caption "Cleopatra" emphatically connects modern Egyptian politics to ancient, somewhat legendary affairs.

Although the guilelessness of the slight female sucked into the Soviets' clutches seems to contrast in terms of agency with the confident seductiveness of Nasser fawned over by the superpowers, in fact they differ little.

DEMONSTRATION ON FILLING A VACUUM

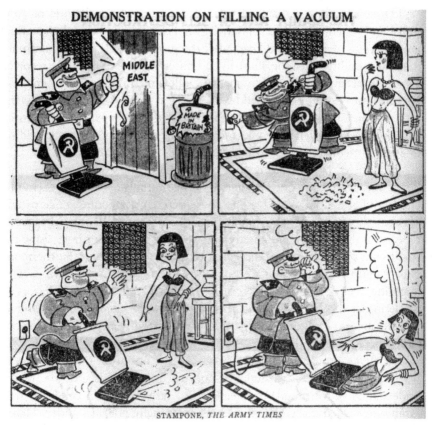

STAMPONE, *THE ARMY TIMES*

Figure 6.1. John Stampone, 1956. *Army Times.*

While the latter image suggests that Nasser can attract the attentions of his foreign admirers, his agency remains obviously "feminine" and passive, attaining nothing actively, only through the kind offices of the "masculine"—that is, powerful—Soviet Union and United States.

Cartoonist Bill Mauldin expressed similar views in a *St. Louis Post-Dispatch* image from 1961 portraying a different context. Opening the flaps of his desert tent in the dead of night, Soviet premier Nikita Khrushchev greets two veiled women carrying suitcases respectively marked "Algerian moderates" and "Tunisian moderates." The couple's footprints lead back to a tent marked as that of French president Charles DeGaulle.[7] Fitting patriarchal and heteronormative expectations, these moderates appear as unfaithful, attractive women moving from one man to another as they abandon French for Soviet support. Their ability to leave one for another seemingly represents

Cleopatra

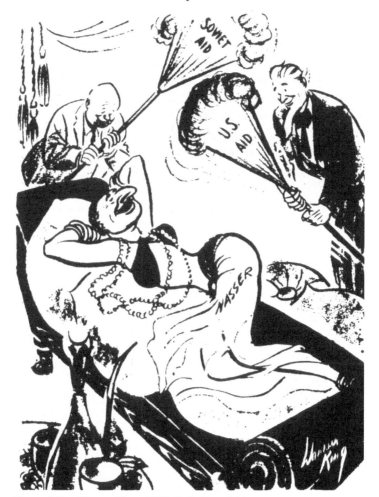

Figure 6.2. Warren King, 1959. *Daily News* (NY).

the extent of their agency, as emphasized by the anxious look out of the corners of their almond-shaped eyes as they watch for any unwanted observers.

Overall, therefore, three themes dominate the editorial cartoons of this period: Arabs as (1) archaic, (2) feminine, and (3) passive. Other cartoons reflect the prevalence of these themes. One, made by Richard Yardley for the *Baltimore Sun* in 1956, depicts Nasser as a camel. While a smiling woman symbolizing the United Nations pats his injured rear, Uncle Sam waves a patronizing finger at the unhappy figures of Marianne (symbol of

France), John Bull (Great Britain), and David Ben-Gurion (Israel's prime minister) while saying, "He'll respond to patience and kindness." Both John Bull and Ben-Gurion hold ruined riding crops that they have apparently broken on the camel's hind. Nasser's caricature as a camel represents not only his obstinacy but also his association with an archaic culture. Meanwhile, background pyramids, an overhanging palm tree, and a crescent moon and stars further situate the scene in Egypt. We must note that the moon and stars featured prominently on the Egyptian national flag at the time and, therefore, were meant by the cartoonist to symbolize Nasser's Egyptian quality, not his Muslim identity.

Another cartoon from the same year, by Leo Thiele, takes a different tack to depicting Nasser through stereotypes (figure 6.3). While a grimacing

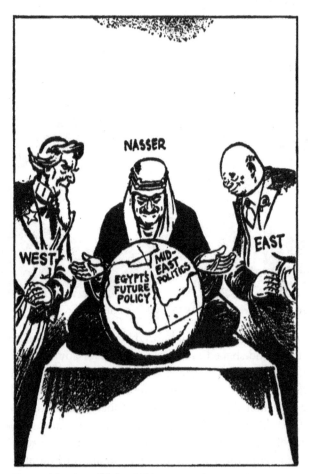

Figure 6.3. Leo Thiele, 1956. *Los Angeles Mirror-News.*

Uncle Sam and Nikita Khrushchev look on from either side, Nasser sits on an elevated platform in front of a crystal ball that shows Africa and West Asia. These are labeled "Egypt's future policy" and "Mid-East politics." Staring at the ball, Nasser extends an open hand—palm up—in the direction of each figure while saying, "Cross my palms with silver." The cartoonist's effort of associating Nasser with the charlatan claims of crystal ball readers—whose claims to mystical knowledge are often buttressed by their supposedly exotic origins—is reinforced by Nasser's kaffiyeh, headgear central to American stereotypes of Arabs yet almost never worn by the Egyptian leader. As in figure 6.2, Nasser's passivity barely hides his effort to swindle money from the superpowers as he plays the fortune-teller.

Divergence exists in a small number of cartoons that take an opposite position to the earlier examples in their portrayal of Nasser; these are the exceptions that prove the rule. Compared to the feminine and/or manipulative Nasser in the previous cartoons, a cartoon by Hy Rosen published in the Albany, New York, *Times-Union* in 1958 exaggerates Nasser's masculinity. The cartoonist has liberally dabbed the Egyptian leader's legs, forearms, chest, and chin with hair stubble to magnify a brutishness also made visible in both his conniving grimace and the array of weapons at his side. This recalls the thuggish depiction of the Soviet officer in figure 6.1. Editorial cartoonists of this period used both extremes of masculinity, as described in chapter 5, to portray Nasser as aberrant from the "normal" man: either mockingly faux-feminine or menacingly hypermasculine. Association with ancient Egypt would also be a central theme to this and other period portrayals.

It should be noted that the physical differences in portrayals of Arabs in this period focus primarily on clothing and that Muslim identity did not seem to matter. Whereas the caricature of Soviet premier Nikita Khrushchev wears a business suit, the symbolic Uncle Sam dons his emblematic striped pants and tails, and other international leaders or symbols wear Western clothes, none of the images of Nasser portray him in the business suits that he favored. Instead he wears an ancient Egyptian wrap, a diaphanous dress, and an Arab kaffiyeh. In yet another image, he is a camel in all but his recognizable facial profile. Despite their use of this unusual clothing, these cartoons do not represent Arabs as *bodily* different from others. Most notable, however, is the absence of references to Islam or stereotypes of Muslims in these images. It would not appear that Nasser's Muslim identity mattered in the perceptions of these cartoonists so much as his identification with Egypt, an identification defined by its ancient past. However, a stereotype presuming racial and religious difference would soon dominate portrayals of Arabs and, later, other Muslims.[8]

Oil Crisis: 1973–1974

On October 17, 1973, during the Arab-Israeli Yom Kippur War (also called the Ramadan War or October War), several of the Arab oil-producing states—most notably Saudi Arabia—imposed an oil embargo on the United States, Japan, and certain European countries. Ostensibly this was in response to American support for Israel in the war. The use of oil as an economic, and therefore political, bargaining chip succeeded, and the price of oil in the United States skyrocketed. Prices immediately rose 70 percent and eventually reached 400 percent of their original price in the United States over the course of the six-month embargo. This concerted strategy on behalf of the Arab oil states came as a surprise to most Americans and the US government. The Nixon administration and many others, assuming that any effort at Arab unity would fail, had dismissed Arab threats of using oil for political leverage.[9] In fact, Henry Kissinger remarked derisively about the Saudi foreign minister: He's "a good little boy," so "we don't expect an oil cutoff in the next few days."[10]

The energy crisis in the United States provoked a sense of anger toward the Arab oil states. Media accounts and editorials angrily condemned the Arab use of oil as a "weapon."[11] Some feared that an economically hobbled America would be vulnerable to proliferating purchases of businesses and real estate by Arabs.[12] Political cartoons prodigiously manifested this resentment through pernicious stereotypes of male Arab physical features, aggressive countenance, and moral character. During this period, cartoonists represented Arabs as undifferentiated in their stereotyped qualities as scheming and money-mongering, qualities already portrayed in caricatures of Nasser two decades earlier. Now, however, Arabs were not acting passively. Instead, the united effort of some to institute an embargo had apparently put them in control of the economic fate of the United States. Underlying the majority of the cartoons during this period, we see that the deep-rooted association among Europeans and Americans of Islam with violence, nascent during Nasser's rule and the Suez Crisis, emerges more prominently, providing a backdrop for understanding of this modern, economically driven situation.

Caricatures of this period rely upon several potent symbols that would become standard in the portrayal of Arab men, and Muslim men generally, from then on. Throughout this era, the use of the kaffiyeh immediately informs the reader that the subject is an Arab. The caricatures commonly wear facial hair, angry smirks, droopy eyes, and heavy eyebrows, and their noses cast beaklike and broken from their faces.

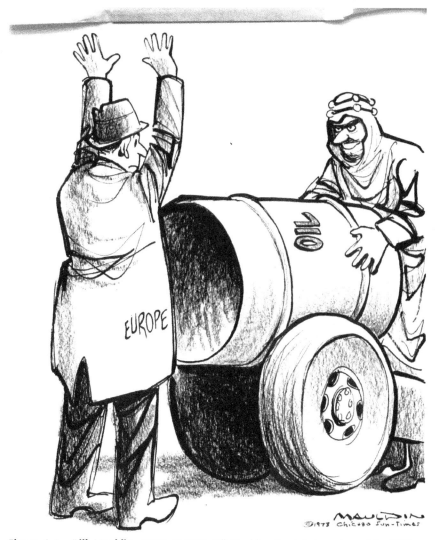

Figure 6.4. Bill Mauldin, 1973. © 1973 Bill Mauldin. Reprinted courtesy of the William Mauldin Estate.

The two characters in figure 6.4 mark the perceived contrast between Arab and European physiognomy and aggression. The Arab's nose and facial hair are as prominent as his threatened or actual violence. As is also the case in figure 6.5, a kaffiyeh-adorned Arab man wields oil or oil prices as a weapon to intimidate or assault unarmed and dismayed Western nations, also personified as men. Furthermore, the weapon the second cartoonist chooses is symbolic: an exaggerated scimitar. Originally, Christian Europeans viewed

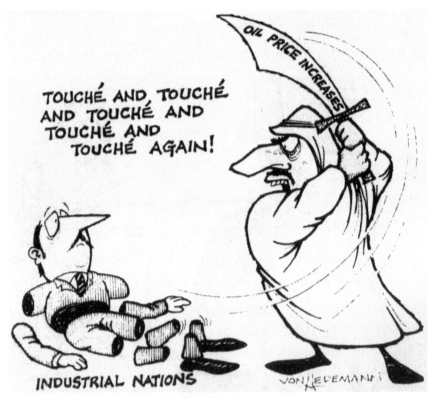

Figure 6.5. Neal von Hedemann, 1974. King Features Syndicate.

the scimitar as a symbol of Muslim Arab martial difference and weapon sophistication that distinguished them from Crusaders. Here, in a modern context, it instead suggests Arab backwardness. The presence of a scimitar to depict a situation that involved no actual violence against industrial nations offers a historical foreshadowing of its prominence in depictions of later, armed confrontations between the United States and Arab or Muslim states or organizations, as noted in chapter 3.

The overall tenor of many of the cartoons from this period emphasizes an Arab will to power. Another cartoon by Bill Mauldin, published at the height of the embargo in December 1973, makes no overt reference to the oil crisis. With its image of a contentedly smiling Arab playing with a globe at the end of a string, it makes no effort to convince its audience of a fact that it assumes its audience will already know: the embargo derives from Arab avarice. The cartoonist suggests that the Arab-Israeli conflict, the oil embargo, and global manipulation are all of a piece.

If these editorial cartoons played to the stereotype of Arabs being medieval and aggressive in contrast with Americans and Europeans as modern and sensible, other cartoons would emphasize Arab extremism. Two cartoons by Pat Oliphant depict the sensuality and gluttony often associated with Muslim male hedonism.

Figure 6.6 lays bare in a surprisingly obvious way the historical roots of these stereotypes. Oliphant's composition appears to owe its framing, perspective, and scale entirely to a nineteenth-century Orientalist painting by Jean-Léon Gérome entitled *Le Charmeur des serpentes* (The Snake Charmer).[13] Instead of the painting's depiction of a turbaned group of Arab warriors reclining against walls decorated with Islamic calligraphy and enjoying the view of a naked boy enwrapped by a phallic python, the cartoon portrays kaffiyeh-wearing Arabs reclining against a wall of oil barrels and intoxicated by their indulgent pastime, as though the Arab producers and not the American customers were the oversatiated consumers of oil. Although the homoeroticism and pedophilia of the original image have not been rendered, the portrayal of a leisurely, indulgent, and sensuous male existence remains. Note how the speaker initiates the Venezuelan—Venezuela being the major non-Arab OPEC state—into the stupefying Arab ways of appreciating life.

If the cartoons of the oil embargo period rely on the extremes of either rage or indulgence to stereotype Arabs, they predictably do so by portraying

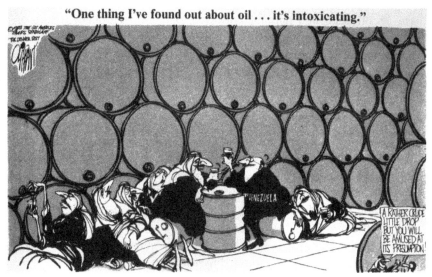

Figure 6.6. Pat Oliphant, 1973. Oliphant © 1973 Universal Press Syndicate. Reprinted with permission. All rights reserved.

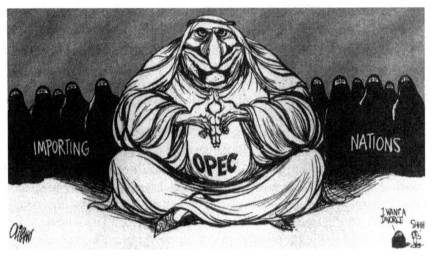

Figure 6.7. Pat Oliphant, 1973. Oliphant © 1973 Universal Press Syndicate. Reprinted with permission. All rights reserved.

them only as male. As previously discussed, these extremes inherently assume an oppressed or victimized female. The harem—that obsessive feature of so much Western attention from the medieval period through to the modern—commonly symbolizes this other extreme. Oliphant demonstrates this with his rapacious male personification of OPEC dominating his "harem" of oil-importing nations, portrayed as repressed women (figure 6.7). This gendered personification presents a commentary on both the political situation and the situation of women in societies in which harem culture is supposedly—though, in fact, not—characteristic.

A final example demonstrates how, from the 1970s onward, a presumed Muslim character increasingly would become central to the depiction of Arabs. Replicating one of the postures in Muslim formal prayer, the kneeling position of this caricature (figure 6.8) of Saudi Arabia's King Faisal, combined with his altered nose, implies that his religious supplication is indistinguishable from his financial covetousness. Meanwhile, the stereotyped distinctiveness of his nose, so clearly familiar from the anti-Semitism of the first half of the century, has been obscenely transformed into a symbol of not only Arab otherness but Arab greed as well.

The cartoons of the 1973 OPEC oil crisis consistently employ certain symbols and stereotyped features. Physically, Arabs are portrayed as men with large misshapen noses, facial hair, furry eyebrows, and generally vile and sly countenances. They strictly wear matching kaffiyehs. They are greedy, conniving, scheming, and violent, and they control the future of the United

Figure 6.8. David Levine, 1974. © Matthew and Eve Levine.

States, as well as the few female figures cartoonists include. As Melani McAlister points out, "This was the beginning of what would soon become a staple of American pop cultural images: the greedy oil sheiks, with their hands on America's collective throat."[14] In many instances, the caricatures appear to have drawn unconsciously on anti-Semitic stereotypes that were used—and occasionally still are used—to communicate similar qualities about Jews: physical features negatively signifying behaviors and values. Although there are only some overt allusions to Islamic traditions in this period, the references to violence, oppressiveness, and a certain indulgent lifestyle certainly draw on latent associations between Arab and Muslim, associations that American responses to events in the near future would recall and reinforce.

Iranian Revolution and Hostage Crisis: 1979–1980

As described briefly in chapter 3, the Iranian Revolution of 1979, as well as the depth of anti-American feeling that accompanied it, came as a shock to many Americans.[15] Although a broad spectrum of Iranian political interests— from the leftist Fedayeen to the rightist mullahs—and common citizens rose

up against the US-backed government of Mohammed Reza Shah Pahlavi, it was ultimately Ayatollah Ruhollah Khomeini, a Shii social reformer and government critic, who would become the political and religious leader of Iran. When the deposed shah was granted sanctuary by President Jimmy Carter in the United States, all sides supporting the Iranian Revolution were furious. The shah represented for many Iranians an oppressive regime first established by a coup. Engineered by British intelligence and the CIA, the 1953 conspiracy replaced the democratically elected prime minister with the shah's father. Incensed by yet another American intrusion into their domestic politics and in order to force the return of the shah, young Iranian revolutionaries took over the US embassy in Tehran, seizing more than seventy American hostages in the process.[16]

During the 444 days of the crisis, the hostages in Iran became a frustrating and humiliating symbol of America's inability to act. Nightly television reports on the situation brought the hostages and their individual stories into American homes. Accompanying these reports and updated daily, a count measured the number of days the crisis dragged on. American news media made the revolution an American event, portraying Khomeini as "obdurate, powerful, and deeply angry at the United States," and presenting the popular revolt as a defeat for the United States rather than as a complex political, economic, and religious movement.[17] In his survey of print journalism and rhetoric during the Iran hostage crisis, R. E. Dowling observed several descriptive categories consistently employed by the media to describe Khomeini: old and sick, mentally deficient, morally wanting, spiritually bankrupt, politically opportunist, and incompetent as a leader.[18]

The political cartoons of this period contributed to this impression. They presented Khomeini and the Islamic revolutionaries of Iran as crazy, backward, and violent, although they had just nonviolently overthrown one of the militarily best-equipped governments in the region. For the first time in twentieth-century America, Islamic traditions—as a set of religious phenomena—stood at the forefront of depictions of a political challenge by people who happen to be Muslim. Many Americans assumed Islamic ideologies to have been the motivating force behind all Iranian revolutionaries when, in fact, they were not. Whereas earlier in the century Middle Eastern antagonists had been Arabs who *happened* to be Muslim, those in this period were seen as antagonistic *because* they were Muslims and were Muslim in their entire character. This portrayal indicted not only Iranian Muslims but all Islamic traditions.

This contrasted significantly with cartoon depictions of Iranians and their leaders preceding the 1979 revolution. Typical of these is this Herbert Block ("Herblock") image published in the *Washington Post* in 1975 (figure 6.9).

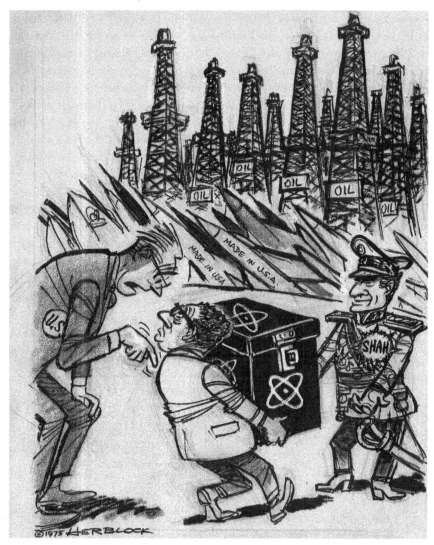

Figure 6.9. Herblock, 1975. A 1975 Herblock Cartoon © The Herb Block Foundation.

Expressing trepidation with regard to the Ford administration's continuation of the Nixon administration's plans to sell nuclear energy technology and advanced weaponry to the shah's government,[19] Block uses two caricatures— of the shah and of Secretary of State Henry Kissinger—and a stereotype of Americans, a white man. Neither the shah nor Iran (as depicted by its oil derricks and American weapons), let alone the Americans, evince any religious character or qualities.

Few editorial cartoons of the pre-Revolution era suggest a religious quality to Iranians. In one example, Art Bimrose composed an image for the *Oregonian* in 1953 depicting an angry man labeled "Iran" opening a pipeline marked "political intrigue" with another one called "oil settlement" remaining untouched. The cartoon's title, "Favorite Pipeline," suggests a preference for scheming on the part of the Iranian government and/or people while the character's garb of pillbox hat and *thobe*-like dress suggests his Muslim character. However, this appears more in keeping with the previously described tendency of some cartoonists to use Muslim stereotypes to depict people who happen to be Muslim, without seemingly intending to comment on Islamic traditions per se.[20]

In contrast, many contemporary cartoons of the immediate post-Revolution period depict Khomeini's Islam as the worst kind of religion. If the atheism of the Soviet Union represented one extreme on the spectrum of religion and politics, the overtly religious language and leadership of postrevolutionary Iran stand at the other extreme. Not only do cartoons of this period make farce of the religious tenor of Iranian political rhetoric but they also imply a primitiveness and violence to the religion itself. In the context of American social memory, the marriage of politics and religion appears a dangerous step backward toward the intolerant tyranny of medieval government. Whether portrayed as the master of a witches' coven (figure 6.10) or as inscrutable and

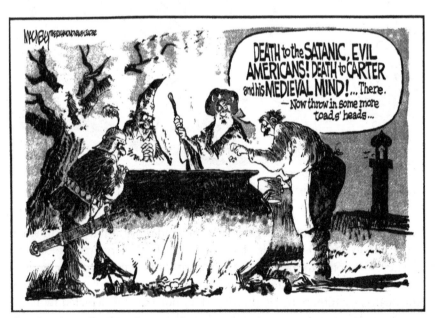

Figure 6.10. Jeff MacNelly, 1979. © 1979 MacNelly, Inc. Distributed by King Features Syndicate, Inc.

Figure 6.11. Mike Peters, 1979. © 1979 King Features Syndicate, Inc.

scimitar-wielding (figure 6.11), Khomeini appears as the nightmarish enemy of normative American secularism and a hazard to his own people.

Many Americans assume that all political systems should adhere to a single progressive track that mirrors the West's own history: from states legitimated by religion to the supposed secularism of the modern United States. This outlook immediately disapproves of the replacement of the shah's authoritarian regime—no matter how oppressive—by the ayatollah's theocratic democracy. Certainly, Khomeini's regime was repressive and rejected many Western and liberal institutions that existed under the shah. However, cartoonists in their representations totalized these rejections as a turning-back of the clock. Indeed, in 1979 cartoonist Hy Rosen published an image in the *Albany Times Union* that depicted Khomeini forcing back the hands of a clock that are poised between the seventeenth and twentieth centuries. Such images presume that when Islamic traditions play any public role, this must imply a total rejection of all that modernity offers. In other words, Islam fosters backwardness (figure 6.12) when allowed into the public sphere.

We also find the familiar pattern of the gendered image of the fanatical Muslim man countered with a portrayal of the oppressed Muslim woman. Despite the important role of Iranian women in the revolution, their place

Figure 6.12. Jeff MacNelly, 1979. © 1979 MacNelly, Inc. Distributed by King Features Syndicate, Inc.

in American editorial cartoons seems relegated to one of fashion and slavery. They seldom appear in any depictions of their nation's successful mass movement, despite the prominence of their participation. In figure 6.13, the burqa (uncommon in postrevolutionary Iran, where women more commonly wear chadors that cover their hair but show their faces) not only hides the woman from Tehran but also apparently makes her short, stooped, and deformed relative to the stick-limbed Westerners. Ironically, the fact that the artist portrays the Iranian woman's oppression by showing how she is unable to appear beautiful in relation to Western women reflects the very fixation on public demonstrations of female attractiveness that many Muslim women in a variety of cultures negatively associate with Western societies. Many—living in and out of the West—have sought to escape what they describe as sexual exploitation by voluntarily adopting various forms of more conservative dress.[21] This does not ameliorate the restrictions that forced many Iranian women into chadors against their will. It does, however, emphasize that Iranian women demonstrated more agency than that which is portrayed in political cartoons, which often reflect American expectations more than foreign realities.

It is, of course, important to recognize that some cartoonists could critique the stereotypes that seized so many in the United States during this period, even as the newscasters' tallies of the days of America's indignity steadily

Figure 6.13. Mike Keefe, 1979. Mike Keefe, InToon.com.

grew larger. Berkeley Breathed, for one, captured the unfortunate mixture of ignorance and anger that led to the harassment at this time of so many people—many not even Iranian—on the mistaken assumption that their appearance, accent, or religion identified them as Iranian (figure 6.14).

Cartoons of this period portray Khomeini and the Iranian Revolution as backward, violent, crazy, and irrational, in part because of their association with Islamic traditions. The cartoonists present "Islam" as a powerful, fearful influence and Khomeini as the evil symbol of that force. Significantly, the cartoons grappling with the Iranian Revolution do not rely on the

The Academia Waltz by Berkeley Breathed

Figure 6.14. Berkeley Breathed, 1979. © 1979 Berkeley Breathed. Distributed by the Washington Post Writers Group. Reprinted with permission.

physiological stereotypes contemporarily used to portray Arab men. Although Khomeini's beard and garb may have served in caricatures of him, cartoonists do not depict him or other Iranians with stereotypical Arab features. Moreover, while their work borrows certain Muslim-associated themes (e.g., violence) and symbols (e.g., the scimitar), the cartoonists do not use Arab-related symbols to depict Iranians, despite the fact that a 1980 poll showed that 70 percent of Americans thought that Iran was an Arab country.[22] (In general, Iranians do not view themselves as Arab, and their language is not a Semitic one, as is Arabic.) However, the differentiation of Muslims demonstrated in this period would frequently fail at the turn of the century, as artists too often collapsed Arab, Muslim, Islam, terrorist, and oppressor into one image.

9/11, Reprisal on Afghanistan, and the Invasion of Iraq

The entirely unanticipated horrors of the September 11, 2001, attacks succeeded in their goals of terrorizing many complacent Americans and rallying some disaffected Muslims. However, these criminal acts originally brought unprecedented global sympathy and support for the United States—from Muslims and non-Muslims alike. Although a small number of Muslims, among others, around the world cheered at America's supposed humbling, they remained a minuscule minority at the time.

Editorial cartoonists joined other Americans with forceful patriotic demonstrations. As outlined in chapter 3, these commonly relied on the dual depiction of a victimized America symbolized by a dazed and battered Ms. Liberty (figure 6.15) and a vengeful America in the person of an angry and resolute Uncle Sam.

Understandably, editorial cartoonists portrayed the hijackers responsible for the murder of thousands in the most sinister manner. However, the particular symbols and stereotypes they employed suggest much more than the diabolical character of these individuals, reaching into stock portrayals of Muslims and Islamic traditions.

Although the widely published photographs of the terrorists showed the world almost uniformly clean-cut men in "Western" apparel, many cartoonists relied on a standard stereotype of a militant Muslim for their caricatures. For example, in figure 6.16, besides the bandolier and time bomb suggesting this hijacker's cartoonlike belligerence, his head wrap and scraggly beard immediately distance him from the American audience as a Muslim man identifiable through stereotypes. Indeed, despite the published and broadcast condemnations of these unjustifiable crimes by Muslim leaders around

Figure 6.15. Glenn McCoy, 2001. Glenn McCoy © 2001 *Belleville News-Democrat*. Reprinted with permission of Universal Press Syndicate. All rights reserved.

Figure 6.16. Glenn McCoy, 2001. Glenn McCoy © 2001 *Belleville News-Democrat*. Reprinted with permission of Universal Press Syndicate. All rights reserved.

the globe,[23] American news outlets often focused on Muslim celebrations of the attack—a pattern Donald Trump repeated during his 2015–2016 presidential campaign, with his false allegations of Muslim Americans cheering in Jersey City.

Unsurprisingly, many cartoonists correlate hijackers and masterminds like Osama bin Laden with hellishness (figure 6.17). However, the deep persistence of this motif, coupled with other stereotypes about Muslims, suggests that they more than accidentally echo medieval formulations that Islam is inherently evil, as described in chapter 4.

Many cartoonists express the notion of a monolithic "Islam" as flawed, prone to violence, and essentially oppressive. Following the attacks, the United States swiftly roused from its shock. First, it took to dismantling the Taliban leadership in Afghanistan that had sheltered bin Laden and his al Qaeda camps. Then, in 2003, it led an assembly of nations to invade Iraq on the incorrect premises that Saddam Hussein's oppressive and brutal regime stood in league with al Qaeda and developed weapons of mass destruction. Throughout these foreign engagements and in response to other world events, a great many editorial cartoons emphasized the retarded, repressive, and renegade nature of Islamic traditions. Apparently caught in the rush to judgment following the 9/11 assault, in October 2001 artist Tony Auth pic-

Figure 6.17. Pat Oliphant, 2001. Oliphant © 2001 Universal Press Syndicate. Reprinted with permission. All rights reserved.

Figure 6.18. Tony Auth, 2001. © Tony Auth.

tured al Qaeda springing from the roots of Iran and Iraq (figure 6.18). Despite the historical conflict between these nations and the complete disinterest both governments expressed toward al Qaeda, the easily appreciable identification of them as "Muslim" countries led by governments antagonistic to the United States seemed to prove the case of complicity. When President George W. Bush in 2002 defined Iran and Iraq as an "axis of evil" along with North Korea, many in his American audience understood the same implied relationship. The reference to them as an axis intended to allude to the ir-redeemable evil of the tripartite Axis of World War II—Germany, Italy, and Japan—despite the fact that there was no semblance among Iran, Iraq, and North Korea of the type of cooperation that made the earlier alliance truly an axis. Nevertheless, the inference worked, and by 2003 more than a third of Americans polled by Gallup believed that Iraq had ties to al Qaeda before the war. Even more considered this likely, while admitting some uncertainty.[24]

The Axis powers of the 1940s could be—and were—defeated, democratized, and transformed into allies. However, the contemporary threat in Afghanistan, Iraq, and, potentially, every Muslim nation arises from what many Americans consider an irredeemable feature of those countries that prohibits constructive change: "Islam." The danger comes from an inherently extreme religious ideology presumed to be antagonistic to modern education, science, nationhood, and democracy, and characterized instead by backward-

ness, intolerance, extremism, and violence. This is what makes possible the notion that the War on Terror amounts to a "forever war" that will continually create its own enemies. Meanwhile, even at a time when local school boards around the United States debate the inclusion in public education of intelligent-design curricula based on Christian theology, as demonstrated in figure 4.14, education systems in Muslim-predominant nations become suspect and excoriated when Islamic learning is included.

The cartoon by Ben Sargent (figure 6.19) assembles a familiar set of symbols used by cartoonists to personify terrorism as a primitive, rag-headed Muslim wielding his scimitar. Post-9/11 portrayals of the hijackers as technological naïfs pummeling the modern world with their medieval weapons stand in stark contrast with the nightmarish images—burned into the individual and collective memories of all Americans—of Muslim terrorists piloting advanced airliners with devastating precision into iconic buildings. Cartoonists similarly depicted the Taliban even as they combatted other Afghans—the Northern Alliance—using tanks and helicopters. Only the fixity of Islamic backwardness in the popular imagination can possibly account for the coexistence of these images in the media.

A cartoon from the first Gulf War demonstrates that this ingrained notion of Muslim backwardness did not diminish following the Iranian Revolution.

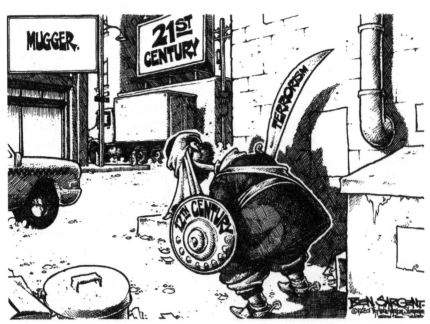

Figure 6.19. Ben Sargent, 2001. Sargent © 2001 *Austin American-Statesman*. Reprinted with permission of Universal Press Syndicate. All rights reserved.

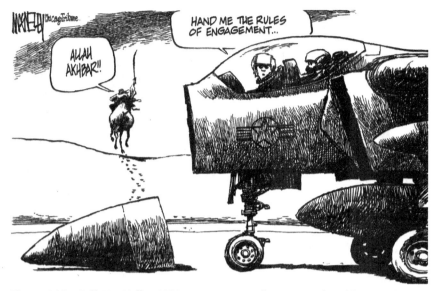

Figure 6.20. Jeff MacNelly, 1990. © 1990 MacNelly, Inc. Distributed by King Features Syndicate, Inc.

Despite the fact that the Iraqi military at that time fielded a considerable force of modern armored vehicles and combat aircraft and that Hussein's Baathist government could hardly be described as Islamic, the cartoonist visually depicts the enemy as a primitive horse rider and verbally demonstrates his Islamic character (figure 6.20). The raised scimitar underlines the connection between the two qualities.

The perception of the questionable character of Islamic traditions also coincides with Western fixations on specific gender issues. So, for instance, a focus in the media on the seventy-two virgins supposedly promised to male Islamic martyrs met American expectations regarding the hedonism of Muslim men. Focus on this religiously promoted sexual bonanza impeached the religion that promoted it and the martyrs ostensibly driven by it while simultaneously distracting American attention from the complaints against the United States that martyrs declared to have most motivated their self-destructive choice (figure 6.21).

According to such portrayals, the exaggerated masculinity of Muslim men lends itself to an irrational violence not only among those defying US policy aims but even among America's Muslim allies. A Jeff Danziger cartoon from 2001 portrays a wide-eyed Uncle Sam using leashes in an attempt to restrain two manic members of the Northern Alliance. While Uncle Sam unconvincingly assures someone on his cell phone that he's in charge, one of the Pashtun-dressed men yells, "ON TO PAKISTAN!!" and the other, "KILL! KILL!"

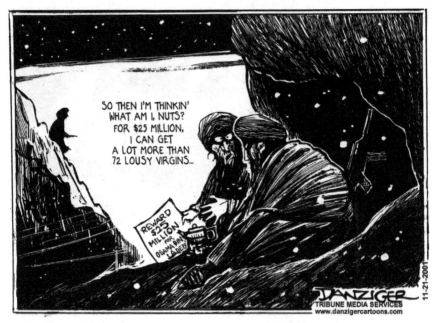

Figure 6.21. Jeff Danziger, 2001. Jeff Danziger, New York Times Syndicate.

It is interesting to note that such representations most often appear in the context of the failing War on Terror, mocking the hypermasculinity of the apparently unending supply of Muslim warriors/terrorists/separatists (figure 6.22). However, in situations of American victory, the defeated Muslim males slide to the other extreme as their masculinity gives way to feminization (figure 6.23).

Meanwhile, the allegations of Arab and Muslim double-dealing and faithlessness remained unmitigated throughout this period in relation to "moderate" Arab states. Egypt (personified by President Hosni Mubarak), Saudi Arabia, and Turkey had for decades served as the closest Middle Eastern allies to the United States outside of Israel, but when their governments refused to support American plans to invade Iraq, cartoonists portrayed them as traitors (figure 6.24). Although Germany and France also failed to live up to the expectations of the Bush administration, cartoonists seldom depicted them as vociferously as they depicted these predominantly Muslim countries (figure 6.25). In a 2003 cartoon, Bill DeOre drew a deviously smiling Lucy pulling away the football from the hapless Charlie Brown to depict Turkey's decision not to support the US-led invasion of Iraq.

All of this is not to ignore the critical engagements of political cartoonists with American foreign policy and cultural and religious stereotypes. Some,

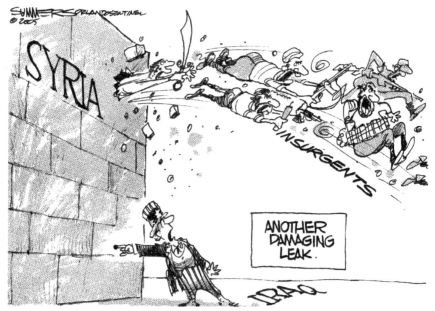

Figure 6.22. Dana Summers, 2005.

Figure 6.23. Bill DeOre, 2001.

Figure 6.24. Tony Auth, 2001. © Tony Auth.

Figure 6.25. Pat Oliphant, 2003. Oliphant © 2003 Universal Press Syndicate. Reprinted with permission. All rights reserved.

Figure 6.26. Garry Trudeau, 2002. Doonesbury © 2002 G. B. Trudeau. Reprinted with permission of Universal Press Syndicate. All rights reserved.

like Garry Trudeau's *Doonesbury* strip, seek to satirize sensationalized media portrayals of Muslims and Islam (figure 6.26). Trudeau especially succeeds when he uses his stock group of familiar characters to interface with individuals whose mundane concerns (such as saving treats for one's younger brother) intersect with current events. *Doonesbury* aims at more than irony in such depictions, intending instead to demonstrate that despite their differences, members of demonized groups share a basic humanity with the reader.

Meanwhile, singular examples of editorial cartoons have challenged stated American policy interests and motivations while simultaneously transcending Arab and Muslim stereotypes in their portrayals of Iraqis and Afghans. These have prompted their American audience to perceive these people as not reducible to an ethnic or religious identity and as having suffered due to American aggression. In one image, Ben Sargent comments on the unrecoverable loss suffered by Iraqis with the looting of Baghdad's Iraq Museum when American troops destroyed government control in the city, rushed to protect the oil ministry, but left unprotected such civic institutions (figure 6.27). More poignantly, Jeff Danziger in May 2003 portrayed a group of al Qaeda members huddled in deliberation under the artist's heading "Report Says 1700 Civilians Killed in US Attack on Baghdad." One of the group declares, "So then, if each one has a father or a brother we should have plenty of suicide volunteers for a while."

Yet other cartoonists have seen beyond American secular norms and recognized the ways in which particular government programs—like the faith-based (read: Christian) initiatives that have long served to distribute US foreign aid—have a decidedly religious bent (figure 6.28). In so doing, they help Americans appreciate concerns many Muslims have regarding the confluence of American policy and missionary interests. Many Middle Easterners, North Africans, and South Asians (among others) remember

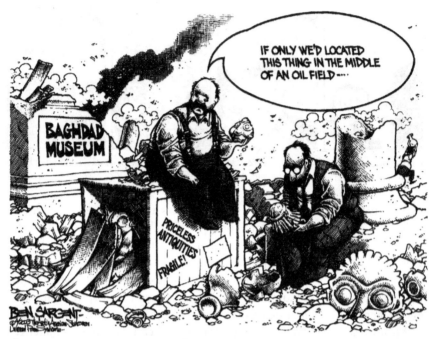

Figure 6.27. Ben Sargent, 2003. Sargent © 2003 *Austin American-Statesman*. Reprinted with permission of Universal Press Syndicate. All rights reserved.

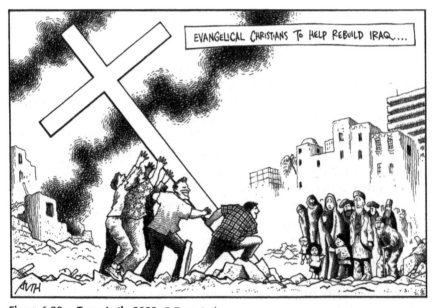

Figure 6.28. Tony Auth, 2003. © Tony Auth.

how the European imperialism of the last two centuries condoned, and often promoted, Christian proselytizing.

Unfortunately, such examples remained in the minority in the first decade of the twenty-first century, while many more depictions relied on an understood homogeneity among Muslims. This may be expressed with a visual lack of differentiation or with a resignation to the inscrutability of Muslims and their cultures (figure 6.29).

Such inscrutability makes understanding impossible. When understanding fails, so does communication and, with it, the chance to find common cause and a shared humanity.

Fortunately, as the next chapter will illustrate, increasing numbers of artists have committed themselves to crafting increasingly discrete and decreasingly stereotyped cartoons dealing with Muslims and Islamic traditions. Perhaps this trend has resulted from a greater awareness of the discrimination and violence visited upon Muslim Americans—if not of the impact on other Muslims—that stereotypes and misinformation enable.

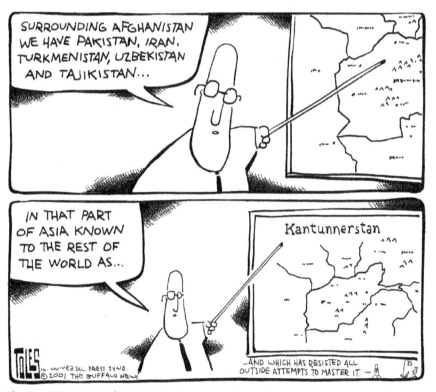

Figure 6.29. Tom Toles, 2001. Toles © 2001 *The Washington Post*. Reprinted with permission of Universal Press Syndicate. All rights reserved.

Perhaps it stems from the need of Americans to discover Muslim civilians in foreign combat zones to be worth the cost of their soldiers' lives. Or perhaps the change accrues from the efforts of activists, journalists, and scholars—Muslim and non-Muslim—to name Islamophobic and anti-Muslim sentiments as such, helping some Americans to recognize patterns of bias too long hiding in plain sight. Unfortunately, while these changes have informed many liberal cartoonists' art, conservative cartoonists have largely perpetuated negative stereotypes and attitudes, reflecting the state of the nation's political divide and culture wars, as we shall see next.

CHAPTER 7

—m—

Since 2006

The Emotions of Resurgent Nativism and Liberal Empathy

There is, however, historical evidence to suggest that the dissemination of emotions does not always require direct physical contact or proximity. As rumors spread, emotions may accompany them. Mass communications—films, newspapers, radio, and (particularly) television—can transmit people's emotions far beyond their geographical perimeters.

—Elaine Hatfield and Richard L. Rapson[1]

In March 2016, Republican presidential candidate Donald Trump spoke with Anderson Cooper on CNN.

COOPER: Do you think Islam is at war with the West?

TRUMP: I think Islam hates us. There's something, there's something there, that, that there's a tremendous hatred there. There's a tremendous hatred; we have to get to the bottom of it. There is an unbelievable hatred of *us*—

COOPER: In Islam itself?

TRUMP: Ahh, you're going to have to figure that out, ok? . . .

COOPER: I guess the question is, is there a war between the West and radical Islam or is there a war between the West and Islam itself?

TRUMP: Well, it's radical but it's very hard to define. It's very hard to separate because you don't know who is who. Look, these two young people that got married, she supposedly radicalized him. Who knows what happened—

COOPER: The San Bernardino terrorists.

TRUMP: The bottom line is, they killed fourteen people. They gave them baby showers. I mean, they were friends of theirs, so they walked in and they killed them. . . . There's a sickness going on that's unbelievable. . . . And honestly, you have to get to the bottom of it.[2]

Candidate Trump answered his interviewer's question regarding war by referencing an emotion: hatred. His reply implied that—as opposed to America's wars that have been justified by defense of citizens, territory, ideology, and/or economic interests—this war proceeds purely from the malevolence of a self-declared enemy. Also in contrast with previous conflicts, this one pits the United States not against another nation but against an entire religion: "I think Islam hates us." This emotion has no rationale or cause, apparently, other than "a sickness."

Because this illness is endemic to "Islam," all Muslims must be suspect "because you don't know who is who" and one cannot tell who will catch the contagion. Therefore, "radical Islam" is indistinguishable from "Islam." Illustratively, Trump referenced Tashfeen Malik and Syed Rizwan Farook, who were responsible for the murder of the latter's coworkers, seemingly suggesting that any Muslim American is capable of their crime and, thus, providing a justification for his campaign promise to forbid Muslim immigration to the United States. Five months earlier, Trump identified another emotion with regard to Arabs. Despite a demonstrated lack of evidence, he repeated his earlier claim: "There were people that were cheering on the other side of New Jersey, where you have large Arab populations. They were cheering as the World Trade Center came down."[3] Expressing the ill-informed yet common conflation of Muslim and Arab identity by many Americans, as described in chapter 3, Trump portrayed Muslims/Arabs as hating Americans and happy about the carnage of the September 11 attacks. In doing so, he also distinguished Arabs from Americans, eschewing the possibility of Arab Americans.

So far, this book has focused mainly on how editorial cartoons express what many non-Muslim Americans *think* about Muslims and Islamic traditions and less on what they *feel* about them. But our everyday experiences make clear enough that how we feel about people or things shapes our thinking about them and our responses to them. Hence, non-Muslim American views of Muslim Americans and Muslims abroad cannot be properly understood without exploring their emotional associations, and cartoons often endeavor to express these, if not actively evoke them. Conversely, Muslims in the United States and elsewhere have their own emotional responses to cartoon representations and the controversies that have surrounded them.

Understanding this conjunction of ideas and feelings helps us appreciate how—despite national ideals of freedom, liberty, and inclusion—many Americans resist not only *knowing* Muslims as Americans but *feeling* them to be so as well. These Islamophobic and anti-Muslim feelings find parallels with the paternalism many men feel toward women, the disdain many whites feel for blacks,[4] the suspicions many Gentiles harbor toward Jews, and the revulsion many Americans feel toward queer sex (and thus toward gays and lesbians). Our ability to identify these feelings as expressions of sexism, racism, anti-Semitism, and homophobia allows us to connect these and other emotions with a constellation of ideas latently evident among many Americans and actively promoted by others. Some commentators have attempted to dismiss such isms and phobias as criticism-curtailing shibboleths of the politically correct that interfere in the national endeavor of identifying and protecting against enemies. Other commentators have embraced these terms and the phenomena they describe as essential to the effort of making the United States a more inclusive nation, viewing the terms as an essential challenge to the stereotypes and attitudes that these notions identify and critique.

Since 2006, American political cartoonists have diverged noticeably, as those evincing more socially and politically liberal stances increasingly have eschewed Islamophobic and anti-Muslim sentiments, emphasizing empathy and a pluralistic model of the nation. More conservative-leaning artists also use word and image—equally expressing ideas and emotions—but more in keeping with earlier patterns linking stereotyped images of Muslims with fear, disgust, and anger toward them and their religious traditions. Many of these commentators share President Trump's anxiety that a pluralism embracing Muslims and Islamic traditions naïvely facilitates an alien threat to the nation and its native-born population.

A Note about Emotion

This chapter considers an individual's emotions as resulting, in significant ways, from her or his specific sociocultural contexts. In ways outlined by Catherine A. Lutz and Lila Abu-Lughod, emotion both is shaped by and shapes public discourse and physical interaction. Emotions communicate affective content or effects and are themselves communicated, in part, by language, which results from specific social conditions. As a discursive practice, therefore, emotions are observable. As these two anthropologists argue, "The study of emotion as discourse allows us to explore how speech provides the means by which local views of emotion have their effects and take their

significance." Hence, they say, "We must understand emotional discourses as pragmatic acts and communicative performances."[5]

In short, then, emotions are here examined as "embodied discourses." As such, they can be used by speakers, performers, or—as in the case of editorial cartoonists—artists to engage audiences, promote solidarity around issues, and identify threats to community. Emotion discourse can help create, reaffirm, or undermine social hierarchies and power dynamics. Positive emotions can be effectively communicated so they become associated with an individual or group and can help that individual or group seem more appealing to the larger community. Negative emotions may erode sympathy or even generate antipathy for someone. Meanwhile, discourse *about* emotion (especially when in regard to a specific group) can be used to critique those viewed as harboring dangerous emotions or lacking adequate emotional response. This hints at how society regulates emotion and creates expectations for appropriate contexts for the expression of specific emotions. A group that defies these expectations might be socially judged as too volatile for safe inclusion in larger society or, on the other hand, insufficiently involved with key social concerns.[6] The stereotype of the hypermasculine Muslim man qualified by his excessive anger reflects this dynamic (see, for instance, figures 4.9, 5.2, 6.5, and 7.8).

The Emerging Divergence

During the first five years following the devastation of September 11, 2001, many Americans were preoccupied with the twin invasions of Afghanistan and Iraq, the pursuit of Osama bin Laden, the search for weapons of mass destruction (WMDs) in Saddam's arsenals, and a public reckoning of what a post-9/11 American security state involved in terms of airport screening, threats of personal liberties, and surveillance of Muslim communities. Dissatisfactions with the failure to find either bin Laden or WMDs, the resurgence of the Taliban, the collapse of Iraq into civil war with the attendant attraction of foreign fighters targeting coalition forces, and increasing complaints regarding police discrimination and racial profiling of Muslim Americans did not sufficiently dim the passion for restoring security confidence and national affirmation that helped President George W. Bush's reelection in 2004. However, revelations regarding detentions at Guantánamo Bay, Abu Ghraib, and various CIA-run "black sites" made "waterboarding" a household term and fostered increasing skepticism among many Americans. Nevertheless, al Qaeda bombings in Istanbul (2003), Madrid (2004), and Bali (2005) reinforced fears of a persistent terrorist threat.

The decade since 2006 can be characterized by a widening divide regarding attitudes toward Muslim Americans, foreign Muslims, and Islamic traditions. While one must be suspicious of oversimplistic characterizations of political party positions, the accelerating polarization of Democrat and Republican stances regarding a range of issues encompassed attitudes toward Muslims as well. The 2008 congressional and presidential elections proved particularly salient in marking this divide. Various congressional candidates from around the country campaigned by playing on Islamophobic themes, but the innuendo regarding Senator Barack Obama's candidacy proved most salient. Various instances demonstrated the bizarre lengths to which racist conflations of African/Arab/Muslim ran in attitudes toward the first black American to receive a major party's nomination. Prominent commentators made allegations that he had not been born in the United States, that he had been schooled in a madrasa, and that he hid his actual Muslim identity. When one audience member suggested to candidate John McCain that Obama was "an Arab," his reply indicated his understanding of the racist premise of the comment: "No, ma'am. He's a decent family man, citizen, that I just happen to have disagreements with on fundamental issues, and that's what this campaign is all about."[7] McCain's attempt to undermine this pervasive claim tripped over its very basis as an accusation: the presumption that Arabs are not decent.

Many Republican candidates continued the Islamophobic drumbeat in the 2010 campaign. In Florida, for instance, Tea Party candidate Allen West declared, "Islam is a totalitarian, theocratic, political ideology. It is not a religion." Republicans from North Carolina to Nevada campaigned on the proposal to build an Islamic center and prayer space in a building blocks away from Manhattan's Ground Zero. And Nevada GOP Senate candidate Sharron Angle took up the dull cudgel of "shariazation" when she erroneously fed into the widespread rumor that Dearborn, Michigan, and Frankfort, Texas, had come under sharia law.[8] In the next election cycle, various Republican primary contenders gave voice to anti-Muslim sentiments. During one event, the June 2011 Republican presidential debate in New Hampshire, Islamophobic concerns dominated the conversation at one point. Herman Cain suggested that Muslims required special scrutiny for jobs in government and then diverged into a disapproval of sharia in American courts, which received audience applause. In contrast, Mitt Romney, when pressed on whether or not he agreed with the need to scrutinize Muslims, implicitly condemned Cain's fearmongering when he replied, "I think we recognize that the people of all faiths are welcome in this country. Our nation was founded on a principle of religious tolerance."[9] Nevertheless, Cain reflected

the efficacy of a concerted campaign, mostly waged by one man, to portray a Muslim conspiracy of replacing constitutional law with sharia (for which no credible evidence exists).* According to the Southern Poverty Law Center, since 2010 state legislators have introduced 201 bills in 43 states that prohibit the use of sharia in courtrooms. Fourteen have been enacted, although some have been thrown out by the courts.[10]

Not coincidental to the timing of the 2012 election, Representative Peter King (R-Long Island) held congressional hearings in March 2011 on the radicalization of American Muslims (to which he called only two Muslim witnesses). Many criticized King for not focusing on radicalization in general, given the far higher levels of European American right-wing violence than any involving Muslims, and many Muslims worried that the hearings would only strengthen non-Muslim associations of "Muslim" and "Islam" with "radical." Given the abuses coming to light from intrusive and aggressive law enforcement observation—such as the New York City Police Department's Muslim surveillance program that engaged in suspicionless surveillance and religious profiling—Muslims felt increasingly fearful and under scrutiny in their homes, businesses, and places of worship. Meanwhile, Lower Manhattan was not the only site of contestation for mosque construction. Increasingly, nonlocal politicians inflamed local disputes about the siting, building, and traffic flow of mosques into far larger controversies.

Significantly, in the same month as King's hearings, Senator Dick Durbin (D-Illinois) initiated congressional hearings on violence against Muslims. Durbin's initiative represented an acknowledgment by growing numbers of Americans that Muslims suffered unwarranted levels of suspicion. Although the Federal Bureau of Investigation and many police departments publicly recognized the role of Muslim Americans in helping law enforcement prosecute some who were considering acts of violence, persistent distrust dogged them.

Crucially, the popularization of the term "Islamophobia" in the past decade helped coalesce attention to a phenomenon toward which Americans increasingly have become attentive. Muslim organizations like the civil rights advocate Council for American-Islamic Relations, the Islamic Society of North America, and the Muslim Students Association represent only

*Instances of Muslims using Islamic law codes in American courts occur in instances in which both sides in an arbitration or civil law case (such as distribution of a will) agree to this. Parallel instances have occurred when Christians have used "biblically based arbitration" and Jews have employed Halakhah in public courts. See Cynthia Brougher, "Application of Religious Law in U.S. Courts: Selected Legal Issues Legislative," Congressional Research Service, May 18, 2011; and Eugene Volokh, "Religious Law (Especially Islamic Law) in American Courts," Oklahoma Law Review 66, no. 3 (2014): 431–58.

some of the many Muslim American groups that have continued to fight misperceptions, maligning, and unconstitutional laws directed toward them. News media previously doubtful of anti-Muslim discrimination have proven more sensitive in their reporting; scholars, such as John Esposito, Mayanthi Fernando, and Moustafa Bayoumi, and pollsters, such as Dalia Mogahed, have brought public attention to their research. Many other academic and nonprofit researchers have made Islamophobia and anti-Muslim sentiment increasingly rich, overlapping fields of inquiry.

Two particularly significant works emerged from this productive whirl of investigative activity that helped connect the dots with regard to those most responsible for proliferating Islamophobic and anti-Muslim falsehoods, misinformation, and fearmongering. In August 2011, a team of researchers at the Center for American Progress (CAP) made available online their highly detailed report "Fear, Inc: The Roots of the Islamophobia Network in America." Of central importance, the CAP report outlined the mutually intertwined and enabling donors, misinformation experts, grassroots and religious organizations, media enablers, and political players who all willingly collaborate to erect and sustain the façade of imminent and present danger from Muslims. The next year, scholar Nathan Lean published *The Islamophobia Industry: How the Right Manufactures Fear of Muslims*, in which he details many other facets of the topic. He particularly explores the exacerbation of anger online, the use of broadcasting, the role of both the Christian right and the pro-Israel right, as well as the involvement of government. Other important, emergent publications included volumes by Lori Peek, Anny Bakalian, and Mehdi Bozorgmehr that described the impact of rising intolerance and suspicion on Muslim American individuals and communities. Still other scholarly contributions have also considered Islamophobia and anti-Muslim sentiment in Europe, India, and beyond.

Despite these exertions, antipathies have continued to climb. Each violent assault in the United States by those justifying their actions via an Islamic ideology has seemed echoed by attacks abroad, making for a desperate timeline: the Boston Marathon (2013), Paris (2015), San Bernardino (2016), Istanbul (2016), Nice (2016), and Manchester Arena (2017). Meanwhile, in a development that seemed scripted to make manifest all the worst allegations of the Islamophobia industry, the so-called Islamic State emerged in 2014. It declared a caliphate (a form of Islamic government not previously enacted for more than a century), initially expanding with considerable speed and exercising terrible crimes in order to garner media attention that helped advertise itself and attract new recruits—many of them Westerners. IS (a.k.a. ISIS, ISIL) offered professional Islamophobes

the perfect exemplar of "Islamic" depravities. The movement repelled most Muslims and helped further propel the Syrian refugee crisis as many fled away from IS-controlled territory.

President Trump's Islamophobia and anti-Muslim prejudice does not represent an aberration but a culmination of two turbulent decades in which the United States has had its military, economic, and political insecurities exasperated by the 9/11 attacks, the Great Recession beginning in 2008, and an enduring congressional gridlock. It is deeply entwined with a virulent nativism of a sort seen repeatedly in American history that views and feels immigrants as a threat, instead of a boon, to the nation. In order to under-stand the last decade, we need to consider a final dimension of Islamophobia and anti-Muslim sentiment that is inherent in those terms, yet too often not considered on its own terms: emotion.

Feeling for the Nation: The Universal and the Exceptional

As described in chapter 5, nationalism provides one of the salient forms of identity among humans nearly no matter where they live. Regardless of where they were raised, almost all people have at least one national identity, and many if not most are encouraged by their governments, schools, and communities to consider it their most important political affiliation. In the United States, the youngest schoolchildren learn to recite the Pledge of Al-legiance and the national anthem in addition to lessons on the central nar-ratives of their country that illustrate the qualities of its citizens. Narratives portraying Native Americans, Puritans, revolutionaries, rebels, unionists, civil rights marchers, and liberators of occupied countries help mold a self-perception of "American" in students' minds that is meant to valorize that identity with qualities such as free, patriotic, equal, courageous, and toler-ant. The study of biographies of George Washington, Susan B. Anthony, Rosa Parks, and Caesar Chavez invites students to identify with patriots and imagine themselves as perhaps someday also helping to fulfill national-ist ideals. Adult immigrants, too old to learn these stories and qualities in school, must master a curriculum that communicates them, in order to pass a citizenship test before their application for naturalization can be approved. Thus citizens-in-the-making become socialized through a cumulative set of narratives shared by—and formative of—the nation.

This formation of nationalist identity has an emotion dimension as well. The characters and events in these stories imbue them with emotional resonances. Parades on the Fourth of July and Memorial Day evoke pride around memories of the Revolution and other wars, with solemn remem-

brances of those who "gave their lives for their nation." Citizens are meant not only to understand the political differences between revolutionary patriots and the British government but also to feel differently about them as well. Pride in American GIs and abhorrence of Nazi enemies are presumed. But negative emotions are not reserved for foreign enemies alone, as domestic groups also face critical assessment for their conformity to "American values" that lead to emotional associations. Mainstream entertainment and news media narrations of certain stories recognize members of both the Ku Klux Klan and the Civil Rights Movement as Americans but invoke feelings of disgust for one and admiration for the other. The salience of this phenomenon is evident when US neo-Nazis and Confederacy proponents publicly demonstrate. Many Americans become perplexed as to how fellow citizens can affiliate with these mainstream exemplars of nationalist antipathy, given that current mainstream American narratives celebrate the defeat of Nazism and the Confederacy.

Ultimately, local and state governments join the federal government in efforts to invest the nation, its citizens, its symbols, its ideals, its history, and its landscape with positive emotions intended to foster attachment, while negative emotions help define its enemies, domestic tragedies, and competing ideologies. News and entertainment media commonly echo and amplify this imaginary with its associated ideas and emotions. During the Olympics, for example, particular athletes promoted by the media ascend to national adulation, often based both on their performance and their biographies' ability to manifest "American values" or the "American dream." While instances of international competition create one type of context that might heighten feelings, repeated psychological experiments in terror management theory demonstrate that heightened awareness of mortality promotes group solidarity and decreases attraction to those with different worldviews. In other words, explicit reminders of death help diminish associations with those perceived as an out-group, such as foreign nationals or domestic communities suspected of not sharing "national values" or outlooks.[11] In times of war, governments routinely remind citizens of the perils they face and the lives lost in combat, effectively galvanizing nations through fear and anxiety while potentially exposing those perceived as deviant to distance, distrust, and/or anger. Images—drawn or videographed, still or moving—have proven particularly effective to these ends at various times in American history.[12]

Overall, the creation of a nationalist identity—or set of nationalist identities—is a two-sided coin. It both requires *an inclusivity* that gathers diverse individuals together despite their differences and *an exclusivity* that distinguishes citizens from noncitizens. As anthropologist Talal Asad has

pointed out, nations often rely on some form of secularism that helps fashion a commonality among citizens by surmounting differences of gender, class, and religion.[13] In the case of many nations, this transcendence relies on ideals considered universal, such as freedom for all, equality under the law, and liberty of conscience. All citizens supposedly find common shelter under this inclusive canopy. During the 2016 presidential campaign, the Democratic Party deployed two first-generation Americans to espouse a more inclusive ideal at their national convention. Standing with his wife Ghazala, Khizr Khan—Muslim, first-generation American, father of an American serviceman killed in action—reflected the pride and hope that have often been attached to an American immigrant ideal (though perhaps most often imagined with regard to white immigrants) when he declared, "Like many immigrants, we came to this country empty-handed. We believed in American democracy; that with hard work and goodness of this country, we could share in and contribute to its blessings. We are blessed to raise our three sons in a nation where they were free to be themselves and follow their dreams."[14]

Meanwhile, as anthropologist Mayanthi Fernando has demonstrated so well with regard to French Muslims, this universalism of citizenship has a flip side: a particularism that defines the specific essential qualities of the citizen, thus distinguishing citizens of one nation from their counterparts in other nations. Declarations of American exceptionalism often rely implicitly on notions of *Americans'* exceptionalism. While ingenuity, industriousness, and indivisibility might be claims made about the supposedly unique character of Americans, nativists argue for a white, European, and "Judeo-Christian" ideal, as evident in Trump's presidential campaign. Since at least the early nineteenth century, nativist movements have relied upon various formulations of race, religion, and ethnicity to define the proper "native" citizen. Instances have included the anti-Catholic Know-Nothing movement of the mid-nineteenth century, the antagonism directed at Eastern European Jewish immigrants of the latter part of that century, and the anti-Catholicism and anti-Semitism of the revived Ku Klux Klan of the 1920s. Often born of a confluence of economic uncertainty, changing demographics, and political opportunism, nativist movements have repeatedly sought to exclude those they judge as new arrivals who do not fit racial, religious, or ethnic assumptions of American belonging.

For instance, although Roman Catholics have suffered marginalization at different times and in different places since the early days of European settlement of North America, nativist antagonism to them particularly followed the influx of Irish Catholics in the first half of the nineteenth century. Because the arrival of immigrants occurred at a time of economic upheaval

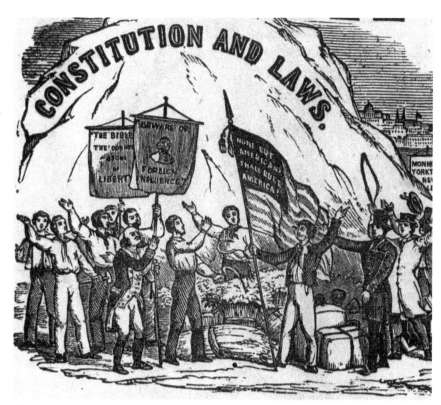

Figure 7.1. Nativists protesting. Detail from an advertisement for the Boston nativist newspaper *American Citizen,* **1852.** Courtesy of the Library of Congress, Prints & Photographs Division, LC-USZ62-96392.

as a demographic shift occurred from the East Coast to midwestern and western lands newly seized from Native Americans, nativist anger often flared. Despite the current self-promotion of Boston as deeply steeped in Irishness— including its Bruin and Celtic sports franchises—the city used to seethe with Protestant nativist antagonism toward Irish Catholics. The details from a pictured used in a Boston nativist newspaper ad from 1852 (figures 7.1 and 7.2) contrast the emotions of pride and celebration among "Americans" with those of anger and malevolence of the pope's alleged followers.

Similarly, the arrival of Eastern European Jews in the latter part of that century and their settlement in identifiable communities in various coastal cities was met by nativist fear married to new racial ideologies. A cover of the satirical magazine *Judge* merges the longstanding stereotype of Jews as avaricious moneylenders to a newly emerging racial stereotype of them as a separate race. The artist deliberately defies contemporary conventions of

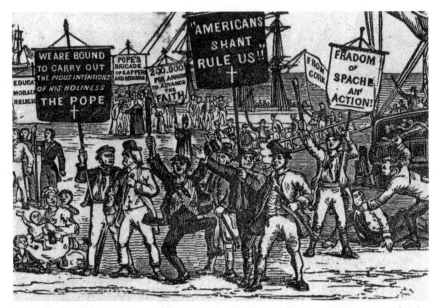

Figure 7.2. Irish Catholics as threats to America. Detail from an advertisement for the Boston nativist newspaper American Citizen, 1852. Courtesy of the Library of Congress, Prints & Photographs Division, LC-USZ62-96392.

beauty and activates a sense of disgust in his reader when portraying the heavy-lidded, swollen-nosed, and bent-backed Jew preparing to take advantage of the upright farmer (figure 7.3).

But nativists are not alone in promoting racial sentiments of belonging in the United States. As mentioned in chapter 4, Sherman Jackson helpfully directs our attention to how, historically among most Americans, there have been two sets of "racially authentic Americans": white people and black people. Although black Americans have too often suffered the indignities of prejudice and discrimination, their Americanness has seldom been challenged in comparison with other racialized groups. Some of these occasionally may be accorded an "honorary whiteness," but this has seldom been the case for people of Arab and South Asian ancestry, the two groups most associated with "Islam."[15] Historically, such formulations have served legal endeavors to obstruct entry of desirous immigrants, deny naturalization to would-be Americans, and challenge membership of suspect citizens. (Indeed, it was not until 1965 that the Immigration and Nationality Act removed race and ancestry as criteria for permission to immigrate and naturalize.) They also remind us to distinguish Islamophobia and anti-Muslim sentiment from one another as different, yet not distinct, attitudes.

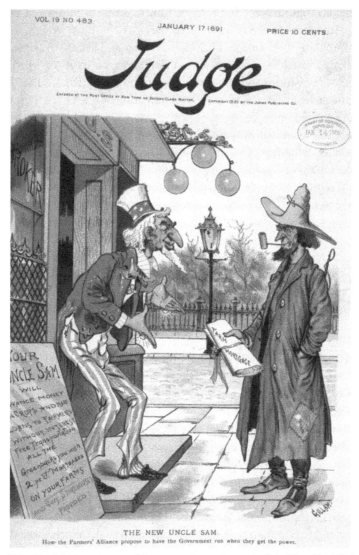

Figure 7.3. Racial stereotypes of Jews—such as those depicted in this 1891 satiric magazine cover—led the government to argue whether or not Jews were white, as many claimed. Courtesy of the Library of Congress, Prints & Photographs Division, LC-USZC4-5126.

These dynamics seem at work among the 29 percent of Americans who believed Barack Obama to be Muslim in 2015.[16] They likely identified him as such because of his Kenyan grandfather's religion and his dark complexion. Photoshopped images of former president Obama often portray him bowing to Arab leaders and/or wearing a turban, and they spread virally on

social media that attempt to promote him as either a Muslim or as under-mining American interests in favor of overseas Muslims. Presumably those who manipulate these images choose these themes because they view Arabs and turbans, just like foreignness and dark skin, as icons of Muslim-ness. Although anti-Muslim sentiment can easily be rooted in fear of Islam, it often reflects fear of immigrants as well as fear of people of color and certain racialized groups.

These definitions of American belonging create not only narrative, ra-cial, and ethnic images of who does and who does not deserve that label but also emotional conditions of empathy and antagonism. Ideas and emotions mutually reinforce one another's dynamics of promoting *associations among* citizens and engendering *difference toward* noncitizens and suspect citizens. This creates the possibility of emotional bonding across vast distances and interpersonal differences.

The immediate concerns of most of us—geographically limited to our neighborhood and relationally restricted to our friends and family—are sel-dom impacted in any tangible manner by most domestic, let alone foreign, events. So why do we care about what we see and read in news broadcasts? Empathy creates connections between us and others, even distant others. But we are not equally empathetic with everyone on the planet; we are em-pathetic primarily with those whose cultures and communities seem similar to ours or with those in seemingly similar situations as ours.[17] In other words, our sense of similarity (and dissimilarity) with others depends in no small part on socially constructed associations. And so, the experiences of those with whom we are socially conditioned to most closely associate help fashion the thrust and direction of our concerns: toward *these* people and away from *those*. Tellingly, the tragedy of the September 11 attacks more likely struck the emotional core of most Americans more intensely than knowledge of a ter-rible toll of violence on the Mexican border. This was likely so even for many Americans living in border states like Texas and California, geographically far closer to Mexico than to New York yet emotionally much more distant.

Therefore, the empathetic extension of those who identify as American has the potential to create a realm of concern that reaches beyond their physical vision and social realm. Emotions emerge as a result of events that appear to touch on their concerns, reaffirming and reinforcing empathetic connections to those others with whom they most emotionally associate. Generally, the more one feels empathy for another, the more likely that one's awareness of self and other intertwine, making possible an extended sense of a social self.[18] Events impacting this in-group most likely trigger one's antipa-thy toward any out-group contributing to an event that negatively impacts

one's expanded self's concerns, reinforcing the otherness of the out-group. Meanwhile, as terror management theory suggests, the more a group's survival seems threatened, the more bonded members are likely to feel toward those perceived as sharing common values and worldviews and the more distant they are likely to feel toward others. Through these processes, ideas and emotions perform a dance in which one reinforces the other while—with every event of concern—tightening the bonds of association with in-groups and deepening the chasm of difference with out-groups depending on levels of threat. How the nation, therefore, imagines and defines itself influences how its citizens understand the limitations of their empathies.

Of course, perceptions that others view them as a threat and resulting experiences of social marginalization help generate emotional responses among Muslims in the United States and elsewhere. The research of psychologist Patricia M. Rodriguez Mosquera has demonstrated this in multiple contexts. In one study, she demonstrated how the *Charlie Hebdo* cartoon controversy and subsequent non-Muslim responses in Britain generated responses of shame and anger among Muslims there. Perceptions of the Muslim community's devaluation by others in this context led to harm to their social image of themselves and, therefore, to their sense of self-value, thus prompting shame. On the other hand, the sense that this devaluation is wrong and defies expectations of respect sparks anger.[19] While this chapter focuses on how editorial cartoonists attempt to communicate and prompt emotions alongside their views, we need to remember that Muslims have their own emotional responses to images and controversies about them.

The fact that polling data has demonstrated that the stronger Westerners gauge their national identity, the more likely they are to consider Muslims violent and fanatical[20] suggests that these identities are configured in ways that diminish emotional ties non-Muslims might otherwise have with their Muslim neighbors, whom they may consider increasingly alien. Prejudice depends upon both stereotypes and context because it often relies on in-group members reacting to the presence of members of the target group in an unaccepted role. For instance, white Americans may accept black Americans as fellow citizens yet object to their presence as neighbors, or men may accept other men as their doctors but not as nurses.[21] A 2011 poll plumbed these sentiments when it asked respondents their comfort level regarding Muslim presence, among other concerns. It found nearly as many Americans uncomfortable with a Muslim teaching in an elementary school in their community as building a mosque near their home. The same poll demonstrated that 47 percent of respondents believed that "the values of Islam" were at odds with "American values and way of life."[22]

Cumulatively, these results suggest that much of the prejudice against Muslim Americans exists because many Americans consider Muslims "out of place" in the United States, a conclusion reinforced by the contemporary wave of nativism. Indeed, according to a 2016 poll, more than a third of respondents considered most or at least half of Muslim Americans to be anti-American.[23] The more Americans associate Muslims with danger, the more vulnerable and endangered they feel, which heightens their sense of threat toward every individual Muslim. Such concerns motivated Obama to avoid the term "Islamic terrorism," despite the criticism mounted by his opponents, so as not to alienate Muslim Americans or suggest that the US government equates the brutality of organizations such as the so-called Islamic State with "Islam." If these Americans seek emotional safety in the imagined community of the nation, they are likely to draw on the pride and strength of their self-conception as citizens and patriots, which many have sought to portray as not including Muslims by definition (despite the service and sacrifice of Muslim American military personnel). In contrast, portraying himself as willing to speak truth to "political correctness" while maneuvering for the best nativist appeal, Trump has repeatedly discussed "radical Islamic terrorism," while presidential candidate Hillary Clinton sought a middle ground by declaring her willingness to use the term yet avoiding doing so.[24] Significantly, those who value diversity and multiculturalism are less likely to manifest Islamophobic sentiments,[25] demonstrating the linkage between how Americans imagine their nation and how they feel about Muslims living there.

"Loyalty" serves as a particularly salient emotion for nationalism because it evokes sentiments of attachment to the corporate body of all citizens that comprise the nation, if not also to the state. It tends to be a jealous emotion, requiring not only fealty to one nation above all others but, in secular societies, to the nation above all religious or other commitments. A 2010 poll found that 93 percent of Muslim Americans believed their coreligionists in the United States to be loyal to the country.[26] However, a 2006 Gallup poll found only 49 percent of Americans believed Muslims in the United States were loyal. Perhaps unsurprisingly, 44 percent of respondents also replied that Muslims were too extreme in their religious beliefs, reinforcing the notion of Muslims not fitting the normative middle ground as described in chapter 5.[27]

These mismatched findings suggest that contemporary Islamophobic and anti-Muslim sentiments interfere with non-Muslims accepting Muslims as fellow Americans despite the legal and emotional facts of their citizenship. However, the statistics also suggest the potential for empathy because of

perceptions of Muslim Americans increasingly fitting a marginalized position in society that members of other groups share. Polling data from 2010 notes that Jews, Catholics, and atheists were more likely than Protestants to describe Muslims as loyal to the United States as well as to agree that most Americans are prejudiced against Muslims. Significantly, this same pattern held among respondents who agreed that they had experienced religious or racial discrimination in the past year. Probably without coincidence, Jews, Catholics, and atheists were also more likely than Protestants to describe Muslims as loyal to the United States.[28] As the notion of "Islamophobia"—not a commonly used term before 2008—has gained recognition among Americans, groups such as Jews, Catholics, and atheists may be drawing on their communities' own experiences with discrimination to find common ground as Americans. Figure 7.4, a 1909 cartoon by Thomas Nast, the seminal political cartoonist of his day, reflects the suspicion he and many Protestant Americans held that Mormons and "foreign" Catholics sought to overthrow American religious liberty.

Indeed, in one of the few polls that measured emotion, the Pew Research Center asked respondents how they rated various religious groups on a "feeling thermometer." Their 2017 results echoed the group sentiments already noted. Among Protestants, blacks demonstrated far warmer feelings toward Muslims than either white mainline or white evangelical members, suggesting

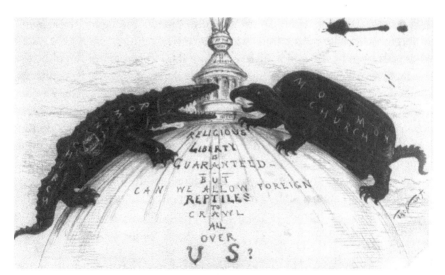

Figure 7.4. Nineteenth-century cartoonist Thomas Nast mastered the art of political commentary and emotional provocation, as evident in this undated image warning against supposed Catholic and Mormon assaults on secularism. Courtesy of the Library of Congress, Prints & Photographs Division, LC-USZ62-50658.

possible empathy with regard to discrimination. (However, this may also have to do with the fact that higher percentages of blacks report knowing a Muslim than do whites.)[29] Such mental and emotional impressions have proven instrumental in disrupting nativist campaigns in the past.[30]

Nativism succeeds only by creating both a cognition of immigrants as incapable of loyalty and assimilation and emotions of suspicion, anxiety, and/ or hatred. Once reaching a critical mass of awareness, each of these serves to stimulate the others in a heightening spiral of informed fear. Hence the significance of Trump's interview as a prelude to promote his campaign promise of prohibiting future Muslim immigration. His invocation of sharia and Muslim anger seeks to justify his evocation of fear and anger. Meanwhile, the more fearful and angry toward Muslims that non-Muslim Americans become, the more their sense of danger increases, which brings a concomitant focus on purportedly threatening Muslim individuals and movements and a heightened likelihood of seeing all Muslims as such. For instance, despite any evidence that meaningful numbers of American Muslims seek to bring sharia into the American court system, 31 percent of Republicans fear that Muslim Americans desire sharia law as the law of the land compared to 15 percent of Democrats, according to a 2011 Public Religion Research Institute (PRRI) poll.[31] As a result, "between 2010 and 2012, lawmakers in at least thirty-two states introduced bills to restrict the circumstances in which state courts can consider foreign or religious laws in their decisions."[32]

The same 2011 poll demonstrates the role of media in shaping these mental and mood-driven associations with Muslims. Adding nuance to the statistics generated by the poll is PRRI's finding that 45 percent of Republicans who most trust Fox News as their news source figure among the Republicans who believe Muslim Americans seek to establish sharia, while only 23 percent of other Republicans and 22 percent of the general public believe the idea. Similarly, 65 percent of Republicans who most trust Fox News do not think Muslim Americans have done enough to oppose extremism in their communities, while 45 percent of other Republicans and 47 percent of the general public agree that they have. This demonstrates that discriminatory views of Muslims are not simply a function of political affiliation. The PRRI data affirm the significance of perceived knowledge, given that 53 percent of Republicans who most trust Fox News consider themselves well informed about Islam while only 34 percent of other Republicans do.[33]

Overall, therefore, individuals' emotional disposition toward other individuals and groups is guided by their sense of how others touch on their concerns. These dynamics have the cumulative effect of creating a mutually reinforcing dynamic between the narrative and pictorial portrayal of

groups and the emotional associations others have toward them. Nations, like smaller-scale communities such as families and voluntary organizations, cohere through the mutual self-construal of identities founded on common concerns that, altogether, create empathy among members. When these communities sense a threat to their interests from others, they likely respond with feelings such as fear, threat, anger, and disgust, which influence their thoughts about those others. Polling data suggest that different political communities—influenced by specific media outlets and social networks—vary in their views toward Muslims and Islamic traditions based on differing assessments of them as threats to native-born Americans or as emblematic of American pluralism.

Opining, Evoking, and Invoking in Editorial Cartoons

News media not only transmit information but evoke emotions as well. News articles portraying starvation in drought-afflicted regions seldom rely on cold calculations of victims and refugees but usually offer descriptions and narratives intended to communicate pathos. Reporting on sports events such as the Olympics often celebrates certain athletes' accomplishments in ways that evoke surprise or admiration. Editorials comment on contemporary issues using praise or condemnation meant to communicate optimism or disapproval. Images included in print, digital, and broadcast news most especially are meant to arouse emotions from viewers.

Editorial cartoons, in their own way, merge all of these dynamics. While not intended to report on events, they may be the first alert a reader has to an issue. More particularly, they merge editorial with images in order to provoke a response from the reader. They are at their best when their insight matches their humor, creating poignancy from this synergy. The comicality might be derisive or jovial, droll or absurd, full of contempt or akin to gallows humor. In the space of a few centimeters each cartoon must describe the relevant situation, communicate the artist's opinion, and evoke a smile. As such, editorial cartoons serve as a useful vehicle to gauge the emotional dimension of different opinions, especially in the period since 2006 when twin yet divergent trends of rising nativism and greater empathy have prompted different emotions toward Muslims and Islamic traditions.

In this period, a notable variance has emerged between artists evincing conservative and liberal views, with the latter demonstrating far more neutrality or empathy for Muslims in contrast with the generally unaltered views of conservatives. Polling demonstrates that this reflects an overall shift in the American population as conservative and liberal attitudes since 2001 toward

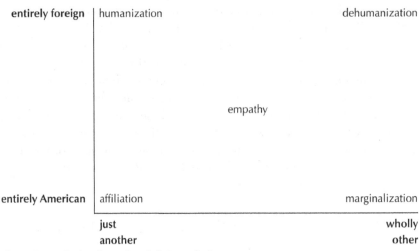

Figure 7.5. Scale of emotional dis/association.

Muslims and their religion sink and rise, respectively. Recent cartoons reflect a wide range of views toward Muslims and Islamic traditions among Americans, and the ways in which ideas and attitudes are intimately correlated and mutually cocreated.

Degrees of acceptance and antagonism regarding non-Muslim American attitudes toward Muslims and their religious traditions might be mapped using two axes (figure 7.5). One axis positions Muslims relative to the degree of their acceptance as Americans. Those who disagree that Muslims can ever assimilate assume them to be forever and entirely foreign. Meanwhile, the other axis indicates the degree of empathy allowed a Muslim, viewing her or him at one extreme as just another person, like oneself, and at the other extreme as wholly other.

When a non-Muslim American sees a Muslim as just another American, the non-Muslim American in some way associates with her or him. But when viewed as wholly other, the Muslim American often is perceived as the marginalized "immigrant," even if his or her family has been American for generations. Empathy can impart a humanity to an entirely foreign Muslim, making that person just another person, albeit not American. However, when considered both entirely foreign and wholly other, Muslims lose any recognizable humanity and the ability to earn empathy from non-Muslims. Our analysis will proceed through the declining degrees of disassociation and increasingly negative emotion, before returning to positive attitudes and increasing association.

Now broaching the matter of emotion, we are compelled to wonder about the emotional dimension of the historical ideas and stereotypes examined in previous chapters. The contemporary constellation of negative emotions and stereotypes has resulted from centuries of Islamophobic and anti-Muslim sentiment in the United States.[34] These longstanding feelings and ideas represent a fluid inheritance, loudly expressed at certain historical moments, silently latent in most others, somehow abiding even as they transmute according to the particular political and social circumstances of their material-ization. When Muslims appear to threaten American concerns, some avatar of these somnolent feelings and stereotypes reemerges, shaped in accordance with the context. In many ways, these parallel historical anti-Semitism and anti-Judaic attitudes in the United States that also date from the first Euro-pean settlers. But these feelings and views do not reappear unbidden; some political and other actors actively foment antagonism, as was the case with America's earlier nativist movements.

For instance, when Timothy McVeigh destroyed the federal office build-ing in Oklahoma City in 1995, news outlets did not immediately suspect right-wing or Christian militants, despite the fact that the perpetrator had ties to the criminal Christian Identity movement or that national law enforcement had recognized right-wing extremism as a significant threat. Instead, the FBI declared an all-points bulletin for three "Middle Eastern" men deemed suspects.[35] In the immediate aftermath, various reporters pub-licly implicated Middle Easterners, implying Muslim culpability.[36] Reflecting that such a skewed association between violence and religious identity can shape perceptions, the August 2011 PRRI poll found that only 13 percent of respondents believed that someone who claims to be Christian and commits an act of violence in the name of Christianity is truly Christian, while 44 percent believed that a Muslim in similar situations is truly Muslim.[37] These statistics suggest an "obviousness" implicit in the manner in which many Americans interpret violent events. In September 2016, then-President Obama motioned toward this dynamic as a reason for not using the term "Islamic terrorism" when he explained at a town hall meeting, "If you had an organization that was going around killing and blowing people up and said, 'We're on the vanguard of Christianity.' As a Christian, I'm not going to let them claim my religion and say, 'you're killing for Christ.' I would say, that's ridiculous. . . . That's not what my religion stands for. Call these folks what they are, which is killers and terrorists."[38]

Ultimately, when it senses danger, a society becomes vigilant toward the threat and those whom the society associates with it. Informed by discomforts,

fears, anxieties, and perhaps even hate, this vigilance demands the society's focus, drawing attention from other events and groups—such as the rise of right-wing violence in the United States—while potentially overestimating the danger from larger groups that the public associates with a few who have acted violently or threatened to do so.[39] In the case of the European Union since 2001, Christopher Allen and Jørgen S. Nielsen have found that the fears fostered by the September 11 assaults have engendered an all-encompassing ethnic xenophobia that has heightened preexisting prejudices.[40] Similarly, the Trump campaign successfully demonstrated how fears of crime, terrorism, job loss, and immigration could be harnessed to populist nativism, while the spike in hate crimes against Muslims, Latino/as, blacks, Jews, and immigrants in the wake of the November 2016 election[41] evidenced how broadly members of marginalized groups can be held responsible for focal events. These crimes proved particularly prevalent against Muslims, who collectively are perceived by many Americans as threatening their physical safety and their cultural values.[42] Yet, the United States General Accountability Office has determined that from late 2001 through 2016, 73 percent of homicides committed by American extremists were done by the predominantly European American members of the far right and only 27 percent by Muslim Americans.[43] Meanwhile, the tragic parade of school attacks and other mass shootings—from Littleton, Colorado, to Parkland, Florida—has sparked neither police surveillance of nor widespread alarm regarding the demographic of young white men who have largely been responsible.

In order for exaggerations of a singular group threat to work in regard to Muslims, Americans need to view them as indistinguishable. In figure 7.6, conservative cartoonist Dana Summers presents an assemblage of popularly perceived enemies of the United States. While Russia and North Korea are represented by caricatures of Vladimir Putin and Kim Jong-un—identifiable through the systematic exaggeration of their physical features—ISIS and Iran are not represented by their respective heads of state.

Instead, the artist has relied upon stereotypes of "the" Muslim man and woman. Reflecting a racial stereotype common in the United States for at least two centuries—and distinct from cartoon depictions of Iranians during the 1979 hostage crisis (see chapter 6)—the man sports ill-kempt facial hair and a large nose. He also wears a confused assortment of clothing representative of no particular style yet demonstrative of his foreignness. Meanwhile, the ISIS figure, while indeterminate in terms of gender, fits prevailing views of Muslim women forced to wear oppressive clothing, which was predominantly the case under the so-called caliphate. Notably, although none of these figures appears threatening, signaling instead their happy approval of

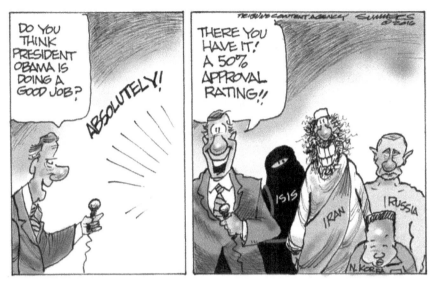

Figure 7.6. Dana Summers, 2016.

Obama, their context signals them as enemies. Hence the image reaffirms these physical stereotypes of all Muslims as emblematic of danger. Similarly, a 2016 image by Chip Bok (figure 7.7) depicts four Iranian gunboats gathering around a US naval vessel that is firing a pallet of money at them. Criticizing the Obama administration's release of frozen funds to the Iranian government in exchange for their agreement to limit nuclear weapons development, the cartoon identically depicts the four Iranians as scraggily bearded, turban-wearing, and aggressive. As he prepares to catch the cash, one Iranian cries, "Death to America!" Physiological stereotypes, therefore, often carry a sense of threat, even in political contexts without immediate danger. Threat activates heightened vigilance. Hostility due to a native hatred calls for particular concern.

Images of Muslims as inherently threatening to Americans intend to invoke fear. Glenn McCoy's 2016 cartoon (figure 7.8) opines that President Obama misjudged the threat to the nation when he called for more police oversight. The officer's uniform identifies him as such, while the Muslim's "Allahu Akbar" T-shirt, "Death to America" tattoo, and smoking automatic weapon complement the stereotypical hirsuteness, skullcap, sandals, and scowl.

While the cartoonist might have intended to portray only militant Muslims, the physiological stereotype implicates all Muslim men (at least) as

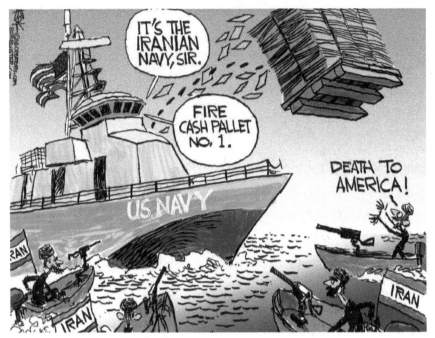

Figure 7.7. Chip Bok, 2016. © 2016 Chip Bok. By permission Chip Bok and Creators Syndicate.

Which one does the President continually warn us not to rush to judgement about?

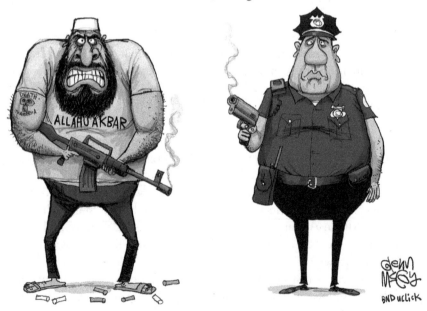

Figure 7.8. Glenn McCoy, 2016. Glenn McCoy © 2003 *Belleville News-Democrat*. Reprinted with permission of Universal Press Syndicate. All rights reserved.

potentially frightening. The hapless expression on the police officer's face, his undersized weapon, and the lack of multiple spent casings at his feet (as seen by the Muslim) do not evoke fear or even concern. Meanwhile, the artist also clearly links this anti-Muslim depiction with Islamophobia when he portrays the common Islamic exclamation "Allahu Akbar" ("God is great"). It is here implicated as a battle slogan—only one of many contexts in which Muslims say this to praise God. The fear of a single Muslim aggressor thus becomes a fear of Islam and, by implication, Muslims in general. Lisa Benson's December 2015 cartoon entitled "Ringing in the New Fear" (chapter 3, figure 3.1) makes this anxiety tangible and warranted, as a masked Muslim with an oversized scimitar chases a wide-eyed baby representing the new year.

Many conservative commentators endeavor to criticize Americans and their government for not demonstrating sufficient fear. Such is the case in the 2016 Chip Bok cartoon (chapter 3, figure 3.7) that mocks President Obama for not fearing widows and orphans in the manner that Republicans properly do. In the previous year, Glenn McCoy accused Obama's political correctness of blinding him to such warranted concerns. McCoy's image portrayed Obama as a psychologist who listens to his patient, Uncle Sam, describe a recurring dream about the Islamic State sneaking into the country and then Obama flatly declares him a racist. The image's subtext finds fault with Obama's immigration policy and its liberal proponents who alleged racism against the policy's critics.

Various liberal cartoonists have criticized this fearmongering. During the US Republican primary contest, Stuart Carlson depicted candidate Ted Cruz criticizing Obama for visiting Cuban leaders Fidel and Raúl Castro. Instead, the cartoon sardonically asserts, he should be doing what Cruz did after the terrorist attack on Brussels: exacerbating anti-Muslim hysteria for his political gain. Similarly, Jeff Danziger portrayed a couple in their gun store explaining that they are having a "scared out of your mind because you think the Islamers are coming sale" (chapter 4, figure 4.7). The characters' ignorance of the term "Muslim" communicates their superficiality, which does not interfere with their ability to profit from exaggerated fears. Such satires disparage the claims of a universal Muslim threat and parody the vigilance enacted by some.

It is possible that liberal commentators—who, after all, have a similar inheritance of emotions and national memories as their conservative counterparts—have resisted the negative emotions that occasions of threat might elicit. Research has demonstrated that individuals can consciously reevaluate a negative scene in ways that diminish the possibility of negative emotional responses.[44] This reminds us that individuals have the agency to resist social

expectations about how to feel in particular contexts toward specific groups. It helps explain how many liberal cartoonists have demonstrated that they are less likely to express negative sentiments about Muslims or their religious traditions than they did in their earlier work. We can only hypothesize that increased awareness about Islamophobia and anti-Muslim bias in the past decade has helped them to cognitively check their emotional responses to events that other Americans perceive as threatening.

On the spectrum of emotional dis/association, registering disgust may represent a step away from empathetic association and toward an unreasonable sense of threat. In an endeavor to undermine concerns regarding Trump's inappropriate attitudes toward and relationships with women, McCoy makes a pictorial argument of moral equivalence that Democratic presidential nominee Hillary Clinton is in at least as compromising a position (figure 7.9).

Whereas Trump was accused of misogyny for his recorded comments and of molestation for his unwanted advances, McCoy accuses Clinton of prostituting herself to Arabs. Beyond their stereotyped image of headgear, large

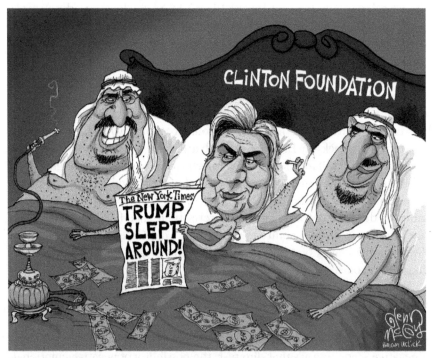

Figure 7.9. Glenn McCoy, 2016. Glenn McCoy © 2016 *Belleville News-Democrat*. Reprinted with permission of Universal Press Syndicate. All rights reserved.

hawk-like noses, and unkempt bodily and facial hair, as well as the hookah one of the men smokes, the Arabs' bodies appear deliberately meant to evoke disgust. The fat lips, leering looks, and sagging breasts contrast negatively with the bodies and comportment McCoy draws when imaging those with whom he sympathizes, while the charge of prostitution and group sex adds a moral repugnancy to both the men and Clinton.

Depictions of fearsome and disgusting humans exist on a spectrum of decreasing humanity comprising a series of steps in intensified othering: the monstrous, the animalistic, the nonanimal, and finally pure abstraction. For instance, in June 2016, McCoy depicted President Obama and his attorney general, Loretta Lynch, confronting a massive glowering man labeled "ISIS." Surrounded by romantic hearts demonstrating their affection for him, Obama and Lynch wish to lovingly embrace the grotesquely looming figure whose arm is tattooed "Death to America" and whose fingers drip blood. He is a creature of sheer malevolence. With an intense emotion of repulsion, the so-called Islamic State is portrayed as human yet monstrous and barbaric, while sharing the same brown complexion as Obama and Lynch. Taking a different tack toward depicting repulsion and uncertain humanity, after the November 2015 Paris attacks, Jeff Danziger drew an image labeled "Allahu AK." Hanging atop the Eiffel Tower, a blood-red-garmented man extends his arm to fire his AK-47 assault rifle. His face is nothing but a mass of black hair with the exception of two triangular shapes where the mouth should be, suggesting fangs. While the figure registers as human, the face—our most distinguishing feature—does not. The uncertainty of how to interpret it makes it loathsome and repellent.

As a demonstration of the reduction of an opponent to an animal, Benson's response to the Paris assault depicts a wolf standing outside a home captioned "The West" (figure 7.10). Sporting a bag labeled "radical Islam," the wolf looks malevolently at the three pigs inside, while one naïvely offers to let him in if he promises to behave. Although the dangerous manifestation of Islam and "the West" both are portrayed as animals, the pink-skinned, clothed (and bespectacled, in one case) pigs appear more human (if only for their use of language) than the ravenous, black-hued wolf bearing his teeth. In the images by Benson and McCoy just described, Westerners are portrayed as uninformed and harmfully optimistic about the possibility of embracing Muslims. In other words, their lack of knowledge puts them in harm's way of some Muslims. In each cartoon, the threatening Muslim glares hatefully, driven by no other apparent motive than pure hatred.

On a deeper level of disassociation, Muslims lose their humanity—even their animality—altogether. After the March 22, 2016, attack on Brussels,

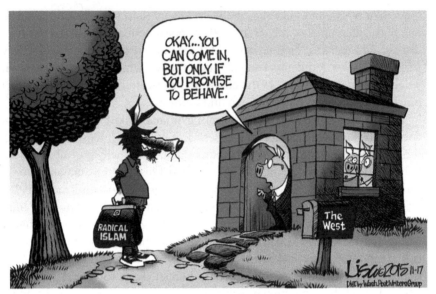

Figure 7.10. Lisa Benson, 2015. © 2015 Lisa Benson/*The Washington Post*.

cartoonist Nick Anderson conjectured on terrorism's spread from Belgium by portraying a series of thorn stalks sprouting out and curling across the planet. The murderers thereby are reduced to mindless plant life, that is, they are unrecognizable as human. The artist evokes emotions of fear of a malignant growth and derision for a weed-like infestation. This fits a more general dynamic found in many cultures in which, especially between combatants, the enemy's humanity is dismissed with depictions of them as germs, viruses, cancer, or even mere abstractions.[45]

However, some cartoonists editorialize about violent Muslims in a manner that evinces a parallel with other violent individuals, creating a negative moral and emotional equivalence between them. The liberal artist Signe Wilkinson uses this technique to criticize interpretations of the Second Amendment of the Constitution—meant to provide weapons for militias serving the state—that allow people to arm themselves in defense of principles not intended to protect the nation and likely to harm innocent Americans (figure 7.11).

The cartoon expresses the similarity between armed men of various unfortunate motivations used in the recent past to murder the blameless. Except for the ISIS member's beard, it does not distinguish between him and others. Even his skin tone matches that of the majority. Similarly, in a December 2015 image, Anderson crafts an equivalence between "radical Muslims" and

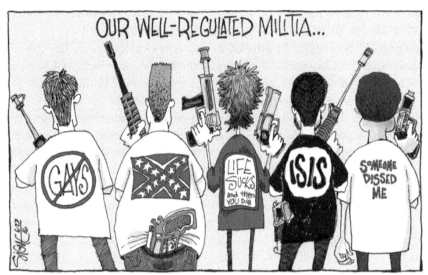

Figure 7.11. Signe Wilkinson, 2016. Signe Wilkinson Editorial Cartoon is used with the permission of Signe Wilkinson, the Washington Post Writers Group, and the Cartoonist Group. All rights reserved.

"radical anti-abortionists" using a figure representing each and labeled as such, who have fired their assault rifles to spell out "terrorism" on a blood-splattered wall. They share a teeth-gritting smile and maniacal gaze with each other in silent assent of the violence. They also share the same skin complexion and beards, although the Muslim wears a turban, which redundantly marks his religion (since he wears a shirt emblazoned with the term "radical Muslims"). Such cartoons invoke a similar distaste for the violence associated with of all these ideologies. However, one notes that although most violent anti-abortionist activists act out of a Christian ideology, Anderson prefers not to identify them by religion, as he has his radical Muslim. This returns us to Obama's awareness of this lack of equivalency (mentioned above). The caroonist distances a peaceful Christian norm from criminal acts done by those motivated by Christian principles, in contrast to the ready religious identification of all Muslim assailants described in chapter 4.

It is notable that the turn toward equivalence, sympathy, and empathy tends to be most evident among liberal cartoonists. This in part reflects the divergence in the past two decades of Democrats' attitudes from those of Republicans toward Muslims and Islamic traditions, as the polls discussed earlier have demonstrated. This trend has undoubtedly been exacerbated by the direct harnessing of Islamophobic sentiment to Republican campaigns since at least the 2008 campaign cycle, in which many Republican candidates made

the local issue of building an Islamic center in Lower Manhattan—among other Muslim-focused issues—a national referendum on collective Muslim guilt for the September 11 attacks. In the same election, many Republicans challenged the Christian self-identity of the first black presidential nominee for a major political party, arguing that he was a secret Muslim instead.

Emotions associated with citizenship include positive ones as well. One of these is empathy. As one observes the experiences of another, empathy creates various positive cognitive, emotional, and interpersonal outcomes. For instance, it improves the ability to estimate someone else's feelings, thoughts, and qualities. It also facilitates forgiveness, helping, and tolerance, while making intersubjective consensus building between self and other more likely.[46]

Meanwhile, as mentioned earlier, national identities are not only defined by particular formations of race, ethnicity, and religion but also by transcendent ideals in which the citizenry also invests emotions. Returning to the comments of Khizr Khan, we hear the enunciation of an American immigrant ideal that may or may not foster empathy or even sympathy on the part of other Americans, almost all of whom have an immigrant origin. For instance, even as she references her immigrant experience, author Asra Q. Nomani has used ideals of universal social justice and civil rights as reasons *not* to sympathize with those Muslims who very much live in fear in Trump's America. In a postelection opinion essay in the *Washington Post*, titled "I'm a Muslim, a Woman and an Immigrant. I Voted for Trump," the former journalist wrote, "I have absolutely no fears about being a Muslim in a 'Trump America.' The checks and balances in America and our rich history of social justice and civil rights will never allow the fear-mongering that has been attached to candidate Trump's rhetoric to come to fruition."[47] Hence, Nomani denies majoritarian oppression of Muslims, challenging any emotional connection non-Muslims might generate as a positive response to Muslim marginalization and victimization.

In contrast, a variety of editorial cartoons suggest not only non-Muslim association and sympathy for Muslims, but even empathy. For example, Mike Luckovich borrows the famous saying of Lutheran pastor Martin Niemöller, who confronted Nazi bigotry and was incarcerated in concentration camps for seven years. Luckovich's cartoon lampoons Americans for ignoring the persecution of minorities by showing Uncle Sam—his head in the ground— ignoring a nearby paper that reads "First they came for the Muslims, then Mexicans, then blacks, then Jews, then . . ." The cartoon simultaneously criticizes Americans for a lack of sympathy and makes a case for empathy.

In figure 7.12, it is the tiny, pink-hued refugees whose fear we see, while the towering figure of Texas—face darkened by anger at them—invites us to

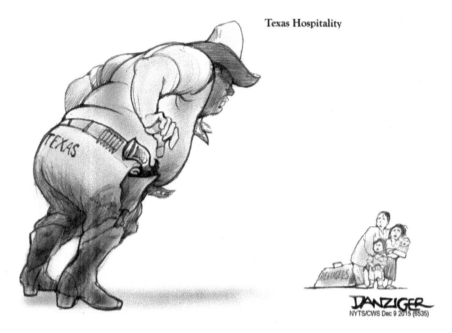

Texas Hospitality

Figure 7.12. Jeff Danziger, 2015. Jeff Danziger, New York Times Syndicate.

feel sympathy—if not empathy—for the refugees. Similarly, a Signe Wilkinson cartoon from January 2016 portrays a crowd of refugees, their faces awash with desperation as Uncle Sam looks for an answer all too evident to everyone else, including the reader. His back turned to these pale-skinned masses, Uncle Sam's lack of empathy obstructs his ability to reason properly as he wonders aloud, "Who can we find to counter the jihadist message?" He remains oblivious to the despairing refugees volunteering.

Overall, therefore, the period since 2006 has demonstrated how, until the feedback loop of mutually reinforcing sets of Islamophobic and anti-Muslim ideas and sentiments can be disrupted, American and non-American Muslims will struggle against misperceptions and malice. This loop relies on violence in the Middle East and the relatively few instances of Muslims perpetuating attacks in Europe and the United States to "know" all or most Muslims as potentially a threat to non-Muslim American "values." This false knowledge of imminent threat creates an experience of alienation and dehumanization among many Muslims that makes connections with non-Muslims more difficult, while also potentially prompting feelings of shame and anger, as discussed above. Meanwhile, a broad set of responses against Islamophobia and anti-Muslim bias have emphasized association, sympathy, and empathy.

CHAPTER 8

—ഡ—

Moving Pictures
The Trope of "Islamic Terrorism"

The video begins in a modern neighborhood, with a murderous assault on men and women by wielders of axes and swords wearing white skullcaps and *thobes*. As the police pointedly stand aloof, the rioters obey the admonishments of a man in a long beard to "burn out these forsaken Christians." As he writes on a whiteboard an equation to explain this violence, a Christian doctor says to his daughter, "Man plus 'x' equals Islamic terrorist. Islamic terrorist minus 'x' equals Man." His daughter queries, "But what is 'x'?" He replies solemnly, "You need to discover it for yourself." The remaining dozen minutes or so of this "theatrical trailer" clearly demonstrate that the director believes that the "x" factor can be summed up in a single name: Muhammad. In scene after scene, characters interact with a prophet who promotes lechery, greed, intolerance, extortion, pedophilia, cruelty, a fabricated Quran, and, most of all, violence against civilians.[1]

Wooden acting, stilted dialogue, clumsy editing, and cartoonish backgrounds proved no barrier to the trailer for a supposed film titled *Innocence of the Muslims*. The trailer gained a global audience and more media attention than most film distributors could ever hope for after it was uploaded to YouTube in 2012.[2] The fact that the video repeats a millennium worth of Christian excoriations against Muhammad, Muslims, and Islam did not prove an obstacle either. From Dante to Cotton Mather to Franklin Graham and Terry Jones, similar tropes of sexual, material, and violent excess have served European and American Christian efforts to discredit Muhammad and, thereby, the religion he promoted. Similar motifs helped spur tens of

thousands of European Christians to join the Crusades and Reconquista in the first half of the second millennium, justify the enslavement of Africans in the second half, and legitimize the imperial and colonial domination of peoples from Morocco to the Philippines until the middle of the twentieth century. They continue to motivate Christian missionaries to strive for the Holy Grail of proselytization: success in Muslim-majority lands (the coveted 10-40 window),* which have proven enduringly resistant to conversion. Although the expression of these derogatory themes has changed according to the specific cultural, political, and economic circumstances of their use, most found in the video attributed to "Sam Bacile" reflect enduring topics long familiar—even if at times only in the shadowy outline of an almost subconscious prejudice—to European and American audiences.

Despite its recapitulation of medieval views, the video employs at least one historically recent trope to frame its disparagements: "Islamic terrorism." While the motivations of the American resident but Egyptian-born Copt Sam Bacile remain obscure, it seems clear that he aimed at disseminating a video that would both provoke a response from Muslims and garner attention from Anglophone non-Muslims. Perhaps inspired by the outrage that followed the Danish publication of derogatory cartoons of Muhammad in 2005, the director crafted a "trailer" that did at length what one of the cartoons most despised by Muslims did in brief: characterize Muhammad as a terrorist. By using the phrase "Islamic terrorist" as the explanatory segue between depictions of a supposedly contemporary atrocity and its purportedly historical root, Bacile may have hoped it would have the same catalytic effect as the image of the prophet with a calligraphically inscribed bomb extending from his head. If so, subsequent events proved him successful. American audiences watched in practiced disdain as their news outlets offered scenes of Muslims in various countries rising to the bait and protesting with unbridled fury. Any complaint that news sources overlooked peaceful demonstrations, which outnumbered the violent ones, sounded hollow after an attack—later labeled "terrorist" by the dazed Obama administration—killed the ambassador and three consulate workers in Benghazi, Libya (later dramatized in the film *13 Hours*). Although the video release and consulate attack were later considered coincidental in timing, the filmic charge of Islamic terrorism appeared answered by actual terrorism, adding even faster spin to the news cycle and stronger affirmation for American Islamophobia and anti-Muslim sentiment.

*The "10-40 window" references the area of North Africa and Asia that lies between latitudes 10° north and 40° north that is Muslim-majority but also home to most of the world's Hindus and Buddhists.

The connection between terrorism and these biased images of Muslims is not coincidental. A 2011 CBS/*New York Times* poll found nearly a third of the American population considers Muslim Americans more sympathetic than other Americans toward terrorists,[3] despite the fact that 81 percent of Muslims responding to a Pew poll the same year replied that violence against civilians was never justified to protect Islam.[4] A 2011 Gallup poll found Muslim Americans far less willing to consider violence against civilians to ever be justified relative to their Jewish, Catholic, Protestant, and Mormon neighbors.[5] Nevertheless, in 2012 researchers found that 44 percent of Americans consider conflict between Western and Muslim "civilizations" inevitable due to basic differences.[6] Statistics also indicate the impact such negative sentiments have had on Muslims. The same Pew poll found that more than half of Muslim Americans surveyed felt their group was targeted by the government for surveillance, while 43 percent had experienced harassment in the past year. The latter had increased three points since 2007,[7] with a particularly high spike following the Trump election, as mentioned in the last chapter.

As many scholars have demonstrated, film has served to repeatedly reinscribe Islamophobic and anti-Muslim, as well as anti-Arab, themes that have held an enduring, if shifting, hold on European and American imaginations. However, the American advent of "terrorism" as a broad social concern has altered the ways in which Hollywood screenwriters and directors have portrayed Muslims and depicted Islamic traditions. While also mirroring the perennially embedded Islamophobia of American culture in general, Hollywood films since the 1920s have demonstrated how particular periods have given rise to specific manifestations, often in response to individual events. From the Orientalist fantasies of Rudolph Valentino's *Sheik* films and Sylvester Stallone's *Rambo III*, to portraits of women in *Not Without My Daughter* and *Sex and the City II*, to the postcolonial dramas of *From Russia with Love* and *Tears of the Sun*, to action-hero films such as *Iron Man* and *Black Panther*, the ways Muslims have figured in films often escape easy stereotype or critique.

The river of Islamophobia that has swelled in film since the 1990s has been fed by a variety of streams from the American imaginary—including sentiments regarding Arabs, Africans, and Mongols—which often has demonstrated the underlying current of Christian normativity discussed in previous chapters. Meanwhile, in the twenty-first century, endeavors to promote pluralist visions of Muslim-Jewish-Christian cooperation have tended to reflect a secularist vision that has crafted noble portrayals of individual Muslims but only under the condition that they not actually practice their religion on screen. In other words, American filmmakers' recent efforts to

create an inclusive image of Muslims to counter Islamophobia and anti-Muslim sentiment ironically have helped further instantiate it by depicting Muslims as "safe" only when shorn of religious practice. Ultimately, then, each generation of American filmgoers has an Islamophobic retinue of films to fit its historical context, and in recent decades the tropes of Islamic terrorism and misogynistic violence have become paramount within such films. For these reasons, we depart from our previous attention to the single frames of individual editorial cartoons to consider the globally influential portrayal of Muslims and Islamic traditions in Hollywood's movies.

Muslims, Islamic Traditions, and Terrorism

As any piece of writing on "terrorism" and "terrorists" must note up front, defining these terms proves challenging. Sidestepping a prolonged reflection on the matter, suffice it to say that two of the most challenging features of the words that confront the writers who would use them descriptively or analytically is that they are (1) pejorative terms and (2) utilized today only by outsiders.[8] By definition, therefore, "terrorism" and "terrorist" exist only in the negative realm of what-those-people-are-though-they-won't-admit-it-and-I-am-not. Of course, it is not uncommon to describe others using pejorative terms with which they are unlikely to self-identify (e.g., "cheat," "liar," "unattractive," "foolish"), so this problem is not a reason for altogether disregarding the terms "terrorist" and "terrorism." However, when control of social and news media is lopsided enough, it does create a situation in which the representations of one group can eclipse the self-representations of another.

Moreover, a larger issue resides in the application of the terms. While recognizing its divergent meanings, various studies of the American notion of "terrorism" identify a common understanding of it as the systematic practice of violence or the threat of violence against nonmilitary targets in order to coerce political or moral change.[9] Yet, of course, various historical actors have done exactly this and have been rewarded with more flattering adjectives than "terrorist." The Reagan administration viewed the Nicaraguan Contras as "freedom fighters"; President Truman understood the creation of nuclear weapons that destroyed two largely nonmilitarized Japanese cities as "the greatest achievement of organized science in history";[10] and generations of Americans have learned that "patriots" painfully tarred and feathered colonial officials and collaborators (yet probably have not learned that for years patriots threatened and assaulted loyalist civilians until many fled for their lives).[11] Hence, the decision regarding who and what constitute terrorists and terrorism remains a subjective judgment call that

says at least as much—and often much more—about those using the terms than about those described by them. As inclined toward terrorism, then, the stereotypical Muslim serves as a carnival's inverse mirror that reminds the disoriented viewer of normalcy or, in other words, as a foil for defining normative Americans, as described in chapter three.

Terrorism represents a central trope that allows a crucial shift in the Western view of Muslims as threatening and as foils. While public expressions of Islamophobic and anti-Muslim sentiment have waxed and waned among non-Muslim Westerners over the last centuries, the number of Muslim-led states that represent any direct military or political threat has dwindled sharply. Despite the recurring reassertion of political scientist Samuel Huntington's essentialist thesis regarding a "clash of civilizations" between "Western" and "Islamic" contenders,[12] Americans and Europeans primarily have suffered in this supposed conflict only from momentary and distant moral, policy, and economic inconveniences by assertive Iranians, plaintive Palestinians, and punitive OPEC nations. Without the imminent threat that the Ottomans represented for centuries, Muslims began to fail as foils for "Western" states, cultures, religions, and values.

From the 1960s to the 1970s, as Europe and the United States rocked to the explosions and other public violence committed overwhelmingly by white, European-heritage subversives,* they found a new foil/threat in the person of the Muslim/Arab terrorist. While the Red Brigades kidnapped prominent Italians, the Red Army Faction, the Irish Republican Army, and the Weather Underground all detonated explosives against civilian targets. Meanwhile, Palestinian gunmen (as well as others, such as various Latin Americans) hijacked airliners. When news efforts to identify the villains as communists failed, most of these agents of violence could not serve as social foils because they represented a threat from insiders.

However, the Palestinian Liberation Organization (PLO) and, later, the postrevolutionary Iranian state, Hezbollah, and al Qaeda fit the age-old mantle of the Arab/Muslim threat to Westerners that some authors have suggested allows many or all Arabs and Muslims to represent a foil to Western values. This perhaps culminated in President George W. Bush's claim in light of the 9/11 crimes that "they hate us because we're free." It also helped allow the Bush administration to bolster public support for its invasion of Iraq with the false inference that Saddam Hussein's government cooperated with al Qaeda. As mentioned in chapter 6, in 2003 Gallup found that 40

*Indeed, it is worth considering that the term "terrorist" originated in the French Revolution as a term for those participating in the Jacobin "Terror" against perceived enemies of democracy.

percent of Americans polled believed it certainly true that "Iraq had ties to Osama bin Laden's terrorist organization" before the war. Forty-two percent considered it likely, though they admitted to not being certain.[13] Iraq as a state posed no significant threat to the United States, but an alignment with "terrorists" helped legitimate the state's destruction under the placid-sounding agenda of "regime change."

Surpassing other qualifiers, the label of "terrorism" allowed news outlets, the American government, and the coalescing "Islamophobia industry" to reconstitute the enduring Western notion of violent Muslim threat. Within this, the valorization of Western roles for women could be celebrated in light of the purported victimization of Muslim women. The success of the "War on Terror" to provoke some Muslims to arms against Americans abroad (as has happened in Iraq and Afghanistan) and at home (according to the testimony of many of the few Muslim American militants) has helped establish a "forever war" against a nonuniformed enemy potentially living next door and defined as intercultural, religious, and brutal.

The endeavors of some to demand that all Muslims publicly decry and condemn every act of public violence committed by a Muslim while ignoring exactly these efforts by various Muslim organizations serve to instill mistrust among non-Muslims toward their Muslim neighbors. In addition to the examples provided in the introduction, consider the example of Mike Pompeo following the Boston Marathon bombing of 2013. As a Republican congressman from Kansas, he took to the floor of the House of Representatives to declare, "Silence has made these Islamic leaders across America potentially complicit in these acts." Although informed that many Muslim American groups had publicly condemned the attack, Pompeo—later head of the CIA and chosen by President Trump to serve as secretary of state—never withdrew his claim.[14] Such allegations make any Muslim American a potential enemy by definition.

"By definition" matters here. In American parlance, the "terrorist" is inherently unjustified. "Terrorists" represent nonstate actors who use violence against the state and/or society. As scholar J. David Slocum outlines, popular opinion views only modern nation-states as legitimately able to use violence. When used against its own population, violence falls under the rubric of policing. Against external enemies, the nation-state wages war. When civilians use aggressive violence against one another, the state prosecutes it as a crime. When they act against the state, theirs is the more serious crime of treason. Those non-state actors who strike against the state or society are labeled "terrorists." By definition, their violence lacks legitimation no matter their cause.[15] Although the nation-state may practice the same type of violence against civilians—such as bombing them with no strategic goal

other than terrorizing them (as practiced with equal abandon by Germans, Britons, Japanese, and Americans during World War II)—it legitimates its actions as warfare. This analysis does not intend to justify, legitimate, or excuse crimes committed against civilians (or the military, for that matter) or to establish an equivalence between the different exercises of violence practiced by individuals, groups, and nation-states. However, recognizing the semantics of "terrorism" helps explain how the term fixes one of the few expressions of Muslim political agency depicted in American media as inherently illegitimate and unjustifiable.

For these reasons, we here strive to take an agnostic approach to the term. The films chosen for consideration all make reference to terrorism in the context of Muslims and/or Islam, and it will be in that context that we examine them. Certainly, a reasonable argument could be made to include here films portraying state-sponsored practices that—intentionally or not—terrorize civilians, such as Italy's invention of concentration camps for civilians in colonial Libya as seen in *Lion of the Desert* (1981), American special forces operations in Mogadishu portrayed heroically in *Black Hawk Down* (2001), or the aerial bombardment of Afghan homes depicted graphically in *Restrepo* (2010). As this short list suggests, such a focus would draw more attention to portrayals of Muslims as victims of coercion and violence and less to them as perpetrators of such. But that analysis would say more about *the authors'* understanding of terrorism when our intention is to explore what American screenwriters and directors represent when they project before our eyes images of Muslims and Islamic traditions in contexts that *they* describe as terrorism. Notably, the number of Hollywood films produced that focus on Muslims as individuals or in Muslim-majority communities (e.g., *Argo, Not Without My Daughter*) without reference to terrorists pales relative to those that focus on Muslims as terrorists. We understand this chapter as an exploration, not as a complete accounting of all the pertinent films and their associated themes, a great many of which the late scholar Jack Shaheen explored in vast detail through his two helpful books.[16] Nevertheless, a brief consideration of this popular theme using one of the most powerful forms of media for projecting images of others allows a broad consideration of how the entertainment industry crafts and communicates sentiments and ideas that impact not only Americans but audiences around the globe.

Six Types of Films

Devising new genres for films would seem an inadvisable pursuit: it may suggest intentionality and continuity that proves difficult to demonstrate.

However, in order to assess what Hollywood films reflect about popular American perceptions, we necessarily need to take into account audience expectations when they view a film in a theater or as a video at home. Trailers and other advertisements prime audiences with expectations, attracting some and dissuading others, so that those who do sit before the screen watch through a lens shaped in part by anticipation.

Films that depict Muslims in deliberately construed contexts of terrorism tend to fall within at least one of six categories. Fantasy combat films emphasize heroic—and often exaggerated—violence in response to fictional terrorist threats. Sober combat films often emphasize the same theme, albeit with the additional gravity inherent to narratives claiming to follow "true events" involving violence against actual Americans and others. Political films primarily endeavor to describe and critique some aspect of domestic and/or international policies. Terrorist victim films depict the lives of those personally affected by acts of terrorism. Counterterrorism victim films portray those caught up in government responses to terrorism. Finally, satires use farcical situations to level social and/or political critiques. Certainly, overlap exists between all six, and some individual films could easily fit in more than one category. Yet the primary thrust of each film's narrative suggests a categorical variance that audiences likely recognize. Because fantasy combat films represent the most common type of film dealing with Muslims and terrorism, and because political films are the most likely to challenge the stereotypes found in Hollywood films, most of the following analysis will focus on these.

Fantasy Combat Films

Fantasy combat films represent the most common, most popular, and most successful type of film that Hollywood produces about Muslims, Islamic traditions, and terrorism. For example, *Act of Valor* (2012) more than doubled the return on its investment in its first weekend in the United States alone.[17] While their mix of action, adventure, and heroism fits American movie appetites well, it also diminishes the possibilities for nuance in character or narrative development. Although some measure of a personal dimension may be afforded the protagonist, antagonists tend to be shadow boxers whose motivations—much less background—matter little to the audience. In fact, because motivations and background would lend more humanity to the heroes' enemies and could lead audiences to think about their views, screenwriters and directors may view such details as hindering their ability to craft protagonists with whom audiences reflexively and unreservedly associate.

Some fantasy combat films edge into the political film category with bits of critique. For instance, *Iron Man* (2008), which depicted foreign fighters with Arabic-derived names in Afghanistan terrorizing villagers, narratively hinges on its protagonist's realization that his weapon manufacturing business contributes to Afghan suffering. However, the film stops far short of prompting audiences to consider a larger conclusion: American businesses supply more weapons to the world than businesses in any other country do, so they may collectively bear responsibility for innumerable civilian casualties across the globe. In an earlier example, *The Delta Force* (1986) aimed a critical lens at the failed effort six years earlier to liberate American embassy staff held hostage in Iran, which left the bodies of American servicemen in a hostile country. But in all such cases, conflict and action take precedence over any narrative device that might arrest the adventure's tempo long enough to prompt audiences to reflect about matters outside the film's narrative frame.

This shallowness of development for any but the film's main character, combined with the fact that, in the overwhelming number of examples, fantasy combat films about terrorism feature Muslims only as antagonists, mean that such movies more likely than not project the crassest stereotypes of Muslims and Islamic traditions. Given the brevity of the camera's attention on them, fantasy Muslims must be instantly identifiable by the audience (a quality these films share with editorial cartoons). Screenwriters, therefore, often portray them using qualities easily recognizable by Americans. Muslim men, therefore, tend to be angry, violent, loud, intolerant, and misogynist, while Muslim women usually only appear in order to serve as objects of male oppression and disregard. Demonstrating how Americans have often constructed a singular stereotype for the two groups, these qualities have long been stereotypes of not only Muslim but Arab men as well. If in stereotypes this is how Muslim and Arab men probably behave, then in fantasy terrorism films they must certainly behave in these ways in a maximum manner.

True Lies (1994) provided one of the worst examples of Arab and Muslim stereotyping, as exhaustively detailed by Shaheen.[18] Perhaps most notably, it differentiates hero from villain by distinguishing which is justified in his mistreatment of women. At different stages of the movie, both the male protagonist (played by Arnold Schwarzenegger) and prime antagonist Aziz (played by Art Malik) abduct the same woman and verbally abase another woman using the same slanderous term. However, the film justifies both the protagonist's coerciveness as helping to save his marriage (because it is his wife whom he abducts) and the lashing out at the other woman because she is an accomplice to nuclear blackmail. In contrast, Aziz plays to the

anti-Muslim/anti-Arab misogynist stereotype since he ultimately abducts not one but three females and accompanies verbal abuse with double slaps to one woman's face even though she is his ally. While *True Lies* represents a more vivid example than many, terrorist fantasy films often rely on stereotypes to shape audience responses to characters, especially when protagonists and antagonists engage in similarly egregious and violent behavior.

In part because of their prevalence throughout the last four decades, fantasy combat films provide ample evidence of changes among American perspectives. The first six James Bond films (1962–1971) demonstrate a very different sentiment toward terrorism than films released between 1971 and 2001, which differ again—though less markedly—from those produced following the crimes of September 11. Although a British production company filmed 007's adventures, concern for the US market ensured that their producers would shape the movies to appeal to a popular American sensibility. Apparently, this sensibility did not initially equate Muslims with terrorism. In each of the first six films, an operative of the transnational crime syndicate SPECTRE orchestrates the plot-driving mischief, and the nefarious organization's *T* stands for *terrorism*.[19] Yet neither does this term figure much into dialogue, nor are any of the characters who play Bond's nemesis-of-the-moment identifiably Muslim. In fact, the second film in the series, *From Russia with Love* (1963), features Kerim Bey, a Turk working for British intelligence as "head of Station T, Turkey." While his office in a carpet shop and his portrayal as a familial patriarch may play to certain Orientalist images of Middle Eastern men, the film clearly depicts Kerim Bey as intelligent, motivated, normatively masculine, and, at various times, more insightful than Bond (figure 8.1). Meanwhile, the script makes no hint of his religion. The belly-dancing scenes both of the opening credits and, later, in a gypsy camp more concretely adhere to nineteenth-century Orientalist depictions that tended to portray women as either scantily clothed objects of titillation or entirely covered objects of oppression. In either case, these films—in keeping with contemporary American sentiments—tended to identify Middle Easterners according to their nationality or racialized group (that is, as Arabs), not as Muslims. However, change was afoot.

Bond films gradually reflected changing American stereotypes. While *Thunderball* (1965) depicted SPECTRE operatives—largely Italian—stealing two nuclear weapons in a Caribbean setting, the film's remake *Never Say Never Again* (1983) has European SPECTRE operatives placing one of the stolen devices at a site near North African oil fields named "The Tears of Allah." The film firmly relies on stereotypes based on the extremes of over- or underdressed women and hypermasculine men when it depicts a SPEC-

Figure 8.1. Mixing Orientalist stereotype with modern apparel, Kerim Bey (Pedro Armendariz) talks with James Bond (Sean Connery) in his Istanbul carpet shop in *From Russia with Love* (1963). United Artists/Photofest.

TRE operative dealing with a captured "Bond girl." Tied to a post, Bond's female, niqab-wearing accomplice is forcibly disrobed and then auctioned to a rabble of horse-riding, leering, brown-skinned men wearing headgear and dark robes. On the other hand, Bond has to deal with a sadistic assassin by the name of Fatima Blush. Her wardrobe veering between very revealing and concealing, this villainess transgresses the usual Muslim extremes of how much or how little women are dressed, extremes that are used to define the norm for American women (as discussed in chapter 4). Ultimately, Fatima represents a woman whose sexuality and violence are only matched by her cruelty, as demonstrated when she threatens to castrate the hero.

The rise of media-ready violence committed by the PLO and other Middle Eastern–based groups against Israelis and Westerners in the 1960s

and 1970s coincided with a coalescing concern among Americans for violence committed by supposed Soviet proxies in Europe and Latin America. Attempting to get a rhetorical handle on these attacks, Americans increasingly relied upon "terrorism" as a word and a concept to label the seeming escalation of unconventional warfare committed by nonstate organizations against civilian targets often for the sake of garnering international attention and support. This built on a previous, narrower use of the term to describe anticolonial and revolutionary insurgents during the first decades following the Second World War.[20] Although few of this era's Middle Eastern guerilla groups self-identified as explicitly Muslim or organized around an Islamic ideology, the enduring American conflation of Arabs with Islamic traditions meant that the association lingered just below the surface of popular sentiment. With the jolting and protracted embarrassment of the Iranian hostage crisis at decade's end (1979–1980) followed by Hezbollah's catastrophic suicide bombing of Marine barracks in Beirut (1983), "Islam" sprang into a far more prominent position in the American-imagined Middle East. In each instance, Islamic motivation appeared to have canceled US military superiority in a sudden and humiliating moment. "Arabland" (the term that Shaheen uses to describe Hollywood's geographic sensibility)[21] increasingly became "Muslimland." While Islamist ideologies did increasingly figure into the social and political landscape of the region, film and other media forms in the United States too often exchanged reductionist racial and ethnic explanations for equally simplistic religious ones. As a comparison between two movies demonstrates, over the past three decades, fantasy combat film treatments of "Islamic terrorists" have reflected shifting American concerns without offering any deeper understanding of the motivations behind the violence they seek to portray.

Separated by more than two decades, *Navy Seals* (1990) and *Act of Valor* (2012) offer insightful points of comparison that reflect both the particulars of their periods and the continuities of American attitudes. Both portray a pair of Navy special operations combatants (SEALs) as friends and colleagues dedicated—along with the rest of their unit—to the protection of American lives while operating in the Middle East. Lewis Teague directed *Navy Seals* in the aftermath of the 1983 Beirut bombing, and the event figures in both the motivation of one protagonist and in the choice of the city as the movie's main location. The film begins with a fictional Islamic terrorist group, al Shuhada, shooting down a US Navy rescue helicopter and taking its crew hostage. The movie then moves, in abrupt contrast, to introduce the two main protagonists as they attend a SEAL comrade's wedding—a ceremony soon interrupted by a call to duty. In a trope repeated through most fantasy combat films (and many

nonfantasy ones as well), the protagonists of *Navy Seals* are American men defined not by any discernible religious identity but by their commitment to family and nation, while the antagonists are Middle Eastern men qualified almost exclusively by their Islamic and violent characteristics. One scene allows Ben Shaheed, al Shuhada's leader, to give voice to his motivations through a television interview: "You cannot invade our land and talk about security. You cannot send soldiers into our homes and talk about peace. You cannot kill a man's family and talk about human rights." While this signals the possibility that Shaheed is dedicated to his nation and family, the film offers no visual that makes this concrete, as it does with the SEALS. Although he justifies the barracks bombing "in the reprisal for the shelling of our homes and the murder of our families by American warships," American audiences in 1990 were unlikely to accept this as much more than posturing: contemporary news coverage of the US naval bombardment of Lebanon focused on Syrian and Druze military targets, not civilian casualties.[22] Meanwhile, posters of Ayatollah Khomeini line many of the movie's war-torn Beirut streets, reminding audiences of another dimension of Islamist danger, one that targeted American civilians. Hence the director affords the audience an empathetic connection to the protagonists alone while undermining the legitimacy of his chief antagonist's claim to victimization by American violence.

Navy Seals offers two different types of masculinity through the two lead protagonists, Lieutenant Dale Hawkins (played by Charlie Sheen) and Lieutenant James Curran (Michael Biehn). While Curran expresses a confident stolidity as a soldier leader, Hawkins plays the mischievous prankster whose masculine image builds upon his challenge to the normative order. So he arrives late and wet to the wedding, having thrown himself from a moving jeep into a river on the way there. Moreover, throughout the film he makes crass comments about people and locations that dare patricians of politeness. Perhaps the most prominent occurs during a scene in which he attempts to replace Curran in the developing affection of a television reporter, Claire Varrens.

Describing Beirut, Hawkins says, "What a shithole."

VARRENS: Have you ever been there?

HAWKINS: Are you kidding? Rags knocking one another off like the national pastime.

VARRENS: Rags?

HAWKINS [circling his head with his finger]: Rag heads. A-rabs. They're all just a few inches shy of a pygmy.

VARRENS: I happen to be half Arab myself. My mother's Lebanese.

After Hawkins apologizes for "insulting your heritage," Varrens giggles and they have their dinner. While the director may have intended the scene to demonstrate Varrens's strength to remain unperturbed by Hawkins's callousness, her giggle and smile implicitly assent to his aggressiveness, just as the silence of other characters does toward Hawkins's derogatory language. Of note, Varrens—in keeping with the film's portrayal of other positive characters—never identifies or acts religiously. In contrast, the Islamically driven acts of Shaheed culminate in the death of a SEAL, whose interrupted wedding and sobbing fiancée offer emotional markers of the costs of "Islamic terrorism."

Twenty-two years later, *Act of Valor*, like *Navy Seals*, begins with an attack on innocents and a focus on family. As the initial scene unfolds, a voice intones a eulogy-like monologue addressed to an unseen child about his father. Listening to the somber comments about duty and honor, the audience concludes that it is written by a SEAL about a fallen comrade. A scene then depicts a suicide bomber's use of an ice cream truck in a crowded Manila schoolyard to murder an American ambassador as he buys his son a treat. The location then shifts to Costa Rica, where a Chechen smuggler orders the abduction and torture of a young, female CIA officer who works undercover as a schoolteacher. In preparation for her rescue, a briefing of SEALs considers a video of another Chechen, Muhammad Abu Shabal, who proclaims a jihad until Americans stop assisting in the "genocide" against Chechens and the occupation "of all Muslim countries." Soon Lieutenant Rorke and Chief Dave (both played by actual SEALs) stand on the lip of their aircraft, prepared to parachute in to rescue this hostage. They share some words:

> DAVE: Yeah, I tell you what, the only thing better than this right here is being a dad. Except for that whole changing diaper thing but, Sandy does that anyway for me, so—
>
> RORKE: I'm actually looking forward to it.

As with *Navy Seals*, *Act of Valor* uses a Muslim terrorist as a foil to promote a model US warrior. While twenty-first-century American notions of masculinity may have shifted to accommodate childcare responsibilities entirely absent from the 1990 film and rely less on the culturally insensitive bad-boy role played by Sheen, the "Islamic terrorist" remains largely the same. The screenplay offers Abu Shabal—like Shaheed before him—no opportunity to appear in a family setting, let alone to be happy. He stalks across the screen, often barking at those near him, with a scowl as firmly affixed as the scars on his face. Although the film portrays him as unmistakably masculine,

unlike the SEALs his gender qualifications are exaggerated and exceed the audience's notions of normativity.[23] In contrast with the unlimited rage of both Muslims, the SEALs in the 1990 film express anger only in combat and only temporarily, while those in the 2012 movie seem to eschew emotion entirely as part of mission preparedness. Hence, an unrestrained, Muslim, hy-permasculine anger threatens women, children, and the public order, while a normative American masculinity attracts women, nurtures children, and protects the public sphere.

Act of Valor, like its predecessor, also reflects contemporary American social anxieties. In contrast with fears for American military personnel in the Middle East at the hands of Palestinian terrorists, Act of Valor combines concerns for the violence of pan-Islamic terrorism and the subterfuge of narcotics smuggling. The film ends in a confrontation in clandestine tun-nels beneath the US-Mexican border as the Chechen Abu Shabal shep-herds his flock of Filipino suicide bombers (both men and women) to their American targets. This borderland shotgun marriage of narco-terrorism[24] and "Islamic terrorism" perfectly reflects culminating American insecuri-ties about both the permeability of the country's physical boundary and the integrity of its body politic.

Race plays an important role in defining America in many of these mov-ies. Fantasy terrorism films almost all have white, male protagonists strug-gling against antagonists of color, whether Arab (The Siege, The Kingdom, Delta Force, True Lies), Nigerian (Tears of the Sun), or Filipino (Act of Valor). The exceptions among the protagonists are African Americans, who some-times even serve as a film's star (The Siege, The Kingdom), thus demonstrating again Sherman Jackson's thesis about race and authentic Americanness in popular imagery. Meanwhile, director Ridley Scott—like Lewis Teague in his Navy Seals—sought to escape anti-Arab and anti-Muslim stereotypes in his films Black Hawk Down (2001), Kingdom of Heaven (2005), and Body of Lies (2008) but repeatedly if inadvertently reinforced an Islamophobic theme: Islam, when practiced, makes people dangerous. He repeated a strategy to demonstrate diversity among Muslims (as well as Christians) but marked the villains on both sides by their religious language and practices.

A final film in this category bears consideration because it contravenes this convention of "the practicing Muslim is a dangerous Muslim," also de-scribed with regard to The Siege (1998) in chapter 4. Traitor (2008) works against this so dramatically that perhaps it should be listed among political films instead. Director Jeffrey Nachmanoff crafts a protagonist largely defined by his Muslim identity and Islamic devotion in Traitor. Perhaps without par-allel, Don Cheadle portrays a Muslim whose religious commitments compel

Figure 8.2. Good Muslim, bad Muslim: Samir Horn (Don Cheadle) and Omar (Saïd Taghmaoui) in *Traitor* (2008). Overture Films/Photofest.

him to infiltrate an Islamic terrorist network. The film introduces Cheadle's character, Samir Horn, as a young Sudanese boy praying, playing, and reading the Quran with his father. The audience learns that he resided in the United States and, when grown, served in the military. Horn uses passages of the Quran and Hadith to counter some of the terrorists' views even as he feigns working with them. Meanwhile, the self-described terrorist leader echoes Jackson's conclusions when he directs the African American Horn on a mission within the United States that he and the other Arab leaders (figure 8.2) cannot accomplish: "We need somebody who can move about the country without drawing attention: somebody who blends in." Of course, this affirms Sherman Jackson's argument discussed in chapter 7 that whites do not question the patriotism of black Americans in the way they do other racialized people, such as Arabs. Nevertheless, *Traitor* conveys the possibility of an American immigrant who can serve his country not *despite* or *in lieu of* being Muslim but *because* he is Muslim.

Sober Combat Films
One of the most significant dimensions of nonfiction film is reflected in the subtitle of the book on which director Michael Bay based his film *13 Hours*. The book title, *13 Hours: The Inside Account of What Really Happened*

in Benghazi, entices potential readers with a story that "really happened," suggesting the weight of actual, consequential events. Moreover, it offers not only insight into a violent attack that killed an American ambassador, among others, but also a look behind the façade of mistruth. Bay communicates something similar by taking the unusual move of providing a subtitle to his 2016 movie *13 Hours: The Secret Soldiers of Benghazi.* This movie and others like it—*Argo, Lone Survivor,* and *Zero Dark Thirty*—promise to inform audiences as well as entertain them, to educate them about pertinent events while providing edge-of-seat action. Screenwriters and directors of such movies must strike a balance between providing a gripping narrative that satisfies audiences and keeping close enough to facts (or what appear to be facts) in order to satisfy the viewers' desire for the "more" that nonfiction provides relative to fiction. The results are films that dramatize reported events yet must prove the authenticity of the general picture that they portray. Such claims inevitably lend greater weight to the portrayal of the characters involved and hence heighten the possibility of reinforcing or undermining stereotypes.

Based on the autobiographical account of Marcus Luttrell, a member of an ill-fated SEALs team, *Lone Survivor* (2013) draws on many of the themes familiar from fictional combat films. Director Peter Berg begins by establishing the primary characters (Luttrell and his three teammates) in two sets of families. Even before that obligatory intonation of "truthiness" flashes on the screen—"Based on a real story"—the film portrays how the SEALs' training galvanizes them into a band of brothers, which represents the immediate family for whom they will fight, reiterating a theme long familiar from combat films and literature. This prelude, shot in a raw style contrary to the rest of the film, suggests a documentary and, hence, greater realism. The introduction includes a scene in which trainees link arms while standing in the ocean and sing "Silent Night," unexpectedly connecting them to normative American Christianity. The film—now in full color and with a stronger Hollywood feel—shifts abruptly to a helicopter carrying a bloodied Luttrell to a hospital in Afghanistan, where he flatlines. Next and just as suddenly, the audience arrives at Bagram Air Force Base three days earlier, as the film introduces them to the team. Amid the jocularity of the warriors in their downtime, Mike excitedly shares an email from his fiancée about wanting a horse, Matt sweet-talks his wife over the computer, and Dietz expounds on his wife's décor decision, while the camera pans across the montage of family photos decorating Marcus's quarters (like those of almost all his comrades). Among other potential reasons for its inclusion, this scene helps alleviate homophobic concerns that audiences might confuse the camaraderie with romantic

affection. (HBO's miniseries *Generation Kill* included a line, recorded from an actual Marine by journalist Evan Wright, acknowledging how their closeness and banter in combat might appear: "Man, we Marines are so homoerotic. It's all we talk about. You ever realize how homoerotic this whole thing is?")

Lone Survivor's first depiction of Afghans offers a sharp contrast to the family-focused Americans. In a flashback situated during a SEAL team briefing for their upcoming mission—indeed, like most such films, Muslims seldom have significance except in the context of non-Muslim American action—an Afghan identified as Taraq hacks off the head of a village man in front of his family. The briefing thus establishes the legitimacy and urgency of the mission that will target Taraq and his leader and pit these family-embedded American men against their family-destroying enemy. The scene also creates a binary among the Afghans: there are those in need of saving and those from whom the first group needs saving. In other words, justifiably aggressive, hypermasculine Americans will target unjustifiably aggressive Afghans who prey on passive Afghan victims. Meanwhile, the scene adds an additional incentive to kill Taraq's leader when the briefing officer explains that he killed twenty Marines the week before.

Notably, however, the film depicts a shift of agency from Americans saving Afghans from other Afghans to Afghans saving an American from Afghans when a local villager takes the lone SEAL team survivor into his home (figure 8.3) after the mission goes fatally wrong. Crediting the hospitality to the Pashtun principle of *pashtunwali* that includes protecting one's guests even at the risk of one's own life, the film re-centers on an Afghan family as they care for Luttrell. Berg reemphasizes his valorization of this principle by ending the film with a description:

> The Afghan villagers who protected Marcus did so out of duty to the 2,000 year old code of honor, known as Pashtunwali.
>
> Pashtunwali requires a tribe to undertake the responsibility of safeguarding an individual against his enemies and protecting him at all costs.

Interestingly, although most Pashtuns view these principles as inextricably encompassed within their Islamic practices—and thus provide audiences a rare opportunity to view a favorable movie reference—the film offers no mention of religion other than the understood Islamic quality of the Taliban. Even that iconic marker of Muslim locations, the mosque, is absent in the family's village. However, the repeated identification of Taraq's forces as Taliban cements an unequivocally negative association with Islamic identity and traditions.

Figure 8.3. Pashtun but not Muslim: Gulab (Ali Suliman) saves Marcus (Mark Wahlberg) in *Lone Survivor* (2013). Universal Pictures/Photofest.

Lone Survivor ends by shifting the power dynamic back from one of Afghans protecting an American to Americans saving Afghans. Instead of the description in his memoir in which Luttrell meets a Special Forces rescue team while escorted out of the village by his host Mohammad Gulab, the film ends with helicopter gunships and an AC-130U Spooky gunship (named "The Hand of God" in the script)[25] destroying a Taliban assault intending to kill Luttrell and destroy the villagers. Luttrell's embrace of Gulab's son in the final moment before he leaves reasserts his connection with yet more family beyond his SEAL brothers and stateside family. Earlier, the movie portrays the deaths of two of his teammates with specific references to their wives. In contrast, it never depicts the Taliban as family men.

Kathryn Bigelow's *Zero Dark Thirty* entirely upends these themes of domesticity. The film's dialogue makes clear that her heroine has no family and has dedicated her last twelve years solely to the capture of Osama bin Laden, who, to complete the inversion, hides in Abbotabad, Pakistan, with his family. Although a SEAL team plays a role, the narrative does not entirely rely on the forged band of brothers affection seen in *Lone Survivor*, *Navy Seals*, or *Act of Valor*, focusing instead on their rough-hewn professionalism and courage. Most notably, however, the screenplay reserves the deepest intimacy for the camaraderie between the heroine and a fellow CIA analyst, which never hints at anything sexual or romantic. While this camaraderie may offer some warmth to the otherwise cold, hyperfocused personality of the lead character, it appears primarily intended to create a binary. On the one hand, actress Jessica Chastain's heroine—Maya—exhibits the characteristics of silent strength and violent agency usually reserved for strong male leads (although she is questioned and sexually objectified by her fellow agents). Her resolve initially manifests as she first stomachs and then masters various practices of torture, which the film repeatedly credits with finding bin Laden. Meanwhile, her colleague Jessica suggests a less cynical and more emotional character hewing to more common portrayals of women. Indeed, she nearly squeals with delight when a highly placed informant agrees to a meeting, for which she makes him a birthday cake.

MAYA O.S.: Muslims don't celebrate with cake.

JESSICA: Don't be so literal. Everyone likes cake. It's not too late for you to come, you know. It will be fun.

Overlooking the odd universal claim about Muslims not celebrating with cake (which is untrue for many Muslim Americans, at least), the exchange hardly matches the sober conversations between the entirely serious and skeptical CIA officers on which the first two-thirds of the film focuses. When Jessica's informant arrives, he detonates a car bomb that annihilates her, among others. In a nod to Maya's humanity in a later scene, her computer's desktop is shown to display a picture of Jessica.

Perhaps unsurprisingly, given that one of the few women directors in Hollywood created it, *Zero Dark Thirty* portrays a woman protagonist who can fight in the War on Terror because she has eschewed family (as many films depict their leading men doing) and who is negatively defined by the naïve, domesticated woman who dies because of her homey impulses (in contrast with the family-defined quality of SEALs and other male combat team members in many films: they may die, but their domesticity warms—not

Figure 8.4. Warrior among warriors: Maya (Jessica Chastain) among SEAL Team Six in *Zero Dark Thirty* (2012). Columbia Pictures/Photofest.

weakens—their characters). The film's final third develops Maya's character primarily through her interactions with SEAL Team Six as she helps them prepare for their mission to kill bin Laden (figure 8.4). This hirsute combat team provides the final test of her mettle as she endures and overcomes their incredulity of her conclusions, just as she did that of her male CIA colleagues. The steeliness of her intelligence matches the steeliness of their soldiery.

In contrast with the CIA and SEAL characters whose portrayals largely ignore family, the absent character who is everyone's focus throughout the entire film—bin Laden—is surrounded by family. Wives, young children, and adult sons live with the al Qaeda figurehead hiding in Pakistan. But Bigelow does not allow the film to develop him as a character, only as a target, so audiences have no glimpse of his person, family, or life until his final chapter begins. As SEAL Team Six conducts its invasion of bin Laden's expansive compound, family represents only so many obstacles. The team members shoot dead two sons who wield weapons, while carefully yet firmly moving two wives and various children out of their way. A SEAL kills a woman as she rushes to protect her husband, one of bin Laden's assistants, who is also shot. Some Hollywood combat films about World War II, such as *The Enemy Below* (1957) and *Tora, Tora, Tora* (1970), and about the war in Vietnam, such as *We Were Soldiers* (2002) and *The Quiet American* (2002),

provided sympathetic depictions of a fictional U-boat captain, the supreme commander of the Japanese navy, a North Vietnamese Army officer, and an imagined Vietnamese Communist operative. While it is likely that humanizing someone responsible for an act as despicable as the September 2001 attacks will long remain unlikely, one wonders whether any character labeled "terrorist" can ever be empathetically portrayed in a similar manner to former American war enemies (although Steven Spielberg's 2005 film *Munich* motioned toward this possibility).

The challenge of humanizing enemies becomes particularly pronounced in films portraying combat from extreme distance. While the psychological demands of injuring or killing fellow humans in combat have long required unsympathetic depictions of enemies—if not their total dehumanization—drone warfare has sparked controversy in the United States. The advantage of attacking with immunity from a distance also, according to critics, proves too tempting and promotes unrestricted killing with impunity. Changing weapon technologies have allowed increasingly impersonal engagement with enemies: hand-to-hand combat using clubs, spears, and swords gave way to line-of-sight battle with muskets, rifles, and rockets, and then to over-the-horizon weapons such as ballistic and cruise missiles. Drones such as the MQ-1 Predator and MQ-9 Reaper offer target imaging that seemingly promises more exact attacks and fewer civilian casualties than cruise missiles. The film *Good Kill* (2014) quickly followed by *Eye in the Sky* (2015) critically examined these weapon systems and their human cost on both sides of the control stick in the context of terrorism by focusing on the dehumanizing effects on Western combatants who use weapons that remotely kill their dehumanized opponents.

Director Andrew Niccol frames *Good Kill* to straightforwardly criticize the unlimited use of armed drones by setting his protagonist as a former fighter pilot now flying drones remotely from Creech Air Force Base. Off-duty, Major Thomas Egan returns to his wife and children in nearby Las Vegas. However, the steady body count of women and children killed alongside Taliban targets, as well as the repeated viewing of dismembered bodies and victims bleeding out on his grainy gray television image, both erodes Major Egan's confidence in his mission and undermines his emotional stability and, thus, family life. Niccol challenges the prevailing logic of inevitable civilizational conflict with a sparring match between two members of Egan's crew after a particular attack in which they waited until rescuers arrived to pull casualties from the wreckage before striking the same target again. One, Airman Suarez, asks, "Was that a war crime?" She continues,

SUAREZ: No wonder they hate us.

ZIMMER: They always hated us. We'll always be the Great Satan because we have *Hustler*, Hooters, and we let women drive to school. And they won't stop hating us until the savages have sharia law everywhere on the goddam planet.

Later, commenting on an Afghan boy who witnesses a drone strike, Suarez describes her Air Force unit as "a terrorist factory" and mentions how news regarding drone attacks motivated the failed attempt by "the Times Square bomber."[26] Not coincidentally, the sympathetic Suarez is the only significant character of color outside of the Afghans, and she alone gives voice to an objection to the drone operations.

Gavin Hood injected more subtlety and complexity when he directed *Eye in the Sky*, a British film developed by the BBC. The action occurs in multiple locations: Nairobi, Kenya, where Kenyan forces wait to capture Muslim militants as city residents begin their day; a London military base, where Colonel Katherine Powell quarterbacks the entire operation; Creech Air Force Base, from which a crew pilots its Reaper above Nairobi, half a world away; and the Ministry of Defence in London, where senior military and political officials supervise and authorize events. Hood deftly demonstrates the transnational quality of both militants and the military. The radicals who gather represent Somalis, Britons, and an American. But neither they nor the al-Shabab militia that controls the neighborhood where they meet are the only Muslims in evidence. Characters among the Kenyan police and the British military have Arabic-origin names that suggest a Muslim heritage (without suggestion that any might be sleeper agents or under suspicion) (figure 8.5), while a family living near where the radicals gather serves as a fulcrum for the action. Comprised of a hijab-wearing mother, a father donning a skullcap adorned with a mosque, and their small daughter, Alia, the family demonstrates a commitment to certain Muslim practices as well as to Alia's education. The film's drama hinges on whether a drone strike on the radicals as they prepare two suicide attacks can be morally, militarily, and legally justified if it results in Alia's death after she wanders into the target area.

Both *Eye in the Sky* and *Good Kill* firmly fix their main characters in family settings. Hood begins with Alia's mother baking bread and her father making her a hula hoop, followed by scenes of Powell and an American drone pilot in their respective family homes. While the film shows none of the "terrorists" living a domestic life, two are married. And despite the harsh grip that the al-Shabab members keep on their Nairobi neighborhood, some rush to the rescue of a civilian drone strike victim. In contrast,

Figure 8.5. Jama Farah (Barkhad Abdi), an intelligence operative, mixes with Muslim civilians and militants in *Eye in the Sky* (2015). Bleecker Street Media/Photofest.

Niccol's *Good Kill* never takes the audience out of Egan's narrative frame, let alone to a ground-eye view of Afghanistan. Emphasizing the emotional detachment that follows from his physical distance, Afghans only appear as gray, flat, pixelated figures on a screen. This harsh remove allows no sense of any Afghan's motivation, experience, or affect, and Egan's declining mental health reflects how the uncertainty even of his targets' guilt grinds on him. The film ends with the entirely disaffected pilot seeking a final, redemptive moment of confirmed merit when he locks out his crew and blows up a gun-toting Afghan man who had routinely raped a village woman in her family home as Egan helplessly watched from his panoptic perch above. In this penultimate scene, just before the pilot turns his back on his unit and sets out to reunite with his own family, he now watches with relief and appreciation as a small boy runs to his mother, who was knocked down but not killed by the blast. Despite their critical perspective on this facet of the War on Terror, both films nevertheless rely on the same trope of family to de/humanize certain characters.

Meanwhile, in a final aspect, these two films about drone warfare demonstrate a significant departure from *Lone Survivor* and *Zero Dark Thirty*, which both appear to countenance with little debate extraordinary forms of violence against Muslims. In *Lone Survivor*, in a scene with few parallels in Hollywood history, Berg depicts a protracted argument among the SEAL team members about three goatherds who have stumbled upon the team's

observation post. The operators give long deliberation to killing these civilians to avoid being found by the Taliban. One member advocates for it, and another abstains from a decision. Luttrell initially appears against the murder only because CNN will portray them as bad guys. No one argues for the immorality of killing unarmed civilians only for the sake of avoiding observation, a contingency not allowed by their rules of engagement and only seriously entertained in few—if any—other combat films. The film (like Luttrell's memoir) suggests the team leader made the wrong choice, as one of the freed goatherds runs directly to the Taliban and points him in the SEALs' direction, a scene not included in the memoir because the operators had no way of observing such an event. Despite the myriad films about World War II, it would be hard to imagine one justifying GIs killing a German elder and child who blunder upon their position. Even in films about the complex moral universe of the Vietnam war in which some American forces racially abase their enemy, a similar scene would be implausible. Yet, *Lone Survivor*'s advocacy for killing Muslim civilians to save American combatants caused little public comment.

More controversially, Bigelow's depiction of torture used in interrogating al Qaeda suspects suggests that the information garnered proved instrumental to the eventual discovery of bin Laden's hideout. Despite the widespread publication of various experts' opinions during the first eight years of the War on Terror that waterboarding and other "enhanced interrogative techniques" prove more counterproductive than productive,[27] *Zero Dark Thirty* offers little doubt of its utility or morality. Unlike *Good Kill* and *Eye in the Sky*, *Lone Survivor* and *Zero Dark Thirty* appear to depict Afghan civilians and al Qaeda suspects as not meriting the legal and military protections that—while not always observed in America's battlefields or enforced in its courts—have seldom if ever been uncritically denied to silver-screen enemies in recent Hollywood history. In the eyes of some directors and producers of sober combat films, Muslim enemies apparently deserve nothing more.

Political Films

Although fantasy and sober combat films may include political commentary, and political films do not lack in action, a distinction remains useful. Political film scripts hinge their narratives on the critical engagement of one or more elements of a political, social, and/or moral order. For instance, Steven Spielberg's *Munich* depicts Israeli secret operations to assassinate the Palestinians responsible for the 1972 massacre of Israeli Olympic athletes with as much drama and excitement as many combat films. However, the film makes central to its unfolding action an ongoing moral and strategic

questioning of the premises for state-sponsored counterterrorism. Moreover, Spielberg practiced another form of critical engagement through his careful crafting of narrative and characters by portraying Palestinians—both individually and collectively—as more than just the perpetrators of that heinous act, which the film rightfully condemns. As a measure of this care, the movie never projects Muslim identities onto the Palestinian characters or confuses their ideology with an Islamic one. Although *Munich* proffers few Palestinian voices, those included prove to share a humanity with Israelis (and the audience), showing the same range of interests and emotions as the Israelis who hunt them. One Palestinian even offers a justification for violence in defense of his homeland that the lead Israeli agent realizes matches his own. The sharp condemnation many critics aimed at Spielberg and screenplay writer Tony Kushner for making a film that these critics thought offered an apology for the Palestinian attacks[28] offers ample evidence of both the critical intent and effect. An examination of four political films demonstrates how, despite the differences in the concerns that motivate them, most films of this genre pursue their critiques of the reigning order through stereotype-challenging attention to individual characters.

Syriana (2005) presents a complicated narrative tree whose branches ultimately stem from a single trunk of economic interest that has roots in American, Arab, European, and Chinese soils. Instead of "Islamic terrorism" existing as a simple given, as depicted in most fantasy combat films, director Stephen Gaghan's movie depicts it as the poisonous fruit of one of those branches. The film intermittently follows the path of two young Pakistani men as they try to eke out a living in the politically and environmentally inhospitable landscape of an unnamed country in the Arabian Gulf. As the parallel narrative streams depict political and commercial machinations that they can only dimly sense, let alone influence, Wasim and Farooq gradually respond to an older man's friendship, an Islamic school's hospitality, and, finally, a reactionary Islamist political view. Wasim moves toward his decision to become a suicide attacker, prodded by the enduring bleakness of impermanent menial jobs, the blunt truncheons of unsympathetic government guards, misguided thoughts for his parents' welfare, and a utopian theological promise. In this portrait, *Syriana* repeats the combat film tradition of accenting terrorist narratives with family narratives but with the difference that the film includes Muslim families as well. Although *Syriana* is unusual for doing so in the case of a suicide bomber, such efforts to portray Muslim characters as individual personalities and not as stereotypes represent a common theme in films offering trenchant critiques.

Few films match *Syriana* in offering such a range of identifiably Muslim and non-Muslim characters with an equivalent mix of laudable and lamentable qualities among them. However, by doing so, these films take another step in the normalization of Muslims in the eyes of American audiences (which, of course, include Muslims). As the film shifts among its various locales, Iranians, Pakistanis, and Arabs appear in ways that neither conflate them as homogeneous "Muslims" nor reify them as ethnically stereotypical. Similarly, Michael Winterbottom's *A Mighty Heart* (2007) depicts a variety of Americans and Pakistanis whose *individually specific* qualities of generosity, duplicity, caring, arrogance, intelligence, and/or pompousness distinguish them from one another. Winterbottom uses his narrative of journalist Mariane Pearl's efforts to free her kidnapped husband, Daniel, in Pakistan as an opportunity to portray a cross-section of American-Pakistani mutual involvements that transcends mere diplomatic relations without trying to dodge the moral and emotional weight of the situation. The American military's use of Pakistan to invade Afghanistan, the conditions for detainees in Guantánamo, Muslim conspiracy theories about Jews, suspicions regarding CIA operatives, and the American-approved use of torture by Pakistani authorities all appear in the film. Winterbottom uses these to offer a critical portrayal of the political and military entanglements that characterize the two countries' relations.

Reflective of the wider contexts in which both *Syriana* and *A Mighty Heart* persistently set their action, these films do not repeatedly rely on images of local minarets and mosques to serve as cinematic reminders of the exotic Islamic setting as do most fantasy combat films. Instead, the cityscapes of Karachi, Tehran, Beirut, and the unnamed Gulf country portrayed by Gaghan and Winterbottom are depicted as filled with a variety of buildings and not just bristling with minarets. Not all political films, however, have taken this approach, among others, to provide more robust depictions of Muslims.

Five years before the release of *Syriana*, another political film appeared that also straddled Middle Eastern and American locations while tracing intertwining conduits of military, diplomatic, and political interests, though with a significantly different approach to representation. *Rules of Engagement* (2000) depicts the legal consequences for Marine colonel Terry Childers (played by Samuel L. Jackson), who commands his forces to fire on a hostile crowd attacking the US embassy in Sanaa, Yemen. Visually, the film's director, William Friedkin, establishes this setting's "Islamic" nature: The camera first frames a view of the city that prominently features minarets before pulling out to a larger view as the protest's noise (including ululation) grows.

When the camera then turns to the fist-shaking crowd, the audience sees that all the women wear niqab, all the men don kaffiyeh, all the boys have skullcaps, and all the girls have head scarves. However, only a few protestors (and only men) fire weapons. In contrast to this wholly Muslim scene, none of the American characters at any stage of the film admit to religion at all: nary a small cross, Star of David, or crescent moon dangles from the Americans' necks, nor do religious comments slip from their lips. However, Friedkin's conclusion transforms Sanaa's angry Muslim quality into a murderous Islamic one when an uncovered videotape operates as a cinematic device to revisit the protest. As the tape plays, the film revisualizes the initial Yemen scene so that practically everyone in the crowd—even, as Shaheen has deftly pointed out, a small girl that the film earlier led audiences to sympathize with for having lost a leg to an American bullet[29]—is depicted blazing away at Childers's marines. This moment of visual infidelity between Friedkin and his audience crudely yet deliberately severs the sympathy created for the dead and wounded Muslim protestors, emotionally punishing viewers for their trust in what the film depicted and chastising them for trusting their own visual witness over Childers's claims of innocence. Friedkin communicates his political message by turning his film against itself.

As political films, *Syriana*, *A Mighty Heart*, and *Rules of Engagement* craft the action to promote their critiques. Gaghan juggles the myriad characters and finesses the complicated narrative to provoke audiences toward a larger understanding of strategies in and foreign consequences of America's pursuit of its national interests in the Middle East. Winterbottom seeks something similar, though on a more constrained and more emotional scale, in his depiction of Mariane Pearl's even-minded effort to understand the larger circumstances leading to the sad denouement of her husband's situation. Friedkin, on the other hand, as his opening scene in Vietnam foreshadows, wants to protest the political pillory of combat leaders for the choices they make under fire.[30] As such, the location is merely incidental. The director's choice of a Muslim crowd of adults and children in Yemen whipped to violence by cassette tapes promoting "Islamic jihad" therefore represents his calculation of what enemy an American audience at the beginning of the new millennium would consider most realistic and justifiably massacred.

Certainly this choice gave no pause to the US Marines or the Department of Defense (DoD), which lent their support to the film's production. As journalist David L. Robb has described, such support is hard won and often requires changes to the script but pays off with film use of military hardware (aircraft, vehicles), locations (bases, ships), and training. Notably, many more fantasy and sober combat films—such as *Navy Seals*, *True Lies*, and

Black Hawk Down—have enjoyed this approval than have political films, while *Act of Valor* was commissioned by the Special Warfare Command of the Navy and filmed using actual SEALs as actors.[31] In so doing, the DoD has become a partner with Hollywood in fashioning the commercially promoted, public image of "Islamic terrorism" and Muslim terrorists.

Terrorist Victim Films

While the period since 2001 has had no shortage of films dealing with "Islamic terrorism," precious few have braved the emotionally perilous subject of victimhood. Among the less than a handful that have, almost all have focused on September 11, and almost none have sought to depict the perpetrators or the Muslims who were among their victims. Oliver Stone's *World Trade Center* (2006) and Stephen Daldry's *Extremely Loud & Incredibly Close* (2011) depict the World Trade Center attack, respectively, through its immediate victims in the person of two police officers trapped in the rubble and through the extended suffering of a victim's family a decade later. Except for a vague, passing reference in each, neither film reflects on the hijackers or their motivations, focusing instead on the physical or emotional pain that the protagonists pointedly suffer and the audience viscerally shares.

United 93 (2006) offers an entirely different approach to victimhood through the imagined portrayal of the only flight whose passengers are known to have risen against their captors. Whereas political films tend to put an individuated and human face on Muslim militants, and fantasy combat films portray them as an indistinguishable horde led by a maniacal leader, Paul Greengrass's movie demurs on naming any of the individual passengers of United flight 93. Instead, the audience engages them as they might their fellow passengers during any actual flight, distinguishing individual passengers from one another by some particular item of clothing or specific quality of appearance in lieu of knowing their names. This dynamic helps energize the moment when many of the passengers banded together to overwhelm the hijackers and struggle for control of the doomed aircraft.

Of course, the audience knows the Muslim identity of the hijackers even before the lights dim in the theater. The film reinforces this through an initial series of juxtaposed images: an aerial view of Times Square, a militant shaving his chest and genital hair, a New York skyline scene, the men doing their *salat* prayers, another skyline view, the hijackers embracing one another and praying, and a highway drive past shipping containers saying "God Bless America" and decorated with a US flag as the Twin Towers accent the background view of the city. The back-and-forth seems to suggest how New York would be irrevocably shaped by the hijackers' Islamic commitments that day.

However, the film ends with a more striking juxtaposition as the frame shifts alternately between a militant praying in Arabic and passengers saying the Lord's Prayer. This goes on repeatedly: the camera cuts back and forth between English and Arabic prayers before ending with a focus on one hijacker praying and the camera then panning to a dead flight crewman. By this point all the hijackers are doing nothing but praying, as though Islamic traditions composed the entirety of their being. While most fantasy combat films depict Muslims as only Muslims and Americans as not publicly religious, *United 93* ends with the implication that the passengers were almost uniformly Christian, so that their courageous stand against the hijackers' murderous crime almost appears as a study in contrasts between Christianity and Islam itself.

Counterterrorism Victim Films

While American films have feigned to assert that certain US military operations amount to state-sponsored terrorism, a number have sought to demonstrate the unintended human impact of "the War on Terror." Some films do this in an offhanded manner as seen in *V Is for Vendetta* (2005), in which the loathsome English chancellor talks about ridding the country of Muslims, homosexuals, and other "undesirables" in the implied context of American counterterrorism efforts coming to the United Kingdom. *Babel* (2006) does so more directly by portraying how the false presumption of Muslim terrorism by both governments and the media precipitates far more fateful consequences for a Moroccan boy with a new rifle and his hapless American victim than an accidental shooting might otherwise. *Rendition* (2007) does much the same, though in the narrower context of the US government and a green-card holder of Egyptian birth. While only brief reference to Muslims and terrorism occurs in *V Is for Vendetta*, the other two films offer more sustained, though quite divergent, engagement with these themes. *Babel* carefully depicts a variety of Westerners, Japanese, and Moroccans—including a compassionate man who performs *salat* while aiding the wounded American—in the context of what becomes a politically and media-generated nonevent of terrorism. *Rendition*, on the other hand, condemns the US government's practice of extraordinary rendition to foreign torture centers while reinforcing Islamophobic and anti-Muslim stereotypes. The film portrays a religion-less, Egyptian-born protagonist (married to a European American without obvious religion) dragged into a North African setting replete with brutish men, oppressed women, a militant madrasa, and violent Muslims. The North African official in charge of the torturous interrogation cajoles a queasy CIA official that the work they do is "sacred."

Figure 8.6. Writer and actor Sayed Badreya plays Los Angeles café owner Mustafa Marzoke in *AmericanEast*. © Twentieth Century Fox Home Entertainment.

Unusual among all the categories is *AmericanEast* (2007) by Egyptian American director Hesham Issawi, which features Muslims as most of the characters, including the primary one (figure 8.6). Among the challenges many of these Los Angeles citizens face, suspicion of "Islamic terrorism" by both law enforcement and fellow Angelenos haunts them. In a café in Little Arabia that exists in a parallel universe to Spike Lee's pizzeria in *Do the Right Thing* (1989), the various Arab Americans portrayed wrestle with their own and one another's issues of ethnic, religious, gender, racial, and national identity. Persistently and tiresomely, the FBI and city police interrogate two of the Muslim characters until the pervasiveness of deprecating stereotypes finally provokes one to violence—which, of course, only fulfills the typecasting. Although the film's urge to map all the prominent features on the social and political landscape gets in the way of a more convincing and engaging development of the characters (and may have led to its failure to obtain widespread distribution in theaters), *AmericanEast* demonstrates how, despite America's fixation on Muslim terrorists, almost no films have focused primarily on Muslim characters in a context of Muslim normalcy.

Satires
In *Borat*, when Sacha Baron Cohen's title character stepped into the middle of a Virginia rodeo and roused his audience (albeit with diminishing applause) with declarations like "We support your war of terror!" and "May

George Bush drink the blood of every single man, woman, and child of Iraq!" it appeared that the farce could have as subversive a satirical effect on anti-Muslim sentiment as much of the rest of the film had regarding American anti-Semitism. Indeed, preceding the rodeo, Borat was helpfully advised by a rodeo promoter to shave his mustache so he would look less like a terrorist. *Borat* and the small collection of other satires bold enough to tackle "Islamic terrorism" only recapitulate anti-Muslim and Islamophobic stereotypes, suggesting how intractable these are.

All three Cohen-written films released in the United States involve material on Muslims associated with terrorism, using the comedian's signature style of fooling nonactors who agree to what they anticipate to be journalistic interviews. *Brüno* (2009) includes a scene in which Cohen plays a hapless Austrian fashionista who requests a person he identifies as the head of the al Aqsa Martyrs Brigade to kidnap him to ensure his fame. Cohen later settled a lawsuit filed by the Christian Palestinian grocer whom he used in the scene, who claimed he had been duped and contested the claim about him.[32] Meanwhile, in both *Borat: Cultural Learnings of America for Make Benefit Glorious Nation of Kazakhstan* (2006) and *The Dictator* (2012), Cohen carefully crafted protagonists whom the films did not explicitly label as Muslim, but whom audiences likely would read as such because of their origin in Muslim-majority regions and emulation of anti-Muslim stereotypes like misogyny, conservativeness, and anti-Semitism. For instance, as Admiral General Aladeen of Wadiya (North Africa) in *The Dictator*, the bearded Cohen (figure 8.7) uses his country's oil wealth to build a nuclear weapon, entertain Osama bin Laden as a houseguest, and play a Wii game in which he beheads a captive.

Two other post-9/11 satires use Muslim terrorists as a context for their humor. *World Police: Team America* (2006) by *South Park* director Trey Parker imagines a team of American heroes who foil efforts by Derkaderkastan terrorists organized by North Korean leader Kim Jong-Il. The Derkaderkastanis speak gibberish except that "Allah," "Muhammad," and "jihad" pepper their exhortations. In *South Park* fashion, everything stands to ridicule, and both Team America and the WMD-hungry Derkaderkastanis are no different. Indeed, the film satirizes counterterrorism itself as the team destroys every major Parisian and Cairo landmark in their battles to save those cities from terrorist attacks. But in its portrayal of a team member surgically refashioned to fit among the terrorists, who all look and dress the same, the film depicts protagonist Gary Johnston (played by Parker) with darker skin, enhanced facial hair, and a turban (all maladroitly executed, of course). This bald assertion of stereotypes, hidden

Figure 8.7. This Spanish-language poster for *The Dictator* (2012) repeats themes of the Arab/Muslim as backward, brutish, and mock-worthy, while indicating the international reach of Hollywood films. Paramount Pictures/Photofest.

and reinforced by the laughs Gary's clumsy do-over is intended to foster, is paralleled in *Harold & Kumar Escape from Guantanamo Bay* (2007).

When the overzealous surveillance, detention, and prosecution of Muslims in the cause of antiterrorism ensnares Harold Lee and Kumar Patel, they find themselves in detention in Guantánamo Bay. Like Cohen's films, *Harold & Kumar* often plays into stereotypes (of Koreans, Southerners, and African Americans, among others) by offering the audience the opportunity to laugh at absurd, bigoted characters but in a manner that may only serve as an opportunity to enjoy the prejudice's enactment. For instance, the pair encounter three inmates in the infamous prison, one of whom says, "Well, maybe if people in your country stopped eating donuts and started realizing what their government is doing to the world, assholes like us wouldn't exist." The pair gets particularly and farcically angry at the disparagement of donuts. Yet meanwhile, all three inmates sport beards and dark complexions and speak with wide-eyed anger in Arabic accents. Hence, the moment for comedy eschews its own political commentary in favor of a quick laugh powered by a stereotype. In a different scene, a prejudiced Homeland Security agent interrogates two Jews while pouring out pennies. Although the two Jewish characters resent the insinuation, they eagerly collect the pennies at the interrogation's end. Although the film includes a moment in which Kumar responds to the same agent—"We're not even Muslim, you moron. And even if we were, that doesn't make us terrorists"—the line appears almost apologetic in light of the film's own unchallenged use of stereotypes.

Conclusion

While American perceptions of terrorism, Muslims, and Islamic traditions have shifted in the past half-century, Hollywood films have reflected both these changes as well as an unfortunate constancy. The dreadful events of September 11, 2001, have acted to crystallize and promote negative American attitudes toward Muslims and their religious traditions that conflate the two with violence against innocents. But, like some of the editorial cartoonists considered in the last chapter, many screenwriters and directors have also become more aware of these dynamics and worked to sidestep them. Although some have attempted this by including positive Muslim characters marked as "safe" because of their lack of public devotion, more films than before include images of positive Muslim characters performing Islamic practices (usually *salat*). Very few filmmakers have successfully portrayed Muslims as leading protagonists, and the fate of the television show *All-American Muslim* is perhaps instructive. During its first season portraying the everyday

lives of Muslim Americans in Dearborn, Michigan, the reality television show suffered a blow in 2011 when the Florida Family Association successfully convinced the hardware giant Lowe's to withdraw its advertising from the show, which the association described as "propaganda that riskily hides the Islamic agenda's clear and present danger to American liberties and traditional values."[33] The organization itself notes that its mission is to "educate people on what they can do to defend, protect and promote traditional, biblical values."[34] Ratings led the show's channel to cancel it at season's end. This interplay of Muslims, Islamic traditions, Christian traditions, secularism, media, and commerce demonstrates how American society has yet to arrive at a stable balance among these forces, thus leaving "Islamic terrorism" as a continually prominent and popular place for Americans to cinematographically encounter imagined Muslims, both American and non-American.

Conclusion

Common Denominators
versus Essential Difference

In response to the tragedies of September 11, the television series *The West Wing* diverged from its usual storyline with a special episode. Previously, the show, which depicted the lives of a fictitious president and his staff, did not include any Muslim characters unless the plot required a representative of an Arab government and usually when that government sponsored terrorism. In the special episode, a technical expert working in the White House comes under the sharp-edged suspicion of the chief of staff, who harshly interrogates him, already convinced that the man, a Muslim, conspires with terrorists. When proven wrong, the chief of staff proffers an awkward apology as the expression of the screenwriter's moral lesson that we must be careful about stereotypes. Indeed, as this, the last scene in the episode, fades to black, the Vietnam-era Buffalo Springfield song "For What It's Worth" emphasizes the point with its cautionary lyrics of fear instilled and sides taken. Yet these undoubtedly well-intentioned gestures notwithstanding, the silence of all the previous episodes in which nearly no character has a Muslim identity, despite the quite visibly Catholic and Jewish identities of two of the main characters, speaks far louder. Once again, the fact that the media maintains silence with regard to Muslims until they are perceived as a threat means that Muslims only become visible as people when they represent threats *as Muslims*, and thus they exist only as Muslims. This reinforces a negative view of Muslims and enduringly excludes them from the perceived American norm.

This anecdote demonstrates the larger argument of this book: media outlets have broadcast a series of repetitive messages regarding Muslims and

Islam that mutually reinforce negative views among American non-Muslims through both what they say, write, or show *and* what they do not say, write, or show. Because many perceive that Muslims as Muslims do not fit into the American norm, popular representations often have not depicted them as part of everyday American life. Instead, they have appeared when the need arises to include Muslims, and then, shorn of all other identities—like American or football fan or salesperson—they have stood as only Muslim men or Muslim women, to satisfy non-Muslim Americans' built-in expectations about what this means. And because they have existed only as Muslims, they have been assumed to live as a single community acting as a single body that is responsible for every member. Their concerns tend to be editorialized as those of a people apart from the West whose essential qualities put them at odds with the West, especially in terms of human rights. In other words, Muslim concerns arise from and reinforce a difference from those of the West. This is implicit in even the terms of the debate: Muslims versus the West, religion versus secularism.

Paradoxically, even American Muslims who successfully enter mainstream US life often attract negative media attention aroused by Islamophobia. For example, while interviewing Keith Ellison, the first Muslim elected to the House of Representatives, a CNN host in 2006 focused first on Ellison's Muslim identity. As a prelude for engaging him in his stand, shared by most of his Democrat colleagues, against the Iraq War, the host said to Ellison, "No offense, and I know Muslims. I like Muslims. And I have to tell you, I have been nervous about this interview with you, because what I feel like saying is, 'Sir, prove to me that you are not working with our enemies.'"[1] Not only have many members of the media characterized Muslims as Muslims to the exclusion of any other aspect of their identity—like being American—but some in the media have sought to benefit from those who would manipulate Islamophobia for political advantage. A few months after the CNN interview, both Fox News and the *New York Post* reported that Senator Barack Obama, a Democratic contender in the next presidential election, had attended a madrasa and was hiding his upbringing as a Muslim despite his self-representation as a Christian. CNN and a variety of newspapers quickly debunked the story as originating from a conservative online journal without any named author or source.[2] Although some media outlets may resist the temptation, many others have fed their audience's anxieties about Muslims, perpetuating notions of radical difference for the sake of ratings that surge through a sensationalism born at the intersection of fear and anger.

The controversy over the cartoons depicting the prophet Muhammad published in Danish and other European newspapers sadly illustrates this

conclusion. Almost immediately the Western media spun the issue as one fitting into a history of two irreconcilable worldviews locked in a zero-sum contest of survival: the inalienable freedoms of the West and the imperious orthodoxy of Islam. Any concession by either side represents a step backward.

Yet the conflict could easily have been portrayed as similar to previous debates in the West regarding the depiction of minority communities in popular media. Why the sudden amnesia about the vicious depictions of Jews in political cartoons from Nazi Germany? Why the forgetfulness that the Danish publication responsible for commissioning the images had refused a few years earlier to print a cartoon lampooning Jesus's resurrection because it might offend some Christians? Why the rarity of comparison to global Christian outrage regarding the release of the cinematic portrayal of Jesus in Martin Scorsese's *The Last Temptation of Christ* (1989) or similar protest against the satiric critique of Christianity in *Monty Python's Life of Brian* (1979)? Scorsese's film led not only to bomb threats at theaters in the United States but also bans in many nations. In another parallel, at least nine European nations today outlaw the public denial of the Holocaust or the diminishment of its actuality.[3] Instead of placing the controversy among these similar issues, most of the American media immediately depicted the debate as yet another emblem of Muslim difference and Islamic threat.

In fact, no freedom exists without limit. In the United States, hate-speech laws mete out punishment for certain types of invective accompanying violence. Unsubstantiated slander that damages an individual's reputation can be grounds for suit. Incitement to violence may lead to lawful arrest. Society defends coworkers from unwelcome verbal advances through sexual harassment codes.

Of course, as an element of news reporting and an expression of editorial opinion, political cartoons deserve special protection. They intend to provoke, usually relying on caricature, symbolism, and simplicity to express, in few or no words, their message. Throughout modern history and across the globe, such cartoons have enraged their targets by influencing their audiences. Such images can play an important role in public discourse regarding political, economic, social, and religious controversies.

However, various groups have long maintained a strict surveillance and engaged in practiced protests over editorial cartoons, having recognized that their powers of persuasion may run in damaging directions. The long list of stereotyped features (both physical and behavioral) associated with historically oppressed groups such as African Americans, Jews, women, Latino/as, Catholics, and gays and lesbians (to name but a few) need no rehearsal here: They have been publicly protested and successfully minimized, though not

entirely eliminated. Outrage has been the starting point of these groups' efforts to demonstrate that caricatures passing as common knowledge sometimes camouflage, often unconsciously, malicious stereotypes.

For many Muslims, the reduction of the prophet Muhammad to a symbol of terrorism reduced all Muslims to the stereotype of the terrorist. Muslim protest against the Danish cartoons escalated—entwined regionally with divergent political issues—from outrage against the disparagement not only of the exemplar of Islam but of Muslims themselves as well. Most Muslims understand Muhammad as the perfect manifestation of Islam's ideals, the founder of the first Islamic society, and the model of proper human behavior. Any depiction of him as a militant not only abases this beloved figure but also stains the character of Islam and, by default, impugns the very dignity of Muslims, who are already sensitive to Western slanders and suspicions from centuries of European imperial domination followed by today's American hegemony.

The violence that has occasionally accompanied the protests of this cartoon cannot be condoned. And critical inquiry must be protected. However, there must be a realistic recognition that none of the freedoms we embrace stand alone; rather, each balances against other freedoms in an ever-contested, dynamic tension. Westerners must also acknowledge that these particular cartoons exist not in isolation but as the latest manifestation of more than a millennium of Western portrayals of Muhammad as representing the antithesis of truth, godliness, morality, and freedom.

The fact that the same newspaper that originally ran the cartoon rejected cartoons satirizing Jesus because they would "provoke an outcry" demonstrates that its editors recognize that rights must be balanced with responsibility—or, at least, with the newspaper's economic interests. So why does the *potential* protest of Christians prompt an acceptable act of self-censorship while the *actual* protest of Muslims represents reprehensible censorship? The answer to this question rests in the all too readily anticipated conflict between "Islamic intolerance" and "Western truth"—an imagined tension perennially renewed yet a millennium old. The Associated Press gave voice to this view when it reported, "So far the West and Islamic nations remain at loggerheads over fundamental, but conflicting cultural imperatives—the Western democratic assertion of a right to free speech and press freedom, versus the Islamic dictum against any representation of the Prophet Muhammad."[4] Such an oversimplification erases the hundreds of years of cultural, political, military, and economic interactions between a wide variety of societies erroneously lumped together as "Western" or "Islamic."

The editors recognized the potential for caricatures of Jesus to be as inflammatory as the ones of Muhammad. The difference is not in the response but in the decision as to which expected outrage the newspaper sought to inflame and which it sought to avoid. The failure of most news outlets even to acknowledge the comparable earlier decision demonstrates another difference: Christian protests in Europe and the United States tend to be portrayed within a context of normal social negotiation while Muslim complaints are often depicted as a challenge to and rejection of essential societal ideals. Hence, Christians appear an unthreatening part of national debate (even when they are described as contributing to "culture wars") while Muslims materialize as foreign opponents to absolute Western principles such as "freedom of speech."

Despite the span of six decades and differences in location, cause, and actor, the events we have considered in the last century largely include the same set of basic images. Physiologically, the stereotype of the Semitic figure persists throughout these events, with the exception of the non-Arab Iranian Revolution. The ancient European-imagined tropes of Islam, represented through specific symbols, are continually applied to all things Middle Eastern: violence, irrationality, deserts, corrupt leadership, and sexuality. During the middle of the twentieth century, Americans generally did not yet view happenings in the Middle East as being influenced by Islamic traditions; rather, the threat was conceived in terms of the Cold War and as the danger of Pan-Arab nationalism. But cartoonists nonetheless drew on images they associated with Islam, having inherited these conceptions from the Orientalist artistic legacy of the United States, as well as from impressions—perhaps latent—of Islam understood from European history. During and after the Iranian Revolution, Americans came to recognize Islam as a dominant factor—that is, as a motivating force behind certain popular movements. But for political cartoonists, this shift in thought did not complicate their work: They already implicitly utilized Islam as a unifying, explanatory factor in cartoons about the Middle East. Throughout periods of conflict with the perceived Muslim world, Islam provided an understanding of why we were at odds. Historian Christina Michelmore nicely sums up the situation: "As an explanation, Islam eliminates space and time, political complications, ideological incompatibilities. Ageless Islam hates the west."[5] Meanwhile, fellow historian Cemil Aydin has demonstrated how the notion of a singular "Muslim world" has helped shape an ideal of a unified Christian and secular "West" through juxtapositions that—except in unusual moments of Islamophilia—valorize European and American "civilization" and its supposedly singular values.[6]

Of course, such reflections lead us to wonder how issues of representing others play out in non-American Muslim perspectives of Americans. Certainly the defining images in the US media of Muslim attitudes toward Americans—Iranians holding the hostages of the "Great Satan," the 757 poised just meters from the remaining World Trade Center tower, the Palestinian boy supposedly shooting his machine gun in celebration at the news—seem conclusive. But they are not.

Meanwhile, we must recognize the snowball effect some of these images entail. Because Americans tend to have little direct experience with Muslim-majority cultures, they tend to have less counterevidence to challenge what they read and see about those cultures. They are likely then not only to uncritically repeat these conclusions but also to confirm false impressions others might hold. So, for instance, it may not be coincidental that the movie *Argo* (2012) traded on many of the same themes and visual motifs of European American isolation in a sea of threatening Iranians as the anti-Iranian movie *Not Without My Daughter* (1991). After all, what American-made films take place in Iran to challenge such emotion-laden images and negative themes that the earlier movie and others of its ilk might have instilled in the producers of *Argo*?

This book could not hope to examine fully American and non-American portrayals of one another. Such a project requires far more expertise in the diverse historical, linguistic, and cultural backgrounds of Muslims than the authors command. As stated in the introduction, this imbalance is hardly a failure of American cartoons alone. It would be tempting to rely on US websites dedicated to malicious imaging by Muslims, but these selectively choose the most egregious examples from the start. It may appear helpful to examine websites that publish cartoonists from around the world, but these might edit for offensive content. To reach any conclusion beyond the most tenuous requires definitive research in indigenous languages and actual contexts. Moreover, the diversity among Muslim cultures must be taken into account. We fervently hope someone will take up this challenge.

How can the trends in America be addressed? Obviously, the essential simplicity of caricature in editorial cartoons will not change. However, other aspects easily can be altered, and some cartoonists already have made the effort. First, the fact could be recognized that Muslims take part in every aspect of American life as businesspeople, college students, government officials, and neighbors (figure C.1). Their inclusion in images depicting Americans *acting as Americans* would help reinforce this notion in the popular mind. Second, cartoons can use caricatures showing personal traits (as in figure C.2)—thus emphasizing individual differences—instead of stereotypes of group sameness.

Corky's Hawaii

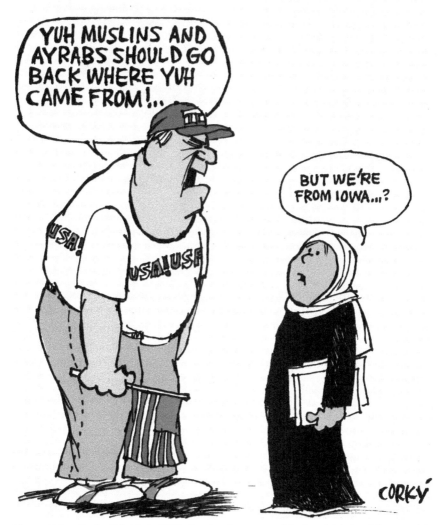

Figure C.1. Corky Trinidad, 2002. Reprinted courtesy of Corky Trinidad and the *Honolulu Star-Bulletin*.

Third, certain symbols by which cartoonists represent Islam should be abandoned since they represent a chauvinistic cultural memory rather than an accurate social reality. Finally, the multiplicity of Muslim perspectives need not be depicted as inherently resulting in violence, the diversity of Muslim cultures can be considered without concluding that Muslims essentially are

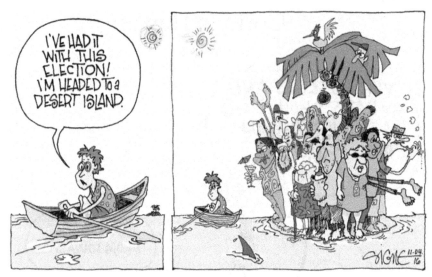

Figure C.2. Signe Wilkinson, 2016. Signe Wilkinson Editorial Cartoon is used with the permission of Signe Wilkinson, the Washington Post Writers Group, and the Cartoonist Group. All rights reserved.

divisive, and the pronouncements of vociferous Muslim ideologues should not be taken as though they represent Islam or hijackers as a whole. In other words, Muslims could be portrayed with the same nuance that most cartoonists bring to their depictions of Christians or Americans more generally.

Further and more in-depth research would certainly contribute to the effort of demonstrating these claims. Clearly the present volume exhausts neither the topic of Islamophobia nor its portrayal in political cartoons. A historically broader and historiographically more detailed examination of political cartoons would consider examples from several other periods, such as World War II, the Afghan resistance to the Soviet invasion, and the first Gulf War. Moreover, a critical engagement with the cartoons could be situated profitably in the larger context of the newspaper and its editorial pages, where the reader commonly sees them. Letters of response could offer important insights into reader reception.[7]

Other efforts could be made to broaden the research done here. For one thing, a more exhaustive survey comparing how American political cartoonists depict various national, racial, religious, and ethnic groups would be most helpful. Also, the work of Muslim cartoonists in the United States and abroad could be examined.

Happily, since the first edition of this volume was published in 2007, an impressive number of scholars, journalists, and activists have made signifi-

cant inroads through both historical and contemporary studies that explore dimensions of Islamophobia and anti-Muslim sentiment. Editorial cartoonists have contributed to the accumulating and deepening critique. Meanwhile, self-identified Muslim characters and characters sporting markers of Muslim identity increasingly find space as part of the normative social fabric within the frames of American representations. From Peter Parker's hijab-wearing classmate sitting almost unnoticeably behind him in *Spider-Man: Homecoming* (2017) to the Iranian American Dinah Madani who serves as a Homeland Security agent in the Netflix series *The Punisher* (2017), increasing numbers of characters counterbalance the Muslims who still serve as foils in popular media. Finally, many news outlets have offered more portrayals of Muslim lives outside of violent contexts and shown more restraint in immediately assigning Muslims blame for mass shootings.

In the wake of violence that some Muslims have perpetuated in the West, many observers have questioned the wisdom of inviting Muslims to settle here. We hope that this book adds to a conversation that wonders not only about the unwillingness of some of these migrants to acculturate to the American norm but also about the inability of many non-Muslim Westerners to imagine Muslims being not just "them" but "us" (as in figure C.3). No matter what ideologues on either side say, the large population of

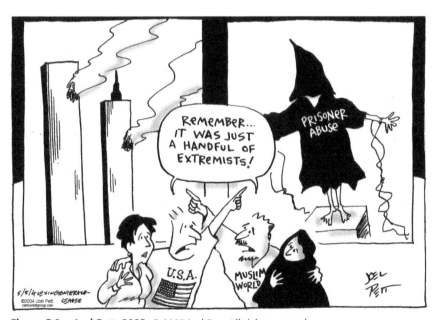

Figure C.3. Joel Pett, 2005. © 2005 Joel Pett. All rights reserved.

American Muslims, to which the increasing number of conversions to Islam in the United States adds annually, means that America is already part of the Muslim world, if there is such a thing. They have already become us. The question remains whether messages in the media will enable the many Muslims who simply wish to lead their lives untroubled among their non-Muslim neighbors to feel included or not. If alienation will be the rule, then it becomes easy to expect Muslims domestically—as so many have abroad—to turn back on non-Muslim Americans the question: "Why do they hate us?"

Glossary

Although this book avoids the use of diacritics as unnecessary for the general audience, diacritics and transliterated renderings of terms from their original are provided here for interested readers. Arabic proper names and place names are given in their original.

Abraham *ibrāhīm*; patriarch and prophet considered a friend of God because of his total devotion, as demonstrated by his sacrifice of son Ishmael.

Allah *allāh*; "the One" or the only god.

burqa *burqaʿ*; a full-length covering some Muslim women wear to completely clothe themselves.

hajj *ḥajj*; the annual pilgrimage to Mecca and Medina to visit the sites associated with the prophets.

hijab *ḥijāb*; a scarf that some Muslim women use to cover part of their head; a variety of forms exist.

Ishmael *ismāʿīl*; celebrated as the son of Abraham and Hagar whom the former nearly sacrificed in obedience to Allah.

Islam *islām*; "to submit."

Jerusalem *al-quds*; popularly recognized site of Muhammad's ascent to Paradise and, therefore, third most revered site for many Muslims.

Jesus 'īsā; one of the book-delivering prophets, he revealed the
 Gospels to humanity; ascended into heaven without dying
 and will return to announce Judgment Day.

jihad jihād; "righteous struggle" that can be against evil in oneself
 or external enemies.

Kaba ka'ba; the mammoth, cube-shaped building (from which the
 English term "cube" derives) considered the first mosque,
 variously described as built by Adam or Abraham; almost
 all Muslims face in the direction of the Kaba while pray-
 ing salat.

kaffiyeh kaffiyah; an Arab headdress worn by some men.

Mecca makka; the birthplace of the prophet Muhammad, the site of
 the Kaba, and the most revered place among most Muslims.

Medina madīna; adopted home of the prophet Muhammad, site of the
 first Islamic society, and the second most revered place
 among most Muslims.

Muhammad muḥammad; 570?–632 CE; considered by most Muslims as the
 final prophet to whom Allah sent the final revelation—
 the Quran—and the leader of the first Muslim society.

Muslim muslim; "one who submits."

People of ahl al-kitāb; the Quran's designation for the Jews, Christians,
 the Book Muslims, and Sabians (whose identity is variably inter-
 preted), communities to whom revealed books were sent.

Quran qur'ān; the final revelation of Allah, transmitted to humanity
 through Muhammad.

salat ṣalāt; the formal, five-times-daily prayer performed by many
 Muslims, comprised of a series of standing, bowing, kneel-
 ing, and prostrate positions.

sharia sharī'ah; the collective name for formal Islamic legal tradi-
 tions; also used to reference a specific school of law from
 among the many that exist.

Notes

Introduction to the Second Edition

1. John E. Woods, "Imagining and Stereotyping Islam," in *Muslims in America: Opportunities and Challenges*, ed. Asad Husain, John E. Woods, and Javeed Akhter (Chicago: International Strategy and Policy Institute, 1996), 45.

2. Michael Lipka, "Muslims and Islam: Key Findings in the U.S. and around the World," Pew Research Center, August 9, 2017, accessed October 1, 2017, http://www.pewresearch.org/fact-tank/2017/08/09/muslims-and-islam-key-findings-in-the-u-s-and-around-the-world.

3. Sami Aziz, "Is Black Panther Islamophobic?" Medium, February 19, 2018, accessed March 22, 2018, https://medium.com/@Chaplain_Aziz/black-panther-is-islamophobic-f3ad73b7bc9f.

4. For examples of such testimony, see Fadwa El Guindi, *Veil: Modesty, Privacy and Resistance (Dress, Body, Culture)* (New York: Berg, 1999); Sherifa Zuhur, *Revealing Reveiling: Islamist Gender Ideology in Contemporary Egypt* (Albany, NY: SUNY Press, 1992); Elizabeth Warnock Fernea, *In Search of Islamic Feminism: One Woman's Global Journey* (New York: Doubleday, 1998).

5. Open Letter to Al-Baghdadi, accessed March 22, 2018, http://www.letterto baghdadi.com.

6. Michael Lipka, "How Many People of Different Faiths Do You Know?" Pew Research Center, July 17, 2014, accessed October 1, 2017, http://www.pewresearch.org/fact-tank/2014/07/17/how-many-people-of-different-faiths-do-you-know.

7. For negative depictions in literature see Edward Said, *Orientalism* (New York: Vintage Books, 1979); on film see Jack Shaheen, *Reel Bad Arabs: How Hollywood Vilifies a People* (New York: Olive Branch Press, 2001); and on the media in general

see Melani McAlister, *Epic Encounters: Culture, Media, and U.S. Interests in the Middle East, 1945–2000* (Berkeley: University of California Press, 2001).

8. "Muslims Must Speak Out," *The Day* (New London), July 20, 2005, A6.

9. Peter Gottschalk and Gabriel Greenberg, *Islamophobia: Making Muslims the Enemy* (Lanham, MD: Rowman & Littlefield, 2007), 11.

Chapter 1: How Cartoons Work and Why Images Matter

1. Avi Selk, "Shariah Flap Pushes Irving Mayor into National Spotlight," Dallas News, July 2015, accessed October 1, 2017, https://www.dallasnews.com/news /irving/2015/07/28/shariah-flap-pushes-irving-mayor-into-national-spotlight.

2. Nigel Duara, "Man Tied to Cartoon Contest Attack Accessed Islamic State List, Authorities Say," *Los Angeles Times*, December 24, 2015, accessed October 1, 2017, http://www.latimes.com/nation/la-na-garland-attack-20151224-story.html.

3. Ian Black, "Charlie Hebdo Killings Condemned by Arab States—But Hailed Online by Extremists," *Guardian* (US edition), January 7, 2015, accessed October 1, 2017, https://www.theguardian.com/world/2015/jan/07/charlie-hebdo-killings-arab -states-jihadi-extremist-sympathisers-isis.

4. Flemming Rose, "Why I Published Those Cartoons," *Washington Post*, February 19, 2006, accessed October 1, 2017, http://www.washingtonpost.com/wp-dyn /content/article/2006/02/17/AR2006021702499.html.

5. Anthony Shadid and Kevin Sullivan, "Anatomy of the Cartoon Protest Movement; Opposing Certainties Widen Gap between West and Muslim World," *Washington Post*, February 16, 2006, A01.

6. Mark MacKinnon, "Word of Mouth Helping to Feed Muslim Rage over Cartoons," *Globe and Mail* (Toronto), February 10, 2006, A10.

7. Alan Cowell, "West Beginning to See Wide Islamic Protests as Sign of Deep Gulf," *New York Times*, February 9, 2006, A1.

8. Krishnadev Calamur, "No Regrets for Organizer of Muhammad Cartoon Contest," NPR, May 7, 2015, accessed October 1, 2017, http://www.npr.org/sections /thetwo-way/2015/05/07/405052650/no-regrets-for-organizer-of-muhammad-cartoon -contest.

9. Stephen Hess and Milton Kaplan, *The Ungentlemanly Art: A History of American Political Cartoons*, rev. ed. (New York: Macmillan, 1975), 13.

10. Christina Michelmore, "Old Pictures in New Frames: Images of Islam and Muslims in Post World War II American Political Cartoons," *Journal of American & Comparative Cultures* 23 (Winter 2000): 37.

11. Ethan Bronner, email correspondence with the authors, November 17, 2003. Mr. Bronner was assistant editorial page editor of the *New York Times* and in this quote paraphrased the view of Gail Collins, editorial page editor of the *Times*.

12. Walt Kelly, "Pogo Looks at the Abominable Snowman," in *The Funnies: An American Idiom*, ed. David Manning White and Robert Abel (New York: Free Press of Glencoe, 1963), 290.

13. Duara, "Man Tied to Cartoon Contest Attack Accessed Islamic State List, Authorities Say."

14. Rose, "Why I Published Those Cartoons."

15. David W. Dunlap, "A Statue of Muhammad on a New York Courthouse, Taken Down Years Ago," *New York Times*, January 9, 2015, accessed October 1, 2017, https://www.nytimes.com/2015/01/10/nyregion/a-statue-of-muhammad-on-a -new-york-courthouse-taken-down-years-ago.html?mcubz=3.

16. Michael Calderone, "New York Times Only Top U.S. Newspaper Not to Publish Charlie Hebdo Cover," *HuffPost*, January 14, 2015, accessed October 1, 2017, http://www.huffingtonpost.com/2015/01/14/new-york-times-charlie-hebdo_ n_6470338.html.

17. Keach Hagey, "Karzai Criticized for Feeding Quran Burning Firestorm," Politico, April 4, 2011, accessed October 1, 2017, http://www.politico.com/blogs /onmedia/0411/Karzai_criticized_for_feeding_Quran_burning_firestorm.html.

18. Saba Mahmood, *Politics of Piety: The Islamic Revival and the Feminist Subject* (Princeton, NJ: Princeton University Press, 2011), 11.

19. "NAACP Calls for Firing of N.Y. Post Cartoonist," CNN, February 21, 2009, October 1, 2017, http://www.cnn.com/2009/US/02/21/chimp.cartoon.

Chapter 2: Overview of Western Interactions with Muslims

1. From http://www.msnbc.com/news/980841.asp, accessed October 21, 2003 (site discontinued).

2. The outcry did prompt General Boykin to claim that his comments had been misinterpreted. "My comments to Osman Otto in Mogadishu were not referencing his worship of Allah but his worship of money and power; idolatry," Boykin said. "He was a corrupt man, not a follower of Islam." Matt Kelley, "General Apologizes to Those Offended by His Religious Comments," Associated Press, October 17, 2003.

3. The terms "Muslim" and "Islam" are less immediately related to the Arabic word *salam* ("peace").

4. All Quranic quotations derive from Majid Fakhry, trans., *An Interpretation of the Qur'an: English Translation of the Meanings* (New York: NYU Press, 2004).

5. Frederick Denny, *An Introduction to Islam*, 4th ed. (New York: Macmillan, 2010), 135.

6. Musa ibn Ishaq, *The Life of Muhammad*, trans A. Guillaume (Karachi: Oxford University Press, 1987), 683.

7. Titus Burckhardt, *Mirror of the Intellect: Essays on Traditional Science & Sacred Art*, trans. William Stoddart (Albany, NY: SUNY Press, 1987), 96.

8. Dante Alighieri, *The Divine Comedy*, trans. Henry Francis Cary (New York: Thomas Y. Crowell & Company, 1897), 154–55.

9. Denny, *Introduction to Islam*, 136.

10. From http://www.msnbc.com/news/980841.asp, accessed October 21, 2003 (site discontinued).

11. See John V. Tolan, *Saint Francis and the Sultan: The Curious History of a Christian-Muslim Encounter* (New York: Oxford University Press, 2009).

12. Albert Hourani, *Islam in European Thought* (Cambridge: Cambridge University Press, 1991), 9.

13. Elizabeth Siberry, "Images of the Crusades in the Nineteenth and Twentieth Centuries," in *The Oxford Illustrated History of the Crusades*, ed. Jonathan Riley-Smith (New York: Oxford University Press, 1995), 385.

14. Narcus Bull, "Origins," in *Oxford Illustrated History of the Crusades*, 31.

15. Robert E. Van Voorst, *Readings in Christianity* (New York: Wadsworth, 1997), 121.

16. Robert M. Seltzer, *Jewish People, Jewish Thought: The Jewish Experience in History* (New York: Macmillan, 1980), 355.

17. Jonathan Riley-Smith, "The Crusading Movement and Historians," in *Oxford Illustrated History of the Crusades*, 4.

18. Debra Higgs Strickland, *Saracens, Demons, & Jews: Making Monsters in Medieval Art* (Princeton, NJ: Princeton University Press, 2003), 188–89.

19. W. Montgomery Watt, *The Influence of Islam on Medieval Europe* (Edinburgh: Edinburgh University Press, 1972), 46.

20. Europeans came to know the Iberian Muslims as Moors. The term derives from Mauretania, an ancient Roman province in North Africa from which the Muslims who invaded the Iberian Peninsula originated.

21. Watt, *Influence of Islam*, 46.

22. Norman Housley, "The Crusading Movement: 1274–1700," in *Oxford Illustrated History of the Crusades*, 268–69.

23. Christopher Columbus, *The Libro de las profecías of Christopher Columbus: An en face edition*, trans. Delno West and August Kling (Gainesville: University of Florida Press, 1992), 63.

24. This global perspective on Western imperialism and hegemony derives from the work of preeminent world historian of Islam Marshall Hodgson, particularly the third volume of his authoritative *The Venture of Islam* (Chicago: University of Chicago Press, 1974).

25. Quote from Nathaniel Morton in 1669, in Kathleen Donegan, *Seasons of Misery: Catastrophe and Colonial Settlement in Early America* (Philadelphia: University of Pennsylvania Press, 2014), 131.

26. Peter Gottschalk, *American Heretics: Catholics, Jews, Muslims, and the History of Religious Intolerance* (New York: Palgrave Macmillan, 2013), 7–28.

27. Syed Ahmad Khan, "The Importance of Modern Western Education," in chapter 5 of *Sources of Indian Tradition*, vol. 2, *Modern India and Pakistan*, ed. Stephen Hay (New York: Columbia University Press, 1988), 189.

28. William Muir, quoted in Hourani, *Islam in European Thought*, 19.

29. Michael A. Gomez, *Exchanging Our Country Marks: The Transformation of African Identities in the Colonial and Antebellum South* (Chapel Hill: University of North Carolina Press, 1998), 67.

30. Allan D. Austin, *African Muslims in Antebellum America: Transatlantic Stories and Spiritual Struggles* (New York: Routledge, 1997), 12.

31. Sylviane A. Diouf, *Servants of Allah: African Muslims Enslaved in the Americas* (New York: New York University Press, 1998), 17–18.

32. David Nirenberg, "Race and the Middle Ages: The Case of Spain and Its Jews," in *Rereading the Black Legend: The Discourses of Religious and Racial Difference in the Renaissance Empires*, ed. Maureen Quilligan, Walter Mignolo, and Margaret Rich Greer (Chicago: University of Chicago Press, 2007), 79.

33. Diouf, *Servants of Allah*, 149.

34. Diouf, *Servants of Allah*, 54.

35. Austin, *African Muslims in Antebellum America*, 13.

36. Diouf, *Servants of Allah*, 99–100.

37. Gomez, *Exchanging Our Country Marks*, 68, 82.

38. As quoted in Austin, *African Muslims in Antebellum America*, 79; Mark Twain, "American Travel Letters, Series 2 [the last letter]," *Alta California*, August 1, 1869.

39. Robert J. Allison, *The Crescent Obscured: The United States and the Muslim World, 1776–1815* (New York: Oxford University Press, 1996), 35.

40. Allison, *Crescent Obscured*, 40.

41. Allison, *Crescent Obscured*, 46.

42. Allison, *Crescent Obscured*, 59.

43. Allison, *Crescent Obscured*, 10.

44. Francis Scott Key, "Song," in *Poems of the Late Francis Scott Key, Esq.* (New York: Robert Carter & Brothers, 1857), 34–36.

45. Allison, *Crescent Obscured*, 33.

46. Holly Edwards, "A Million and One Nights: Orientalism in America, 1870–1930," in *Noble Dreams, Wicked Pleasures: Orientalism in America, 1870–1930*, ed. Holly Edwards (Princeton, NJ: Princeton University Press, 2000), 39–40.

47. Edwards, "A Million and One Nights," 43, 50.

48. Shaheen, *Reel Bad Arabs*, 424–25.

49. Frank Ninkovich, *The United States and Imperialism* (Oxford: Blackwell, 2001), 32.

50. Ninkovich, *The United States and Imperialism*, 52.

51. McAlister, *Epic Encounters*, 37–38.

52. Jane I. Smith, *Islam in America*, 2nd ed. (New York: Columbia University Press, 2009), 53.

53. McAlister, *Epic Encounters*, 49.

54. McAlister, *Epic Encounters*, 52.

55. McAlister, *Epic Encounters*, 81.

56. Charles Tripp, *A History of Iraq* (Cambridge: Cambridge University Press, 2002), 31.

Chapter 3: Symbols of Islam, Symbols of Difference

1. Paradoxically, in typical cases of derogatory names used by the majority (such as "nigger"), oppressed minorities have often appropriated the symbols of their sub-jugation and converted them into symbols of pride, as many lesbians and gays have taken the Nazi-derived symbol as their own. In so doing, these groups assert agency

over the symbols and slurs used in their oppression, transforming them—at least for themselves—into symbols and names of pride and unity.

2. Helmut Nickel, "A Crusader's Sword: Concerning the Effigy of Jean d'Alluye," *Metropolitan Museum Journal* 26 (1991): 123.

3. The authoritative *Oxford English Dictionary* fails to find an adequate etymology for the term. One of the more plausible origins is the Persian *shamshir*, which refers to a sword with a sharply curved blade first produced in seventeenth-century Persia. See A. R. Zaky, "Medieval Arab Arms," in *Islamic Arms and Armour*, ed. Robert Elgood (London: Scholar Press, 1979), 211.

4. George S. Patton Jr., "The Form and Use of the Saber," *Cavalry Journal*, March 1913.

5. For a brief history of the US Marine Corps sword, see "Module 3," *USMC Culture*, http://www.hqmc.marines.mil/Portals/143/Presentations/Marine%20Corps%20 Acculturation/Module%203%20Culture.pdf, 11; accessed February 17, 2018.

6. Erika Bourguignon, "Vienna and Memory: Anthropology and Experience," *Ethos* 24, no. 2 (June 1996): 379.

7. Cemil Aydin, *The Idea of the Muslim World: A Global Intellectual History* (Cambridge, MA: Harvard University Press, 2017), 93–94.

8. Interestingly, Conrad used this same technique in a 1970 cartoon depicting a Southeast Asian city bombed by Americans. See Foreign Policy Association, *A Cartoon History of United States Foreign Policy, 1776–1976* (New York: William Morrow, 1975), 147.

9. For a fully articulated argument for and demonstration of this, see Leila Ahmed's *A Border Passage: From Cairo to America—A Woman's Journey* (New York: Penguin, 2000), 93–134.

10. For two excellent examples from Egypt, see Mahmood, *Politics of Piety*; and Sherine Hafez, *An Islam of Her Own* (New York: NYU Press, 2011).

Chapter 4: Stereotyping Muslims and Establishing the American Norm

1. Aasif Mandvi, "How Aasif Mandvi Became 'The Jihadist of Irony' for *The Daily Show*," *Vanity Fair*, October 29, 2014, accessed August 24, 2017, https://www .vanityfair.com/hollywood/2014/10/aasif-mandvi-daily-show.

2. Sherman Jackson, "Muslims, Islam(s), Race, and American Islamophobia," in *Islamophobia: The Challenge of Pluralism in the 21st Century*, eds. John L. Esposito and Ibrahim Kalin (New York: Oxford University Press, 2011), 93–106.

3. Randall P. Harrison, *The Cartoon: Communication to the Quick* (Beverly Hills, CA: SAGE, 1981), 54.

4. William Feaver, "Introduction," in *Masters of Caricature*, ed. Ann Gould (New York: Knopf, 1981), 10–12. It may not always be clear whether the features of a caricature originally become associated with a specific animal because of a perception of

the nature of the animal or because of a perceived likeness between the animal and a vilified group of people.

5. Ronald Stockton, "Ethnic Archetypes and the Arab Image," in *The Development of Arab-American Identity*, ed. Ernest McCarus (Ann Arbor: University of Michigan Press, 1994), 119.

6. Walter Lippmann, *Public Opinion* (New Brunswick, NJ: Transaction, 1991), 31, 89.

7. Valarie Kaur, "His Brother Was Murdered for Wearing a Turban after 9/11," Public Radio International, September 23, 2016, accessed March 25, 2018, https://www.pri.org/stories/2016-09-23/his-brother-was-murdered-wearing-turban-after-911-last-week-he-spoke-killer.

8. The image originates from an advertisement for a Parisian anti-Semitic publication. See Gertrude Himmelfarb, "The Jewish Question: Then and Now," *Weekly Standard*, June 20, 2016, accessed September 9, 2017, http://www.weeklystandard.com/the-jewish-question/article/2002778.

9. Of more than passing interest, the American caricature was published by JTA, the self-described "global news service of the Jewish people" (http://www.jta.org). Jeremy Zwelling argues that once they have obtained a position of perceived acceptance, it is not unusual for Jews, like other groups that have suffered oppression, to turn the themes of their oppressors against other opponents (personal conversation, May 3, 2006). See Amnon Rubinstein's *The Zionist Dream Revisited: From Herzl to Gush Emunim and Back* (New York: Schocken, 1984).

10. Timothy Williams, "The Hated and the Hater, Both Touched by Crime," *The New York Times*, July 18, 2011, accessed March 25, 2018, https://www.nytimes.com/2011/07/19/us/19questions.html.

11. John L. Esposito and Dalia Mogahed, *Who Speaks for Islam? What a Billion Muslims Really Think* (New York: Gallup, 2007), 49.

12. George W. Bush, Address to a Joint Session of Congress and the American People, Office of the Press Secretary, September 20, 2001, accessed April 21, 2006, http://www.whitehouse.gov/news/releases/2001/09/20010920-8.html (site discontinued).

13. Allison, *Crescent Obscured*, 43–45.

14. Allison, *Crescent Obscured*, 46, 53.

15. Mahmood Mamdani, *Good Muslim, Bad Muslim: America, the Cold War, and the Roots of Terror* (New York: Pantheon, 2004), 17–19.

16. "President Commemorates Veterans Day, Discusses War on Terror," November 11, 2005, accessed November 13, 2005, http://www.whitehouse.gov/news/releases/2005/11/20051111-1.html (site discontinued).

Chapter 5: Extreme Muslims and the American Middle Ground

1. *National Geographic*, February 2002.

2. Don Belt, ed., *The World of Islam* (Washington, DC: National Geographic, 2001), 1–13.

3. Rahimeh Andalibian, *The Rose Hotel: A Memoir of Secrets, Loss, and Love from Iran to America* (Washington, DC: National Geographic, 2015), 284.

4. Frank Newport, "Six in 10 Americans Would Say 'Yes' to Muslim President," Gallup, September 22, 2015, accessed September 10, 2017, http://www.gallup.com /opinion/polling-matters/185813/six-americans-say-yes-muslim-president.aspx.

5. McAlister, *Epic Encounters*, 52.

6. The use of the term "fundamentalist" represents yet another imposition of Christian concepts on Islam. An early twentieth-century American Christian revivalist movement originated the term to describe its quest to return to Christianity's fundamental beliefs. Since the latter part of that century, common usage has ascribed a negative connotation to the term, suggesting a religious impulse prone to narrow-mindedness and dogmatism.

7. See Erica Bornstein, *The Spirit of Development: Protestant NGOs, Morality, and Economics in Zimbabwe* (Stanford, CA: Stanford University Press, 2005).

8. Jeff Sharlet, "Jesus Killed Mohammed: The Crusade for a Christian Military," *Harper's* (May 2009): 31–43.

9. Tripp, *History of Iraq*, 31.

10. George W. Bush, Speech delivered at Elmendorf Air Force Base in Anchorage, Alaska, November 14, 2005, accessed May 16, 2006, http://www.whitehouse .gov/news/releases/2005/11/20051114-3.html (site discontinued).

11. Daniel L. Byman and Jennifer R. Williams, "ISIS vs. Al Qaeda: Jihadism's Global Civil War," Brookings Institute, February 24, 2015, accessed March 28, 2018, https://www.brookings.edu/articles/isis-vs-al-qaeda-jihadisms-global-civil-war.

12. See "The Nation of Islam," FBI Records: The Vault, https://vault.fbi.gov/Na tion%20of%20Islam.

13. Although based on the autobiography of a woman who, with her child, was forced by her Iranian American husband to remain in Iran after a visit there, the film exaggerates what the victim wrote by portraying not a few but all Muslim Iranians as uniformly antagonistic to her and her plight.

14. McAlister, *Epic Encounters*, 51–53. For a critique of the notion of an "Islamic" or "Muslim world," see Aydin, *Idea of the Muslim World*.

15. "Radio Address by Mrs. Bush," White House Archives, November 17, 2001, accessed October 1, 2017, https://georgewbush-whitehouse.archives.gov/news/re leases/2001/11/20011117.html.

16. "Misleading Information from the Battlefield: The Tillman and Lynch Episodes. First Report by the Committee on Oversight and Government Reform Together with Additional Views," September 16, 2008. Washington, DC: US Government Printing Office, 2008; Abigail Pesta, "I'm Jessica Lynch and Here's My Real Story," *Glamour*, June 3, 2007, accessed March 30, 2018, https://www.glamour.com /story/jessica-lynch.

17. "Background on Women's Status in Iraq Prior to the Fall of the Saddam Hussein Government," Human Rights Watch, November 2003, accessed May 7, 2006, http://www.hrw.org/backgrounder/wrd/iraq-women.htm.

18. For a personal account of the role of elder women as Islamic teachers, see Ahmed's *A Border Passage*. For a study of Egyptian women choosing to wear head scarves and face covering, see Zuhur, *Revealing Reveiling*.

19. For instance, the National Center for Injury Prevention and Control, part of the Centers for Disease Control and Prevention, reports that more than 5 million incidents of women victimized by intimate partners occur in the United States each year. This leads to almost 2 million injuries and nearly 1,300 deaths annually. Overall, almost 30 percent of all American women have been physically or psychologically assaulted or raped by someone they knew well at one time in their lives. See "Intimate Partner Violence: Overview," Centers for Disease Control, accessed March 17, 2006, http://www.cdc.gov/ncipc/factsheets/ipvfacts.htm.

20. Laurie Marczak et al., "Firearm Deaths in the United States and Globally, 1990–2015," JAMA 316, no. 22 (December 13, 2016): 2347, doi:10.1001 /jama.2016.16676.

Chapter 6: Moments: 1956–2006

1. Besheer Mohamed, "A New Estimate of the U.S. Muslim Population," Pew Research Center, January 6, 2016, accessed September 14, 2017, http://www.pew research.org/fact-tank/2016/01/06/a-new-estimate-of-the-u-s-muslim-population.

2. Peter Hahn, "National Security Concerns in U.S. Policy toward Egypt, 1949–1956," in *The Middle East and the United States: A Historical and Political Reassessment*, ed. David W. Lesch (Boulder, CO: Westview Press, 2003), 91.

3. Stephen E. Ambrose and Douglas G. Brinkley, *Rise to Globalism: American Foreign Policy since 1938* (New York: Penguin, 1997), 153–57.

4. McAlister, *Epic Encounters*, 81.

5. Many of the images used here were featured in the Foreign Policy Association's *A Cartoon History of United States Foreign Policy, 1776–1976*.

6. Ambrose and Brinkley, *Rise to Globalism*, 158.

7. Bill Mauldin, "Well! This Is a Surprise," *St. Louis Post-Dispatch*, August 30, 1961, Library of Congress, CD 1–Mauldin, no. 766 (A size).

8. We thank Bruce Masters for this insight.

9. Ambrose and Brinkley, *Rise to Globalism*, 263.

10. Higgins, "In Quest for Energy Security," A6.

11. McAlister, *Epic Encounters*, 135.

12. Woods, "Imagining and Stereotyping Islam," 67.

13. Coincidentally (and accurately) enough, the painting provides the cover art for Edward Said's *Orientalism*.

14. McAlister, *Epic Encounters*, 136.

15. Ambrose and Brinkley, *Rise to Globalism*, 293–98.

16. Ambrose and Brinkley, *Rise to Globalism*, 298.

17. Said, *Covering Islam*, 6.

18. Ralph Edward Dowling, "Rhetorical Vision and Print Journalism: Reporting the Iran Hostage Crisis in America" (PhD diss., University of Denver, 1984), ii. Dowling contrasts this with the portrayal of Carter, whose descriptions included good leader, restrained, Christian, humanitarian, concerned for the hostages, politically motivated, and then finally, bad leader.

19. Roham Alvandi, *Nixon, Kissinger, and the Shah: The United States and Iran in the Cold War* (New York: Oxford University Press, 2016), 126–70.

20. Art Bimrose, "Favorite Pipeline," March 4, 1953, Library of Congress Prints & Photographs Division. DLC/PP-1953:R9.12.

21. For scholarship on this trend, see El Guindi, *Veil*.

22. Shelly Slade, "The Image of the Arab in America, Analysis of a Poll on American Attitudes," *Middle East Journal* 35, no. 2 (Spring 1981): 148.

23. For samples of these Muslim condemnations, see the bibliography.

24. Frank Newport, "Americans Still Think Iraq Had Weapons of Mass Destruction before War," Gallup, June 16, 2003, accessed September 28, 2017, http://news .gallup.com/poll/8623/americans-still-think-iraq-had-weapons-mass-destruction-be fore-war.aspx.

Chapter 7: Since 2006: The Emotions of Resurgent Nativism and Liberal Empathy

1. Elaine Hatfield and Richard L. Rapson, "Emotional Contagion: Religious and Ethnic Hatreds and Global Terrorism," in *The Social Life of Emotions*, ed. Larissa Z. Tiedens and Colin Wayne Leach (New York: Cambridge University Press, 2004), 140.

2. Theodore Schleifer, "Donald Trump: 'I Think Islam Hates Us,'" CNN, March 10, 2016, accessed September 16, 2017, http://www.cnn.com/2016/03/09/politics /donald-trump-islam-hates-us.

3. Law enforcement authorities contradicted Trump's claim, which no news accounts could corroborate either. See Glenn Kessler, "Trump's Outrageous Claim That 'Thousands' of New Jersey Muslims Celebrated the 9/11 Attacks," *Washington Post*, November 22, 2015, accessed September 17, 2017, https://www.washingtonpost .com/news/fact-checker/wp/2015/11/22/donald-trumps-outrageous-claim-that-thou sands-of-new-jersey-muslims-celebrated-the-911-attacks/?tid=a_inl&utm_term =.e756e8dbead4.

4. Sean McElwee, "The Hidden Racism of Young White Americans," PBS, March 24, 2015, accessed September 16, 2017, http://www.pbs.org/newshour/updates /americas-racism-problem-far-complicated-think.

5. Catherine A. Lutz and Lila Abu-Lughod, "Introduction," in *Language and the Politics of Emotion*, ed. Catherine A. Lutz and Lila Abu-Lughod (New York: Cambridge University Press, 1999), 10–13.

6. Lutz and Abu-Lughod, "Introduction," 13–17.

7. Kayla Epstein, "Five of John McCain's Most Courageous Political Moments," *Washington Post*, July 20, 2017, accessed October 2, 2017, https://www.washington

post.com/news/the-fix/wp/2017/07/20/five-of-john-mccains-most-courageous-politi
cal-moments/?utm_term=.21fb04d74c46.

8. Brian Montopoli, "Fears of Sharia Law Grow among Conservatives," CBS News, October 13, 2010, accessed October 2, 2017, https://www.cbsnews.com/news /fears-of-sharia-law-in-america-grow-among-conservatives.

9. "Republican Debate," CNN, June 13, 2011, accessed October 2, 2017, http:// transcripts.cnn.com/TRANSCRIPTS/1106/13/se.02.html.

10. "Anti-Sharia Law Bills in the United States," SPLC, August 8, 2017, accessed April 8, 2018, https://www.splcenter.org/hatewatch/2018/02/05/anti-sharia -law-bills-united-states.

11. Abram Rosenblatt et al., "Evidence for Terror Management Theory: I. The Effects of Mortality Salience on Reactions to Those Who Violate or Uphold Cultural Values," *Journal of Personality and Social Psychology* 57, no. 4 (1989): 681–90. Jeff Greenberg et al., "Evidence for Terror Management Theory: II. The Effects of Mortality Salience on Reactions to Those Who Threaten or Bolster the Cultural Worldview," *Journal of Personality and Social Psychology* 58, no. 2 (1990): 308–18. Jacob Juhl and Clay Routledge, "Putting the Terror in Terror Management Theory: Evidence That the Awareness of Death Does Cause Anxiety and Undermine Psychological Well-Being," *Current Directions in Psychological Science* 25, no. 2 (2016): 99–103. Our appreciation to Sarah Kamens for insight into this phenomenon and suggested research.

12. See Sam Keen, *Faces of the Enemy: Reflections of the Hostile Imagination* (New York: Harper & Row, 1991).

13. Talal Asad, "Introduction: Thinking about Secularism," in *Formations of the Secular: Christianity, Islam, Modernity* (Stanford, CA: Stanford University Press, 2003), 5.

14. Jess Staufenberg, "Khizr Khan's DNC 2016 Speech: Read the Full Transcript from the Grieving Muslim Father Who Addressed Donald Trump," *Independent*, July 29, 2016, accessed April 30, 2017, http://www.independent.co.uk/news/world /americas/dnc-2016-khizr-khan-donald-trump-read-full-transcript-father-muslim-sol dier-a7161616.html.

15. Jackson borrows the term "racially authentic Americans" from James Baldwin. See Jackson, "Muslims, Islam(s), Race, and American Islamophobia," 95.

16. CNN and ORC International, "Poll 9," September 4–8, 2015, 15.

17. Mark H. Davis, "Empathy: Negotiating the Border Between Self and Other," in *The Social Life of Emotions*, ed. Larissa Z. Tiedens and Colin Wayne Leach (New York: Cambridge University Press, 2004), 22.

18. Davis, "Empathy," 33–34.

19. Patricia M. Rodriguez Mosquera, "Honor and Harmed Social-Image. Muslims' Anger and Shame about the Cartoon Controversy," *Cognition and Emotion* (November 20, 2017). See also P. M. Rodriguez Mosquera, T. Khan, and A. Selya, "American Muslims' Anger and Sadness about In-Group Social Image," *Frontiers in Psychology* 7, article 2042 (2017): 1–9.

20. Sabri Ciftci, "Islamophobia and Threat Perceptions: Explaining Anti-Muslim Sentiment in the West," *Journal of Muslim Minority Affairs* 32, no. 3 (2002): 302.

21. Alice H. Eagly and Amanda B. Diekman, "What Is the Problem? Prejudice as an Attitude-in-Context," in *On the Nature of Prejudice: Fifty Years after Allport*, ed. John F. Dovidio, Peter Glick, and Laurie A. Rudmen (Hoboken, NJ: Blackwell, 2005), 25.

22. Public Religion Research Institute, "PRRI 2011 Pluralism, Immigration and Civic Integration Survey. August 1–August 14," 2011, 12–13.

23. Pew Research Center, "Republicans Prefer Blunt Talk about Islamic Extremism, Democrats Favor Caution," February 3, 2016, 3.

24. Eric Bradner, Dan Merica, and Jeremy Diamond, "Side by Side: How Clinton and Trump Respond to Attacks," CNN, September 22, 2016, accessed October 1, 2017, http://www.cnn.com/2016/09/18/politics/hillary-clinton-donald-trump-terror-attack-response.

25. Sherman A. Lee, Jeffrey A. Gibbons, John M. Thompson, and Hussam S. Timani, "The Islamophobia Scale: Instrument Development and Initial Validation," *International Journal for the Psychology of Religion* 19, no. 2 (2009): 98–100.

26. Abu Dhabi Gallup Center, "Muslim Americans: Faith, Freedom, and the Future," August 2011, 35.

27. Lydia Saad, "Anti-Muslim Sentiments Fairly Commonplace," Gallup, August 10, 2006, accessed May 5, 2017, http://www.gallup.com/poll/24073/antimuslim-sentiments-fairly-commonplace.aspx.

28. Abu Dhabi Gallup Center, "Muslim Americans," 39–40. This pattern, however, did not hold for Mormons, who were most likely after Muslims to have experienced discrimination in the past year. Yet they were least likely to agree that Muslim Americans faced prejudice and as likely as Protestants to say Muslims in the United States were loyal.

29. Pew Research Center, "Americans Express Increasingly Warm Feelings toward Religious Groups," February 15, 2017, 8, 19.

30. See the multiple examples of this in Gottschalk, *American Heretics*.

31. Sahil Kapur, "Fox Devotees Twice as Likely to Fear Sharia Law in US: Poll," Raw Story, February 17, 2011, accessed May 5, 2017, http://www.rawstory.com/2011/02/fox-devotees-twice-as-likely-to-fear-sharia-law-in-us-poll.

32. "State Legislation Restricting Use of Foreign or Religious Law," Pew Research Center, April 8, 2013, accessed February 25, 2018, http://www.pewforum.org/2013/04/08/state-legislation-restricting-use-of-foreign-or-religious-law.

33. Greg Sargent, "Poll: Fox News Watchers Far More Likely to Have Negative Views of Muslims," *Washington Post*, February 16, 2011, accessed May 5, 2017, http://voices.washingtonpost.com/plum-line/2011/02/poll_fox_news_watchers_far_mor.html.

34. See Denise Spellberg, *Thomas Jefferson's Qur'an: Islam and the Founders* (New York: Vintage, 2014), and Allison, *Crescent Obscured*.

35. Jade Boyd, "Bomb Tears Apart Oklahoma City Federal Building," UPI, April 19, 1995, accessed May 7, 2017, http://www.upi.com/Archives/1995/04/19/Bomb-tears-apart-Oklahoma-City-federal-building/9530023433931.

36. Council on American-Islamic Relations, "A Rush to Judgement: A Special Report on Anti-Muslim Stereotyping, Harassment and Hate Crimes Following the Bombing of Oklahoma City's Murrah Federal Building, April 19, 1995," September 1995.

37. Public Religion Research Institute, "PRRI 2011 Pluralism, Immigration and Civic Integration Survey," 14.

38. Daniella Diaz, "Obama: Why I Won't Say 'Islamic Terrorism,'" CNN, September 29, 2016, accessed October 2, 2017, http://www.cnn.com/2016/09/28/politics/obama-radical-islamic-terrorism-cnn-town-hall/index.html.

39. A survey of law enforcement officials demonstrates this disparity in threat assessments of Muslims and right-wingers. See Charles Kurzman, Ahsan Kamal, and Hajar Yazdiha, "Ideology and Threat Assessment: Law Enforcement Evaluation of Muslim and Right-Wing Extremism," *Socius* 3 (2017): 1–13.

40. Christopher Allen and Jørgen S. Nielsen, "Summary Report on Islamophobia in the EU after 11 September 2001," http://fra.europa.eu/sites/default/files/fra_uploads/199-Synthesis-report_en.pdf.

41. "Update: Incidents of Hateful Harassment Since Election Day Now Number 701," SPLC, November 18, 2016, accessed May 7, 2017, https://www.splcenter.org/hatewatch/2016/11/18/update-incidents-hateful-harassment-election-day-now-number-701.

42. Ciftci, "Islamophobia and Threat Perceptions," 307.

43. United States General Accountability Office, "Countering Violent Extremism: Actions Needed to Define Strategy and Assess Progress of Federal Efforts," April 2017, 4–5.

44. Kevin N. Ochsner et al., "Rethinking Feelings: An fMRI Study of the Cognitive Regulation of Emotion," *Journal of Cognitive Neuroscience* 14, no. 8 (2002): 1215–29. Thanks to Charles Sanislow for this reference.

45. For the use of editorial cartoons and other art forms in this extreme othering, see Keen, *Faces of the Enemy*.

46. Davis, "Empathy," 19–28, 34.

47. Asra Q. Nomani, "I'm a Muslim, a Woman and an Immigrant. I Voted for Trump," *Washington Post*, November 10, 2016, accessed May 14, 2017, https://www.washingtonpost.com/news/global-opinions/wp/2016/11/10/im-a-muslim-a-woman-and-an-immigrant-i-voted-for-trump/?utm_term=.bcc32f391ebe.

Chapter 8: Moving Pictures:
The Trope of "Islamic Terrorism"

1. "Sam Bacile—The Innocence of Muslims Trailer," accessed April 8, 2018, https://www.youtube.com/watch?v=YJBWCLeOEaM&bpctr=1523211876.

2. The original English version upload occurred in July 2012, but nearly no response followed until an Arabic version appeared two months later.

3. CBS News/*New York Times*, "Assessing Security and the Threat of Terrorism Ten Years Later," August 2011.

4. Pew Research Center, "Muslim Americans: No Signs of Growth in Alienation or Support for Extremism," August 30, 2011, accessed October 24, 2012, http://www .people-press.org/2011/08/30/muslim-americans-no-signs-of-growth-in-alienation-or -support-for-extremism/?src=prc-headline.

5. Nicole Naurath, "Most Muslim Americans See No Justification for Violence," Gallup, August 2, 2011, accessed November 3, 2012, http://www.gallup.com /poll/148763/muslim-americans-no-justification-violence.aspx.

6. Dina Smeltz, "Foreign Policy in the New Millennium: Results of the 2012 Chicago Council Survey of American Public Opinion and U.S. Foreign Policy," 2012, 25.

7. Pew Research Center, "Muslim Americans."

8. Bruce Hoffman, *Columbia Studies in Terrorism and Irregular Warfare*, rev. and enl. ed. (New York: Columbia University Press, 2006), 23.

9. See Hoffman, *Columbia Studies in Terrorism and Irregular Warfare*; and J. David Slocum, ed., *Terrorism, Media, Liberation* (Piscataway, NJ: Rutgers University Press, 2005).

10. Press release by the White House, August 6, 1945; Subject File, Ayers Papers; Harry S. Truman Library & Museum, accessed April 7, 2018, http://www .trumanlibrary.org/whistlestop/study_collections/bomb/large/documents/pdfs/59 .pdf#zoom=100.

11. See Holger Hoock, *Scars of Independence: America's Violent Birth* (New York: Crown, 2017).

12. Samuel P. Huntington, "The Clash of Civilizations?" *Foreign Policy* 72, no. 3 (Summer 1993): 22–49.

13. Frank Newport, "Americans Still Think Iraq Had Weapons of Mass Destruction before War," Gallup, June 16, 2003, accessed September 28, 2017, http://news .gallup.com/poll/8623/americans-still-think-iraq-had-weapons-mass-destruction-be fore-war.aspx.

14. Laurie Goodstein, "Pompeo and Bolton Appointments Raise Alarm Over Ties to Anti-Islam Groups," *New York Times*, April 6, 2018, accessed April 7, 2018, https://www.nytimes.com/2018/04/06/us/pompeo-bolton-muslims.html.

15. J. David Slocum, "Introduction: The Recurrent Return to Algiers," in *Terrorism, Media, Liberation*, 1–36.

16. See Jack Shaheen, *Guilty: Hollywood's Verdict on Arabs after 9/11* (Northampton, MA: Olive Branch Press, 2008); and *Reel Bad Arabs*.

17. Tatiana Siegel, "SEALs Storm B.O., sans SAG Card: 'Act of Valor' Stars Were Employed by U.S., Filmmakers Say," *Variety*, March 3, 2012, accessed October 24, 2012, http://variety.com/2012/film/box-office/seals-storm-b-o-sans-sag-card-1118050980.

18. Shaheen, *Guilty*, 500–504.

19. As explained by Dr. No in 1962, SPECTRE stands for SPecial Executive for Counter-intelligence, Terrorism, Revenge, Extortion.

20. Hoffman, *Columbia Studies in Terrorism and Irregular Warfare*, 16–17.

21. Shaheen, *Reel Bad Arabs*; *Guilty*.

22. The earlier *Delta Force* (1986) features a Catholic priest who pointedly argues against an angry Arab hijacker's claim that the navy had shelled Beirut. He gets beaten up for his trouble.

23. Although the film depicts the first Chechen character speaking caringly to his child in a phone call, the same scene reveals that he is, in fact, Jewish.

24. For more on narco-terrorism representations, see Robert Merrill, "Simulations and Terrors of Our Time," in Slocum, ed., *Terrorism, Media, Liberation*, 180–84.

25. "Lone Survivor," Stephen Follows Film Data and Education, accessed September 29, 2017, https://stephenfollows.com/resource-docs/scripts/Lone%20Survivor.pdf.

26. Faisal Shahzad left an inoperative car bomb in Times Square, New York, in May 2010.

27. "Ethics on Film: Discussion of 'Zero Dark Thirty,'" Carnegie Council for Ethics in International Affairs, March 11, 2013, accessed September 30, 2017, https://www.carnegiecouncil.org/publications/ethics_onfilm/0007.

28. Shaheen, *Guilty*, 142.

29. Shaheen, *Reel Bad Arabs*, 404–5.

30. The film's screenplay was written by Jim Webb, a Vietnam War veteran who later served as secretary of the US Navy and as a senator from Virginia.

31. Jordan Zakarin, "'Act of Valor' and the Military's Long Hollywood Mission," *HuffPost*, February 17, 2012, accessed September 25, 2012, http://www.huffingtonpost.com/2012/02/17/act-of-valor-military-hollywood_n_1284338.html.

32. "Sacha Baron Cohen Settles Slander Suit over Grocer Portrayed as Terrorist in Film," *Telegraph*, July 20, 2012, accessed September 24, 2017, http://www.telegraph.co.uk/news/worldnews/middleeast/palestinianauthority/9413864/Sacha-Baron-Cohen-settles-slander-suit-over-grocer-portrayed-as-terrorist-in-film.html.

33. "LOWES Will Not Advertise Again on *All-American Muslim*," Florida Family Association, accessed April 8, 2018, http://floridafamily.org/full_article.php?article_no=117.

34. "About Us," Florida Family Association, accessed April 8, 2018, http://floridafamily.org/full_article.php?article_no=94.

Conclusion: Common Denominators versus Essential Difference

1. Noam Cohan, "With Brash Hosts, Headline News Finds More Viewers in Prime Time," *New York Times*, December 4, 2006, C1.

2. "CNN Debunks False Report about Obama," CNN, January 23, 2007, accessed February 11, 2007, http://www.cnn.com/2007/POLITICS/01/22/obama.madrassa/index.html.

3. Matthew Schofield, "Historian Gets Prison for Denying the Holocaust," *Boston Globe*, February 21, 2006, accessed February 23, 2006, http://www.boston.com/news/world/europe/articles/2006/02/21/historian_gets_prison_for_denying_the_holocaust.

4. Njadvara Musa, "At Least 15 Die in Nigeria Cartoon Protest," Associated Press, February 19, 2006.

5. Michelmore, "Old Pictures in New Frames," 47.

6. Aydin, *The Idea of the Muslim World.*

7. We thank Vijay Pinch for this suggestion.

Select Bibliography

Note: The bibliography is organized with the following headings:

Islam and Muslim Cultures

Abdo, Geneive. *Mecca and Main Street: Muslim Life in America after 9/11*. New York: Oxford University Press, 2006.

Ahmed, Leila. *A Border Passage: From Cairo to America—A Woman's Journey*. New York: Penguin, 2000.

———. *A Quiet Revolution: The Veil's Resurgence, from the Middle East to America*. Cambridge, MA: Cambridge University Press, 2012.

Asad, Talal. *Formations of the Secular: Christianity, Islam, Modernity*. Stanford, CA: Stanford University Press, 2003.

Aydin, Cemil. *The Idea of the Muslim World: A Global Intellectual History*. Cambridge, MA: Harvard University Press, 2017.

Ayoub, Mahmoud M. *The Qur'an and Its Interpreters*. 2 vols. Albany, NY: SUNY Press, 1984.

Brougher, Cynthia. "Application of Religious Law in U.S. Courts: Selected Legal Issues," Congressional Research Service. May 18, 2011.

Burckhardt, Titus. *Mirror of the Intellect: Essays on Traditional Science & Sacred Art.* Translated by William Stoddart. Albany, NY: SUNY Press, 1987.

Denny, Frederick. *An Introduction to Islam.* 4th ed. New York: Macmillan, 2010.

El Guindi, Fadwa. *Veil: Modesty, Privacy and Resistance (Dress, Body, Culture).* New York: Berg, 1999.

Ernst, Carl W. *Following Muhammad: Rethinking Islam in the Contemporary World.* Chapel Hill: University of North Carolina Press, 2003.

———. *The Shambhala Guide to Sufism.* Boulder, CO: Shambhala Press, 1997.

Esposito, John, ed. *The Oxford Encyclopedia of the Islamic World.* 6 vols. New York: Oxford University Press, 2003.

———. *The Oxford History of Islam.* New York: Oxford University Press, 1999.

Fakhry, Majid, trans. *An Interpretation of the Qur'an: English Translation of the Meanings.* New York: NYU Press, 2004.

Fernando, Mayanthi. *The Republic Unsettled: Muslim French and the Contradictions of Secularism.* Durham, NC: Duke University Press, 2014.

GhaneaBassiri, Kambiz. *A History of Islam in America: From the New World to the New World Order.* Cambridge, MA: Harvard University Press, 2010.

Haddad, Yvonne Yazbeck, Jane I. Smith, and Kathleen M. Moore. *Muslim Women in America: The Challenge of Islamic Identity Today.* 2006. Reprint, New York: Oxford University Press, 2011.

Hafez, Sherine. *An Islam of Her Own: Reconsidering Religion and Secularism in Women's Islamic Movements.* New York: NYU Press, 2011.

Hodgson, Marshall. *The Venture of Islam.* 3 vols. Chicago: University of Chicago Press, 1974.

Ibn Ishaq, Musa. *The Life of Muhammad.* Translated by A. Guillaume. Karachi: Oxford University Press, 1987.

Kamali, Mohammad Hashim. *Shari'ah Law: An Introduction.* Oxford: OneWorld, 2008.

Khabeer, Su'ad Abdul. *Muslim Cool: Race, Religion, and Hip Hop in the United States.* New York: NYU Press, 2016.

Kurzman, Charles, ed. *Liberal Islam: A Sourcebook.* New York: Oxford University Press, 1998.

Lawrence, Bruce. *The Qur'an: Books That Changed the World.* London: Atlantic Books, 2008.

Mahmood, Saba. *Politics of Piety: The Islamic Revival and the Feminist Subject.* Princeton, NJ: Princeton University Press, 2011.

Marzouki, Nadia. *Islam: An American Religion.* 2013. Reprint, New York: Columbia University Press, 2017.

Meijer, Roel, ed. *Global Salafism: Islam's New Religious Movement.* London: Hurst & Company, 2009.

Nasr, Seyyed Hossein, Caner K. Dagli, Maria Massi Dakake, Joseph E. B. Lumbard, and Mohammed Rustom, eds. *The Study Quran: A New Translation and Commentary.* New York: HarperOne, 2015.

Ruffle, Karen. *Gender, Sainthood, and Everyday Practice in South Asian Shi'ism.* Charlotte, NC: University of North Carolina Press, 2011.

Smith, Jane I. *Islam in America*. 2nd ed. New York: Columbia University Press, 2009.

Volokh, Eugene. "Religious Law (Especially Islamic Law) in American Courts." *Oklahoma Law Review* 66, no. 3 (2014): 431–58.

Zaky, A. R. "Medieval Arab Arms." In *Islamic Arms and Armour*, edited by Robert Elgood, 202–12. London: Scholar Press, 1979.

Zuhur, Sherifa. *Revealing Reveiling: Islamist Gender Ideology in Contemporary Egypt*. Albany, NY: SUNY Press, 1992.

Historical Interactions

Achinger, Christine, and Robert Fine, eds. *Antisemitism, Racism and Islamophobia: Distorted Faces of Modernity*. New York: Routledge, 2015.

Allison, Robert J. *The Crescent Obscured: The United States and the Muslim World, 1776–1815*. New York: Oxford University Press, 1996.

Alvandi, Roham. *Nixon, Kissinger, and the Shah: The United States and Iran in the Cold War*. New York: Oxford University Press, 2016.

Ambrose, Stephen E., and Douglas G. Brinkley. *Rise to Globalism: American Foreign Policy since 1938*. New York: Penguin, 1997.

Asbridge, Thomas. *The First Crusade: A New History*. New York: Oxford University Press, 2004.

Austin, Allan D. *African Muslims in Antebellum America: Transatlantic Stories and Spiritual Struggles*. New York: Routledge, 1997.

Bull, Narcus. "Origins." In *The Oxford Illustrated History of the Crusades*, edited by Jonathan Riley-Smith, 13–33. New York: Oxford University Press, 1995.

Bulliet, Richard. *America and the Muslim World—A Series of Five E-Seminars*. Columbia Interactive. 2004. http://ci.columbia.edu.

Columbus, Christopher. *The* Libro de las profecías *of Christopher Columbus: An en face edition*. Translated by Delno West and August Kling. Gainesville: University of Florida Press, 1992.

Diouf, Sylviane A. *Servants of Allah: African Muslims Enslaved in the Americas*. New York: New York University Press, 1998.

Elgood, Robert, ed. *Islamic Arms and Armour*. London: Scholar Press, 1979.

Fromkin, David. *A Peace to End All Peace: The Fall of the Ottoman Empire and the Creation of the Modern Middle East*. New York: Henry Holt, 1989.

Gomez, Michael A. *Exchanging Our Country Marks: The Transformation of African Identities in the Colonial and Antebellum South*. Chapel Hill: University of North Carolina Press, 1998.

Greene, Molly. *A Shared World: Christians and Muslims in the Early Modern Mediterranean*. Princeton, NJ: Princeton University Press, 2000.

Hahn, Peter. "National Security Concerns in U.S. Policy toward Egypt, 1949–1956." In *The Middle East and the United States: A Historical and Political Reassessment*, edited by David W. Lesch, 89–99. Boulder, CO: Westview Press, 2003.

Hoffman, Bruce. *Columbia Studies in Terrorism and Irregular Warfare*. Revised and enlarged edition. New York: Columbia University Press, 2006.

Housley, Norman. "The Crusading Movement: 1274–1700." In *The Oxford Illustrated History of the Crusades*, edited by Jonathan Riley-Smith, 260–93. New York: Oxford University Press, 1995.

Hussain, Amir. *Muslims and the Making of America*. Waco, TX: Baylor University Press, 2017.

Mueller, John. *Policy and Opinion in the Gulf War*. Chicago: University of Chicago, 1994.

Nickel, Helmut. "A Crusader's Sword: Concerning the Effigy of Jean d'Alluye." *Metropolitan Museum Journal* 26 (1991): 123–28.

Ninkovich, Frank. *The United States and Imperialism*. Oxford: Blackwell, 2001.

Riley-Smith, Jonathan, ed. *The Crusades, Christianity, and Islam*. New York: Columbia University Press, 2011.

———, ed. *The Oxford Illustrated History of the Crusades*. New York: Oxford University Press, 1995.

Rubinstein, Amnon. *The Zionist Dream Revisited: From Herzl to Gush Emunim and Back*. New York: Schocken, 1984.

Seltzer, Robert M. *Jewish People, Jewish Thought: The Jewish Experience in History*. New York: Macmillan, 1980.

Siberry, Elizabeth. "Images of the Crusades in the Nineteenth and Twentieth Centuries." In *The Oxford Illustrated History of the Crusades*, edited by Jonathan Riley-Smith, 365–85. New York: Oxford University Press, 1995.

Slocum, J. David, ed. *Terrorism, Media, Liberation*. Piscataway, NJ: Rutgers University Press, 2005.

Spellberg, Denise. *Thomas Jefferson's Qur'an: Islam and the Founders*. New York: Vintage, 2014.

Watt, W. Montgomery. *The Influence of Islam on Medieval Europe*. Edinburgh: Edinburgh University Press, 1972.

X, Malcolm. *An Autobiography*. New York: Ballantine, 1964.

Contemporary Muslim Perceptions of Islamophobia

Ali-Karamali, Sumbul. *The Muslim Next Door: The Qur'an, the Media, and That Veil Thing*. Ashland, OR: White Cloud, 2008.

Bakalian, Anny, and Medhi Bozorgmehr. *Backlash 9/11: Middle Eastern and Muslim Americans Respond*. Berkeley: University of California Press, 2009.

Esposito, John L., and Dalia Mogahed. *Who Speaks for Islam? What a Billion Muslims Really Think*. New York: Gallup, 2007.

Garrod, Andrew, and Robert Kilkenny, eds. *Growing Up Muslim: Muslim College Students in America Tell Their Life Stories*. Ithaca, NY: Cornell University Press, 2014.

Klausen, Jytte. *The Cartoons That Shook the World*. New Haven, CT: Yale University Press, 2009.

Morey, Peter. *Islamophobia and the Novel*. New York: Columbia University Press, 2018.

Nimer, Mohamed, ed. *Islamophobia and Anti-Americanism: Causes and Remedies.* Beltsville, MD: Amana, 2007.

Peek, Lori A. *Behind the Backlash: Muslim Americans after 9/11.* Philadelphia: Temple University Press, 2010.

Muslim Perceptions of Non-Muslim Westerners

Ahmed, Leila. *A Border Passage.* New York: Penguin, 1999.

Al-Jabarti, Abd al Rahman. *Napoleon in Egypt: Al-Jabarti's Chronicle of the French Occupation, 1798.* Princeton, NJ: Markus Wiener, 1997.

Bin Laden, Osama. *Messages to the World: The Statements of Osama bin Laden.* Edited by Bruce Lawrence. New York: Verso, 2005.

Gopal, Anand. *No Good Men among the Living: America, the Taliban, and the War through Afghan Eyes.* New York: Picador, 2014.

Hay, Stephen, ed. *Sources of Indian Tradition.* Vol. 2, *Modern India and Pakistan.* New York: Columbia University Press, 1988.

Khan, Syed Ahmad. "The Importance of Modern Western Education." In chapter 5 of *Sources of Indian Tradition.* Vol. 2, *Modern India and Pakistan*, edited by Stephen Hay, 188–90. New York: Columbia University Press, 1988.

———. *A Voyage to Modernism: Syed Ahmed Khan.* Translated by Mushirul Hasan and Nishat Zaidi. Delhi: Primus, 2011.

Mahomet, Dean. *The Travels of Dean Mahomet: An Eighteenth-Century Journey through India.* Translated by Michael Fisher. Berkeley: University of California Press, 1997.

Rushdie, Salman. *The Satanic Verses.* New York: Viking, 1988.

Contemporary Non-Muslim Western Perceptions of Muslims

Abu-Lughod, Lila. *Do Muslim Women Need Saving?* Cambridge, MA: Harvard University Press, 2015.

Allen, Chris. *Islamophobia.* New York: Routledge, 2010.

Ernst, Carl W., ed. *Islamophobia in America: The Anatomy of Intolerance.* New York: Palgrave Macmillan, 2013.

Esposito, John, and Ibrahim Kalin, eds. *Islamophobia: The Challenge of Pluralism in the 21st Century.* New York: Oxford University Press, 2011.

Gottschalk, Peter. *American Heretics: Catholics, Jews, Muslims, and the History of Religious Intolerance.* New York: Palgrave Macmillan, 2013.

Halliday, Fred. *Islam and the Myth of Confrontation.* London: I. B. Tauris, 1995.

Jackson, Sherman. *Islam and the Blackamerican: Looking toward the Third Resurrection.* New York: Oxford University Press, 2011.

———. "Muslims, Islam(s), Race, and American Islamophobia." In *Islamophobia: The Challenge of Pluralism in the 21st Century*, edited by John L. Esposito and Ibrahim Kalin, 93–106. New York: Oxford University Press, 2011.

Kurzman, Charles, Ahsan Kamal, and Hajar Yazdiha. "Ideology and Threat Assessment: Law Enforcement Evaluation of Muslim and Right-Wing Extremism," *Socius* 3 (2017): 1–13.

Lean, Nathan. *The Islamophobia Industry: How the Right Manufactures Fear of Muslims.* London: Pluto Press, 2012.

Malik, Maleiha, ed. *Anti-Muslim Prejudice: Past and Present.* New York: Routledge, 2010.

Mamdani, Mahmood. *Good Muslim, Bad Muslim: America, the Cold War, and the Roots of Terror.* New York: Pantheon, 2004.

McAlister, Melani. *Epic Encounters: Culture, Media, and U.S. Interests in the Middle East, 1945–2000.* Berkeley: University of California Press, 2001.

Morey, Peter, and Amina Yaqin. *Framing Muslims: Stereotyping and Representation after 9/11.* Cambridge, MA: Harvard University Press, 2011.

Qureshi, Emran, and Michael A. Sells, eds. *The New Crusades: Constructing the Muslim Enemy.* New York: Columbia University Press, 2003.

Said, Edward. *Covering Islam.* Rev. ed. New York: Vintage, 1997.

Sayyid, S., and AbdoolKarim Vakil, eds. *Thinking through Islamophobia: Global Perspectives.* New York: Columbia University Press, 2010.

Shaheen, Jack G. *Guilty: Hollywood's Verdict on Arabs after 9/11.* Northampton, MA: Olive Branch Press, 2008.

———. *Reel Bad Arabs: How Hollywood Vilifies a People.* New York: Olive Branch Press, 2001.

Sheehi, Stephen. *Islamophobia: The Ideological Campaign against Muslims.* Atlanta: Clarity Press, 2011.

Woods, John E. "Imagining and Stereotyping Islam." In *Muslims in America: Opportunities and Challenges,* edited by Asad Husain, John E. Woods, and Javeed Akhter, 45–77. Chicago: International Strategy and Policy Institute, 1996.

Historical Non-Muslim Western Perceptions of Muslims

Alighieri, Dante. *The Divine Comedy.* Translated by Henry Francis Cary. New York: Thomas Y. Crowell & Company, 1897.

Bayoumi, Moustafa. "Racing Religion." *CR: The New Centennial Review* 6, no. 2 (2006): 267–93.

Belt, Don, ed. *The World of Islam.* Washington, DC: National Geographic, 2001.

Benjamin, Roger, ed. *Orientalism: Delacroix to Klee.* Sydney: Art Gallery of New South Wales, 1997.

Bourguignon, Erika. "Vienna and Memory: Anthropology and Experience." *Ethos* 24, no. 2 (June 1996): 374–87.

Daniel, Norman. *Islam and the West: The Making of an Image.* 1960. Reprint, Oxford: Oneworld, 1997.

Dowling, Ralph Edward. "Rhetorical Vision and Print Journalism: Reporting the Iran Hostage Crisis in America." PhD diss., University of Denver, 1984.

Edwards, Holly, ed. *Noble Dreams, Wicked Pleasures: Orientalism in America, 1870–1930*. Princeton, NJ: Princeton University Press, 2000.

Franklin, Benjamin. "On the Slave Trade." In *The Works of Benjamin Franklin: Consisting of Essays, Humorous, Moral, and Literary with His Life, Written by Himself*, 231–34. Halifax: H. Pohlman, 1837.

Gottschalk, Peter. *Religion, Science, and Empire: Classifying Hinduism and Islam in British India*. New York: Oxford University Press, 2012.

Greenberg, Gabriel M. Fenster. "Images of Islam in American Political Cartoons." BA thesis, Wesleyan University, 2004.

Hourani, Albert. *Islam in European Thought*. Cambridge: Cambridge University Press, 1991.

Kahf, Mohja. *Western Representations of the Muslim Woman: From Termagant to Odalisque*. Austin: University of Texas Press, 1999.

Key, Francis Scott. "Song." In *Poems of the Late Francis Scott Key, Esq*. New York: Robert Carter & Brothers, 1857.

Lippmann, Walter. *Public Opinion*. New Brunswick, NJ: Transaction, 1991.

Patton, George S., Jr. "The Form and Use of the Saber." *Cavalry Journal*, March 1913.

Reeves, Minou. *Muhammad in Europe: A Thousand Years of Western Myth-Making*. New York: New York University Press, 2000.

Said, Edward. *Orientalism*. New York: Vintage, 1979.

Sha'ban, Fuad. *Islam and Arabs in Early American Thought: The Roots of Orientalism in America*. Durham, NC: Acorn Press, 1991.

Shryock, Andrew, ed. *Islamophobia/Islamophilia: Beyond the Politics of Enemy and Friend*. Bloomington: Indiana University Press, 2010.

Slade, Shelly. "The Image of the Arab in America, Analysis of a Poll on American Attitudes." *Middle East Journal* 35, no. 2 (Spring 1981): 143–62.

Southern, R. W. *Western Views of Islam in the Middle Ages*. 1962. Reprint, Cambridge, MA: Harvard University Press, 1980.

Stockton, Ronald. "Ethnic Archetypes and the Arab Image." In *The Development of Arab-American Identity*, edited by Ernest McCarus, 119–53. Ann Arbor: University of Michigan Press, 1994.

Strickland, Debra Higgs. *Saracens, Demons, & Jews: Making Monsters in Medieval Art*. Princeton, NJ: Princeton University Press, 2003.

Twain, Mark. *The Innocents Abroad*. New York: Modern Library, 2003.

Van Voorst, Robert E. *Readings in Christianity*. New York: Wadsworth, 1997.

Political Cartoons

Block, Herbert. *Herblock's State of the Union*. New York: Simon & Schuster, 1972.

Damon, George H., Jr. "A Survey of Political Cartoons Dealing with the Middle East." In *Split Vision*, edited by Edmund Ghareeb, 143–54. Washington, DC: American-Arab Affairs Council, 1983.

Dewey, Donald. *The Art of Ill Will: The Story of American Political Cartoons*. New York: NYU Press, 2008.

Feaver, William. "Introduction." In *Masters of Caricature*, edited by Ann Gould, 8–39. New York: Knopf, 1981.

Fisher, Roger. *Them Damned Pictures, Exploration in American Political Cartoon Art*. North Haven, CT: Archon, 1996.

Foreign Policy Association. *A Cartoon History of United States Foreign Policy, 1776–1976*. New York: William Morrow, 1975.

Göçek, Fatma Müge, ed. *Political Cartoons in the Middle East*. Princeton, NJ: Markus Wiener, 1998.

Gould, Ann, ed. *Masters of Caricature*. New York: Knopf, 1981.

Halloran, Fiona Deans. *Thomas Nast: The Father of Modern Political Cartoons*. Durham, NC: University of North Carolina Press, 2013.

Harrison, Randall P. *The Cartoon: Communication to the Quick*. Beverly Hills, CA: SAGE, 1981.

Hess, Stephen, and Milton Kaplan. *The Ungentlemanly Art: A History of American Political Cartoons*. Rev. ed. New York: Macmillan, 1975.

Hoff, Syd. *Editorial and Political Cartooning: From Earliest Times to the Present, with Over 700 Examples from the Works of the World's Greatest Cartoonists*. New York: Stravon Educational Press, 1976.

Keen, Sam. *Faces of the Enemy: Reflections of the Hostile Imagination*. New York: Harper & Row, 1991.

Kelly, Walt. "Pogo Looks at the Abominable Snowman." In *The Funnies: An American Idiom*, edited by David Manning White and Robert Abel, 284–92. New York: Free Press of Glencoe, 1963.

Kemnitz, Thomas Milton. "The Cartoon as a Historical Source." *Journal of Interdisciplinary History* 4, no. 1 (Summer 1973): 89–93.

Mauldin, Bill. *Up Front*. New York: Henry Holt, 1945.

Michelmore, Christina. "Old Pictures in New Frames: Images of Islam and Muslims in Post World War II American Political Cartoons." *Journal of American & Comparative Cultures* 23 (Winter 2000): 37–50.

Navasky, Victor S. *The Art of Controversy: Political Cartoons and Their Enduring Power*. New York: Knopf, 2013.

Northrop, Sandy. *American Political Cartoons: The Evolution of a National Identity, 1754–2010*. Rev. ed. New York: Routledge, 2011.

Schiffrin, André. *Dr. Seuss & Co. Go to War: The World War II Editorial Cartoons of America's Leading Comic Artists*. New York: New Press, 2011.

Somers, Paul P., Jr. *Editorial Cartooning and Caricature: A Reference Guide*. Westport, CT: Greenwood Press, 1998.

Walker, Rhonda. "Political Cartoons: Now You See Them!" *Canadian Business and Current Affairs* 26, no. 1 (Spring 2003): 16–20.

Westin, Alan F., A. Robbins, and R. Rothenberg, eds. *Getting Angry Six Times a Week: A Portfolio of Political Cartoons*. Boston: Beacon Press, 1979.

Index

Page references are *italicized* for images and **boldfaced** for definitions.

About the Authors

Peter Gottschalk is professor of religion and coordinator of Muslim studies at Wesleyan University. Among other books, he has authored *Religion, Science, and Empire: Classifying Hinduism and Islam in British India* (2012) and *American Heretics: Catholics, Jews, Muslims, and the History of Religious Intolerance* (2013).

Gabriel Greenberg graduated from Wesleyan University. He is the rabbi of Congregation Beth Israel in New Orleans.